IMAGE EVALUATION
FOR AERIAL PHOTOGRAPHY

Publishers
FOCAL PRESS LIMITED
31, *Fitzroy Square, London, W.1, England.*

IMAGE EVALUATION
FOR AERIAL PHOTOGRAPHY

An Appraisal of Current Techniques

G. C. Brock, *M.Sc., F.R.P.S.*

THE FOCAL PRESS
LONDON and NEW YORK

Printed and bound in Great Britain by
A. Wheaton & Co., Exeter, Devon

CONTENTS

To American Friends

8

PREFACE

Those of us with long enough memories cannot fail to be impressed by the progress in photographic image-evaluation. Thirty years ago, even in aerial photography, always a fairly sophisticated branch of the art, and one vitally concerned with the recording of fine detail, there was little understanding of the basic factors that determine micro image quality. It seemed impossible to bridge the gap between the aberration calculations of the lens designer and the image quality of the aerial photograph, and to get a common language for all parties in the development and use of the aerial camera. Only a few pioneers saw how to do this with the aid of the optical transfer function (OTF), and developed physical-mathematical models of the photographic system. The full benefit of these ideas was not reaped until many years later, and the pressure for their application came from optical physicists and workers in other technologies, such as television, rather than from the photographers. As an interim bridge between lens performance and image quality in the photograph, resolving power, already used for many decades, was systematised and intensively applied, under the pressures of World War II. Resolving power then became frozen into the fabric of aerial photography, and remains paramount to this day. In the newer approach to image evaluation, the separate physical factors that together determine resolving power and other aspects of image quality are isolated for precise measurement. The OTF, in particular, can be the basis of a more accurate evaluation of lens performance, which is convertible into practically useful terms, unifies several aspects of aerial photography, and facilitates understanding of image quality, at sizes of detail moderately greater than the resolution limit. The accompanying Fourier theory, advanced techniques of microdensitometry and other instrumentation, and the application of large computers, have transformed and enormously enlarged the scope and applications of image evaluation.

In all this, however, there are certain dangers. The concepts and techniques of modern image evaluation, indispensable for advanced purposes, seem to be getting away from many engineers and practitioners in aerial photography. There has been a tendency to exaggerate the advantages of the OTF, to condemn resolving power for wrong reasons, and to believe that these two approaches to image evaluation are mutually exclusive. Such misunderstandings arose because the physicists who introduced the new concepts had inadequate experience of aerial photographic practice, while photographers failed to understand the physical nature of the OTF. Many photographic engineers, users of aerial photography, and others, who may not have access to large computers, elaborate OTF measuring equipment, or even sophisticated microdensitometers, nevertheless need to know more of the background and basis of the new techniques. It is bad for any society to be subservient to its experts; we can be grateful for what they give us without abandoning our right to our own opinion as to when it is useful, necessary, and within our means. When we appreciate the real

significance of an *accurate* measurement of the OTF, the cost of obtaining reliable data for aerial lenses, and the problems of interpreting what we get, we may suspect that we are in some danger of being taken for a ride on a tiger. In such situations, we should know enough about the new concepts to be able to form sound opinions about their value for our own problems.

This book is an attempt to meet what I felt to be a need, not a textbook, but an appraisal in simple terms of the newer ideas and their reaction on older ideas, with the needs of aerial photography foremost in mind. It follows current thought by first treating the optical image or "signal" in both spatial and spatial-frequency terms (Chapters I through IV). The grain or "noise" of the photographic image is introduced, via resolving power, in Chapter V. The importance of resolving power as the established and actually-used criterion of performance in aerial photography called for the extended discussion of its oft-proclaimed but little-appreciated limitations, as well as its advantages, and its derivation from the MTF, in Chapters V through VIII. Chapter IX discusses physical versus subjective assessments, and the problems of finding a "summary measure of image quality". Finally, Chapter X makes suggestions for what appear to be the more pressing needs in image evaluation within the aerial photographic community.

The book inevitably has a personal slant, and is far from a complete account, even within its limited scope. I am only too aware of the omission of much valuable material from the huge literature. Unfortunately it was not possible to discuss the optimisation of aerial systems, details of instrumentation, and image processing, within the present text. No doubt some expert readers will disagree with my interpretations. I trust that some of the other readers will be sufficiently interested to start arguments, the mainspring of all progress.

It was my privilege to spend some years in the United States aerial photographic community, and I cannot be sufficiently grateful for the stimulus of working in that environment. Invidious though it may be, when so many gave of their knowledge, I must pay tribute to my former colleagues at Itek Corporation, William L. Attaya and Brian O'Brien, Jnr. Dr. Duncan E. Macdonald and Col. Richard Philbrick gave frequent encouragement. Dr. F. Dow Smith, Robert R. Shannon, Geoffrey Harvey, Donald Kelly, Richard Barakat and Richard E. Swing did their best to improve my physical optics. I benefited from many discussions with Claus Aschenbrenner, Hutson K. Howell, Denis Kelsall, Louis Rosenblum, Robert Kohler, Jnr., Emil Myskowski, Richard Williams III, and others in the community too numerous to mention. So far as my text has any value it is due to contact with these workers; its weaknesses are my responsibility.

I particularly appreciate the help of Dr. D. A. Spencer and Mr. E. W. H. Selwyn in reading the MS. and offering constructive criticisms. Finally, I thank the Directors of W. Vinten Ltd. for permission to use material gathered in their laboratories.

Bury St. Edmunds G. C. Brock.

I. SPATIAL FREQUENCIES AND TRANSFER FUNCTIONS

1.1 *The Spread Function*

Our cameras image and record the objects in aerial scenes as areas of differing luminance in the picture plane. Ideally, the dimensions of these areas and the tonal transitions at their boundaries would be exact reduced scale facsimiles of the corresponding entities in the object space, whatever the size of the images might be. In practice there is a lower limit to the image size at which objects can be discriminated, and in approaching that size there is a progressive deterioration in the fidelity of the reproduction. This limit, and its neighbouring degradation, are consequences of the finite size of the image formed by a lens, even when the object, e.g. a star, is effectively of negligibly small dimensions. The size and intensity distribution within the star image are described by the *point spread function*, which is characteristic of the lens. If the

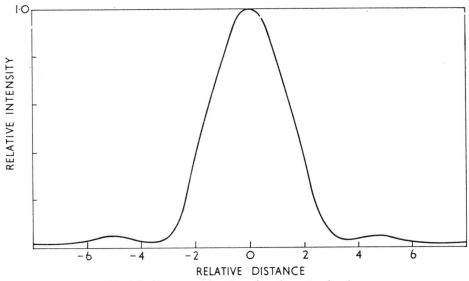

Fig. I.I Line spread function of an aberration free lens

star is replaced by a long line of light, e.g. a distant slit source, a section of the image gives a *line spread function*. Fig. 1.1 is the line spread function for an aberration free lens. When a narrow line image is formed on an emulsion, the light spreads out into a distribution not quite like Fig. 1.1, but of the same general form. The spread function concept can be extended to other sources of image degradation, e.g. image motion, or

11

the effective blurring due to atmospheric turbulence. At this point it is not necessary to pursue the differences between spread functions of different origin. The diameter of the spread function is obviously an important parameter, but the existence of different shapes precludes a single definition of effective size. For approximate designation, the diameter at the base (first minimum), or the diameter at the half intensity level (so-called "half-width") can be used.

The spread function is the pencil point with which the primary image is drawn, and certain consequences of its finite width are fairly obvious. Just as the finite size of the phonograph stylus sets a lower limit to the wavelength that can be traced on the record, so the finite diameter of the spread function limits the ability to separate or resolve the images of closely adjacent objects. Sharp edges in the object are blurred more or less in the image. Isolated objects will be recorded at reduced contrast according to their size relative to the spread function, and their outlines will be distorted. For the study of these effects in image evaluation it is convenient to use standard forms of object, typically the simple bar form, as used in resolving power targets. The intensity profile of such a bar is a rectangular pulse, but according to the image size and the form of the spread function the imaged profile may be more or less rounded off, the semblance of a rectangle may be lost, and the contrast may fall. The order of magnitude of such effects is illustrated in Fig. 1.2, based on the spread function shape of Fig. 1.1, which is that of an aberration free lens. Figs. 1.2*a*, *b*, and *c* show the intensity profiles that result when the nominal width of the image of a single bar is approximately 5, 1, and one quarter times the half width of the spread function. Figs. 1.2*d*, *e*, and *f* show the corresponding profiles for a two-bar image when the nominal bar image widths are approximately 2·5, 1 and 1/2·5 times the half width of the spread function. The rounding off of the profile is appreciable even when the bar is much wider than the half width, while the shape distortion and loss of contrast with further decrease in

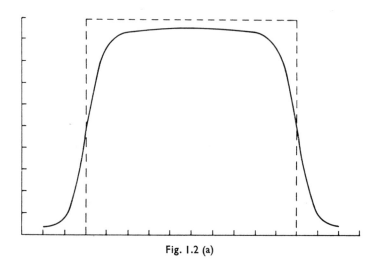

Fig. 1.2 (a)

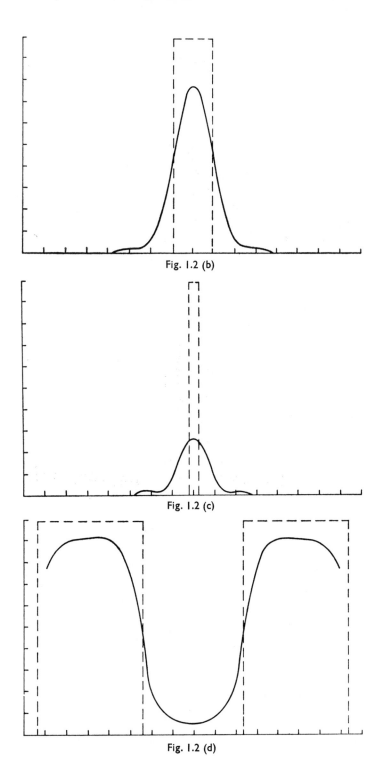

Fig. 1.2 (b)

Fig. 1.2 (c)

Fig. 1.2 (d)

13

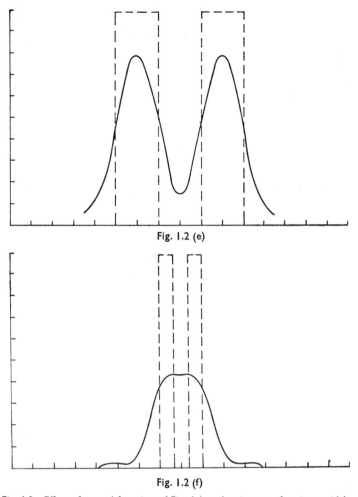

Fig. 1.2 (e)

Fig. 1.2 (f)

Fig. 1.2 Effect of spread function of Fig. 1.1 on bar images of various widths.

nominal image width are quite marked. With the two separated bars there is a noticeable fill-in between the bars at 2·5 half widths, at one half width the profile approximates to sinusoidal, and at 1/2·5 half widths the two images fuse into one. (The distance normally quoted as a resolving power is of course equal to two bar widths.)

1.2 *The Edge Spread Function*

The point and line spread functions define the performance of the imaging system in terms of an isolated patch of luminance of negligible size. The luminance is constant,

14

e.g. zero, over a finite distance, suddenly rises to a finite value for a very small distance, then as suddenly collapses again to the original level. In the limit, the luminance rises to an infinite value for an infinitely short distance, the total luminous flux within the patch (or unit length of the patch when it is infinitely long, for the line spread function) remaining equal to unity. This object generates the image which is the spread function. If the luminance does not collapse, but continues indefinitely at the new level, we have a step function or ideal edge object. The image of this is the *edge spread function*, which, also, is a valuable concept in image evaluation. Indeed, it has applications of a more practical nature than the line spread function, especially in aerial photography.

The relationship between the line spread function and edge spread function can be visualised from the graphical construction of Fig. 1.3. The discontinuity of the ideal edge or step function occurs at distance x_0; to the left, there is zero intensity, to the

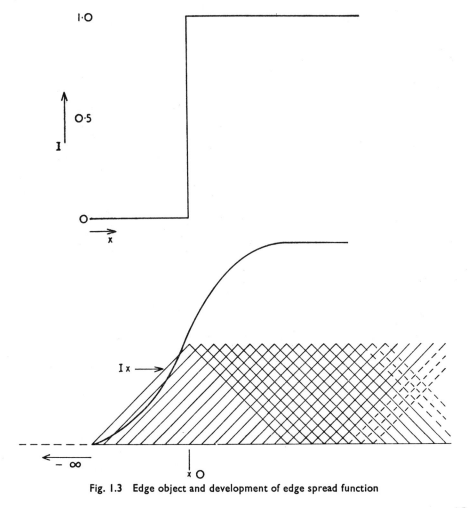

Fig. 1.3 Edge object and development of edge spread function

15

right, finite uniform intensity. We imagine the area of finite intensity or luminance to be made up of an infinite number of elementary lines at right angles to the paper. The images of these form a series of line spread functions, as suggested by the triangles in the lower part of the figure. (No real system has a triangular spread function, but this is a graphical convenience.) The first spread function is centred at x_0, with the series stretching to the right. Well to the right of x_0, the intensity contributions from all the spread functions add up to the same total at any value of x. Moving left, towards x_0 after a certain point (half the width of the spread function from x_0, in this case) the intensity begins to decline, since the spread functions stop at x_0 and the light lost by diffusion to the left is not made up by an equal inwards diffusion. Going out into space left of x_0, the contributions from the right of the edge-centred spread function gradually fall away, and we reach zero intensity at half the spread function width from x_0. The sigmoid curve is the summation of all the intensity contributions at each value of x (divided by a normalising constant). This is the edge spread function. If we started with the line spread function half a width to the left of x_0 and moved it to the right across the edge, the accumulated sum of ordinate intercepts would trace out the same edge spread function curve. The edge spread function's value at x_0 is proportional to the area swept out by the spread function as it crosses the edge moving in from minus infinity to be centred at this point, and correspondingly for other values of x. In this sense the edge spread function is the integral of the line spread function. The same argument holds good for any shape of line spread function, though if its shape is asymmetric, so also will be the edge spread function. In the figure the edge spread function is not quite symmetrical about the edge, due to the finite number of elements taken; the true integral necessarily crosses the edge at the half intensity point.

It follows that the line spread function is the differential of the edge spread function. Since it is easier, experimentally, to obtain the edge spread function than the line spread function, in many situations, while the line spread function is necessary for some methods of image analysis, differentiation of the edge spread function is sometimes resorted to. However, the errors of differentiation are considerable, and this technique is not a preferred one. A direct graphical utilisation of the edge spread function, which is often very useful in practice, is described in Chapter IV.

Image evaluation is largely concerned with images in the order of size within which profiles become distorted, contrasts fall, and resolution of separate objects is marginal. These effects are of particular importance in aerial photography, because the demand for the smallest possible scales often results in objects being recorded at image sizes which are too small for the desirable quality.

In most photographic systems there is another obvious cause of image degradatoin, i.e. the grain of the developed silver, which breaks up the smaller details and is an important determinant of the resolution limit. In analysing image quality we study the nature and consequences of the grain and the blurring due to the spread function as separate phenomena and also in conjunction. In general both are significant limitations on image quality in typical aerial photographs, but we shall defer consideration of grain until Chapter V.

16

So far, we have regarded the object and its image as extensions in two-dimensional space, or one dimensional space in the case of the bar target. It would seem natural, obvious and inevitable to analyse and operate on the image directly, just as we see it. However, there are difficulties in the intuitively obvious approach. It would be convenient if we could describe the deterioration of image quality with decreasing image size as a function of a single variable, and combine the degradations due to two or more causes in some simple way. But the degradation for even the simplest objects cannot be described by a single variable; as Fig. 1.2 shows, there is a simultaneous variation in both shape and contrast. Image profiles can certainly be found by convolution of the ideal image with the spread function, as illustrated for very simple cases in Fig. 1.3. If the spread function is an infinitely narrow pulse, and this is smeared across the ideal image, the trace of the common areas at each point repeats the ideal image of a bar (Fig. 1.4a). But if the spread function is, say, a rectangle identical with the ideal image, and the smearing is carried out as before, with recording of the normalized common areas at each small step, the trace is a triangular function on twice the baselength (Fig. 1.4b). (This comparison recalls the light transmission function when the slit of the focal plane shutter in an aerial camera is moved across the cone of light from the lens, first on the focal plane, then at some distance up the cone.) Convolution can be performed when the spread function has

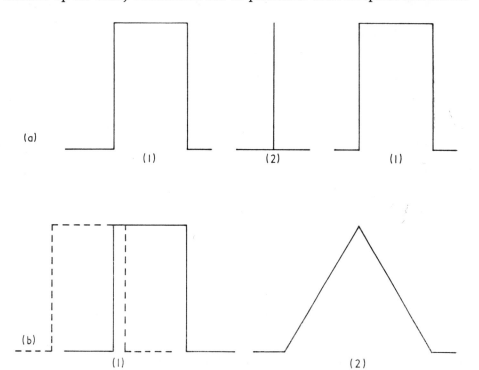

Fig. I.4 Derivation of image profiles by convolution of scaled object profile with spread functions

17

any shape, and not just the very simple shapes shown here, but it becomes very tedious, especially when several successive operations have to be performed. It would be much easier to deal with objects whose shape did not change when imaged, and for which the image contrast could be predicted from a known characteristic function of the lens. Such objects and functions do exist, notably the sinusoidal target and modulation transfer function, which have come to play so large a part in modern image evaluation techniques.

1.3 *The Sinusoidal Target*

The simple bar target, of high contrast, i.e. white bars on a black ground, alternates between intensities of unity and zero in each period, a period being the distance between corresponding points, e.g. points where the intensity is just beginning to rise from zero. If the typical small number of bars is increased, the profile recalls the electrical engineer's "square wave", with the differences that the intensity variation is at intervals of space instead of time, and is always positive, since the intensity of an optical target, unlike an electrical voltage, cannot be negative. (In the actual electromagnetic disturbance, the amplitude can be negative, but light is observed in intensity, which is the square of amplitude and hence is always positive.) The target might be regarded as a biased square wave. Objections have been raised to the term "square wave", and "crenellate object" has been proposed, but square wave is now well established and we shall use it. Although the square wave looks one of the simplest possible objects, its mathematical description is not very simple, and is in fact approached through the sinewave. The sine wave, or sinusoidal target, looks extremely complicated to the non-mathematician, but mathematically it is one of the simplest forms.

Fig. 1.5 shows a square wave and a sinewave of equal period. If abcissa distances are represented by x, and I(x) is the intensity at any distance x, then the functional form of the sinusoidal target is defined by:

$$I(x) = A + B \cos 2\pi k x,$$

where k is the parameter for *spatial frequency*, i.e. the reciprocal of the period. So far as the waveform is concerned, it is obviously immaterial whether sine or cosine is used, but the requirements for expressing phase are met by assuming the wave to start with value $1 \cdot 0$ at zero distance, i.e. a cosine. Spatial frequency is usually measured in cycles per mm, analogous to cycles per second for temporal frequencies. A and B are constants. A is necessary for biasing, since a sine wave goes negative in alternate half cycles, whereas the intensity of a real sinusoidal target must always be positive or zero. B/A is the *modulation* of the target, i.e. the ratio of the alternating to the steady intensity, or, in electrical analogy, the ratio of the A.C. to the D.C. voltage. Modulation can have any value between 0 and 1. If the basic target is black and white, the modulation is $1 \cdot 0$; if we flood it with light (raise the D.C. level), the modulation drops

18

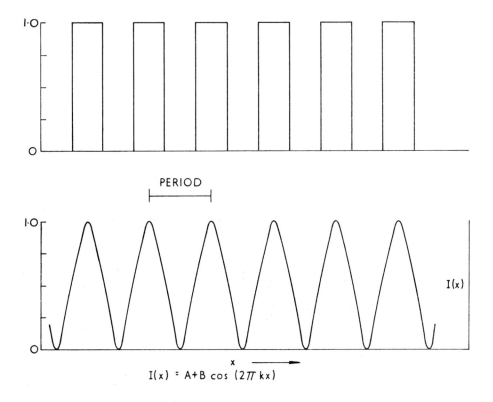

PERIOD

$I(x)$

x

$I(x) = A + B \cos (2\pi kx)$

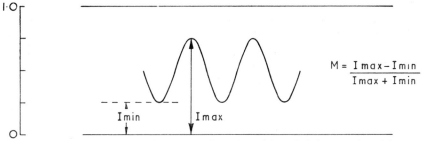

$$M = \frac{I\,max - I\,min}{I\,max + I\,min}$$

Imin Imax

Fig. 1.5 Square wave and sinewave of equal period, with definition of modulation

accordingly. Modulation is usually expressed in terms of the maximum and miminum intensities:

$$M = I_{max} - I_{min}/I_{max} + I_{min}$$

The term "modulation" is often applied to images of non-recurring waveforms such as three bar targets, but it can then be defined in more than one way, and care should always be taken to ensure that the meaning is quite clear.

19

It is convenient at this point to mention some other definitions of contrast and their relationship to modulation. Contrast may be defined as: Contrast Ratio, C; Lorgaithmic Contrast, C_1; or Differential Contrast, C_D.

$$C = I_{max}/I_{min}$$
$$C_1 = \log_{10} (I_{max}/I_{min})$$
$$C_D = I_{max} - I_{min}/I_{min}$$

Modulation and contrast are interconvertible according to the following relationships.

$$M = C_D/C_D + 2 = C - 1/C + 1 = 10^{\Delta D} - 1/10^{\Delta D} + 1$$
$$C_D = 2 M/1 - M = C - 1 = 10^D - 1$$
$$C = 1 + M/1 - M = C_D + 1 = 10^D$$
$$C_1 = \triangle D = \log_{10} (1 + M/1 - M) = \log_{10} (C_D + 1) = \log_{10} C_D$$

Fig. 1.6 is a graph of modulation against density difference. Modulation is seen to be roughly proportional to, and numerically equal to, density difference, for values up to 0·7. Tabulated values of modulation and density difference for practical use are given in Table 1, Appendix 2.

It is often desirable that equal steps on a physical scale of contrast should seem to correspond reasonably closely to subjective impressions. Contrast ratio is not good in this respect; for example a tenfold increase in contrast ratio, from 100 to 1 to 1000 to 1, seems a much smaller step visually than the twofold increase from 2 to 1 to 4 to 1.

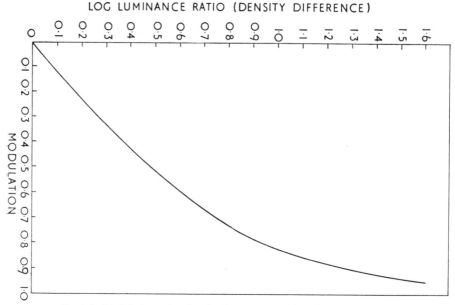

Fig. 1.6 Modulation related to luminance ratio and to density difference

Density difference is better over much of the range, but modulation is better still. The change from 100 to 1 to 1000 to 1 is a density difference change of $1 \cdot 0$, but only a two per cent change of modulation, corresponding much better to the small subjective difference. Defining contrast as the ratio of the extreme intensities to the mean intensity in the image does seem, *a priori*, to be a very suitable method.

1.4 *The Modulation Transfer Function*

When a sinusoidal target is imaged by a lens its modulation is reduced but the profile shape remains unaltered, i.e. the intensity at all points along the wave is reduced in the same proportion. The loss of modulation may be regarded as caused by a spillage of light from all parts of the image to adjacent parts, as determined by the convolution of the original target profile with the spread function. The drop in modulation will be small when the period in the image is large relative to the spread function diameter, but will increase as the period gets smaller. The factor which defines the reduction in image modulation at any spatial frequency is the *modulation transfer factor*, and the function which shows the variation of the modulation transfer factor with spatial frequency, k, is the *modulation transfer function* T(k). The modulation transfer function (commonly abbreviated to MTF) has a fixed shape for an aberration free lens, its actual values depending only on the aperture and wavelength of the light. There is a limiting or cutoff frequency k_c, at which the MTF falls to zero, given by: $k_c = 1/\lambda f$, where λ is the wavelength and f is the ordinary f-number of the lens. Between zero frequency and the cutoff the MTF falls almost linearly with frequency. For lenses with appreciable aberration, such as photographic lenses, the MTF is not simply defined and its course depends on the state of correction. In general the MTF's of practical lenses lie well below the MTF for the aberration free lens of the same aperture, though continuing, with very low values of modulation transfer factor, to the theoretical cutoff frequency. In a typical aerial lens the MTF might fall to the ten per cent level at 50 cycles per mm on axis and at ten cycles per mm off axis. Fig. 1.7 shows the MTF for an aberration free lens and a typical aerial camera lens of the same aperture, to illustrate the orders of magnitude involved.

The imagery of the sinewave at lower modulation but undistorted is somewhat analogous to the electrical case of a passive filter network, which transmits a sinusoidal waveform more or less weakened but still as a pure sinusoid. However, the analogy is not very close. In the electrical case, variation of amplitude transmission as a function of frequency is associated with the presence of reactive as well as resistive elements, and is accompanied by a phase shift, i.e. the wave train is advanced or retarded in time. In the simplest case, with one inductive or capacitative element, the phase shift is simply related to the frequency-dependent amplitude reduction and cannot be separated from it. The simplest optical case is the aberration-free lens, which has a symmetrical spread function and causes no shift of phase as the amplitude falls with increasing spatial frequency. When the aberrations are such as to give an asymmetrical spread

function, phase shifts are introduced, which in general are more pronounced at higher spatial frequencies, but the relationship is not simple. The displacement of the spatial frequency sinusoid from its true geometrical position does not necessarily increase monotonically with frequency. The MTF is therefore an incomplete description of the imaging performance of the lens in spatial frequency terms, and must be supplemented by information about the pase shift if this is appreciable; the complete description, amplitude and phase, is given by the *optical transfer function*, or OTF. Phase shift is further discussed in para 1.7; since, in general, phase shift as a function of spatial frequency only becomes appreciable when the MTF has fallen substantially, its effects in practice are not usually very serious, and the MTF alone is a good description of the lens performance.

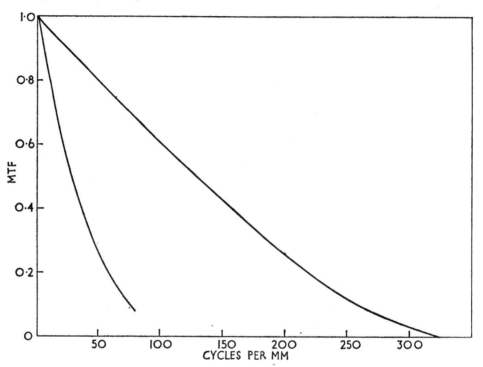

Fig. 1.7 Axial MTF for an *f* 5.6 aerial mapping lens, and MTF for an aberration free lens of the same aperture

We may note a further difference between the MTF and the frequency response of an electrical network or electronic amplifier, to which it is often compared. In most electronic cases, the amplifier can be designed to have a uniform response over the whole working frequency range. In the photographic case, the amplitude transmission falls steadily from zero frequency onwards, and although the MTF may exhibit minor rises and falls, we are never in the position of having uniform frequency response. This

22

is not very serious in many branches of photography, but in aerial photography the picture is always examined under the highest magnification that it will stand, thus we are working right to the limit of the bandwidth, where the MTF has fallen to a few per cent of its maximum value. It must be clearly appreciated that the MTF and OTF provide information only about the effect of the lens on sinusoidal targets over the range of spatial frequencies. Without further information they do not tell us anything about the quality of definition on objects which are not sinusoidal.

1.5 *Spatial Frequency Spectra*

The sinusoidal waveform represents the variation of intensity (or transmittance, or reflectance) as a function of distance along the target. It corresponds, point by point, to something seen in the "real" space in front of us, and is sometimes said to exist in the "space domain". From another point of view, it is a single frequency in the spectrum of spatial frequencies, and may be considered to exist in the "frequency domain". In similar fashion, a monochromatic light, such as the green line of the mercury spectrum, exists as a single line in the spectrum of visible wavelengths, or a sinusoidal oscillation of electric and magnetic field strength as a periodic function in time. In these and similar simple cases, the entity can be quite easily visualised in either domain at will. However, the single frequency sinusoid is an exceptionally simple case, and more generally we have to deal with complicated assemblages of frequencies, whether in spatial or temporal terms. The treatment of such general cases is handled by the branch of mathematics known as Fourier transformation, which is very widely used in numerous branches of physics and other disciplines, where it often clarifies phenomena and facilitates mathematical operations. Quite generally, a Fourier transform is "a method whereby we may obtain the variation of a quantity as a spectral function (i.e. plotted against frequency) from the variation of the quantity as a function of period (plotted against time)[1]". (Jennison) In the present application we substitute spatial frequency for frequency and space, i.e. distance, for time.

The study of Fourier transforms is quite outside the scope of this book, but some elementary appreciation of their nature and significance is necessary for the proper understanding of the use of the MTF. Some feel for the way common objects such as targets "look" in the frequency domain is helpful in understanding problems of imagery. A brief account is therefore given in non-mathematical terms, with apologies to the mathematicians for lack of rigour.

For the present purpose, the essential feature of Fourier transformation is that any function, representing the intensity profile of a target, or a part of an aerial scene, or a complete aerial scene, can be analysed into a series of component sinewaves of different frequencies and in different phase relationships. It will be appreciated that this analysis is essential before we can apply the MTF to deduce the quality of definition for any particular object, since the MTF can only be used to operate on sinusoidal frequencies. The analysis of objects in general requires Fourier mathematical techniques, most

frequently, nowadays, applied in computer programmes. However, a descriptive account of the analysis of a few standard cases will be helpful.

Our first example is the square wave, which may be thought of as a bar target but continuing indefinitely in both directions. The analysis is one dimensional, i.e. the variation is considered to occur at right angles to the bars. It is well known to electrical engineers that the square wave can be represented by the Fourier series, in the following way. If the period of the square wave is 1/k, it can be synthesised from a series of sinewaves having the frequencies k, 3 k, 5 k, 7 k, etc., the corresponding amplitudes being 1, 1/3, 1/5, 1/7, etc., respectively. In principle the series is continued to infinity, using all the odd harmonics at amplitudes inversely proportional to their harmonic number, but even the first few give an approximation to the square wave profile. A graphical demonstration of the synthesis is shown in Fig. 1.8. It will be noticed that the third and subsequent alternate harmonics are to be considered negative relative to the fundamental, since they subtract from its intensity at the middle of the waveform. For this reason the fundamental has a relative amplitude $4/\pi$ when the amplitude of the complete square wave is unity. To be precise, the Fourier series does not give a true square wave. Fig. 1.8 shows the result of adding the odd harmonics up to number 15, and it will be noticed that there are "ears" at the edges of the square wave. With additional harmonics these do not disappear, but merely move nearer the discontinuity. Barakat[2] has shown how to calculate a closer approximation; however, for all practical purposes the Fourier series is adequate. Indeed, in photographic optics we are rarely concerned with more than a few harmonics, because of the rapidly falling MTF.

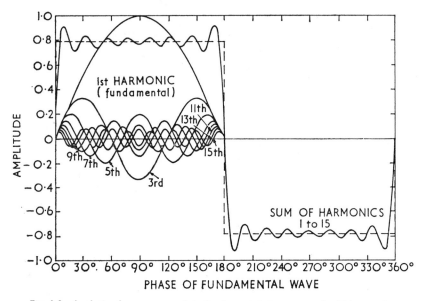

Fig. 1.8 Analysis of square wave into fundamental sinewave and odd harmonics

If now we desire to show the analysis of the square wave in the form of a Fourier spectrum, we make a diagram such as Fig. 1.9. There is a zero frequency component, to bring the negative half of the cycle up to zero intensity level, then a series of isolated lines corresponding to the fundamental and harmonics, the height of each line being proportional to the intensity of the harmonic. We can now predict the effect of any MTF on the spectrum of the square wave target. In general, any MTF cutting off within the harmonic range (which theoretically runs to infinity) must affect the profile of the image seen in the space domain, because the harmonics determine the profile, as a glance at Fig. 1.7 will show. If the MTF cuts out the third harmonic, only the fundamental is left, and the image will be a pure sinewave at reduced modulation. This account is only correct if the square wave extends indefinitely. As soon as it is truncated

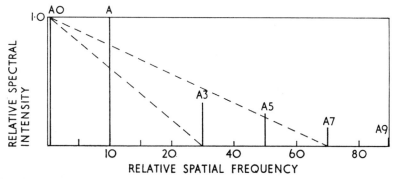

Fig. 1.9 Spectrum of square wave, with MTF's cutting off at different harmonic frequences

to some finite number of cycles, the spectrum loses its purity and the lines are replaced by bands. Fig. 1.10 shows the development of this process, with spectra corresponding to 2, 3 and 4 cycle targets, as given by Charman.[3] The essential characteristic of all these spectra is the replacement of the single-valued fundamental frequency of the square wave by a relatively broad band, centred near a frequency which is the nominal frequency of the bar target, i.e. the reciprocal of the target period. The peak of this fundamental band is not exactly at the fundamental frequency, but slightly below it, and moves nearer to it as the number of bars increases. Also, the fundamental band gets narrower as the number of target bars increases and the pattern approaches closer to an infinite square wave. Negative values signify reversed phase, and it will be noticed that the fundamental band of frequencies is in positive phase for targets with odd numbers of bars, but negative phase for those with even numbers of bars. Even numbered harmonics are absent, recalling the relationship to the square wave, and the harmonic content is concentrated around the odd numbers. Fig. 1.11 shows the spectrum of the Canadian annulus target, also due to Charman. This has an even broader fundamental band than the bar targets; in a sense this makes resolution testing with the annulus target more realistic, because it tends to be representative of the whole lens

25

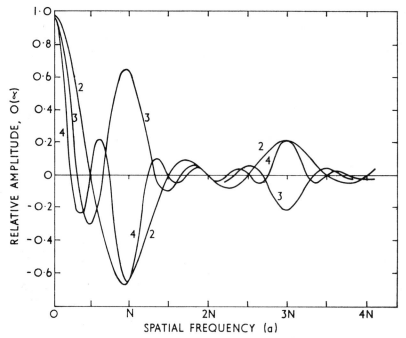

Fig. 1.10 Spatial frequency spectra of bar targets (Charman 1964).

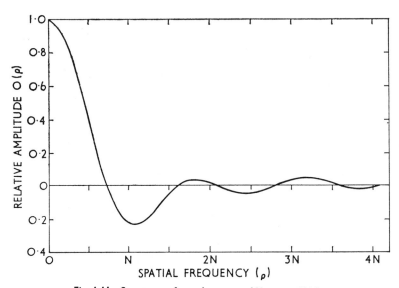

Fig. 1.11 Spectrum of annulus target (Charman 1964).

MTF rather than a single frequency. To a lesser extent this is also true for the other bar targets. It is often said that the resolving power test is unsatisfactory because it provides information about only one spatial frequency; this is only partially correct, although the result will be strongly biased by the performance in the fundamental frequency band.

While it is obvious that the fundamental band must carry the information by which the target is known to be two bar, three bar, etc., and that this must be reproduced if the image is to retain the characteristic number of elements, there is no easy intuitive way of deciding how much of it is necessary, or what the effect will be of removing or weakening different parts of the spectrum. Charman,[3] and also Kelly,[4] have pointed out that if one of these targets is imaged by a lens whose MTF cuts off just at the nominal target frequency, the image still has a finite modulation, though not at the nominal frequency.

We now pass from resolving power-type targets to the single bar, which until recently has been little used or considered as a photographic target, but is of direct importance in aerial photography. The projected silhouettes of such objects as pipes, rails, white road lines, highways, etc., are effectively single bar objects, and their imagery is a matter of considerable practical importance. The spectrum of the single bar turns out to be the familiar function $\sin \pi a x / \pi a x$, illustrated for bars of different width in Fig. 1.12a to c. If we designate the frequency range out to the first zero as the bandwidth, we see that the bandwidth in the frequency domain is inversely proportional to the barwidth in the space domain. In the limit, the single bar turns into the infinitesimally narrow single pulse, whose spectrum extends at a uniform level over all frequencies. Since there is no characteristic or fundamental frequency, there is no fundamental frequency band which must be reproduced if the bar is to be recognised. The alternating bands at higher frequencies serve to define the edges of the bar; as they are progressively removed the edges become rounded off, and as the MTF cuts out more and more of the energy in the primary lobe the contrast of the image falls.

When the bar object becomes very wide it becomes interesting for its edges rather than its width. The spectrum of the edge or step function is the least easy to grasp, although the edge object is the easiest to make and use. In effect, the intensity in the edge spectrum is inversely proportional to frequency, so the graph is hyperbolic, as suggested in Fig. 1.12d.

Consideration of the spectrum of the single bar shows that care should be used in mentally equating size to frequency. A small size is not a high frequency, even though the period corresponding to a high frequency is a small distance. A small object certainly has a wide bandwidth, and its adequate reproduction calls for an MTF extending to high frequencies, but good high frequency response at the expense of low frequency response would be valueless; the full frequency bandwidth is necessary for proper reproduction, but since this is usually impossible, the low frequencies should not be sacrificed, as they carry the contrast by which the object is seen. The wide spectral bandwidth of single bars provides an explanation for the frequent appearance in aerial photographs of isolated objects whose diameter is well below the resolution limit. This

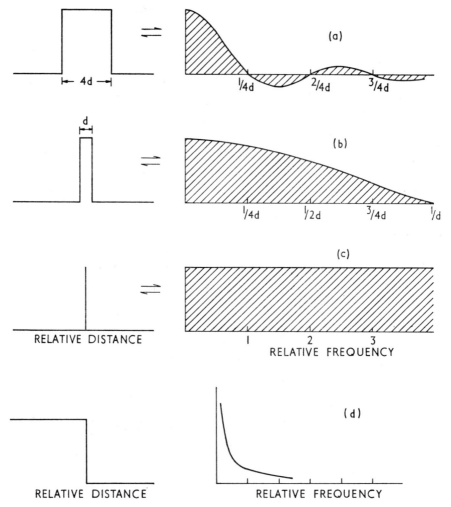

Fig. I.12 Spectra of single bar targets of various widths

is further discussed in Chapter IV, but it will be clear that since there is no fundamental band, any MTF which allows a significant fraction of the total energy in the bandwidth to pass will permit an image to be recorded.

The spectrum of the single bar, sometimes called the "sine" or "sinc" function, is of considerable general importance, and a table of values is given in Appendix 3. It represents the MTF for linear image motion (assuming a perfectly efficient shutter) the frequency at the first zero corresponding to the reciprocal of the distance moved by the image. The shape of the function allows us to understand why image movement in a small amount is not serious, but increases in effect rather rapidly after a certain point.

The negative lobes account for the phase reversal ("spurious resolution") which can be seen in the images of high contrast targets when movement is severe; such effects are not normally visible on low contrast detail. The function also turns up in many situations; for example a limited number of sinewave cycles may be regarded as a continuous wave chopped by a pulse, the sine function of the pulse then being super-imposed upon that of the waveform. Fig. 1.13 illustrates this for a three cycle sinusoid; the first zero occurs at a frequency which is one third of that of the sinusoid, the pulse which terminates the sinusoid wave train being three of its cycles in length. In effect the sinewave spectrum is multiplied by the sine function in frequency space, this being equivalent to convoluting the sine waveform with the rectangular pulse in real space. This combination of the single bar spectrum with the line spectra of the sinewaves is also responsible for the continuous nature of the bar target spectra. Kelly's demonstration is instructive.[4]

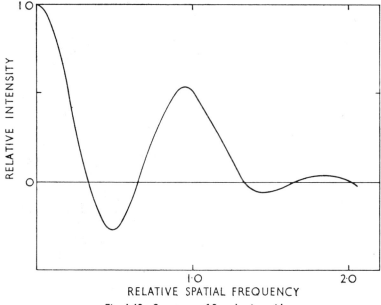

Fig. 1.13 Spectrum of 3-cycle sinusoid

Before leaving bar targets, we may refer to an example which demonstrates the difficulty of translating frequency spectra into their corresponding spatial appearances. For this we have brought together data presented by Charman.[5] Fig. 1.14a represents the spatial frequency spectra of the images of two objects after operation of an MTF which cuts off at the spatial frequency $1/\pi$ Z units. (The meaning of the Z unit is explained in Chapter IV—effectively these are relative units). Object (1) is a single bar of width 2π Z units; object (2) is a two bar target, the period of the bars being π Z units. Fig. 1.14b shows the spatial intensity distribution of the same two images, the

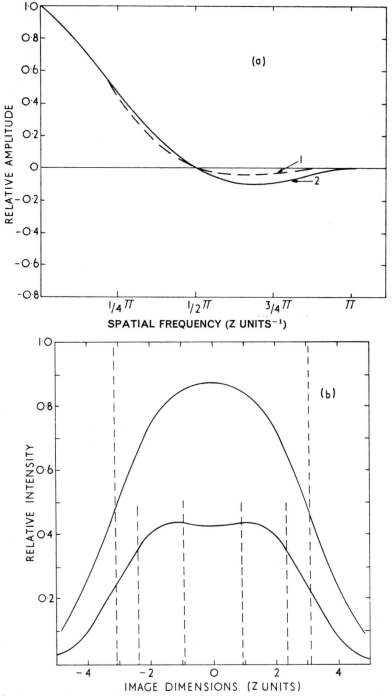

Fig. 1.14 Spectra and image profiles for single bar (2π Z units wide) and two bar target (period π Z units) when imaged by aberration free lens with MTF cutting off at $1/\pi$ Z units^{-1}. (a) Spectra. (b) Image profiles and geometrical images

geometrical locations being indicated by the broken lines. Image (2) shows a trace of the two-bar pattern. (It illustrates, in fact, the point mentioned above, that a bar target image, the MTF cutting off at the nominal target frequency, still retains a little modulation.) Image (1) is obviously different, but it would be hard to say from Fig. 1.14a, without the exact Fourier transform, just what difference would be shown between the two. Both spectra have a small hump between $1/2\,\pi$ and π, and there is no obvious clue to show that one corresponds to a double humped image, the other to a single hump.

1.6 *Application of the MTF*

The MTF cannot be applied to the profile of objects in the space domain. It is an operator which when applied to spatial frequency spectra will give, by simple multiplication, the relative values of each spatial frequency in the image. In principle, use of the MTF therefore requires, first a Fourier transformation of the object into its spectrum, then multiplication of the spectrum by the MTF, followed by an inverse Fourier transformation to obtain the modified profile of the image. In general these operations require the use of a computer, which excludes them from many practical situations. It is not possible to deduce the imaged contrast of objects in general by direct use of the MTF.

The only exception to this statement is the pure sinewave; the image modulation in this case is given directly by the product of the object modulation and the MTF at that frequency. If approximate results are sufficient, then we can also admit as an exception any target of a periodic nature, for which the imaged modulation is very approximately given by the product of the target modulation and the MTF. This is discussed in Chapter IV.

Up to this point we have discussed the MTF only in relation to lenses. However, the MTF itself is essentially the Fourier transform of the spread function, although we approached it in a different way. Other sources of image blur can also be Fourier transformed into MTF's and used to operate on the spectra of objects. The MTF of image motion has already been mentioned. In general, any number of MTF's may be multiplied together, or cascaded, and the product multiplied into the spectrum of the object. One essential requirement, however, is that the part of the system for which the MTF is desired shall have a linear transfer of intensity. This means that the use of MTF's for the photographic emulsion must be indirect. The diffusion of light at the exposing stage, when the emulsion spread function operates, does not introduce non-linearity, but various non-linearities are caused in the processing stages and must be removed before the concept of an MTF can be valid. This subject is discussed in Chapter III.

In the past the OTF and MTF have been known by other names, but formal agreement on their definition was reached in 1961. The terms are summarised in Appendix 1.

1.7 *Phase*

The effects of phase shift are very complex, and the general application of the OTF requires an adequate computer programme. If the spread function is known, a qualitative impression of the effects of the asymmetry can sometimes be obtained. In absence of a computer, however, the best approach is by use of the graphical analysis based on the edge spread function, as described in Chapter IV. A simple account of the general principles operating in cases of phase shift now follows.

In general, phase shift, being the result of an unsymmetrical spread function, distorts the image of an object in an unsymmetrical way. Naturally, the distortion is only noticeable if the image size is comparable with the spread function, which is equivalent to saying that phase shift is only serious when the MTF already shows a noticeable drop. In the representative case of a bar target, the peaks of intensity become displaced from their true geometrical position and the intensity profile is distorted unsymmetrically so that the image does not look like a quasi-sinusoid. We can visualise two kinds of phase shift, linear and non-linear. By linear phase shift we mean that all Fourier components, i.e. harmonics in a square wave, are shifted by an equal number or fractional number of *cycles*. Thus, referring to Fig. 1.8, if the fundamental is shifted laterally one cycle, the third harmonic three cycles, etc., the phase relationship is the same as before, the wave profile is unchanged, but the wave as a whole has moved one period. This kind of phase shift gives the "distortion" which has to be calibrated in mapping cameras; the whole image is displaced from its true perspective position, but its intensity profile is not necessarily changed. (In practice, of course, a change of profile may accompany the displacement.) There might appear to be a difficulty here, in that a zero frequency component, which must always be present, would have to be displaced an infinite amount; however, the location of an image cannot be specified by a zero frequency, and the point is academic. In non-linear phase shift the individual frequency components of the image are shifted by amounts which are not proportional to frequency, hence by incorrect numbers of cycles. The shift may increase monotonically with frequency according to some power law, or may be erratic, with alternating increase and decrease. This non-linear phase shift can distort the intensity profile of the image, as can be imagined by referring to Fig. 1.8. The flat top is given by the balanced amplitudes and phases of the component harmonics; when this balance is disturbed the wave shape can be fundamentally altered.

It is curious that although the ear is effectively almost totally insensitive to phase shifts in the spectra of musical sounds, the eye is extremely sensitive to phase shift in the harmonic components of images, and great care is taken to reduce phase shifts in television circuitry, which lead to serious pictorial distortions. However, this is a question of degree, and the order of phase shift occurring in photographic lenses is not normally disastrous. As already suggested, phase shift tends to be appreciable only when the MTF has fallen appreciably; the phase-shifted harmonics are then often so weak that they contribute little to the image. Moreover, in photographic recording the additional MTF of the emulsion (which contributes no phase shift) further reduces

the strength of the harmonics, so that the effect of the phase shift is frequently trivial in relation to the reduction in image contrast. Of course, everything depends on the individual parameter values, and intuitive deductions about the appearance of the image are often unreliable. While the detailed Fourier analysis is the only satisfactory approach, a few simple sketches illustrating the effects on a square wave of phase shift to a hypothetical but possible extent may be of interest.

The MTF of a good quality mapping camera lens, at 35 degrees in the field, was taken as a representative example. As the OTF was not available, but the spread function was known to be asymmetric, two degrees of non-linear phase shift were assumed, such that the shift was proportional to the 1·1 power and 1·2 power of the frequency. This meant that, for the latter case, the phase shift at the ninth harmonic of the assumed square wave object was 90 degrees, which is substantial. A film MTF as published for Plus X Aerecon was assumed. The graphical construction of Fig. 1.8 was then adapted to derive the image of one cycle of a 10 cycle per mm square wave, employing the lens and film MTF's, with and without phase shift. To reduce the labour of the sketching process, the analysis was not taken beyond the ninth harmonic. The results are shown in Figs. 1.15 and 1.16.

Fig. 1.15a shows the approximation to the original square wave object obtained with the first five harmonics; it is sufficiently close for the purpose. Fig. 1.15b shows the same object but with the phases shifted according to the 1·1 power law; there is considerable distortion of the shape. Figs. 1.15c and 1.15d show the waveform of Fig. 1.15a after operation on the harmonics with the MTF of the lens, and the MTF

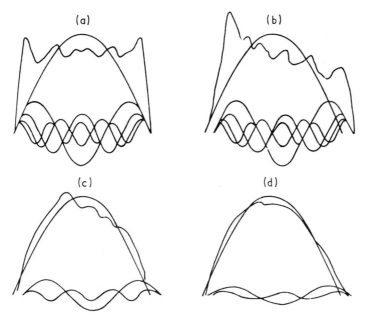

Fig. 1.15 Effects of phase shift (see text for explanation)

of the lens plus film combination. All but two of the harmonics are eliminated, and the residual distortion is trivial, especially in the film image. Fig. 1.16a, b and c show the results of a similar exercise using the 1·2 power law. The distortions are more marked, but again not disastrous, and would probably be hard to see in the film image.

At 10 cycles per mm, with this lens and film combination, the image would be clear of the resolution limit but definitely degraded. It does not appear that this degree of phase shift would be very serious, having regard to the further distortions or break-up due to granularity. Since the object is of rectangular profile, but cannot be imaged as such, it does not matter very much, from a practical standpoint, whether the image is a true sinusoid or some slightly unsymmetrical shape. In application to photogrammetry this statement should be qualified, since when measuring the location of an object, asymmetry in the image may cause its apparent position to be displaced. It will be appreciated that in the actual photographic image further distortions, though of a symmetrical nature, are introduced by the non-linearities, and these would make it even more difficult to assess the practical effect of the phase shifts depicted.

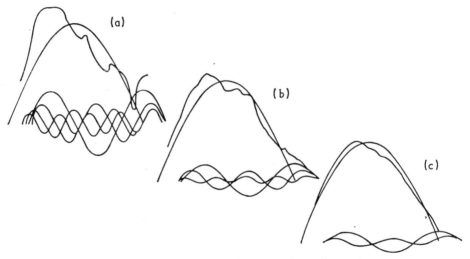

Fig. 1.16 Effects of phase shift (see text for explanation)

In one sense these sketches present an optimistic picture. The square wave object was used as an example because of the simplicity of its spectrum, but the spectra of simpler targets and non-periodic objects are more complex, and are continuous, not being restricted to the odd harmonics. The exact effects of the phase shifts in such cases can only be predicted by detailed Fourier analysis, but they could well be more marked than for the simple square wave. Certainly, marked distortions of shape are noticeable in the off axis images given by wide angle lenses near the resolution limit, especially the older lenses, in which a "streaky" appearance of the image was common.

Nevertheless, it is true that in lenses of well-balanced correction the loss of modulation is more important than the phase shift, and the MTF alone gives a very useful idea of the performance in spatial frequency terms.

If the image of an edge is known, the asymmetric profile of a bar image corresponding to an OTF with phase shift can be derived without Fourier analysis, as shown in Chapter IV.

1.8 *The Pros and Cons of Spatial Frequency Description*

To the non-mathematically minded, Fourier transformation of familiar objects may seem to take us into a strange world, where wide becomes narrow and narrow wide, where the complicated becomes simple and the simple highly complicated, and our normal intuitions cannot be trusted. The reader new to the subject, or even one acquainted with Fourier methods in electronics, may well ask what is gained by this seemingly artificial approach. Why spoil the elegant simplicity of a bar target by saying that it is really a complicated structure of sinewaves that bears no resemblance to the object as we see it? The notion of frequency and the utility of Fourier analysis in acoustics and electronics are not in question; vibrating objects and oscillating electric circuits naturally generate either pure sinewaves or mixtures of sinewaves at different frequencies. The waves will continue as long as we like to keep the generator running; in normal analysis of them we can take samples with an unlimited number of cycles, so that the concept of frequency is obviously valid. Above all, the waveforms are physically *there*, whereas analysis of a bar target into its component sinewaves is a mathematical device. Again, we might note the remark of a television engineer,[6] that it is remarkable that photographers, who deal essentially with objects in spatial extension, should be taking up a sinewave approach just as television workers, who appear to deal in frequency terms exclusively, are abandoning sinewave analysis and going over to spatial methods (no doubt this is a mild exaggeration). There is enough truth, in these and other arguments that could be developed, for us to ask if the complication is worth while. Workers in physics and other scientific disciplines would be surprised at the question; they would take it for granted that Fourier methods could be profitably applied to the study of photographic optics. Photographic and optical scientists know from their own experience how much progress has been made since the Fourier concepts began their rapid spread in the late 1940's. Certainly, at the more sophisticated levels in optical and aerial camera system design, in the research laboratory, especially at the fringes of photography and other disciplines, and as part of the general advance in understanding that constitutes the growth of science and technology, there has been a very clear gain. The concepts of spatial frequency and the MTF have brought new insights and a better appreciation of numerous aspects of image quality factors. In particular, the MTF threw a bridge across the chasm that formerly lay between the lens designer, who naturally thought in point images and wavefronts, and the photographic user, who needed quantitative data that were closer to practical performance,

but could only get them in empirical and sometimes puzzling form by photography of resolving power targets. The depth of that chasm is not easily appreciated to-day, by those who did not experience it thirty years ago. F. Dow Smith[7] has well described the necessity for such different points of view in photographic optics and the value of the Fourier methods in reconciling them.

At more practical working levels the gains have been slower in coming and the prospects have been prejudiced by misunderstanding and unwarranted optimisim, fostered by propaganda on the part of some optical physicists. There has been a tendency, among the less sophisticated, to assume that the MTF would automatically displace all older evaluation methods, particularly resolving power, that its measurement would be easy and accurate, and that somehow it would synthesise all the complexities of photographic image quality into something that was at once a function of size and a single number. Needless to say, no such exaggerated claims were made by the pioneer investigators, notably Selwyn in 1940, and Frieser even earlier, who used Fourier methods and what is now known as the MTF as tools for the investigation of photographic image quality, then expressed as resolving power. It might be thought ironical that the final evaluation of the performance of aerial photographic systems is still most commonly made in terms of their resolving power, even though the MTF may have been used at many points in the system design. However, this merely shows that the designers are alive to the analytical advantages of Fourier techniques, but appreciate the need for a final performance criterion that takes account of all elements in the total system.

In a balanced outlook, the Fourier methods are seen to take their place as a powerful tool well suited to take advantage of modern technology. They have already thrown much light on many aspects of image quality and have led to new techniques of image evaluation.

In the course of this book it will probably become apparent that the ability to alternate between spatial and frequency concepts is often very convenient and of practical use, even at the cost of some rigour. The process of evolution is not complete, and much remains to be done, especially in the measurement, interpretation and application of the MTF.

1.9 *Relationships between Image Quality Parameters*

It may be useful at this point to mention and recapitulate some important relationships between the line spread function, edge spread function, and modulation transfer function, three different ways of looking at the same thing, the imaging quality of a lens.

The modulation transfer function is the Fourier transform of the line spread function, i.e. its equivalent as an integral sum of sinewaves taken over the whole range of spatial frequencies.

The edge spread function is the integral of the line spread function.

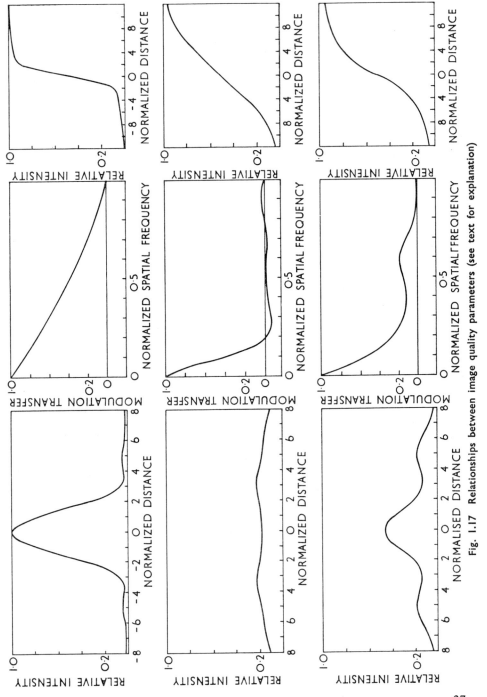

Fig. 1.17 Relationships between image quality parameters (see text for explanation)

37

The area under the modulation transfer function is proportional to the height of the line spread function at its peak.

The slope of the edge spread function where it passes through the zero abcissa value is proportional to the height of the line spread function.

To give some feel for the relative appearance of the three functions, they are displayed side by side in Fig. 1.17. The columns show line spread function, MTF and edge spread function, from left to right. The rows show the functions for three different image quality conditions, viz. aperture limited, in focus; aperture limited with addition of $2 \cdot 1$ wavelengths of spherical aberration; and aperture limited, one wavelength out of focus. Though derived from published rigorous calculations, these illustrations are intended for qualitative use, in broad demonstration of the effect on each function of a drastic change in the others. (In explanation of the scaling, "normalised spatial frequency" is fraction of the cutoff frequency; "normalised distance" converts to actual distance by: $d = D \lambda f/\pi$, where D is the normalised distance, λ is the wavelength of light, and f is the f/– number. Thus for green light (550 nm) and f/8, one normalised distance unit equals $1 \cdot 4$ microns).

References

[1] JENNISON, R. C., *Fourier Transforms and Convolutions*, Pergamon Press.

[2] BARAKAT, R., *J. Opt. Soc. Am.*, **53**, 1371 (1963).

[3] CHARMAN, W. N., *Phot. Sci. Eng.*, **8**, 253–259 (1964).

[4] KELLY, D. H., *Applied Optics*.

[5] CHARMAN, W. N., *Canadian Surveyor*. **XIX**, No. 2 190–205, June 1965.

[6] LEWIS, N. W. and HAUSER, T. V., *J. Phot. Sci.*, **10**, 288 (1962).

[7] SMITH, F. DOW, *Applied Optics*, **2**, 335 (1963).

II. THE OTF'S OF LENSES

2.1 *Introduction*

The OTF is generally considered to represent a very substantial step towards the adequate specification and measurement of the imaging performance of lenses for aerial cameras. A full appreciation of the value of the OTF can only be had by working with it, but we can account for the great interest it has received by four statements giving reasons for its importance, viz:

Measurement of performance by the OTF is purely physical; unlike resolving power, there is no reliance on opinion, and the potential accuracy is much greater.

The OTF provides much fuller information about the lens performance than does resolving power.

The information provided by the OTF can be translated into terms directly relevant to practical performance, either of the lens plus a film, or with the addition of other components of the photographic system.

The OTF can be computed at the design stage of the lens, thus facilitating the early assessment of the value of a design.

While these are true statements, they require qualification and expansion to preserve a balanced view of the situation.

The potential accuracy of measurement is not achieved without cost in the form of more elaborate apparatus of higher precision than is commonly used for resolving power measurements. Careful attention is needed to many sources of error that are swamped "in the noise" in the inherently less precise resolving power determination. Moreover, the OTF does not necessarily replace either resolving power or the various classical optical tests, though it often supplements them and gives them added significance.

The OTF certainly provides more information than resolving power, so much so as to be an embarrassment. It is difficult enough to summarise resolving power data into a single figure of merit representing the averaged performance of a lens over its field. When each resolving power figure is replaced by an amplitude graph and a phase graph the problem is not simplified, to say the least. Again, although the information is fuller, it is of a different kind and cannot be directly compared with resolving power.

The OTF can certainly be translated into practically meaningful terms, but translation is undoubtedly required. Most of the literature has omitted to point out that without additional data concerning the film and other use conditions the OTF data is of decidedly limited practical value. Up to date, interpretation has usually meant translation into resolving power. This is not to decry the value of OTF information, but merely to point out that without knowledge of other elements in the total photographic system, and some insight or experience, the measurement of the OTF can be a sterile exercise. It is particularly necessary to guard against the common error of assuming

that the image quality (whatever that may mean) at any given size of detail is directly represented by the ordinate value of the MTF at the spatial frequency having the corresponding period.

The OTF can be computed at the lens design stage by various techniques, and this allows a better prediction of the probable performance, in terms that can be understood tolerably well by practical users, thus avoiding the construction of many designs. However, some degree of approximation is involved in the computations, and it would probably not be right to assume that all problems have been solved. Moreover, since the conversion to practical performance is currently made in terms of resolving power, which (as discussed in Chapter IX) is not an ideal evaluator of overall system performance, the full potential of the OTF may not yet be realised.

2.2 *The OTF of the Aperture Limited Lens*

The transfer functions of lenses are conveniently examined in two categories, those of the aberration-free or perfect lens, and those of aerial and other photographic lenses. The imaging quality of lenses is determined by diffraction at the aperture and by the geometric aberrations which the designer strives to reduce to an acceptable level. Telescope objectives, microscope objectives, and certain special photographic lenses can have very good correction for aberrations because of restrictions such as covering a very narrow angle, or working in light of narrow spectral waveband, and the performance is then so good that diffraction imposes the major limitation. The general run of photographic lenses, however, does not even approach this standard, because of the compromises necessary when a large field has to be covered and exposures have to be made in white light.

The OTF of the perfect lens is limited solely by the relative aperture and the wavelength of the light, hence the lens is often called the "diffraction-limited" or "aperture-limited" lens. A single OTF curve, with suitable scaling, will represent the performance of all aperture limited lenses, but the OTF of a photographic lens may have almost any shape or value less than that of the diffraction-limited lens of the same aperture (subject, of course, to the restriction that all OTF curves fall from zero frequency). Although the OTF of the aperture limited lens may appear to be of purely academic interest, it is of great utility and importance because of its service as the upper limit of achievable quality, a reference point for general use, and a working tool in numerous image evaluation studies. Moreover, the MTF's of practical lenses can often be usefully approximated by the diffraction-limited MTF of a lens of smaller aperture. This point is further discussed in Chapter IV (page 90 and Fig. 4.1).

As already mentioned, the MTF of the aperture limited lens falls to zero at the spatial frequency $k = 1/\lambda f$, where λ is the wavelength of the (monochromatic) light and f is the f/number of the lens. A physical illustration of the cutoff frequency has been given by F. Dow Smith.[1] It is known that a lens, having two slits in its aperture, parallel to each other and spaced equidistant from the axis, will image a fine line source,

parallel to the slits, as a sinusoidal distribution of intensity, having a period given by λF/d, where F is the focal length and d is the separation of the slits. The sinusoidal distribution is the result of interference between the diffraction patterns corresponding to the slits. Imagine the line source replaced by a sinusoidal object orientated parallel to the slits, with the period in its geometrical image exactly matching that in the original interference pattern. The image will remain sinusoidal, since each "line" of the sinusoidal object will yield a sinusoidal image, and the sum of sinusoids of the same period is also a sinusoid. If now the original observation is repeated with slits spaced wider and wider apart, the period of the sinusoidal image generated from the line source will become smaller and smaller. To keep in step with this, the period of the sinusoidal object must be reduced in the same proportion. Eventually the slits reach the diameter of the aperture; beyond this no light can pass, so this determines the highest spatial frequency. This is a neat demonstration of the fundamental origin of the MTF in the physical optics of the aperture limited lens. The MTF is also the modulus of the Fourier transform of the aperture limited spread function; when aberrations change the size and shape of the spread function, the MTF is the transform of the altered function.

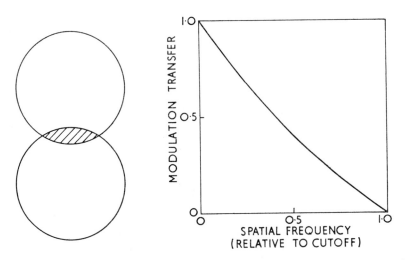

Fig. 2.1 Self convolution of the circular aperture and corresponding MTF of the aperture limited lens

In general each region of the aperture is associated with a particular spatial frequency and the shape of the MTF curve is given by convolving the aperture with itself as suggested in Fig. 2.1. The value of the MTF at any fraction of the cutoff frequency is equal to the relative value of the common area as the two circles are slid across each other. The convolution relationship applies equally if the apertures have any other shapes. An important case for reflecting systems is the central obstruction of an aperture, e.g. by a secondary mirror, as shown in Fig. 2.2. The MTF is then depressed very

41

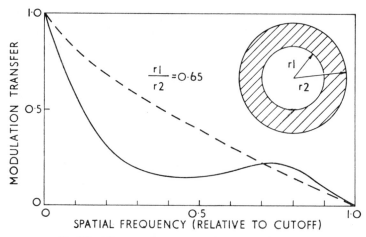

Fig. 2.2 Obstructed aperture and corresponding MTF

markedly in the mid-frequency region, to an extent depending on the degree of obstruction. With sufficient obstruction it may run level over an appreciable range. To anticipate Chapter VIII, what would we then mean by the resolving power of the system? With still further obstruction the MTF may go to zero before the cutoff and divide into two separate portions.

The cutoff frequency can also be looked at via the spread function, which in the case of an aperture limited lens is the diffraction pattern corresponding to a point or line source, exhibiting a strong central maximum, falling to a minimum, then rising to a secondary maximum, and so on (Fig. 1.1). When the peak of one line spread function falls in the first minimum of an adjacent one the resultant intensity pattern shows a drop to about 80 per cent between the two peaks. On bringing the spread functions a little closer together, as defined by the separation being λf, the intensity becomes uniform and no pattern can be seen. (The condition with the maximum and first minimum coinciding is the Rayleigh resolution criterion for line images.) The MTF of the aperture limited lens naturally has different values for every wavelength of light at a given aperture, and in broad banded or white light a composite MTF will be observed, all curves starting from $1 \cdot 0$ at zero frequency and diverging to the different cutoff frequencies according to the individual wavelengths. The cutoff values for any wavelength and aperture can be found from the formula already given, and tabulated values of the function are given in Appendix III. It is convenient to memorize the formula in short form for a common wavelength, thus for green light of wavelength 550 nanometres the cutoff frequency for a sinusoidal object is 1800/f/number in cycles per mm. (The cutoff for a continuous squarewave is the same, but the shape of the MTF is different.)

The MTF referred to so far is that for optimum focus. With defocusing, Fig. 2.3, the first effect is to depress the MTF at intermediate frequencies without much effect in

42

the region near the cutoff. With further defocusing the mid-frequency depression continues, with a tendency to a wide region of low modulation. Since, in practical imaging systems, there is always a lower useful limit of modulation, or threshold modulation, determined by whatever noise is present, this means that in effect the cutoff will appear to move back to lower frequencies. With extreme defocusing the curve goes negative and oscillates, though the final cutoff remains unchanged. The negative region

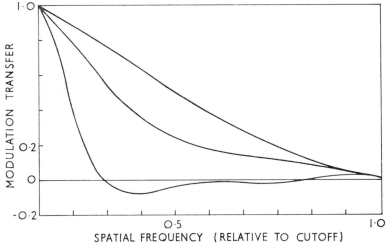

Fig. 2.3 MTF's of an aperture limited lens at different focal positions

signifies a change of phase in the sense that the light and dark of the target change places. This is, of course, distinct from the phase change of sinusoidal components, all imaged at positive values, produced by a lens with asymmetric aberration and discussed in the previous chapter. The effect is sometimes called "spurious resolution", a most unfortunate term, since resolution is not involved at all.

Fig. 2.3 shows aperture limited MTF's for two degrees of defocusing, viz., 0·4 and 1·0 wavelength in the aperture. This is related to the actual distance measured along the axis by:

$$\Delta l = 8 \, \lambda \, f^2 \, W$$

where W is the defocusing in wavelength units, λ is the wavelength of the light, f is the f/number, and Δl is the focus shift. Thus for f/8 and green light the focus shifts in Fig. 2.3 correspond to 0·1 and 0·3 mm in round numbers.

2.3 The OTF's of Photographic Lenses

2.3.1 GENERAL. Photographic lenses in general suffer from several kinds of aberration, which distort the wavefront leaving the exit pupil of the lens, so that the

self-convolution of the aperture yields a function different from and in general of lower value than the aberration-free MTF. In any given lens the amount and kind of aberration will depend upon the aperture and field position, as well as the design and the accuracy of assembly. The OTF's naturally show corresponding diversity, and cannot be represented by standard curves, as in the case of the aperture limited lens. However, it may be of interest to refer to Fig. 2.4, which shows the calculated MTF for an artificially simple case, a lens with spherical aberration only. Three degrees of aberration are shown, i.e. $0 \cdot 1$, $1 \cdot 0$, and $2 \cdot 1$ wavelengths of third-order spherical aberration. A small amount of aberration has little effect on the aperture limited MTF; with increasing aberration the MTF is lowered in the middle frequency region with a tendency to rise again at higher frequencies before the ultimate cutoff. This early fall of the MTF is characteristic of most defects of the image and the wide region of low modulation transfer, or reversal of the curve, is a source of anomalies in resolving power measurement.

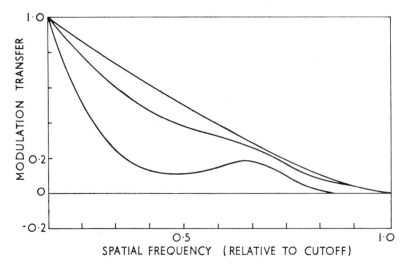

Fig. 2.4 MTF's of an aperture limited lens with addition of 0.1, 1.0 and 2.1 wavelengths of 3rd. order spherical aberration

Figs. 2.5 through 2.13 show MTF's for a selection of photographic lenses, including some aerial lenses. These were not all measured on the same apparatus nor under identical conditions, because the curves were taken from available sources and special measurements were not made. In the present state of application of MTF measurements, each determination is made for some specific purpose and not under universally agreed standard conditions. Indeed, the standardisation of MTF measurements is less advanced than the standardisation of resolving power measurements, although the latter leaves a great deal to be desired. Therefore there is a dearth of strictly comparable

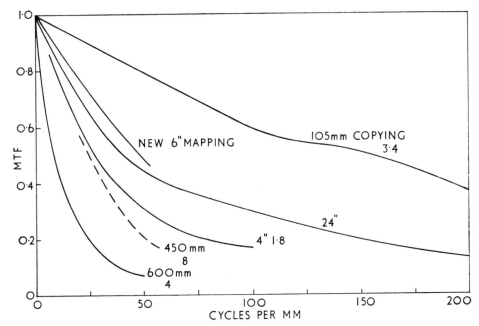

Fig. 2.5 MTFs of five aerial lenses and copying lens, on axis

data for aerial lenses, all determined under exactly standardised conditions corresponding closely to practical use, in such matters as spectral sensitivity. The presented curves should therefore be regarded as showing the general nature of the MTF's found for photographic lenses, and as serving for broad deductions, rather than as a detailed reference source and a means of exact comparison. One or two cautionary remarks should be made. First, it must be appreciated that there is no one MTF for a lens, any more than there is one resolving power, or one H and D curve for an emulsion. As with resolving power, the MTF depends on numerous factors, notably aperture, field position, focal plane, orientation, spectral balance of light, etc. Indeed, the position is worse for the MTF than for resolving power, because the MTF measurement is inherently so much more sensitive and precise. Small errors of focus, or slight misalignments in the apparatus, which could not be detected by resolving power, may be all too obvious in the MTF curves. Second, although in principle the MTF is an exactly measurable physical characteristic for any stated field position, etc., the various measuring techniques do not necessarily give exactly equivalent results in their working form, though any one laboratory may turn out results which are quite consistent in themselves.

This situation will be remedied as standardisation and calibration programmes are applied and more is learned about each apparatus, but for the time being caution should always be exercised when comparing curves for what may be thought to be

45

the same type of lens measured in different laboratories. Differences amounting to five per cent of the zero frequency ordinate are quite usual, and greater differences can occur. It must be appreciated that the high sensitivity of the measurements calls for much greater attention to precision in alignment, and specification of focal planes, than we have become accustomed to in resolving power tests.

It will be noticed that comparatively few off-axis MTF's are shown, which, to the aerial photographer, is a serious omission, since in terms of area-weighted cover the axial regions are relatively unimportant. It is unfortunately true that off-axis data has been less frequently published, partly because in some types of apparatus it is difficult to obtain (by some methods it cannot be obtained) or the results are not considered trustworthy. Again, the MTF shows up, sometimes more dramatically than resolving power, the inferior performance of many lenses off-axis, which possibly has discouraged publication. For high-resolution, narrow angle reconnaissance lenses the omission of off-axis information is less serious, because their performance often holds up quite well over a few degrees, but for the normal and wide-angle mapping lenses information about the full field is essential if the MTF is to be of practical use.

Similarly, no phase data are presented. In fact, phase information is not very often supplied in published measurements, and the difficulties of applying it have already been pointed out. When phase measurements are taken on the same lens by different laboratories, the disagreement tends to be worse than for the MTF's. This is not altogether surprising when we reflect on the significance of phase shifts. At 100 cycles per mm, a phase shift of one tenth of one cycle amounts to only one micron. Making repeatable measurements to this order of accuracy obviously calls for the highest mechanical precision.

2.3.2 DISCUSSION OF MTF'S. Fig. 2.5 shows the MTF's, on axis, of five aerial lenses of different types, also the MTF of a lens used for very high resolution copying in the production of microcircuits. The last-named lens represents about the highest performance obtainable to-day in photographic objectives, and will serve as a reference. Its performance is achieved by correcting for a narrow angle and designing for operation in monochromatic light, hence this level of performance is unlikely to be achieved in regular aerial camera lenses. It reaches 75 per cent of the aperture limited modulation transfer factor at 100 cycles per mm. (The aperture limited curves for each lens have been omitted to avoid confusion.) The other MTF's shown were measured in light of daylight quality. The lowest performance is found, as would be expected, in the 600 mm f/4 lens, which is not of recent design and covers the 9 × 9 inch format. In contrast, the 24 inch f/3.5, a more recent design covering a small angle, has an extremely good performance, which, though not shown here, holds up well in the field. Its performance is substantially better than that of the 4 inch lens covering the same format. However, the 4 inch lens is at a disadvantage because of its larger aperture and the much wider angle which covers a 6 × 6 cm field, these two factors more than offsetting the reduction in absolute aberration which is to be expected, other things being equal, at a short focal length. On the other hand, the 450 mm f/8 lens, covering

about the same angle as the 4 inch, has a worse performance in spite of its smaller aperture. It should be noted that diffraction is not limiting the performance at f/8, since the modulation transfer factor for an aperture limited f/8 at, say, 50 cycles per mm, would be about 75 per cent. The 6 inch mapping lens, of relatively recent design, is the best of the aerial lenses, at least on axis. This refers to the definition in the image plane; in terms of detail resolved on the ground with a given film the 24 inch would of course be greatly superior, especially as its larger aperture would allow use of a finer grained film. Off axis, the 6 inch lens naturally deteriorates, though not so rapidly as the old designs, covering the same wide angle of 90 degrees full field. Fig. 2.5 raises, in a mild way, the question of how one weights the MTF at different frequencies in evaluating one lens against another. This is a difficult question, which is discussed elsewhere in this book. For the moment we may merely note that because of other constraints in the design of aerial systems, lenses for wide angle mapping would not be required to record spatial frequencies above 40 cycles per mm or thereabouts. The modulation transfer of the 6 inch lens is 46 per cent at 50 cycles per mm, which may be considered very satisfactory.

Turning now to the remaining figures, which give more information about individual lenses, we may note in Fig. 2.6 the penalty for having a very large aperture in this lens, designed for the 24 × 36 mm format. The angle is not very wide, and the measurement was made in the middle (green) region of the spectrum, so that the chromatic aberrations (small in any case at this focal length) should be reduced. Nevertheless, the modulation transfer at full aperture falls off very rapidly indeed even in the region 0 to 10

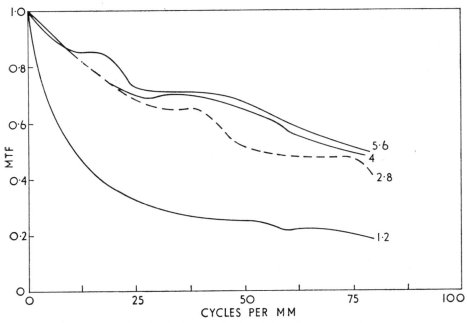

Fig. 2.6 MTF's 55 mm. *f* 1.2 lens (24 × 36 mm. format)

cycles per mm, then there is a wide frequency band with relatively little further change. Stopping down does not give any dramatic progressive improvement; the performance is almost the same from f/2·8 to f/5·6.

Fig. 2.7 refers to another lens for the 24 × 36 mm format, focal length 50 mm, aperture f/2. This would be regarded as of the highest class for its application. Again the measurement was made in green light, this time of rather narrow bandwidth. Note that the axial performance is very good, almost competing with the copying lens and better than the 24 inch aerial lens. Away from axis the performance falls off seriously, and there is a big difference between radially and tangentially orientated directions. Here there is a marked crossover effect at 40 cycles per mm, and the question of how to weight the curves is now more pertinent. We may temporarily shelve it on the ground that in 35 mm photography there is rarely any need for good modulation above 40 cycles per mm.

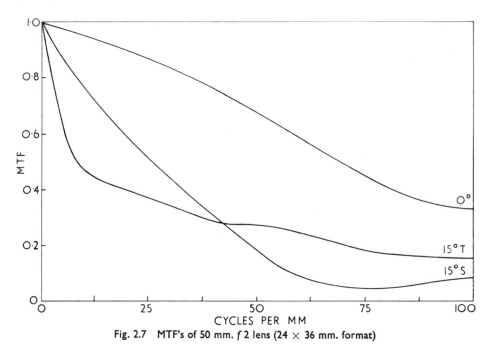

Fig. 2.7 MTF's of 50 mm. ƒ 2 lens (24 × 36 mm. format)

Fig. 2.8 shows MTF's for a long focus narrow angle lens intended for the 24 × 36 mm format, full aperture f/4·8, focal length 280 mm. The data was measured in white light, on axis only. This would be regarded as a very high grade lens of its class, but its modulation transfer at full aperture is not strikingly good. In fairness it should be remembered that the colour aberrations will be more prominent at this focal length, and a measurement in narrow band light might well have looked better. Nevertheless, in relation to the 24 inch aerial lens, which has a rather similar aperture and angular

48

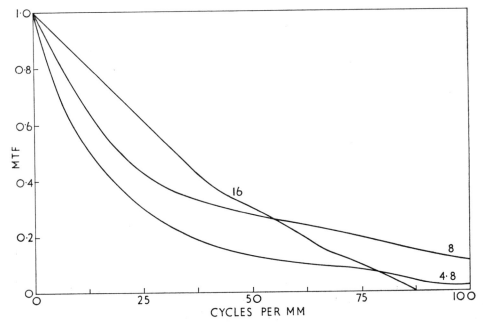

Fig. 2.8 MTF's of 280 mm. f 4.8 lens (24 × 36 mm. format)

cover, its white light performance does not compare very well. On stopping down the performance improves, as one would expect, and at f/16 it is nearing the aperture limited MTF curve.

Fig. 2.9 for the high resolution copying lens on axis shows that its maximum performance is reached at f/3·4; stopping down to f/5·6 lowers the MTF again, and within experimental error the MTF is aperture limited. (No doubt the reader will have noticed how often we refer to the aperture limit as a standard.)

Figs. 2.10 and 2.11 may be considered together. Fig. 2.10 compares the axial MTF's of the higher quality type of mapping lens made after, say, 1952, with the older type designed many years previously. The measurements were made in the same laboratory, using white light with a panchromatic photocell sensitivity, and it is safe to make the comparison. The difference is quite marked. Off-axis it would probably be even more striking, but the data are not available, for the older lens. Fig. 2.11 shows the on and off axis MTF's for the newer type of lens, in this case measured from edge images on film, as given by Charman.[2] Charman actually gives the combined lens-film MTF's for the lens with Plus X Aerecon film; the MTFs in Fig. 2.11 were obtained from these by dividing out the film MTF. The axial MTF is somewhat lower than that in Fig. 2.10. This might be a genuine difference between specimens of the same lens type, or a consequence of the actual film MTF being lower than that published, or a slight focal difference. The latter is quite probable. The choice of focal setting to give an optimum

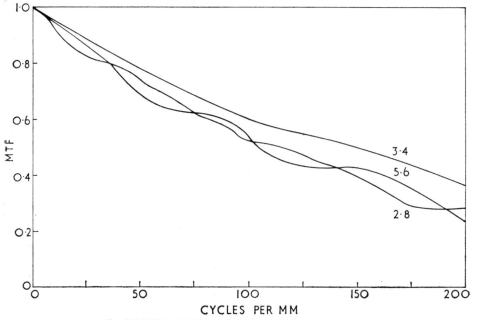

Fig. 2.9 MTF's of l05 mm. *f* 2.8 Microcircuit copying lens

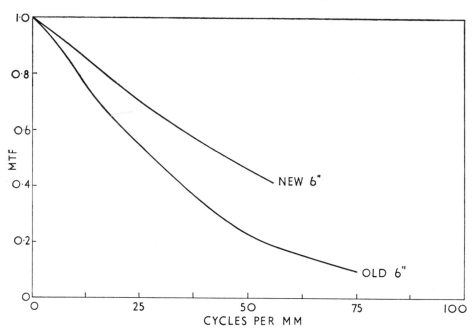

Fig. 2.10 MTF's of old and new type 6 inch mapping lenses (9 × 9 inch format) on axis

50

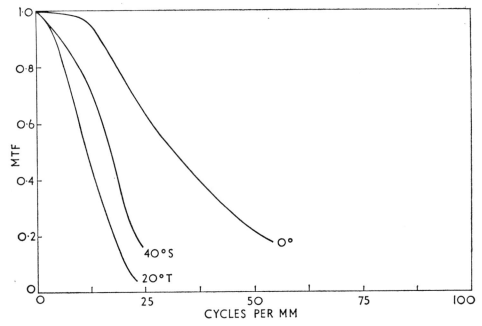

Fig. 2.11 MTF's of new type 6 inch mapping lens (9 × 9 inch format) on axis and at 10 degrees

balance between axial and field performance is somewhat arbitrary, and it is possible to make substantial differences in the MTF's at different field positions according to one's decision. This kind of lens is considered highly satisfactory for aerial mapping, which lends interest to the very low MTF's at 40 degrees. The limiting high contrast resolution corresponding to this MTF could not be much above 20 cycles per mm; clearly definition has been sacrificed for angular cover, even in this excellent lens.

Fig. 2.12 shows on and off axis MTF's for the 4 inch aerial lens. The full aperture, off axis curves both fall well below those for f/5·6; only one is shown, for clarity. Evidently there is a wide range of performance, taking account of the full range of apertures and the whole field. Again, in this case, the actual MTF's and the balance between axis and field, also the optimisation for each aperture, would depend on focal setting. For example, by refocusing, the axial curve for f/5·6 could be substantially improved. It is not practicable to show the mass of curves that would be required for full analysis of the situation. Notice the marked difference of curve shape between full aperture on axis and 16 degrees tangential at f/5·6. The areas under these curves are much the same, therefore the integration of the product (MTF × frequency) is similar, but which is the better MTF? Again anticipating later discussion, we shall merely point out that for the practical application of this lens, using fast film which cannot usefully reproduce frequencies above say 50 cycles per mm, the curve which is higher at the lower frequencies would certainly give better pictures.

51

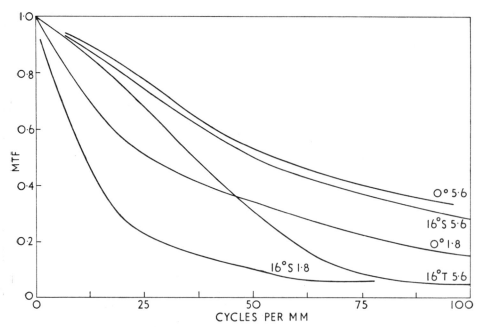

Fig. 2.12 MTF's of 4 inch *f* 1.8 aerial lens, on and off axis

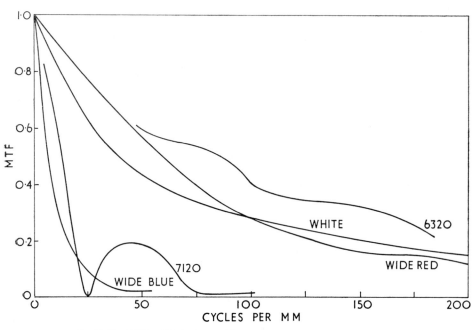

Fig. 2.13 MTF's of 24 inch aerial lens at different wavelengths, on axis

Finally, we consider Fig. 2.13 for the 24 inch aerial lens, noting its extreme sensitivity to the wavelength of the light used. In blue or very deep red light is MTF is essentially wiped out; it is best in monochromatic light at 630 nanometres (light red) but performs well over the green to bright red wavelength range.

2.4 *Measurement of Lens OTF's*

2.4.1 GENERAL. The OTF of a lens can be measured by numerous techniques which have been developed over the past twenty years or so. In principle they all must give the same results; in practice they can do so, to a sufficient approximation, but only if sufficient care is taken to ensure that the technique really behaves in the way indicated by its theoretical basis. In any technique there are various stages which require calibration or investigation to ensure that assumptions made about their contribution to the OTF measurement are correct. This account does not go into details of such qualification procedures, which must be the concern of each laboratory, but does refer to principles which experience as well as theory have shown to be important.

2.4.2 MEASUREMENT TECHNIQUES. A great variety of techniques have been proposed and used for measuring the OTF of lenses. In a review, Kelsall notes that over 50 different kinds of instrument have been devised since Herriott at the Bell Laboratories published data in 1947. It is not proposed to describe any of the methods in detail, but some account of principles is given. References to descriptions are given in (3) and also (4).

The most obvious way of measuring the OTF is to provide sinusoidal targets of various frequencies and at known modulation (normally these will be at the focus of a collimator) and to measure the image modulation, expressing the MTF as the ratio of

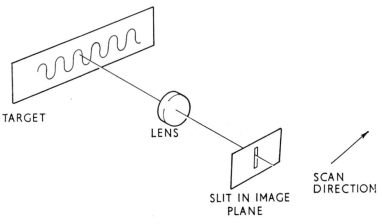

Fig. 2.14 Basis of MTF measurement

modulation at frequency k to the modulation at zero frequency. The basic layout is shown schematically in Fig. 2.14. The targets are uniformly and incoherently illuminated. The sinusoidal image is scanned by a slit, narrow enough to impose no limitation on the frequency range. A photo-multiplier cell, not shown, receives the light that passes through the slit, and with associated amplifiers and recording equipment provides a trace of the sinusoidal scan output. These are the basic elements which are combined in different ways, or substituted by ultimately equivalent elements. Whatever approach is followed, the measurements involve precise and accurate photometry, often on images only a few microns across. They are not to be lightly undertaken if repeatable and accurate results are expected.

Variations on the basic layout include:—

Exchanging the positions of objects and slit.

Using variable area or variable transmittance sinusoidal targets.

Scanning by moving the slit or by moving the targets (the latter often known as "masks") if located in the image plane or at the short conjugate.

Measuring simple transmittance without scanning the slit or masks.

Using pairs of masks, displaced one quarter cycle (sine and cosine) to obtain phase.

The targets or masks disposed on flat plates, drums, or in radial form.

Partly to avoid difficulties inherent in the manufacture of accurate masks or targets, whether sinusoidal in transmittance or in area, square wave scanning in various forms has been used. Instead of a series of fixed frequencies, a continuous progression is often obtained, e.g. by using a radial (Siemens star) target and working along the radius. Other variants use a square wave of fixed frequency and convert to varying frequency by altering the inclination relative to a slit. In general, with square wave targets, the scanning is made effectively sinusoidal by removing all harmonics but the first in a tuned amplifier, which also improves the signal to noise ratio.

A different group of techniques involves measuring the intensity distribution in the spread function by scanning with a slit, either in the image plane, when the object is also a slit, or in the long conjugate, using an illuminated slit (or the reduced image of one) in the short conjugate (normally the image plane). The spread function is then Fourier transformed in a computer programme to yield the OTF. Phase is available in these methods. As another variant, the spread function may be scanned by a knife-edge.

In general, slits to be used in the image plane must be very narrow, say 2 to 4 microns, depending on the frequency range required. Making and using such slits poses severe problems. These are sometimes circumvented by reducing a larger slit through microscope optics, but any use of additional optics to relay or magnify a slit, or indeed the spread function of the lens under test, always introduces some doubts about possible degradations.

All the preceding methods essentially work on the image or its projection through a collimator, but a different group obtain information about the basic source of the

OTF, i.e. the wavefront leaving the lens Various interferometric techniques have been devised for use in monochromatic light, mostly on axis only. The great advantage of these methods is that they are quite independent of any form of target, hence are inherently more accurate and unlimited in frequency range. Also, they can often be employed when it is impracticable to image targets or use a collimator. However, they require more skilled operators and do not seem to be so well adapted to general use. (The requirement for monochromatic light is also a restriction.)

Among unusual approaches we may mention the imaging of a grainy photographic deposit, used as a source of "white noise", i.e. a wide range of spatial frequency at approximately constant intensity throughout the spectrum. The lens images the grain with reduction of intensity at the higher frequencies, the power being measured in frequency bands selected by electronic filtering.

2.4.3 GENERAL REQUIREMENTS FOR LENS OTF MEASUREMENT. Whatever technique is employed, numerous precautions must be observed and standardisations carried out if the results are to be considered accurate, i.e. exchangeable between laboratories. It is relatively less difficult to ensure consistent results within any one laboratory, at least when the lenses tested are broadly of one type. When the tests include a variety of conditions, e.g. large and small apertures, it does not follow that correct results in one condition will automatically mean correct results in all conditions.

2.4.3.1 *Definition of the OTF.* The optical transfer function has two parts, the modulation transfer function or MTF, and the phase transfer function. In general the MTF expresses the transfer of modulation from object to image as a function of spatial frequency in the image plane, while the phase transfer function expresses the displacement of the image from its true geometrical position. However, it is necessary to be a little more precise about the definition of the MTF. The MTF is not simply the ratio of the image modulation to the object modulation, $\dfrac{M_i(k),}{M_0(k)}$ i.e it is not defined in terms of the transfer of contrast from object to image at each frequency, though in practice this definition is often close enough. To be correct, MTF measurements must be normalised to 100 per cent at zero frequency, i.e. the modulation transfer factor (MT factor) at any frequency k is defined as:

$$\text{MT factor} = \lim_{k \to O} \frac{M_i(k)}{M_0(k)}$$

This requires emphasis because the MTF of any lens reaches $1 \cdot 0$ at zero frequency and is less than $1 \cdot 0$ at any finite frequency. If a laboratory assumed that 5 cycles per mm was low enough to be considered "zero frequency" for normalisation its results could be in error. For example, the MTF of an f/5·6 camera lens could well be 0·94 at 5 cycles per mm. If the laboratory normalised to 5 cycles, its figures would be higher than those found by another laboratory which normalised correctly. It has not been

55

unknown for an apparatus to be normalised to some relatively high frequency, e.g. 10 cycles per mm, or to have no provision for normalisation. Again, the definition of the MTF does not take account of veiling glare, i.e. non-image forming light reaching the image plane as a general distribution of fogging or contrast-lowering intensity, originating in scatter or reflection at lens and metal surfaces. The correct MTF could be measured, given correct normalisation, even if the veiling glare were sufficient to cause a great reduction of image contrast, because this reduction would be equally effective at all spatial frequencies, including zero frequency. Thus the actual transfer of contrast from object to image could be less than that indicated by a correctly measured MTF. In other words, the MTF is not strictly a "contrast transfer function" in the obvious sense of the term. A full statement of the imaging performance of the lens would require data on veiling glare as well as the MTF. In practice, of course, the camera body is at least as likely as the lens to generate veiling glare, and in most good lenses the scattered light is very low. Nevertheless, these points cannot be ignored when accurate MTF measurements, agreeing between different laboratories, are required.

2.4.3.2 *Spectral Sensitivity.* In general the aberrations of lenses are dependent on the wavelength of the light, though this is more marked at longer focal lengths; for aperture limited lenses the dependence is direct. If the MTF is to have any value in practical applications, then clearly it must be determined for a balance of spectral energy that corresponds to the conditions of use in aerial photography. In principle, therefore, the spectral sensitivity must be varied to take account of the different emulsions with which the lens may be used, even within the visible spectrum. Thus aerial panchromatic emulsions may cut off anywhere from, say, 640 to 720 nanometres. The extent to which this has an effect on the MTF will depend on the focal length, kind of correction and relative importance of the chromatic aberrations. It would be very difficult to take account of all conceivable combinations of film sensitising, daylight illumination, and scene colour, and some kind of representative spectral sensitivity is required. For purely academic work, or research, monochromatic light can of course be specified, but this would be useless for aerial lenses. In general the spectral sensitivity of the detector in the OTF measuring apparatus should be corrected to match the spectral sensitivity of the emulsion or emulsions, and the spectral composition of the light used in the determinations should match that of the exposing light in aerial photography. (This includes the use of a filter on the lens.) However, for the accurate prediction of the lens-film MTF in mixed radiation, the lens and film MTF's for each monochromatic wavelength must be multiplied and the products summed for the mixed radiation in question.

2.4.3.3 *Specification of Focal Planes.* As in resolving power measurements, the focal plane for MTF's is commonly specified by reference to some plane of optimum focus rather than by any length measured from a datum point on the lens. For example, the reference plane might be specified by the focal plane in which the axial MTF is maximised at 40 cycles per mm. In practice it is more accurate to determine the plane

in which the MTF is some fraction, say 50 per cent, of its maximum, as the rate of change is then more rapid. In any case, the chosen focal planes should be determined with the greatest possible accuracy, as the MTF is so sensitive to change of plane.

2.4.3.4 *Field Position and Orientation.* MTF's must be measured for several field positions, sampling being necessary to determine the number of positions required. Measurements must be made for at least two orientations of the target. The usual convention could be followed, specifying the MTF for radial and tangential orientation of the lines of a sinusoidal target, direction of a slit, etc.

The orientation of the lens should also be specified by reference to some index mark, because the OTF is sensitive enough to reveal errors of lens mounting which could easily escape notice in resolving power. Where serious differences are found according to the lens orientation, i.e. its rotational position around the axis, measurements should be taken in more than one position.

2.4.3.5 *Calibration and Standardisation.* Up to date there has been very little evidence as to the accuracies actually achieved in measurement of the OTF over a wide range of conditions. There has been a little evidence[4] that the accuracies can be much lower than is commonly believed. Unfortunately no satisfactory techniques have yet been developed and adopted for the complete proving and qualification of apparatus over the whole range of conditions in which it is likely to be used. It is not easy to devise adequate check procedures. Aperture limited lenses are restricted to small apertures and monochromatic light.

Within the apparatus itself, experience has shown that there are many sources of potential error which must be individually studied and calibrated. Significant errors have been traced to: the shape and modulation of sinusoidal masks, their scattering characteristics; non-uniformity of illumination over masks, slits, and photocell apertures; the imperfect correction of microscope objectives, collimators and folding mirrors; air turbulence and vibration. The spectral response of the photocell should be measured rather than assumed from catalog data. The linearity of amplifiers and recorders should be verified. The coherence of the illumination should be examined.

When everything possible has been done to eliminate obvious sources of error in the apparatus itself, participation in standardisation and calibration exercises is desirable. At least one such standardisation programme has been started, under the auspices of the British Scientific Instrument Research Association. The aim is to provide for qualification of apparatus in a series of stages, starting with simple one-component lenses, easy to make in reproducible form, as checking standards, and proceeding to more complex lenses covering wider angles and working in white light. Early indications have been that accuracies in the order of two per cent (of the zero frequency ordinate) can be obtained with the simple lenses in monochromatic light. The aim of such exercises is to ensure that each technique of measuring OTF does measure, as closely as possible, something which is a genuine evaluation of the lens, not biased by any peculiarity of the apparatus. Non-fulfilment of this condition will not preclude

useful applications of the OTF, but it will prevent that satisfactory agreement between different laboratories which is essential if the OTF is to be a real advance on resolving power and to become a universally accepted standard by which lens performance can be judged.

2.5 Co-ordinates for Plotting MTF's

So far we have followed the convention of plotting MTF's on linear scales. This is the obvious method and the one used in most publications by physicists or those concerned with the optics alone. For photographic systems purposes, however, the custom has arisen of using log-log co-ordinates, while some laboratories plot modulation linearly against frequency on a log scale, thus following the common practice in analogous electronic cases. There is no right or wrong about these conventions; linear plotting is essential for some purposes, log is convenient for others. However, in the interests of standardisation, and to facilitate use of MTF's, it is desirable that some agreement on a "normal" presentation should be established. The problem would be less serious if every publication of MTF's gave tabulated data as well as the graph, which admittedly is required for a quick impression. For the serious worker actually using MTF's, few things are more infuriating than the effort of extracting numerical data from small scale graphs, often suffering from distortion due to paper shrinkage, and above all when intermediate co-ordinate lines are not shown on logarithmic plots.

In many applications of the MTF we require to know its area, and then the linear-linear plot is obviously the only kind acceptable. Again, the area of the MTF, above some threshold is often an important parameter, and for rapid visual assessments the linear plot affords an impression of relative areas. For more general purposes, especially in photography, an important consideration is that the plot should convey the practical significance of the different regions of the MTF, so far as that is possible. There is, of course, a danger in this of confusing size with frequency, which must always be avoided. Being aware of this, however, there is much to be said for the logarithmic plot of frequency. Photographic engineers are so well used to resolving power targets, which progress geometrically in nominal frequency, that it comes natural to have the same kind of progression on the frequency scale of MTF's, equal increments of distance representing equal multiples of frequency. Apart from usage, one can invoke similar arguments to those which determined the adoption of geometric progressions for almost all resolution targets, viz., that only equal multiples of bandwidth are significant; increasing the MTF cutoff by five cycles per mm is profoundly important if the present cutoff is at five cycles, but trivial if we start from two hundred. Somewhat similar considerations apply here as to the response-frequency curves of loudspeakers and amplifiers in sound reproduction. Another argument is that the contrast, by which the presence of objects is detected above threshold, is largely carried by the lower frequencies; in a linear plot these appear to take up an unrealistically small part of the total extent of the curve. Certainly, when there is a prolonged extension of the MTF,

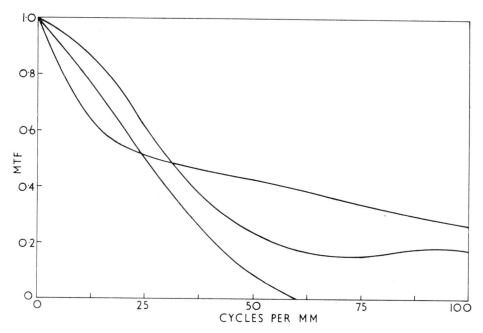

Fig. 2.15 MTF's of a 50 mm. lens at 10 degrees, and aperture limit for f 30, linear plot

at very low modulation level, over a wide bandwidth, one can get a false impression of its value unless alive to this effect.

There are opposing arguments about the log and linear plots of the modulation transfer factor. Since equal changes of modulation correspond, more or less, to equal visual impressions of contrast change, one might say that the linear plot is right, though again remembering the difficulty of translating this frequency-domain impression. On the other hand, it could equally well be argued that what we really want to display is the relative values of the MTF over the frequency band, which favours the log plot. This argument is probably the stronger; certainly the linear plot conceals the rapid drop of modulation transfer through the higher frequencies where the general level is low.

One very practical argument in favour of log plotting derives from a great advantage of MTF's, their cascadability. It is very convenient to multiply MTF's by subtracting ordinates. Again, the effect of changing target contrast can be visualised very quickly, merely by sliding the curve down the ordinate scale.

These points may be considered in relation to the curves (S & T MTF's for a 5 cm f/2 lens at 10°; aperture limit for f/30) plotted in log and linear form in Figs. 2.15 and 2.16 respectively. One obvious comment is that the curves change from convex to the abcissa axis, in the linear plot, to concave in the log plot, due to the compression of the frequency scale. This helps to put the value of the added bandwidth in a more

59

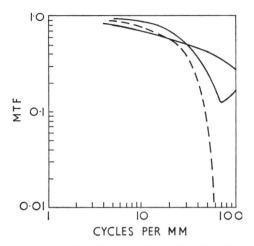

Fig. 2.16 MTF's of lenses in Fig. 2.15 log/log plot

realistic perspective, by its emphasis on the fairly rapid choking off of the modulation. The sharp cutoff of the aperture limited curve is made very clear, and contrasts well with the slower fall of the aberrated lens. The fluctuations in the MTF at the higher frequencies, below a modulation transfer of $0 \cdot 1$, are suppressed by the linear plot but emphasised by the log plot. These very low modulations, however, contribute little or nothing to image quality, especially in aerial photography, and the measurement accuracy is always very poor at this level, so care must be taken to avoid being unduly impressed by them.

There can be no hard and fast rule for using one plot rather than the other. Proper evaluation of the lens MTF for aerial photography requires consideration of other elements right through the system, and the engineer will vary the plotting to suit his own requirements. However, when MTF's are issued for general information the log-log plot can be specifically recommended, because the whole range of MTF's likely to be encountered in real lenses can be accomodated on a three-cycle log frequency scale. Similarly, by neglecting modulations below $0 \cdot 01$, a two-cycle ordinate scale would suffice. Thus a uniform presentation on a 2×3 cycle log scaling could be universally used. This would be a valuable measure of standardisation, enabling users to sum up the merits of an MTF more rapidly than from linear scales, which differ for almost every source and every bandwidth presented. The log-log plot should be supplemented wherever possible by tabular data.

At present, phase information is not very frequently offered, and the opportunities for using it are not very widespread. When given, it is usually plotted linearly on the same graph as the MTF, using a degree scale. This could not conveniently be combined with a log-log MTF plot, but in view of the greater importance of the MTF, the phase could well be supplied in tabular form as the normal procedure.

Finally, there is a great need, at the time of writing, for uniform nomenclature and

set of symbols. Spatial frequency is denoted by such different symbols as R, N, k, ω, etc.; there should be no difficulty in agreeing on standard or recommended practices.

References

[1] SMITH, F. DOW, *Applied Optics*, **2**, 4, 335–350 (1963).

[2] CHARMAN, W. N., *Canadian Surveyor*, **XIX**, **2**, 190–205. (1965).

[3] The Practical Application of Modulation Transfer Functions. Perkin-Elmer Corporation, Norwalk, Connecticut.

[4] Report of Working Group on Image Quality, XIth Congress, (1968). International Society for Photogrammetry.

III. THE MTF'S OF PHOTOGRAPHIC FILMS

"—a grin without a cat! It's the most curious thing!" (*Alice in Wonderland*)

3.1 Introduction

In principle the MTF of a film is defined in the same way as the MTF of a lens, i.e. it is the Fourier transform of the spread function. Thus, if we imagine a very narrow line image to be projected upon the senstive layer, it would be blurred by scattering at the silver halide crystals and the cross-section of the resulting intensity-distribution would be the line spread-function. Likewise, if we projected sinusoidal images upon the film, the MTF at any spatial frequency would be the ratio of the modulation within the sensitive layer to the modulation in the applied image. The MTF so derived would be the Fourier transform of the spread function; each could be obtained by mathematical transformation from a measurement of the other. Only linear optical processes would be involved. This approach gives the concept of the "ideal" or "real" MTF of the film, and follows the lines of the ICO definitions.

In practice we cannot measure the spread function or the modulation of sinewaves within the sensitive layer by direct means; we can only infer them from microdensito-meter measurements on developed images. However, during development various chemical phenomena can occur, which cause the apparent MTF to differ from the true MTF as just defined. Moreover, the developed image is an agglomeration of silver grains of finite size, distributed in depth through a gelatin layer of appreciable thick-ness, whose surface is not necessarily plane, but may be distorted according to the image density and processing conditions. Consequently, the apparent density may depend on the illumination conditions and focus setting of the microdensitometer, in ways which vary with the spatial frequency, the granularity of the image, the exposure it has received and other factors. These effects are often small, but they are not always trivial. Of course, it might be argued that the apparent MTF, which includes the combined effect of all these secondary factors, is what one really needs in practical application, since the behaviour of the sensitive layer during exposure and before development is a somewhat nebulous concept, of purely academic interest; if the "real" MTF can never be known, do we need to worry about it? However, acceptance of this argument would not solve the problem, because many of the effects are non-linear. This reduces the validity with which we can apply one of the valuable properties of the MTF, the possibility of cascading it with other MTF's, and is equivalent to saying that for practical applications we should need not one MTF, but many, according to the types of image and handling conditions encountered. However, one should in any case exercise caution in applying published (i.e. "apparent") MTF's to analysis or prediction of the practical behaviour of materials, because the illumination in microdensitometry is so different from anything encountered in normal use,

whether in printing, enlarging, or examination under the microscope. Overall, we have to recognise that the apparent MTF of a sensitive film can depend on the technique of measurement, and is not definable in the same sense as the MTF of a lens.

The purpose of these remarks is not to suggest that the MTF concept must not be applied to film, but rather to suggest that there are difficulties in doing so, and that they can never be eliminated in the way that we can hope to eliminate the errors of lens OTF measurement. How seriously we regard them must depend on individual circumstances. They can be largely neglected if we merely wish to compare the MTF's of a range of films all produced by one manufacturer and measured in one laboratory. They are often sufficiently important that we cannot safely compare the MTF's of films of different makes without enquiring about the methods of measurement. They could be quite serious if we tried to use the film MTF in exact measurements of other quantities, e.g. if we assumed it in deriving the MTF of a lens from measurements on film images. In such applications, the only safe course would be to determine the MTF under the exact conditions of working, just as one determines the H and D curve under the working conditions in photographic photometry. Subject to these reservations, the MTF concept is valuable in photographic science and image evaluation. Although its measurement involves many complications, it is at least free from the problems of measuring and interpreting phase. The diffusion in the sensitive layer is isotropic, hence the spread function is symmetrical and the phase component of its transform is zero.

Before considering the techniques and complications of film MTF measurement, we shall briefly review some representative MTF's of films used in aerial photography.

3.2 MTF's of Typical Aerial Films

Some MTF's, covering the range of aerial films from the fastest in common use to the slow very high resolution types, are shown in Fig. 3.1. Since the techniques of MTF determination used by different manufacturers may not give exactly equivalent results, the examples have all been drawn from the Eastman Kodak published data. For all the examples, development was in D 19, an active formula which minimizes the non-linear processing effects discussed in section 3.4. The logarithmic plot is convenient here, as it displays basic similarities in the curve shapes. Although these MTF's are broadly similar in shape, they do show some differences, and if the curves are slid sideways to multiply the frequency scale by appropriate normalising factors they would not overlap. As a rough approximation, they all drop from 90 per cent to 10 per cent modulation transfer factor within an octave of spatial frequency. In general the MTF's lie in the same order as the practical evaluation of the image quality of the films, which is the inverse order of their speeds. However, SO 190, though slower and finer grained than 4400, has an inferior MTF. It will be appreciated that curves such as these are liable to become outdated as the manufacturer improves his speed-grain ratio. SO 190 is probably of an earlier vintage than 4400.

For comparison, the MTF of an aperture-limited f/3 lens is included; it falls steeply to an eventual cutoff. In principle the film MTF's do not have a sharply defined cutoff, and in practice it is not possible to measure them accurately much below the ten per cent level, so [little useful can be said of their course in this very low region. In general the film MTF's do not fall so steeply as the aperture limited lens MTF, but fall more steeply than the MTF's of many aberrated lenses, at least over the upper part of the bandwidth covered by the latter.

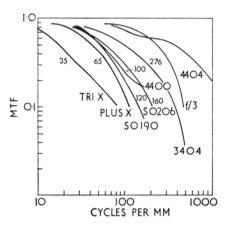

Fig. 3.1 Typical MTF's of aerial films

Resolving power is a commonly accepted measure of image quality, and since it is determined by granularity and gamma as well as by the MTF, it is not to be expected that the MTF's of Fig. 3.1 will show any systematic relationship to the resolving powers of the films. The number against each curve is the resolving power for a three bar target, as published by the makers for a target contrast of 2 to 1, and although these increase more or less parallel with the MTF's, there is no strict proportionality. The SO 190 case is again anomalous, as its resolving power is higher than 4400 although its MTF is lower. Since all these films have roughly the same gamma, the manufacturers can evidently manipulate the balance of the MTF and the granularity, and possibly other factors, to produce a desired performance. Among different makes, also, one could well find different MTF's corresponding to similar resolving powers, among films of broadly equivalent general type.

The MTF's of the slower films are not given at very high spatial frequencies. Even for 3404, which can be made to show clearly resolved images of high contrast three-bar targets out to 800 cycles per mm, the MTF is not given beyond 300 cycles per mm, There are two reasons for this. First, microdensitometry is handicapped by grain noise. which becomes progressively worse beyond 300 cycles per mm, even with 3404. Second, the optical problems of microdensitometry, such as correction for the MTF

64

of the scanning objective and the finite slit width, become more acute. A further reason is the difficulty of knowing what modulation is being applied to the film at very high frequencies. In fact, there is some disagreement in MTF values published for the very fine grain aerial film 3404 (also known as 4404 and SO 132 in earlier versions). The curve in Fig. 3.1 is from earlier published data; more recently the manufacturer has indicated that the MTF is markedly dependent on wavelength (see Fig. 3.12). Again, Schade has given an MTF for 4404, determined in green light, which is very much higher than the manufacturer's curve. This is included for comparison in Fig. 3.1; the part above 600 cycles per mm has been extrapolated by Schade.[1] It is pointed out in Section 3.6 that the MTF of 3404 also depends on the density of the negative. In general, therefore, the curves in Fig. 3.1, while quite representative of the general trend of film MTF's, are not to be regarded as hard and fast for each film shown.

3.3 *Measurement of Film MTF's*

3.3.1 GENERAL. Measurement of MTF's from photographic images may be undertaken to obtain "the" MTF of the sensitive layer, or the overall MTF of a photographic system, e.g. a lens plus film combination, or an aerial camera under operational conditions. For many of the practical system applications it may be necessary to derive the MTF by ways, such as measurements on the image of an edge, which are not ideal but offer the only available means. In the absence of disturbing development effects, the MTF derived from a line or edge image is equivalent in principle to that obtained with sinusoidal targets, but in general its accuracy is lower because the film is sampled over a smaller area and there is more disturbance from grain and other local irregularities. Nevertheless, the edge in particular can be very useful in working with aerial negatives when no other test-target is available. Details of the method of derivation as given by Scott[2] will be found in Chapter IV. Since the MTF is liable to depend on processing conditions and other variables, a determination under one's own conditions, even if of less than the desirable accuracy, can often be more valuable than more accurate data determined under unrepresentative conditions.

When the objective is the MTF of the film itself, the measurement is nearly always made with sinusoidal images, projected upon the film at different spatial frequencies, using targets of known modulation and a lens whose MTF has been calibrated. Since the grain is averaged over many cycles in the data reduction, the errors are substantially reduced. In the Eastman Kodak technique, considerable smoothing of grain is obtained by making the microdensitometer traces with a "comb" of many slits, spaced at the same pitch as the sinusodial images (or at submultiples of the pitch).

The experimental details of the measurement techniques have been thoroughly described in the literature,[3] and there is no need to repeat them here. The methods can be broadly divided into two classes, those in which sinusoidal targets are imaged upon the film by a lens, and those in which sinusoidal intensity patterns are formed on the film by other optical means, such as the interference of coherent light beams. The

second class avoids the complications of making accurate sinusoidal masks, but the optical engineering is more elaborate. One example of this class will be described.

3.3.2 THE EFFECTIVE EXPOSURE IMAGE. As already mentioned, we cannot directly measure the spread function or the modulation in a sinusoidal image formed within the sensitive layer. The difficulty is circumvented by using the film as its own photo-meter, i.e. we expose it to a sinusoidal image of known modulation, measure the density variations in the developed image with a microdensitometer, and derive, via the H and D curve, the modulation which must have been effective within the film to produce these density variations. The image within the film is therefore called the "effective exposure image".

The derivation of the effective exposure from the microdensitometer trace is carried out according to the steps shown in Fig. 3.2. Instead of using an instrument calibrated in density, it is convenient to use a microphotometer that reads transmittance. A step

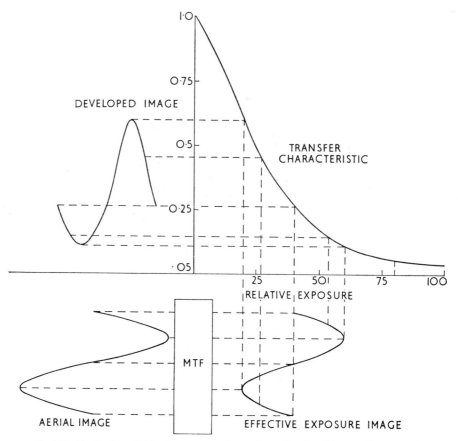

Fig. 3.2 Derivation of effective exposure image from developed image of a sinusoid

66

tablet exposure is made and developed in the same way as the target images. The developed step tablet exposures are read on the microphotometer and plotted as transmittance versus relative exposure, as shown in the "transfer characteristic" at the right hand side of the figure. It is not essential that the photometer should be accurately calibrated for transmittance, provided it is linear and stable. In effect its characteristics become part of the conversion to effective exposure and cancel out, since they appear both in the measurement of the step tablet and the measurement of the sinusoids.

In Fig. 3.2 we consider the reproduction of a single sinusoid, applied as an aerial image to the face of the emulsion. The emulsion MTF reduces the amplitude of the sinusoid, as shown in the figure, when it passes through the MTF box and becomes the effective exposure image. After passing through the transfer characteristic the developed image is seen as a distorted wave, 180 degrees out of phase with the input, since it is now a negative. We have five things to consider; the sinusoidal modulation M_a applied to the film; a smaller sinusoidal modulation M_e postulated to exist within the emulsion, obtainable from M_a on direct multiplication by the value of the MTF, Tk, appropriate for the particular frequency; the non-sinusoidal modulation, M_i, traced in the developed image; and the non-linear transfer characteristic, T_e, which relates M_i to M_e. Looking up from M_e through T_e to M_i, the input sinusoid is seen to be distorted by the non-linearity. In the figure we have used the exposure-transmittance characteristic of a high gamma aerial film, including low densities, i.e. part of the toe of the normal H and D curve. Even at densities lying on the straight line of an H and D curve, however, the exposure-transmittance characteristic is non-linear. Normally, we write,

$$\text{Density} = \gamma \log E + \log k$$

but over the same region,

$$\text{Transmittance} = k \, E^{-\gamma}$$

So, even when gamma is unity, the reproduction is distorted. In Fourier terms, the distortion of the sinusoid creates harmonics of the original frequency. Radio engineers would recognise the distortion in Fig. 3.2 as second harmonic, one half of the cycle being flattened and the other sharpened.

Now looking back from M_i to M_e, the non-linearity converts the distorted waveform back to a sinusoid, thus by tracing M_i and knowing T_e we can generate M_e. The ratio of M_e to the input M_i is of course the MTF for that frequency, and by repeating for a range of frequencies we can find the full MTF. However, there is an essential condition, which may not always be met. The presence of harmonic distortion means that the developed image has higher frequencies than the input, and if these cannot be accurately traced, because of optical limitations or grain noise, we cannot faithfully recreate the input waveform. The apparent modulation of the input could be lowered, as well as the distortion of the wave shape. (Compare with the discussion in Chapter IV, section 4.6.) This problem obviously becomes more serious as the spatial frequency is raised. An input at 400 cycles per mm would make a waveform which even the best micro-densitometers would find difficulty in tracing, apart from the noise limitation.

Another difficulty in getting back to the true input waveform arises in the development process. The transfer characteristic, being determined from regular step-tablet exposures, refers to macro sized areas of film. The validity of the effective exposure concept depends on the assumption that the characteristic applies equally for micro sized areas. But it is well known that the contrast of small details may be inaccurately reproduced due to various processing effects. In general such effects are a function of the size and contrast of the detail, so that we could have what amounts to another MTF, only it would be non-linear. According to the magnitude of these effects, the MTF deduced for the emulsion could be substantially different from the transform of the spread function.

Development effects that can affect the apparent MTF of emulsions are discussed in section 3.4. Usually, it is possible to find processing conditions such that the effects are not a serious source of error, but their potential existence means that unique and linear emulsion MTF's cannot strictly be defined.

3.3.3 THE COHERENT LIGHT TECHNIQUE. Most of the methods for measuring emulsion MTF's are fundamentally alike, in that they represent systematic analysis of formal images produced in essentially the same way as the details that we record and examine in aerial photographs. Such images are produced and observed, as indeed are the majority of the images of things we see around us, by incoherent light, i.e. the multitude of electromagnetic disturbances which fall on the objects and reach our eyes or the emulsion are in a completely random phase relationship. Without special detection arrangements we are not normally aware of light as having a periodic rather than an invariant nature. Occasionally we get hints of its periodic or wavelike nature, as when we see a distant light source at night through the gauze of a screen door. The phenomenon of diffraction then produces multiple images of the source on each side of the main image. (A prolific generator of UFO sightings). The diffraction comes about because the radiation reaching the screen from the distant source at any instant is essentially on one wavefront, hence all parts of the screen receive energy in phase, i.e. the arriving light is coherent. Emerging from the regularly spaced apertures in the gauze we then have numerous sources of radiation in phase, which can interfere to produce local concentrations of intensity at angular distances which depend on the spacing of the apertures and the wavelength of the light. In general the light is not monochromatic and we can see colours, e.g. blue and green from a mercury lamp, at appropriate angles. The subject of diffraction is beyond the scope of this book, but is introduced here because it has been used for a basically different approach to the measurement of emulsion MTF's, which is fundamentally not so limited as the regular imaging methods. The technique has not been applied to MTF measurement to any great extent in practice, largely because it requires fairly elaborate equipment, and skills associated with physical optics rather than photography. However, the method, developed by R. Swing[4] is of such delightful elegance that a brief account cannot be omitted.

The principle of the method is illustrated by Fig. 3.3, which indicates the layout of

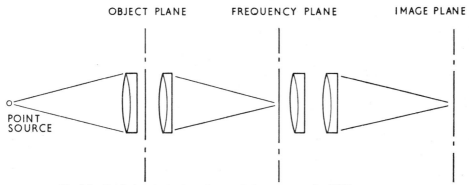

OBJECT PLANE FREQUENCY PLANE IMAGE PLANE

POINT
SOURCE

Fig. 3.3 Optical paths in the coherent light apparatus for MTF measurement

the optical components and the paths of the light, and by Fig. 3.4 which is a schematic representation of the appearances in the three planes. An intense source of coherent monochromatic light was produced by focusing a high pressure mercury vapour arc on to a pinhole 0·006 inch in diameter with a microscope objective. A narrow band filter was included to isolate the mercury line, 546·1 nanometres. (In more recent application, a laser source could replace the mercury arc and pinhole system) The pinhole was in the focal plane of an f/8 24·5 inch collimator lens. An identical lens focused the light in the frequency plane. A pair of similar lenses, located at the frequency plane, imaged the object plane in the image plane. If a transparency, e.g. a sinusoidal target, was inserted in the object plane, its Fraunhofer diffraction pattern

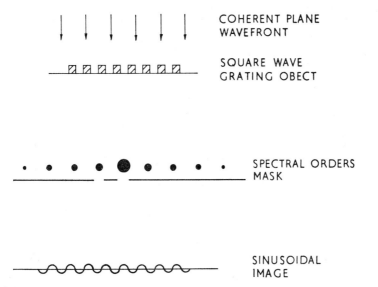

COHERENT PLANE
WAVEFRONT

SQUARE WAVE
GRATING OBECT

SPECTRAL ORDERS
MASK

SINUSOIDAL
IMAGE

Fig. 3.4 Schematic of appearances in the three planes of the coherent light apparatus

was formed in the frequency plane. Now the diffraction pattern is the Fourier transform of the object, hence we find displayed in the frequency plane concentrations of light which represent its spatial frequency spectrum. Since the object was a sinusoid, whose spectrum contains only one frequency, what we observe is a bright spot on the optical axis, corresponding to the image of the point source, with less intense spots symmetrically located each side. The central spot, or zero order, represents the zero frequency or D.C. component, while the two outer spots represent the fundamental frequency of the target. In practice sinusoidal targets are rarely of perfect sinusoidal form, and the presence of small amounts of harmonic distortion is seen at once in the coherent light apparatus by the presence of higher order components, represented by additional spots at distances which are equal multiples of the fundamental distance. If the transparency is replaced by a square wave grating (also known as a Ronchi ruling) the full series of higher order harmonics is displayed, though the number actually visible depends on factors such as the intensity of the source. There is a linear relationship; the higher the spatial frequency in the object plane the further out does its spectral correlate occur in the frequency plane (thus illustrating the Fourier transform relationship).

If the aperture of the third lens combination is large enough, the spectral orders are collected and an image of the grating is reconstituted in the image plane. But if we insert masks in the frequency plane to exclude some of the spectral orders, the image will be modified. For example, if we allow only the zero order and one member of the first side order through, the image will be a pure sinusoid, the modulation depending on the ratio of the intensities of the centre and side orders. If both side orders are passed, the result is a sinusoid of double the frequency, whose modulation drops to zero. With both side orders and the centre order, the basic frequency and twice this frequency appear. In general the apparatus can be used to display and modify the Fourier transform of any transparency and form the spatially filtered image. The significance of the coherent light technique for the measurement of emulsion MTF's is that we can start from a square wave grating, which is readily obtainable, and can generate a sinusoidal intensity distribution of perfect purity as an aerial image. By varying the fundamental frequency of the grating and, to a limited extent, by using the higher orders, we can have a wide choice of spatial frequencies. Thus Swing used gratings of 65 and 133 lines per inch for frequencies out to 100 cycles per mm and above. If the applied modulation is kept low, a film put in the image plane will record an approximately sinusoidal image. If this is then put back into the object plane, its own spectrum will be displayed in the frequency plane, and its modulation can be found from microphotometer measurements of the relative intensity of the centre and side orders. The ratio of the film image modulation to the aerial image modulation is the modulation transfer factor for that frequency. MTF's of emulsions determined by this method agree with those determined by the regular methods in incoherent light.

As the theory of the coherent light technique is fairly involved, reference should be made to the original paper for details of the procedure by which the modulation in

object space is derived from the intensity in the image plane. The paper also gives references to the contributions of other workers in the field.

One essential condition for the technique is that the object transparency must not introduce any phase change in light traversing the system, since this would disturb the derivation of object amplitude from image intensity. Since we are concerned with differences of optical path in the order of a wavelength of light, many defects of photographic images, normally negligible, become significant. The variations in gelatin thickness associated with the varying silver content in different parts of the image could completely invalidate the measurement of modulation. Scratches, small particles of dust, any minor flaws that cause discontinuities in the structure of the base or gelatin, which would be invisible in incoherent light, become painfully obvious in coherent light. Each discontinuity is edged with a halo of diffracted light, such effects being known as "ringing", or "overshoot". So far as these troubles are caused by changes in optical path outside the gelatin layer that holds the image, they can be very largely eliminated by immersing the film in an inert liquid of exactly matching refractive index. Very close matching is needed, sometimes involving mixed liquids and close temperature control. Extreme precautions are needed to ensure cleanliness.

The outstanding advantage of the coherent light technique is its very good signal to noise ratio. The light diffracted from the sinusoid is concentrated into a small spot, but that from the grain noise is spread almost uniformly over the whole aperture of the system, because the grain has an almost flat frequency spectrum. The excellence of the signal to noise ratio is well shown by the clear display of spectral spots from sinusoidal images on film, in which nothing but grain can be seen under magnification in incoherent light, so low is the modulation. In principle there is no upper limit to the spatial frequency that can be applied to the film, but in practice the limit is set by the aperture of the lenses that can be obtained.

The principles of spatial filtering employed in this technique are also applied to the analysis of aerial photographs and other recorded images. The picture is put in the object plane, which causes its Fourier spectrum to be displayed in the frequency plane. Apertures are then inserted in the frequency plane to obstruct different parts of the spectrum in known and controllable ways. The results of altering the balance of frequencies in the spectrum of the picture can then be observed when it is reconstituted in the image plane.

3.4 *Development Effects*

3.4.1 GENERAL.
The H and D curve of ordinary sensitometry is typically determined from exposed areas of film each of which is in the order of one square centimetre in size. The exposure-density relationship so found does not necessarily hold good for smaller areas, say one half millimetre diameter or less, due to phenomena which have been known for years, but are of particular interest because of their influence on the MTF of films. Inasmuch as they act to increase the contrast of fine

details they are naturally of special interest in aerial photography. These phenomena arise from the circumstance that the development process can be retarded by the accumulation of its own reaction products. Within a large uniformly exposed area, the reaction products are produced at a rate which is characteristic of the density being developed and, away from the boundaries of the area, the concentration of reaction products at any moment is the same at all points. When small adjacent areas are developing to different densities, as in a film exposed to sinusoidal targets, or in a detailed area of an aerial negative, cross-diffusion of the reaction products occurs. In a small low density area, the concentration of reaction products is therefore higher, and the rate of development is slower than it would be in a large area which had received the same exposure. Conversely, in a small high density area the concentration of reaction products is lower, and development proceeds more rapidly than in a large area which has had equal exposure. Thus a given difference of exposure can yield a greater contrast for small images than for large areas. In general, the density developed in a given area of film can depend not only on the exposure it has received but also on the size of the area and the exposure received by adjacent areas. These effects are influenced by the composition of the developer and the degree of development, also the agitation in the development process, and some films display them more markedly than others.

Collectively, such phenomena are known as *development effects*. The term *"Eberhard Effect"* is applied when small areas of greater exposure than their surroundings, such as isolated line images, develop to greater density than large areas which have had equal exposure, the density continuing to increase with decreasing area until the effect is overtaken by the contrast reduction due to the influence of the spread function. *Adjacency effect* or *neighbourhood effect* are more general terms for any cases in which development is affected by the development taking place in adjacent areas. Eberhard and adjacency effects are fundamentally of the same nature, and indeed some authors use the two terms interchangeably within the same paper for the same phenomenon, but as this practice could cause confusion we shall restrict ourselves to *development effects*.

Other processing effects exist which may disturb the expected exposure-density relationship for small details. Thus in the Dufaycolor process of additive colour photography, the sensitive emulsion was coated upon and exposed through a mosaic of red, green and blue filters, each filter being 25 microns square. It was found that reversal processing and negative-positive processing did not give identical colour balance and saturation, the differences being partially due to the use of a silver solvent in the first developer of the reversal process, which by a combination of chemical and physical development emphasised the density differences in adjacent areas. Again, fine grain high resolution films are liable to suffer some reduction of image density if left too long in an ammonium thiosulphate fixer; this bleaching effect can cause a distortion of the waveform in sinusoidal images, presumably due to a differential solvent action when adjacent high and low densities are attacked. (The extreme sensitivity of the coherent light technique has proved valuable in studying such effects.) Tanning of the

gelatin, which causes shrinkage more or less proportional to the developed density, can affect the microdensitometry when the light is partially coherent, as it is in many microdensitometers, and can also affect the apparent waveform.

3.4.2 THE IMAGE OF AN EDGE IN PRESENCE OF DEVELOPMENT EFFECTS. An ideal image of an edge is a sharp transition from one level of density to another (Fig. 3.5). Assuming that the spread function is negligible, the density step also should be a sharp transition, but in presence of development effects the density distribution becomes distorted in the near neighbourhood of the edge. In the heavy exposure region there is a higher concentration of reaction products, which slows development in the area as a whole. The products tend to diffuse sideways to regions of lower concentration, as suggested by the left-pointing arrows in Fig. 3.5. As they migrate, their concentration decreases, so that close to the edge they retard development in the lightly exposed

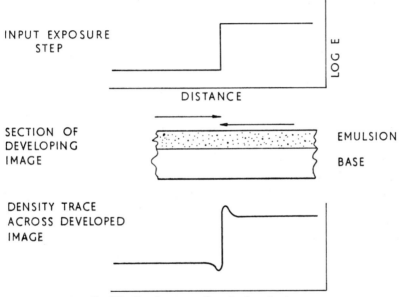

Fig. 3.5 Development effects in the edge image

area, but the action does not spread very far. Likewise, the outwards-diffusing reaction products are being replaced by the inwards-diffusing relatively little used and more active developer, so that development proceeds more rapidly along the boundary of the heavily exposed area than within it. The nett result is that the density is depressed on the low exposure side of the boundary and raised on the high exposure side, within a small distance. Accepting this qualitative explanation as reasonable, the edge effect must depend on at least the following things: the susceptibility of the developer to its own reaction products; the agitation of the developer near the edge, which would

primarily affect the concentration of reaction products in the surface or boundary layer of solution, but also could have effects within the gelatin layer; the duration of development, since if the process goes to completion the effect must disappear; the thickness of the swollen gelatin layer; the relative diffusion rates of the operative chemicals; the salt content of the developer; etc. The actual density difference and the density gradient across the boundary must also have an influence on the actual density deviations observed, the height of the "overshoot" being presumably dependent on these two factors.

In general the density image in absence of development effects is not a sharp transition, but is more or less blurred. The overshoot and undershoot due to the development effects can counteract this blurring to some extent, by introducing opposing density distributions, hence developers which exhibit the effects are known as "sharpening" developers. A moderate degree of sharpening by development effects can be useful, but if overdone an unpleasant "haloing" occurs and the appearance of the picture is very unnatural.

3.4.3 INFLUENCE OF DEVELOPMENT EFFECTS ON THE MTF. In general the development effects cause the apparent MTF of a film to be better than its "true" or "optical" MTF. They bring this about by causing a greater degree of development at high frequencies than at low frequencies or on large areas, as already mentioned. Since the MTF, by the manner of its determination, is normalized to $1 \cdot 0$ at zero frequency via the H and D curve, the increased contrast at higher frequencies necessarily makes the apparent MTF greater than it would otherwise be. The effect can only occur if the development in the larger areas is less than complete. In aerial photography it is usual to give very full development, since maximum film speed is very important, also in many high speed processors strong agitation is employed. Both of these conditions tend to reduce or nearly eliminate the development effects, and are therefore in conflict with the equally important need for recording small low contrast details in the clearest way possible.

As normally seen in published curves, the development effects result in a maximum or hump in the apparent MTF, in the low frequency region, usually between 10 and 30 cycles per mm. Indeed, it is often specifically stated that the effect on the MTF is confined to this low frequency region. While the statement is true in the intended sense that the apparent film MTF does exhibit the maximum in this frequency range, it can be misleading, because the development effects which cause the maximum extend to higher frequencies.

The low frequency maximum is to be seen in many, possibly most, of the MTF's published by film manufacturers, even when development has been conducted in solutions normally considered free from such effects, e.g. D 19 for aerial films. (The curves in Fig. 3.1 do not extend to low enough frequencies for the effect to be obvious; also, it is less obvious in a logarithmic plot.) The maximum is usually small in such curves, i.e. it rises to $1 \cdot 1$ or thereabouts, but in studies of special development conditions reported by many workers the MTF's rise to maxima of $2 \cdot 0$ or more.

An example of the operation of the development effect is given by Selwyn.[5] (Fig. 3.6.) The film was exposed to sinusoidal targets at constant modulation. Two large areas at the maximum and minimum density levels of the targets provided the reference contrast at zero frequency. Development was carried out in two solutions, one essentially free from development effects (upper microdensitometer trace in Fig. 3.6) the other known to give a strong effect (lower trace). The numbers at each frequency block are the ratios of the density ranges of the sinusoidal images to the density range of the images of the large areas. Without development effect the ratios decrease progressively with increasing frequency due to the true or "optical" MTF of the film. With development effect the ratios rise above 1·0 at the lower frequencies, and are higher than those of the upper trace at all frequencies. At the highest frequency the ratio is nearly 2 to 1, and clearly the micro contrast has been maintained over a wide range by the development effect.

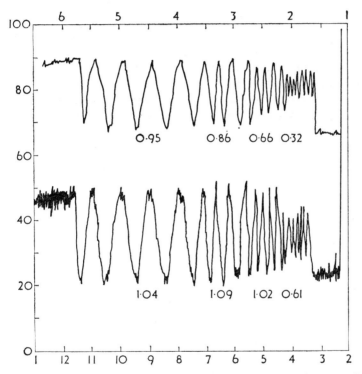

Fig. 3.6 Microdensitometer traces of sinusoidal images: upper trace no development effect, lower trace with development effect (after Selwyn)

It is convenient to think in terms of two MTF's, the falling MTF due to the optical scattering, which is constant, and other MTF's which rise with frequency according to the development effects and are different for each developing condition. Kelly,[6] has called the latter "chemical transfer functions". Strictly speaking they are not transfer

functions because they are non-linear, the amount of contrast enhancement at a given frequency depending on the actual input contrast of the optical image, but the concept is useful.

The relationship of the chemical MTF to the apparent film MTF, as a function of frequency, is illustrated by an example in Fig. 3.7, which is based upon data published by Lamberts.[7] Curve 1 is the MTF as given by Lamberts for Kodak Plus X film (not Plus X Aerecon) developed in D 19 for 3 minutes. Development effects are probably still present to a small extent, but this curve has been used as a reference, on the assumption that they are small enough to be neglected. Curve 2 is for Plus X developed for 10 minutes in DK 50 diluted 1 to 10 (agitation not stated). The low frequency maximum is very pronounced, and the curve lies well above curve 1 at all frequencies. Curve 3 shows the ratio of the MTF's of curve 2 to curve 1. It is approximately a linear function of frequency, and shows no sign of levelling off even at 150 cycles per mm, where the ratio has risen to $3 \cdot 6$. The maximum in the apparent film MTF is the result of combining an approximately hyperbolic film MTF with an approximately linear chemical MTF. The position of the maximum will clearly depend on both curves; in general it shows some tendency to move to higher frequencies with slower films of higher resolution. The maximum does of course indicate a genuine (and undesirable) local increase in the effective film MTF.

Kelly (l.c.) has derived the chemical transfer function for different films and developers, some of his results being shown in Figs. 3.8 and 3.9. In Fig. 3.8, for Panatomic

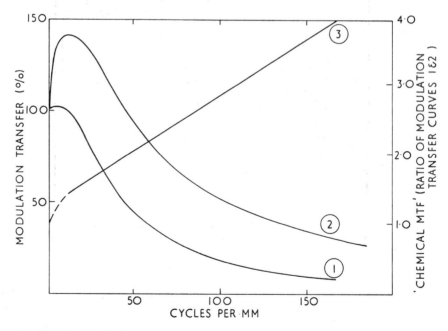

Fig. 3.7 "MTF" of development effect. Curve 1—D 19 developer. Curve 2—DK 50 developer (1:10 dilution). Curve 3—Chemical MTF (ratio of curves 1 and 2)

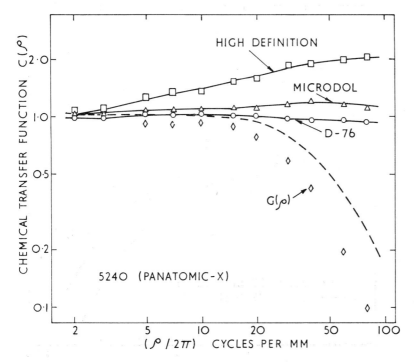

Fig. 3.8 Chemical transfer functions for Panatomic X film developed in three developers (diamond points indicate the lens-film MTF)

X film, the chemical transfer function is seen to be almost level for D 76, an unexpected result, as D 76 is normally found to give marked development effects. Microdol shows a slight peak near 50 cycles per mm, while Kodak High Definition developer rises more steeply, with a slight suggestion of levelling off near 100 cycles per mm. In Fig. 3.9, the results of a special processing technique are shown for Panatomic X and Tri-X film. There is now no sign of levelling off in the chemical MTF even at 100 cycles per mm, and the increase is more marked for the finer grained film.

Details of the processing technique are not divulged, but there is reason to believe that it did not involve stagnant development, indicating that the effects are due to diffusion within the gelatin layer. In this connection, the swollen gelatin may well be in the order of 100 microns thick, which in relation to image widths in the order of 10 to 100 microns gives scope for internal diffusion to be a significant source of development effects.

The rather limited evidence does seem to suggest that the chemical MTF's extend well up into the higher frequencies and are therefore of interest even for high resolution aerial photography. Their influence on the apparent MTF of the film can obviously be profound, and care should always be taken to ensure that the processing conditions are understood when use is to be made of the film MTF in any quantitative way.

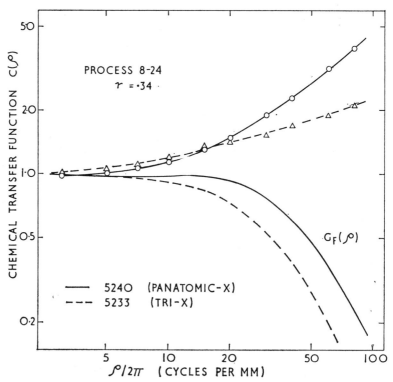

Fig. 3.9 Chemical transfer functions of Panatomic X and Tri-X films with special processing

3.4.4 SIGNIFICANCE OF DEVELOPMENT EFFECTS FOR AERIAL PHOTOGRAPHY. The development effects in general enhance the apparent gamma of the film for small details, or, if we prefer, they hold back the development on the larger areas, while allowing more contrast to develop in the smaller details. This is analogous to the "unsharp masking" techniques, notably electronic masking, which have been found beneficial in printing aerial negatives, hence the use by Kelly (l.c.) of the term "chemical masking" for development effects. In chemical masking, of course, the negative itself is modified, the effects extend to higher spatial frequencies, and are more nearly proportional to frequency. While the special sharpening developers used in amateur photography do have the undesirable haloing effect when the method is used to excess, one cannot lightly dismiss techniques which can raise the apparent MTF of a film by factors in the order of 4 at relatively high frequencies. Such an increase in the effective MTF of a lens would be regarded as remarkable, and the possibilities of marshalling the development effects in the service of aerial photography must be seriously considered.

Two important questions must be asked: Can the low frequency hump be eliminated?, and What are the penalties for the increased micro-contrast?

The low frequency maximum in the apparent film MTF arises from the mismatch

78

between the shapes of the "real" MTF and the chemical MTF. It may not be possible to achieve a better match. It seems very unlikely that the shape of the real MTF can be changed in a controlled way and to a substantial extent, so that the only possibility lies in control of the diffusion process. Very little investigation of these mechanisms appears to have been done, or at any rate published; until more is known about them the prospects for obtaining a more desirable shape of apparent MTF cannot be assessed. There is little doubt that a properly adjusted compensation for the falling optical MTF of the film would be advantageous in many applications of aerial photography, depending of course on the extent to which quality is limited by the film. The films specially produced for aerial photography are often of high contrast as well as fine grain, and undoubtedly this high contrast is helpful in view of the decline of image contrast with decreasing size. However, such films often give excessive contrast on macro areas, and the negatives can be very difficult to print. In practice the undesired high contrast on macro areas is accepted for the sake of the better micro contrast, but it would certainly be preferable to have a processing technique which would give a moderate or low contrast for macro sizes, increasing progressively with decreasing size. But the distortion of the MTF at low frequencies that accompanies any substantial development effect at present is usually an unacceptable penalty.

Apart from the low frequency maximum in the apparent MTF, there are other penalties associated with the application of strong development effects. One of these is the loss of film speed. Incomplete development in the macro areas implies lower speed also. However, this point would bear further investigation, inasmuch as the development is not incomplete for the small details. Possibly a redefinition of the concept of speed is required. Again, solutions which give substantial development effects tend to be unsuitable for machine use or rapid processing of aerial negatives, because they are often dilute, exhaust rapidly, and require relatively long processing times, sometimes with low agitation, which carries the risk of uneven development. Development proceeds further in the small details, which suggests that grain might be increased. In fact the common "sharpening" developers are known to give increased graininess. The photographs illustrating Kelly's paper (l.c.) do exhibit a striking increase in the contrast of small details, but this is accompanied by increased graininess. (It may also be remarked that they have an "unnatural" appearance, that seems to accompany all manipulations of the photographic image, but in this case may be due to a low frequency maximum.) However, one must keep a sense of proportion about the graininess. So far as it is due to full development it may well be no worse than would be obtained by processing to the same extent in the usual D 19; it could equally well be regarded as reduced grain on the larger areas. Nevertheless, it is in the small details that grain is most serious when images are near the limit of resolution and are magnified for maximum extraction of information, as they are in aerial photography. It will be appreciated that investigation of development effects by the MTF alone gives an incomplete picture of their practical value. Desirably, such measurements would be supplemented by measurements of resolving power, which takes account of granularity as well as the MTF.

Although the chemical transfer function continues to rise with increasing frequency, according to most (if not all) accounts, it does not seem to be linear, in the sense that the contrast enhancement at a given frequency increases with the original image contrast. The published information is not adequate to make more quantitative statements, but the non-linearity does appear to exist, to an erratic extent. This is the reverse of what could be desired, since enhancement is least needed when details already have adequate contrast, and conversely it is most needed when their contrast is vanishingly small. At present it is not possible to say more than that the development effects appear to hold considerable promise for aerial photography, but much more investigation will be needed before a balanced assessment can be made.

3.5 *Influence of Halation*

Although most high resolution films for aerial photography have an anti-halation device of some kind, either tinted base or an absorbent layer, this is not universal, and it is worth considering how halation might influence the MTF. Some qualitative ideas can be derived along the lines suggested by Fig. 3.10. This is drawn approximately to scale for $0 \cdot 005$ inch thickness base, though the emulsion thickness can only be suggested. A sinusoid of 20 cycles per mm exposed in the sensitive layer would probably give rise to a uniform distribution of light on the rear of the layer after the double pass through the base thickness involved in reflection from the back, especially when the diffusion within the emulsion itself is taken into account. Therefore the peaks and

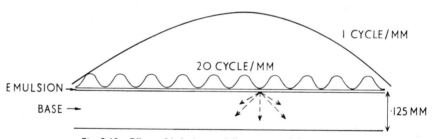

Fig. 3.10 Effect of halation at different spatial frequencies

troughs of the sinusoidal exposure receive equal additions of exposure; in radio terms the D.C. level is raised and the modulation is reduced. This is directly analogous to the effect of atmospheric haze, which adds light equally all over the picture. At some much lower spatial frequency, however, e.g. one cycle per mm, the return light could conceivably raise the exposure level in proportion to the incident light; this is equivalent to raising the D.C. level without lowering the modulation. An analogy to this is the effect on the H and D curve of using a white or reflecting backing behind the film base. Experiments during World War II with high speed film in night photography showed

that the white backing increased gamma without affecting speed. However, use of a reflecting backing behind modern high resolution, almost transparent, aerial films such as SO 243 increases speed without increasing gamma. This speed increase (limited by the tinted base of SO 243) is what would be expected from a straight additive reflection, because this is simply equivalent to shifting the log E axis by a certain amount. The different behaviour with the faster film was evidently due to the simple mechanism being complicated by the greater diffusion and absorption in the thicker and coarser-grained emulsion. Similar complications could arise in the effects of halation on the MTF. According to the simple situation proposed in Fig. 3.9, the MTF over much of its range would be artificially depressed below its value near zero frequency. This effect has been demonstrated, but is in the order of a few per cent hence is not very serious. It can always be eliminated by giving the film an anti-halo backing and is not a fundamental problem, though it may influence some published MTF's.

3.6 *Influence of Exposure Level*

The level of exposure and the density of the image would have no effect on the emulsion MTF, if the latter were truly the transform of the spread function. Some reservation must be made, of course, because the H and D curve eventually saturates. Again, if high modulation targets are used with contrasty films, the extreme harmonic distortion may render it impossible to recover the true waveform. In general, for successful application of the MTF, the modulation should be kept small and the exposure confined to the normally used part of the H and D curve. However, even within these limitations, some dependence of the MTF on the exposure is often observed. According to the literature, high speed films tend to show a decrease of MTF with increasing exposure; this may possibly be due to the image occupying an increasing depth of the layer, so that some parts may be outside the sharpest focus of the micro-densitometer. The opposite effect has been reported for the thinner high resolution films. As one example the MTF of SO 243 aerial film was found to increase quite substantially (order of 50 per cent) when the mean density was raised from 0·4 to 2·09. In Fig. 3.11 the curves from the original publication[8] have been redrawn on a logarithmic scale to illustrate how the increase of MTF with density is almost constant over the frequency range. These curves do not show the actual MTF of the film, because they refer to the measured modulation in images formed on the film by an f/6 aperture limited lens, in narrow band green light, thus the modulation at, say 100 cycles per mm is about half of that in the film MTF. Nevertheless, the variation with density is characteristic of the film. The density figures against the curves are the mean image densities of the sinusoidal patterns at 60 cycles per mm. Development was in D 19 with good agitation, but a small adjacency effect was found to be present. The increase of MTF with density has not been fully explained. It is partially due to a relief effect in the gelatin, which is presumably more marked in thin-film high silver-ratio materials, in which the developed image occupies almost the whole layer thickness and hence can cause more

81

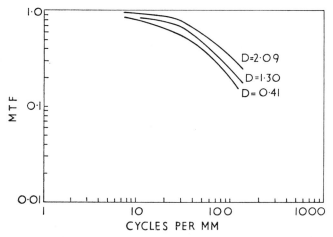

Fig. 3.11 Effect of exposure level on MTF of 3404 film

physical distortion. The existence of the relief was shown by evaporating aluminum on to the surface of the negative, when the sinusoidal ripples of the surface acted as a respectable reflection grating with which optical spectra could be formed. Also, if the silver is bleached out, microdensitometry still yields a faint trace of an image. This could be accounted for by a partial coherence of the microdensitometer optics, responding to a variation of phase caused by the differing thicknesses of the gelatin. However, phase effects due to thickness differences are not the only source of the MTF increase. If images at different densities, corresponding to Fig. 3.11, are aligned in a double microscope, illuminated by the usual diffused (hence incoherent) light such as would normally be used for reading resolving power, with the illumination balanced to compensate for the different densities, the greater contrast of the denser images is clearly seen. It is desirable to point out that this does not mean that one should over-expose aerial negatives to get better image quality. Higher density also means higher granularity, which above a certain density more than offsets the superior micro contrast. In the MTF measurement the grain is averaged out by the long slit, allowing the increase of MTF to be demonstrated unaffected by the noise. This is a good illustration of the sometimes imperfectly understood point that the MTF is not "image quality", but merely one of the factors which determines image quality in conjunction with others which may be at least as important.

Other factors associated with this exposure dependency are adjacency and differential shrinkage possibly due to tanning of the gelatin. The three dimensional nature of images, often overlooked, plays a considerable part in these aspects of image quality. In fact, as we make closer and more accurate studies of the MTF of films, especially those of high resolution, we find greater difficulty in treating it as something independent of the techniques used for exposing the images and measuring their densities after development.

82

The emulsion MTF is affected to a measurable extent by the wavelength of the exposing light, but the effect varies. Fast emulsions of large grain size, rather thickly coated, absorb blue light more strongly than red; the red light is scattered and diffuses further, while the blue is quickly absorbed and kept within closer limits, hence the MTF is best for blue light and worst for red, with green light intermediate. Fine grained emulsions such as 3404 are almost transparent to red light but scatter blue light strongly because of the small size of the grains. The balance of absorption and scattering works out differently in this case, and these emulsions have a higher modulation transfer for red (or green) light than for blue. The difference appears to increase with spatial frequency, and for 3404 the ratio can be in the order of two to one at high frequencies such as 300 cycles per mm. Presumably the resolving power also would be higher for red light, but no data on this seems to have been published. Data for aerial films in

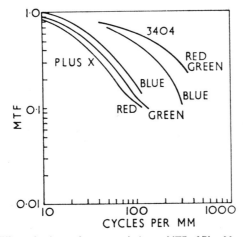

Fig. 3.12 Effect of colour of exposing light on MTF of Plus X and 3404 films

different coloured lights are not always provided. Fig. 3.12 illustrates the order of magnitude of the effects for a high speed negative film (Eastman Plus X Pan Negative 7231) and for 3404 aerial film.[9] For the Plus X film the MTF is markedly higher for blue light than for red; for 3404 the effect is reversed. The common use of red or yellow filters in aerial photography would therefore have different effects on the image quality, so far as this is influenced by the emulsion MTF, according to the type of negative film used. With long focus lenses, when colour aberrations tend to be the limiting factor in optical performance, the effect of a filter change on the emulsion MTF would probably be hidden by the larger effect on the lens. With lenses of shorter focal length, in which residual colour plays a smaller part, the change from a yellow to a red filter

might have a more significant effect. In the case of 3404 the tendency for the MTF to be better at longer wavelengths fits in with the general preference for longer wavelengths in aerial photography because of their superior haze penetration.

3.8 *Significance of the Film MTF for Aerial Photography*

By now, the reader who is primarily concerned with the impact of the MTF on aerial photography in practice, rather than its use as a research tool or an aid to emulsion engineering, may be wondering what an emulsion MTF really is, since a given emulsion can apparently have many MTF's, with the possible exception of the "true" MTF, which alone can be adequately defined. He might also wonder how we apply it, since it does not appear directly in the images we see, does not measure image quality, and does not indicate the relative contrast of anything but a sinusoid. But then, sinusoids are not reproduced as sinusoids, so where do we stand? All these comments are justified, but the obvious conclusion would be too pessimistic.

Perhaps for the reasons just mentioned, some emulsion manufacturers prefer not to issue emulsion MTF's, but publish, instead, "contrast transfer curves", which show the relative contrast in the image of squarewave or progressive squarewave targets, as a function of the nominal spatial frequency. At first sight this may seem attractive, because it includes things which affect the contrast of images as we actually see them, but are deliberately taken out of the picture when the MTF is derived, e.g. the gamma and effects due to the rounding off of the squarewave. Also, any adjacency effects might be more realistically shown by the sharp edged squarewave than by the sinewave. However, these are rather limited advantages, because the contrast transfer characteristics are special to the target used, do not represent general detail, especially isolated detail, and cannot be used for analysis in the same way as MTF's. Of course, there is always the danger that unsophisticated photographers will continue to believe the MTF itself expresses the relative contrast for general detail, and includes the gamma, but this danger is diminishing as more people come to understand the true nature of the MTF.

We have to admit that the emulsion MTF is not a fixed and definite thing, such as the lens MTF can be if we specify the conditions adequately. We can only get at it indirectly by the procedure outlined in Fig. 3.2. This represents the simple case in which there are no adjacency or halation effects, and the microdensitometer works the same way on large uniform density areas as on images with rapidly alternating small local density values. Development and other effects may interpose an "MTF" additional to the one in the box in that figure, which is supposed to be the Fourier transform of the spread function. Kelly (l.c.) and others have proposed to define and apply this MTF, but in view of its non-linear qualities this is of doubtful value for the general user. The only "real" MTF, in the sense that it is characteristic of the emulsion itself apart from the conditions of use, is the one in the box, which we can define but can only measure to a certain level of approximation, when all disturbing factors have been reduced as far

84

as possible. The MTF's which are real, in the sense that they can be measured for specific use conditions and determine the image recording qualities of the emulsion, are also legion, so which of them is "real"? As this is taking us into regions of argument more appropriate to medieval philosophy, we shall strike a more positive note by declaring that the concept of the MTF is indeed important, and without it a great deal of advanced thought on the role of the emulsion in image quality would not have been possible. On a very practical level, the distortion of a sinusoidal image illustrated in Fig. 3.2 may have been well appreciated by sound recording engineers many years ago, but is a relatively new idea in aerial or general photography. Distortion of sinusoids also implies distortion of all small details, and much work remains to be done on the implications of this for aerial photography, in which small details are paramount. For those with adequate computer support, the MTF will be an invaluable aid to such studies. Lamberts has shown that the harmonics of the distortion largely cancel, leaving a waveform of tolerably correct amplitude but distorted shape, if gamma is kept below 0·6 and modulation below 60 per cent, but it is not clear that there is much comfort for the aerial photographer in this conclusion. Distorted waveforms mean distorted outlines, which must affect photo-interpretation. Gammas of 0·6 are hardly practicable for general aerial photography. It may be that the eye cares little for harmonic distortion when looking at small details, and is content with above-threshold amplitudes, but we know little about such problems. Clearly the study of the emulsion MTF concentrates our attention on them.

The way we view the emulsion MTF also depends on what we regard as important deviations from a nominal value. A research worker, trying to prove that the image can be synthesised with extreme accuracy from cascaded MTF's and object spectra, using sophisticated transform programmes, might be worried by differences of five per cent; a practical photographer, seeking information about the broad placing of emulsions in a group, would be quite unconcerned by a variation of ten per cent due to processing changes. So far as the choice and use of negative emulsions in aerial photography is concerned, the user can in fact forget the emulsion MTF as such, if he prefers, without losing anything substantial. At present the main end use of aerial lens and system MTF's is to predict resolving power. For this one does not need to use the emulsion MTF, at least not explicitly; one takes a complete working entity of MTF, gamma and granularity. In any case, one does not, and cannot, buy an emulsion for its MTF. Apart from minor possibilities, the user cannot separate out the MTF from the grain and gamma built in with it by the emulsion manufacturer. The emulsion may reasonably be regarded as a recording device which is presented with an aerial image at one end, and delivers a permanent record of it, further blurred and with added noise and harmonic distortion, at the other end. If the user wants to enquire into what goes on inside the device, the MTF concept and its accompanying researches will help him to understand, but he will not be able to change the contents. He may be able to make certain changes in the way the contents behave, and the MTF will help in understanding and controlling these. In short, the emulsion MTF is not a near-essential in the same sense as the lens MTF, but is a useful and fruitful concept for the engineer and

scientist, and an informative descriptor for the general worker if used with understanding and caution.

3.9 *Acutance and Sharpness*

Although acutance has little to offer the aerial photographer in practice, it is so well known as a measure of sharpness in the developed photographic image that it merits brief reference in this chapter.

The concept of acutance was introduced in the late 1940's, following the realisation that resolving power, measured under unrealistic conditions, does not necessarily correlate with image quality on objects in general. Acutance is an objective measure of the physical characteristics which give the subjective impression of sharpness in a photographic image. As distinct from the emulsion MTF, it incorporates the actual density distribution in this image, hence the effects of any non-linearities. It is measured in terms of the density profile across the image of a knife-edge, as indicated schematically in Fig. 3.13. The ideal density image would have the rectangular profile suggested by the broken line; any real image has a gradually sloping profile determined by the edge spread function, H and D curve, and any adjacency or other non-linear effects. The problem is to evaluate this profile in a way that correlates with the subjective impressions of picture sharpness. Neither the average slope nor the maximum slope

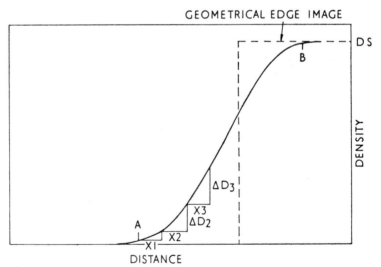

Fig. 3.13 Derivation of acutance from microdensitometer trace of knife-edge image

$$\text{Acutance} \frac{\sum \left(\frac{\Delta D}{\Delta x}\right)^2}{n\,(DS)}$$

86

correlates well. After extensive investigations, Eastman Kodak investigators arrived at the following method. First, limiting density values, A and B, are designated. If one goes too far from the geometrical edge image, the result is unduly weighted by large regions of very low gradient, which do not contribute to the subjective impression of sharpness. It was found that for typical amateur-type photographs, A and B should be located at points where the gradient is $0\cdot005$, when the distances x are measured in microns. The x distance from A to B is then divided into n small intervals Δx_1, Δx_2, etc., and the corresponding values of density increment ΔD_1, ΔD_2, etc., noted. The gradients $\dfrac{\Delta D_1}{\Delta x}$ etc. are then squared, and the average gradient found as

$$\langle Gx^2\rangle Av = \frac{\sum\left(\dfrac{\Delta D}{\Delta X}\right)^2}{n}$$

To take account of differences in the total density range across the step, DS, the acutance is then defined as

$$Acutance = \frac{\langle Gx^2\rangle Av}{DS}$$

Acutance is no doubt a useful parameter for the emulsion manufacturer and a good indicator of the relative sharpness of emulsions in viewing conditions where grain is not an important factor. It has the merit of expressing qualities of the developed image, as distinct from the abstract nature of the MTF. However, it does not offer the facility of the MTF for integration into the total photographic system, and is no guide to the minimum perceptible size of detail.

More recently, a sharpness measurement called "SMT acutance" (system modulation transfer acutance) has been suggested and applied by Crane. This allows the combination of several components in a system, according to the observation that (a) the sharpness is related to σ^2, the square of the standard deviation of a Gaussian spread function, and (b) that the sharpness in a system containing many elements is proportional to the sum of the σ^2's. Since the MTF is found more easily than the spread function, it is assumed that it is proportional to the squared area under the MTF. Summation of the squared areas, in a computation involving certain constants, appears to give good results in predicting required standards of performance, e.g. for sub-standard motion picture photography. The method is not directly applicable to aerial photography, since it takes no account of grain and the limiting detail size.

Finally it should perhaps be emphasised that subjective sharpness is dependent on the actual density step, or contrast, at an edge, as well as on the density profile across the edge, The sharpness of two photographic edges cannot be subjectively compared if their contrasts are unequal. It is common for aerial photographs taken on a hazy day to be judged less sharp than others taken with the same camera on a clear day, yet normalised microdensitometer traces show that the camera had functioned equally

well on both occasions. It is quite feasible to make visual estimates of the relative sharpness of edges in aerial negatives by matching them against standard edges in a suitable instrument, but a contrast match must precede the sharpness match. Again, in photographs showing patterns of fine detail, the impression of contrast in the detail is enhanced by increased sharpness, even when the actual density differences remain the same.

References

[1] SCHADE, O., *J.S.M.P.T.E.*, **73**, 2, pp. 81–119 (1964).

[2] SCOTT, F., *Phot. Sci. Eng.*, **7**, 345 (1963).

[3] e.g. LAMBERTS, R. L. and STRAUB, C. M., *Phot. Sci. Eng.*, **9**, 331–342 (1965).

[4] SWING, S. and SHIN, M. *Phot. Sci. Eng.*, **7**, (1963).

[5] SELWYN, E. W. H., *Photographic Theory*, (Chap. IV: III) Liege Summer School, Focal Press (1962).

[6] KELLY, D. H., *J. Opt. Soc. Am.*, **50**, 269 (1960), **51**, 11 (1961).

[7] LAMBERTS, R. L., *Journ. Soc. M.P.T.E.*, **71**, 635–640 (1962).

[8] Photographic Considerations for Aerospace: Itek Corporation, p. 55 (1966).

[9] LAMBERTS, R. L., *Handbook for Photographic Engineers*, S.P.S.E. (in publication).

IV. BAR TARGET IMAGES AND TRANSFER FUNCTIONS

4.1 *Introduction*

The MTF essentially evaluates imaging quality of a system. If we photographed nothing but sinusoidal targets, and our recording process was perfectly linear, the MTF would also give us, by direct multiplication, image quality, i.e. modulation. It is plausibly argued that the image quality can also be obtained for real scenes, by transforming intensity distributions into spatial frequency spectra, multiplying the spectra by the MTF, and inverse transforming to obtain the image intensity distributions. Considered in detail, this is much less attractive. What do we mean by the spectrum of a scene? The whole scene, or some area that we are interested in? And how do we evaluate the image quality from the relative values of the spectra before and after operation of the MTF? Suppose we are photographing a bare desert. In one frame there is nothing but grains of sand. This would have a very wide spectral bandwitdth, and we might conclude that the MTF of any available system was useless. In the next frame there might be a simple object, a pattern of corrugated sand ripples, at a period of say, one foot. This would have a pure spectrum, well within the capacity of the MTF of a good system. A third frame might show an oil refinery complex. What is the spectrum of this? There is a wide range of sizes and shapes; roads, tracks, pipes, buildings, tanks, vehicles, people, etc. Each has a spectrum, and we could average them, but oil refineries are not identical; how do we weight the average? This kind of argument obviously leads to absurdity. There are only two ways out. One is the statistical. We try to obtain an "average spectral power distribution" representing the mean of a large variety of scenes. While this could no doubt be done, the labour would be immense and the application doubtful. The other way, shorter and more attractive, is to go straight to the real point and decide on the smallest object of interest in the scene. More practically, we ought to know what is the smallest object the system will reproduce at all, at a given scale, on the reasoning that objects of larger size are then almost certain to be better reproduced. This may sound like a roundabout argument for resolving power, which in a sense it is, but it is the aerial photographer's resolving power evolved from the needs of the task. The real purpose of the argument is to emphasise that as aerial photographers we are vitally interested in the dependence of image quality on image size. Most of what we want to know about this could be found in the answers to two questions: "At what size does it vanish into the noise threshold of the system?" and, "What happens to it on the way down to that size?" We can gain considerable insight into the bearing of the MTF on these questions by studying its application to simple regular forms, such as the familiar resolving power bar targets, and to isolated bars. After all, many of the details in aerial scenes, the building blocks of the objects that we recognise, can be reasonably approximated by bars; and though actual periodic detail may be rare, objects are frequently at small separations, so the interaction of adjacent bars is also significant.

For sinusoidal objects there is only one variable, the modulation. For common objects and bar targets, which do not have pure spectra, there is a progressive change of shape as well as size when the images get smaller. For objects in general the changes are extremely complex, but studying them for bar targets at least gives some insight into the probable effects in the more complex general cases. For bar targets, contrast transfer functions, equivalent to the MTF for sinusoidal targets, can be calculated by the Fourier methods or by a simple graphical method. The image shapes can also be derived by these methods; they become surprisingly distorted, even in the linear optical stages, well before they vanish into the noise. The image as determined by the system MTF or OTF becomes distorted by the photographic non linearities before we see it. The complexities in a general treatment of this non-linearity are very great, but we shall discuss an illustrative example.

The MTF's of lenses in general, and other MTF's, have a variety of shapes, which affect the imagery of given targets in different ways. It makes a very convenient simplification to discuss the degradation of the images of bar targets in terms of the MTF of the aperture limited lens. The aperture limited MTF, being of constant shape, whatever the aperture, can be normalised to the target dimensions in the image and used as a reference standard. Restriction to this standard MTF is a limitation, but it is not of solely academic interest. The MTF's of many real lenses can be reasonably approximated by an equivalent aperture-limited MTF, especially if we confine ourselves to the portion which lies above the threshold, or lower useful value of the modulation transfer factor, set by the detecting device, i.e. the photographic emulsion in our case. The actual threshold level may be at a modulation transfer factor as low as a few per cent or as high as forty per cent, depending on the target contrast and other variables, but the general effect of the emulsion factors is to suppress the higher frequency

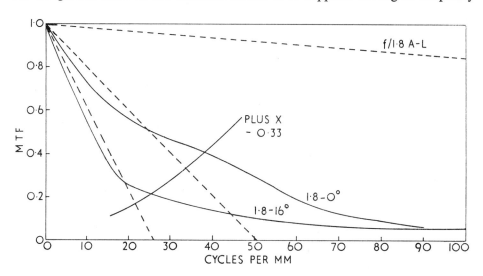

Fig. 4.1 Approximation of effective lens MTF's by equivalent aperture limited MTF's

regions of the lens MTF within which the departures from a smoothly falling curve are usually most marked. As a rough order of magnitude guide, the effective threshold is around ten per cent on the MTF for aerial photography. The emulsion threshold is explained and discussed in Chapter VIII; an example of its effect in assisting the approximation of the lens MTF by a standard shape is shown in Fig. 4.1. The two MTF's are for a 4″ f/1·8 lens at 0 degrees and at 16 degrees in the field. Obviously both are well below the limit for the actual aperture, shown by the upper broken curve. The diagonal line rising to the right is the threshold for Plus X Aerecon emulsion, drawn for a target contrast of 0·33 modulation. Below this threshold line, the emulsion will not resolve, so we may reasonably assume that the only significant parts of the lens MTF's lie above it to the left. Over this region, the MTF's can be approximated by the broken lines, representing the aperture limited MTF's for f/66 and f/36. The value of this approximation naturally decreases as the lens MTF departs further from a "well-behaved" shape, and particularly with excessive phase errors, which would not appear in the MTF. In such cases, the OTF must be used and the full Fourier techniques applied.

4.2 *Modulation and Modulation Transfer for Bar Targets*

The modulation of a sinusoidal target having many cycles is unambiguously defined as $I_{max} - I_{min}/I_{max} + I_{min}$. The same definition holds when the modulation has been reduced by the operation of an MTF, because the sinusoidal shape is unchanged in the image. The modulation transfer factor is the ratio of the image modulation at any spatial frequency to the modulation at zero frequency, and the modulation transfer function (MTF) expresses the variation of the modulation transfer factor with frequency. The modulation of a continuous squarewave object can be defined in the same way, but the modulation transfer factor for its image at any spatial frequency is not the same as for a sinusoid of the same nominal frequency, when both are subjected to the same MTF. The "MTF" for a squarewave does not follow the same course as the true MTF of the same lens, which can be applied only to sinusoids. It is reasonable to apply the term "modulation" to the actual contrast in the image of the squarewave, or in the target, but it is not desirable to use "MTF" to express the relative image modulation as a function of frequency. To do so can lead to confusion, because the modulation in the squarewave image at a frequency k is not the product of the input modulation and the MTF for the frequency k. A different name is required for the transfer function that applies to square waves, but no satisfactory name seems to have been agreed. Such names as "squarewave MTF" are undesirable, because "MTF" has a specific meaning restricted to sinewaves.

When the squarewave has only a few cycles, as in bar targets, there is a further complication, because the peak to trough intensity difference is not the same for all bars and spaces when the modulation has been reduced in the image. The effect is not very marked, fortunately, and can normally be neglected except near the cutoff

frequency. With very unsymmetrical spread functions (large phase errors in the OTF) the image may not resemble either a bar target or a sinusoid, and the value of "modulation" to express equivalent contrast among such different shapes is doubtful. In the visual evaluation of images, some average value, lower than the peak, is probably effective, even for a sinusoid. Nevertheless, factors and functions to express the transfer of contrast in bar target images are certainly required. To cope with such situations, Charman[1] has used the term "Visibility Factor", defined as $I_{max} - I_{min}/I_{max} + I_{min}$, where I_{max} is the mean of the maxima corresponding to the various bars, and I_{min} is the mean of the minima corresponding to the spaces. "Visibility" does not seem particularly appropriate in the present context, where we are primarily interested in the physical contrast, though the term was originally applied by Michelson to modulation in sinusoidal interference fringes. Others have used terms such as "three bar target modulation", and "three bar function", which could be abbreviated to TBF if three bar targets were the only bar targets used. "Contrast Transfer Function", abbreviated to CTF, would be more generally applicable, but risks confusion with the former use of CTF for what is now defined as the MTF. Nevertheless, "Contrast Transfer Factor" and "Contrast Transfer Function" seem to be reasonable compromises and will be used in the present text.

The modulation of a bar target image or bar target is therefore defined as the ratio: $I_{max} - I_{min}/I_{max} + I_{min}$, where I_{max} is the mean of the maxima corresponding to the bars, and I_{min} is the mean of the minima corresponding to the spaces. "Contrast transfer factor" is the ratio of modulation in the image at any spatial frequency to the ratio at zero frequency, and "Contrast transfer function" expresses the variation of contrast transfer factor with frequency.

Transfer factors are usually given as functions of the linear dimensions, or reciprocal dimensions, of the targets, e.g. cycles per mm. When the discussion involves aperture limited lenses it is often more convenient to use dimensionless units defined in terms of the lens aperture and the wavelength of the light. The results are then available in a generalised form and can be converted to actual dimensions for any combination of wavelength and aperture by appropriate substitution. We shall use some data of Charman[2], who gives them in terms of these dimensionless "Z-units".

The Z-unit is defined by

$$Z = \frac{\pi.d}{\lambda.f}$$

where d is the dimension of the pattern, e.g. the period of the sinewave in a sinusoidal image, and f is the f/number of the lens, assumed to be working focussed for an infinite conjugate.

For a lens working at f/8 in green light of wavelength 555 nanometres (0·555 micron), we know that the cutoff frequency is 225 cycles per mm., then

$$Z = \frac{\pi.10^3}{\cdot555 . 8\cdot225} = \pi$$

i.e. the period, or reciprocal of the sinewave cutoff frequency, is π Z-units. Again, for an f/11 lens in light of the same wavelength, the frequency corresponding to 4 Z-units is given by

$$4 = \frac{\pi \cdot d}{\cdot 555 \cdot 11}$$

microns, so $d = 7\cdot7$ microns, and the frequency corresponding to 4 Z-units is 130 cycles per mm.

4.3 *Transfer Functions and Image Shapes for Bar Targets*

4.3.1 SQUARE WAVE. Whereas only the modulation of the sinusoidal target can be changed when it is imaged, bar targets additionally suffer a change of shape as the image becomes smaller, due to the progressive weakening or elimination of the harmonics by the MTF of the imaging system. Visualisation of this process is easiest for the unbounded square wave, which contains only the odd harmonics, at amplitudes inversely proportional to the harmonic number. Fig. 4.2 represents the spectrum of a 20 cycle per mm square wave (the zero frequency component is not shown), together with an aperture limited MTF cutting off at 100 cycles per mm. The fundamental and third harmonic are weakened, while the fifth and all higher harmonics are removed. Since the harmonics give the "square" waveform (Fig. 1.7) the image profile will become rounded. If the MTF cut off at 60 cycles per mm, the third harmonic also

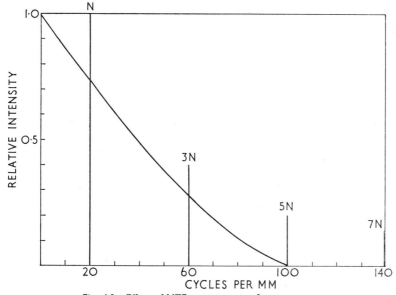

Fig. 4.2 Effect of MTF on spectrum of square wave

would be removed and the image would be a pure sinusoid. Although one might have thought that an MTF cutting off at 100 cycles per mm was adequate to reproduce a 20 cycle waveform, Fig. 4.2 agrees qualitatively with our experience that it is difficult to retain the sharp edges of targets in reproduction. However, the frequency analysis does emphasise the extreme difficulty of retaining the sharpness, because of the wide separation of the harmonics and the rapid fall of the MTF. To retain even the seventh harmonic of the 20 cycle square wave, we should require an MTF cutting off in the region of 300 cycles, and higher harmonics than the seventh make a not negligible contribution to the wave shape. The implications of this for any photographic process involving reproduction of sharp originals will be clear. 20 cycles per mm is but a modest performance in aerial photography, yet if we needed to enlarge, without loss, negatives containing sharp edged detail at 20 cycles per mm, we should need a lens capable of at least 300 cycles per mm with no loss of modulation. This would be completely out of the question, in lenses covering any useful field, and in practice we would accept the results from lenses of far inferior performance. (In actual photographs, square wave objects are of course extremely unlikely, but similar arguments would apply to, say, isolated bar-like objects 1/20 mm wide, whose spectra would extend to equally high frequencies, though with a different amplitude and phase distribution.)

It is curious that we can accept so much loss in sharpness, but we may assume that this is, at least in part, because the details in our negatives have already had their harmonic structure so seriously weakened by the MTF's of camera lens and emulsion that any further losses are hardly noticed. However, it does seem that we are not highly critical about loss of harmonics in small detail provided the basic image can be seen. If an object is known from experience to have sharp edges, then fortunately we tend to see it as such in the photograph or on the television screen, even if the sharpness is not there, provided the contrast is adequate. If this were not so, then satisfactory photographic reproduction would be almost impossible to obtain. How many harmonics of a square wave are needed for "good" reproduction is a matter of circumstance and opinion. In an academic sense, they are all necessary. Thus Kowaliski[2a] states that 1000 harmonics are necessary for the "satisfactory approximation of the straight edge luminance distribution", but this must be a somewhat arbitrary, essentially mathematical criterion. In our ordinary experience of seeing, the harmonic structure of the smallest objects we can detect must obviously be lost by the MTF and retinal structure of the eye, yet we are not conscious of them as blurred objects, merely as sharp objects imperfectly seen. Although looking at pictures is by no means the same as looking at real things, possibly some similar effect operates, so that until we use too high a magnification we do not realise how bad our photographs really are.

The contrast transfer factor for a square wave target is always greater than that for a sinewave target of the same period. In Fig. 4.3 the contrast function for the square-wave is compared with the modulation transfer function for the sinewave target, for the case of the aperture limited lens. (The other targets will be mentioned later.) The square wave curve diverges from the sinewave curve up to one-third of the cutoff

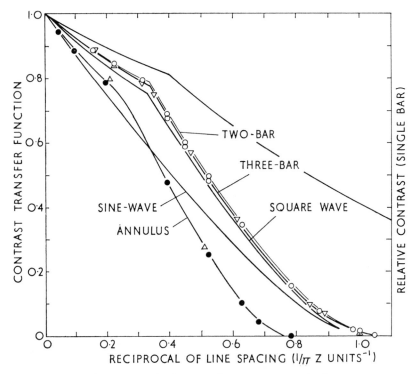

Fig. 4.3 Contrast transfer functions for square wave and other targets

frequency, then converges again, to meet at the cutoff point. From the inflection point to the actual cutoff, only the fundamental of the squarewave spectrum is passed, yet the "modulation" is higher than in the sinewave MTF. The reason for this, in Fourier terms, is that the fundamental sinusoidal component, in a square wave of normalised zero-frequency amplitude $1\cdot0$, has the value $4/\pi$. It must have this greater amplitude, because the third harmonic depresses the peak in making the first contribution to squareness. (See Fig. 1.7.) When the harmonics are removed by the MTF, the remaining fundamental retains its greater amplitude; over the upper two-thirds of the bandwidth in Fig. 4.3 the square wave ordinates are $4/\pi$ times those of the sinewave curve. Over the first one-third, additional harmonics are passed, but their phasing is such as to depress the amplitude of the square wave, and eventually the square wave and sinewave transfer factors are equal, at $1\cdot0$ at zero frequency. In more mundane spatial terms, the square wave shape carries more energy than the narrow-peaked sinewave at the same period, and hence degrades less when both are blurred by convolution with the same spread function.

If the aperture limited MTF is degraded by defocusing, or by aberration, the ratio of sinewave to squarewave modulation does not necessarily remain the same as in

Fig. 4.3 because the weakening of the harmonics does not proceed in exactly the same way. The squarewave modulation will always be higher, but the exact form of the relationship must be worked out by Fourier analysis, or the squarewave modulation can be found with quite reasonable accuracy by the graphical method of 4.5, and the sinewave MTF derived approximately from this. Similar remarks apply to the MTF's of other system components, such as the emulsion.

4.3.2 OTHER BAR TARGETS. As we saw in Chapter I, the Fourier spectra of targets having a finite number of bars, greater than one, consist of broad bands peaked near the isolated lines of the square wave, though the family affinities can always be recognised. Thus there is always one band centred near the characteristic or fundamental frequency corresponding to the period of the bar pattern, and the harmonic bands are concentrated around the odd harmonic frequencies as in the parent square wave. The fundamental must be reproduced at finite modulation if the characteristic number of bars is to be seen or resolved. The modulation as defined in 4.2 is actually expressed in terms of the intensity distribution across the image as seen in the space domain; in frequency terms it may be regarded as approximately the average modulation for the range of spatial frequencies in the bandwidth of the characteristic or fundamental frequency band. For a smoothly falling MTF, e.g. that of the aperture limited lens, the degradation of this modulation with increasing fundamental frequency follows much the same course as for the square wave, as shown in Fig. 4.3. If the MTF has a less regular shape, e.g. a fall followed by a rise at higher frequencies, which could emphasise the harmonics, the relation between CTF and MTF would be less simple. Again, if the OTF had a large phase error, the shape of the bar target image could be seriously affected by the changed phasing of whatever portion of the harmonic spectrum was recorded. Clearly, these effects will be reduced in proportion as the modulation of the harmonics is pushed below the threshold of the detector. In general, accurate prediction requires the full Fourier analysis, indeed this is more necessary than for the square wave because of the greater complexity of the spectra. The exact derivation of contrast transfer functions for bar targets requires two dimensional Fourier analysis to take account of the finite length of the bars, at least for targets such as the Cobb, in which the length of the bars is only three times the width. However, except near the limit of resolution in the aerial image, the diameter of the spread function is small relative to the image, and useful approximations can be made by one dimensional Fourier analysis or the graphical method of 4.5. Fig. 4.3 shows examples of CTF's given by Charman[1]. Others have given identical results expressed in somewhat different terms. It is interesting to see that the two and three bar target CTF's are so close to the square wave CTF and almost indistinguishable from each other. In relation to the one-bar CTF (which will be discussed later) it is clear that adding a second bar to one makes far more difference than adding any greater number to the pair. The scale of the figure tends to minimise the fact that the two and three bar curves diverge from the square wave curve when approaching the cutoff point of the latter, and reach zero at a higher frequency. Moreover, they continue into a negative

region, not shown, in which the images change their basic appearance, the three bar becoming two units and the two bar becoming one unit.

Charman has also derived the CTF for the Canadian annulus target, for which the convention is that "spatial frequency" is the reciprocal of the mean diameter of the annulus, Fig. 4.3. This CTF is broadly similar in shape to the others, but falls to zero at a decidedly lower spatial frequency, and its inflection point is also lower in about the same proportion. Over about half the bandpass it lies below the sinewave MTF, suggesting that for equal nominal spatial frequency the annulus target would give lower resolving power than the bar targets, other things being equal. This agrees with experience. Charman points out that this is also to be expected from the nature of the frequency spectra. In the annulus target the centres of the main frequency bands occur at frequencies somewhat higher than the odd harmonics of the fundamental, while the amplitudes in the fundamental band are lower than in the bar targets.

The continuation of the two and three bar CTF's beyond the nominal cutoff frequency is an interesting physical effect, associated with the broad spectral band corresponding to the fundamental frequency. Fig. 4.4a and b shows the spectrum of a two bar target image before and after multiplication by the aperture limited MTF which cuts off at the nominal frequency, π. Evidently the fundamental band, though severely attenuated, is not eliminated, and appreciable energy remains, though the centre of gravity of the band has been shifted to a lower frequency. Thus the image would still contain a recognisable two peaked pattern, though not at the original fundamental frequency. As Kelly[3] points out in the parallel case for the three bar target, a physical detector of extremely narrow bandwidth, set to examine the image at the single frequency corresponding to the fundamental, would receive no signal. However, we do not observe resolving power in the spatial frequency domain with narrow band detectors, but by observing the presence of a pattern with the right number of units, in the space domain. In purely spatial terms, as will be seen in 4.5, the effect is due to a loss of light from the outer bars, which does not occur in an unbounded square wave. Although such effects are real, they are of little or no practical photographic importance, because they occur at such low levels of modulation, less than ten per cent. The appearance of the image in this condition can be visualised from Fig. 4.5. These effects are of the kind which can be demonstrated by careful experimentation on the aerial image, or even on a very fine grained film with a high contrast target, but are swamped in practice by the multiplication of several MTF's and the relatively high threshold of the photographic detector. Charman has demonstrated a number of other such effects for bar targets near the limit of resolution of an aperture limited lens.

Fig. 4.5 also demonstrates the appearance of the image when the MTF cuts off at frequencies well above and well below the nominal frequency of the target image. When the cutoff occurs at the normalised frequency $1/\pi$, for a target image of nominal frequency $2/\pi$, the double peak of the pattern disappears, because the fundamental frequency band is completely eliminated, but the intensity remains relatively high, all the energy from the two bars having gone into the single blurred patch. The extreme distortion of the image size, apart from the disappearance of the double peak, can be

97

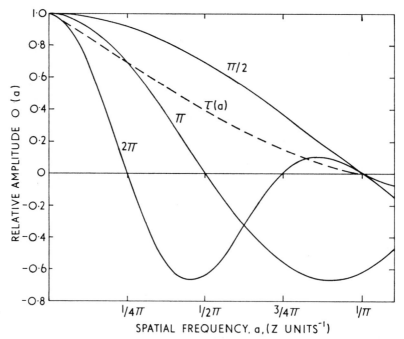

Fig. 4.4 a. Frequency spectra of two bar targets having bar-spacings of $\pi/2$, π, and 2πZ-units

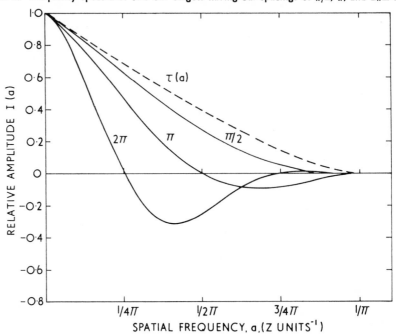

Fig. 4.4 b. Frequency spectra of two bar target images formed by an aperture limited lens

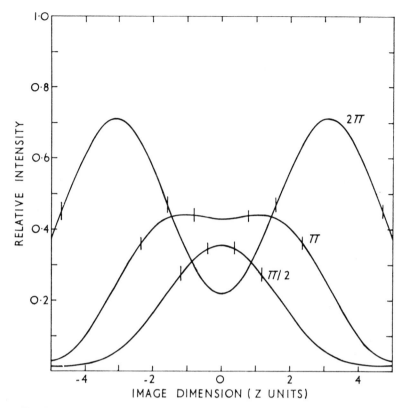

Fig. 4.5 Intensity profiles of the images whose spectra are shown in Fig. 4.4 b

seen by reference to the short lines which define the geometrical position of the bar images. For a cutoff at half the fundamental frequency of the target image, the intensity is quasi-sinusoidal; as reference to Fig. 4.5 shows, all the harmonics which could give sharp outlines have been eliminated. In practice, with lens MTF's of different shapes, and the added effect of the film and other MTF's, the images of bar targets always degrade towards sinusoidal, so far as one can use that term for patterns with only two cycles. The exact effect naturally depends on circumstances, but there is a general tendency for the image of low contrast targets to be "squarer" than those of high contrast targets. The high contrast resolution limit occurs further towards the cutoff of the lens-film MTF, and the harmonics are more likely to be removed, whereas at low contrast the emulsion threshold pushes the resolution back to lower frequencies and the MTF causes less degradation. In the actual photographic images, because of break-up by grain and the non-linear reproduction, it is only rarely that any such differences of shape can be observed. With very asymmetrical images, as given by wide angle lenses off axis, the bar target image can be considerably distorted from the symmetrical

quasi-sinusoidal shape. An example is given in Fig. 4.16. In the photographic image, the asymmetry is, from the nature of the case, observed at sizes above the resolution limit, but it adds considerably to the difficulty of finding a resolution end-point.

4.3.3 THE SINGLE BAR TARGET. The single bar target has been very little used in aerial photography, mainly because it is so obviously inapplicable to resolving power, while its advantages are not immediately apparent. Nevertheless, a consideration of its nature and relevance to aerial photography is instructive and appropriate in the present context. It used to be said that resolving power is not a good guide to performance, because the images of objects having essentially the shape of single bars, e.g. power lines, white road lines, roads seen from a great height, etc., are often clearly visible in aerial photographs when the geometrical image is much narrower than the width of a just resolved bar target. It was always clear that this can happen simply because the narrow bar acts as a luminous line source, which will record even if narrower than the spread function, provided it is bright enough. Of course, the much greater number of single bar objects of lower brightness, which do not record, are conveniently forgotten. Nevertheless, it is interesting to analyse the problem in spatial frequency terms, as this clarifies the issues and also bears on the possible use of the single bar as an image quality criterion.

In Fig. 4.6a the spectrum of the single bar, which, it will be remembered has the form $\frac{\sin \pi_{\mathrm{ax}}}{\pi_{\mathrm{ax}}}$, is shown for three bar widths, expressed in z-units, of $\pi/2$, π, 2π. Also included is the MTF of an aperture limited lens cutting off at the frequency $1/\pi$. Fig. 4.6b shows the same spectra after multiplication by the MTF. Now since the single bar

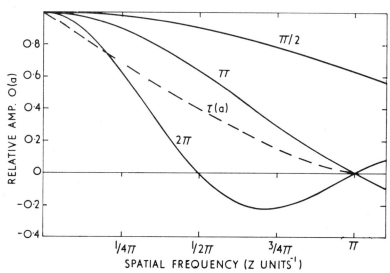

Fig. 4.6 a. Frequency spectra of single bars having the widths $\pi/2$, π and 2π Z-units

has no period, and hence no characteristic fundamental frequency, there is no question of the MTF having any effect on the "resolution". All that can happen is that more or less of the total energy in the spectrum will get through; to the extent that the higher frequency components are degraded and eliminated the rectangular profile of the bar will be degraded to a rounded-off shape, and in general the intensity will fall as the bar gets narrower. In Fig. 4.6b the spectrum corresponding to the 2π barwidth has lost most of its harmonic content, but the energy at frequencies less than $1/2\ \pi$ is well in evidence. The widest spectrum, corresponding to the $\pi/2$ barwidth, has lost a great

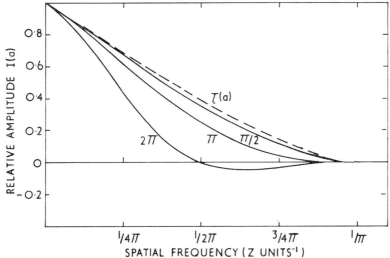

Fig. 4.6 b. Frequency spectra of single bar target images formed by an aperture limited lens

deal of its total energy. We would expect all these images to be reproduced in significant strength, but with progressively increasing distortion and decreasing contrast above threshold, as the barwidth gets narrower. The actual contrasts and image profiles can be derived from Fourier analysis or by the graphical technique, and are shown in Fig. 4.7. The narrowest bar, although broadened to roughly 5 Z-units, still has nearly 0·4 of its original peak contrast. Clearly, the limitation on the width of a single bar that can be recorded will be set only by the threshold of the detector and the intensity of the bar.

In Fig. 4.3 the upper curve is the single bar CTF. To meet the difficulty that the single bar has no "frequency", the convention adopted is that the values of contrast transfer factor are plotted against the frequency which is the reciprocal of twice the bar width, i.e. as though we had removed all but one of the bars from a multi-bar target and then evaluated the relative contrast in the image of the remaining bar. As expected, there is no cutoff point.

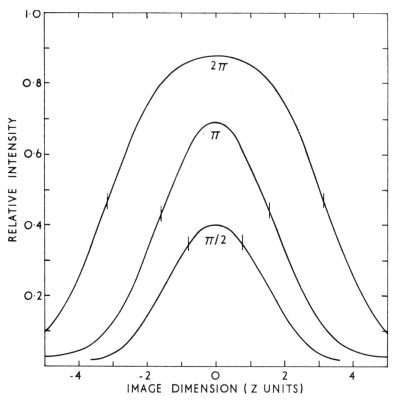

Fig. 4.7 Intensity profiles of the single bar images whose spectra are shown in Fig. 4.6 b

Figs. 4.8 and 4.9 show the shape and relative contrast of single bar and two bar images, formed by an aperture limited lens, over a wider range of dimensions, ranging from 20 to 0·5 Z-units for the single bar width, and 10 to 1 Z-units bar width for the two bar target. Only half of each image is shown, the images being symmetrical about the centre. In these figures (and Fig. 4.5) the bars are assumed to be clear on an opaque surround, and the "relative intensities" of the ordinate scale are normalised to the intensity of a large clear area. The MTF cuts off at $1/\pi$ Z-units, in normalized spatial frequency.

The widest single bar suffers very little reduction of central intensity, and its profile is close to the edge spread function for a perfect lens, i.e. the left-hand edge is far enough away to have no influence on the right-hand edge. As the bar gets narrower, the central intensity falls and the image also gets narrower, roughly in the same proportion, though the image is always wider than the geometrical width. (Its half-intensity point corresponds to the true width for the 20 unit bar, but this relationship is not sustained below the 10 unit bar.) Eventually the image width at the base becomes almost constant, while the central intensity continuously declines. For the narrowest

102

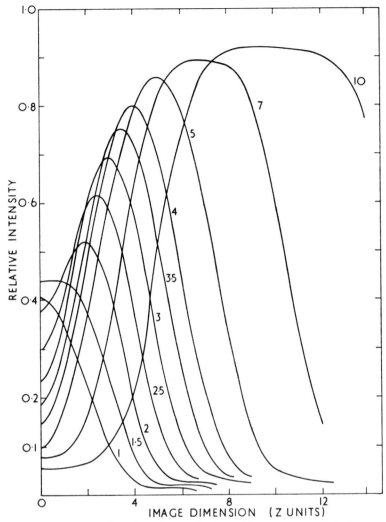

Fig. 4.8 Intensity profiles of two bar images formed by an aperture limited lens

bars, one could hardly say there is "a" width, since the effective width would obviously depend on the bar intensity and the exposure given. This is in qualitative agreement with the well-known method, used by astronomers and others, for measuring the relative intensity of images smaller than the spread function by the relative widths of the photographic images. The two-bar images show a similar approximation to correct shape when very wide relative to the cutoff period of the MTF, but quickly degrade to sinusoidal and reach a condition of zero modulation between 1 and 1·5 Z-units bar width. (The target period is of course twice the bar width.) As would be expected, the

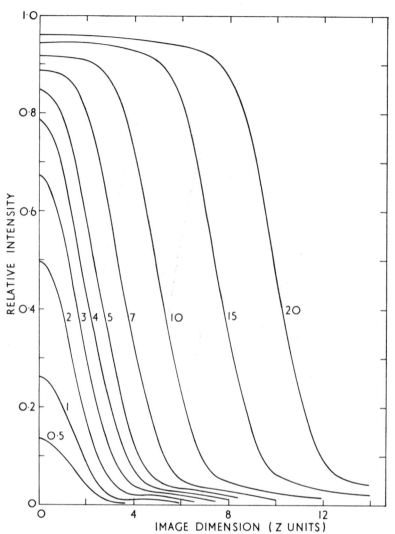

Fig. 4.9 Intensity profiles of the images of one bar objects formed by an aperture limited lens

central intensity in the unmodulated patch corresponding to the two bar image at 1 Z-unit is much greater than that for the single bar image at 1 Z-unit, agreeing with the greater energy in the object.

4.4 *Derivation of CTF's, MTF's, and Image Shapes from the Edge Spread Function*

4.4.1 GENERAL. As we have frequently observed, the OTF provides information about image quality, in a direct way, only for sinusoidal targets. To derive the image

104

of more general objects, including bar targets, we must employ the complete routines of Fourier analysis, which is straightforward for those with access to fairly sophisticated computational facilities, but impracticable for those without this advantage. Being in the frequency domain, the OTF can only operate on the amplitudes and phases of the sinusoidal components in the frequency analysis of the objects whose images we desire. There are no general rules to assist us in making intuitive deductions about the probable effect of an OTF on the spatial appearance of a given object, though in simple cases, e.g. a square wave, and an OTF without appreciable phase shift, we can make reasonable approximations. The difficulty of interpreting the OTF increases when the phase error gets greater.

If we could work in the space domain, the image would not have been broken down into the amplitudes and phases of its sinusoidal components, and we should not be faced with the problem of putting them together again after operation with the OTF. Using the line spread function involves difficulties with convolution, but fortunately there is a simple approach using the edge spread function (ESF). If we can obtain the edge spread function for any system, the image of any object bounded by sharp straight edges can be synthesised by a direct graphical method. This does not offer an easy universal substitute for the OTF, nor does it compete with the power, accuracy and speed of a computer using Fourier programmes, but within limits it can be quite effective, and it is extremely useful to the worker who has no access to a computer.

In practice the ESF is often available when the OTF is not. In the laboratory, the ESF can be measured, either on the aerial image or in photographic images, with less difficulty than the OTF and MTF. In aerial negatives, sharp-edged details often occur and the ESF derived from them by microdensitometry and conversion to effective exposure can be used to construct the images of targets and can be converted into a CTF or MTF for the system in its operational condition. These conversions give the further possibility of deriving the resolving power via the emulsion threshold, even when no targets are present on the ground. As pointed out previously, the ESF is the integral of the line spread function, thus if the latter is available (perhaps rather unlikely) the graphical technique can be used with little further trouble.

The graphical technique seems to have been used first by Cox,[4] and Shack[5], many years ago, but has not received much attention, no doubt because of the growth of interest in Fourier methods parallel with the expansion of image evaluation studies in general. In the author's recollection, Twyman first called attention to the possibilities of the edge image during World War II (communication to British Ministry of Aircraft Production). Again, Joos at Boston University, and Weinstein,[6] have shown its possibilities. More recently, the use of the graphical technique has been associated with Scott,[7] Attaya,[8] and Charman.[9]

4.4.2 GRAPHICAL TECHNIQUE. In Fig. 4.10, A is the intensity-profile of an ideal image of a single bar; a rectangular pulse. A could be synthesised by the difference of two step functions, or ideal ESF's, located as shown in relation to the centre of symmetry of A. C can be regarded as the defect of A from the step function B, which is

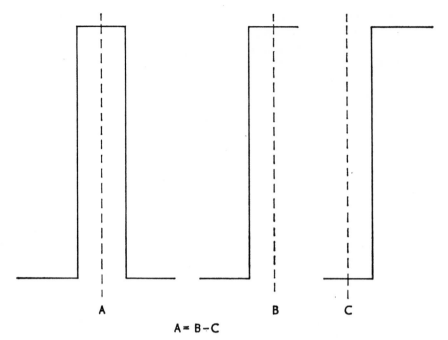

$$A = B - C$$

Fig. 4.10. Bar image shown as the difference of two step functions

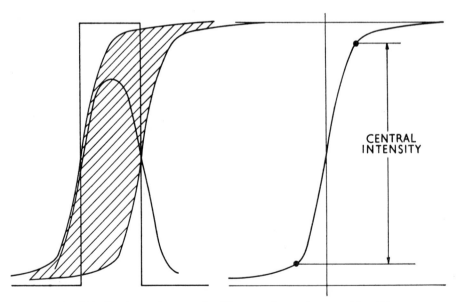

CENTRAL
INTENSITY

Fig. 4.11 Bar image shown as the difference of two edge spread functions

106

considered to extend indefinitely to the right and left, therefore A can be exactly duplicated by subtracting C from B. Now in a real image, B would be represented by an ESF, e.g. that of an aperture limited lens, as shown in Fig. 4.11. It follows that if we put an identical ESF a bar's width to the right, and plot the differences between the ordinates of the two ESF's within the shaded area, against the corresponding abcissae, we shall synthesise the intensity profile of the bar image. Compared to the ideal image, the maximum central intensity is lowered, and the base is broadened. These effects are more pronounced for narrower bars with the same ESF, as in Fig. 4.12. This construction allows us to derive the image of any target if we know the ESF.

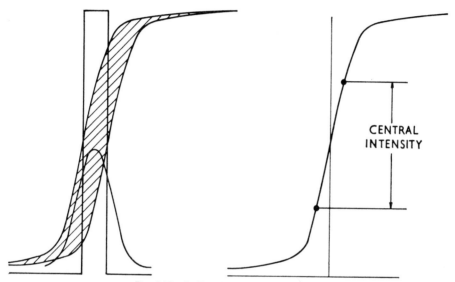

Fig. 4.12 As Fig. 4.11 for narrower bar

Figs. 4.13 and 4.14 show the construction for two and three bar targets, again using the ESF for an aperture limited lens. With more than one bar, light spills across from neighbouring bars, reinforcing the bar intensities within the pattern and filling up the spaces. The intensity at any abcissa point is therefore the sum of the ordinate differences for each ESF pair. Fig. 4.15 shows the image of a single bar, of the same width as that in Fig. 4.14 but imaged by a lens having 1·7 wavelengths of spherical aberration, resulting in a marked broadening of the ESF and a correspondingly greater broadening of the bar image, with a drastic lowering of the central intensity. It will be appreciated that with detail of inherently low contrast, as in aerial scenes, this kind of image is very liable to fall below the threshold of detection.

The method can also be used for asymmetric ESF's. Fig. 4.16 shows the image of a two bar target constructed from the ESF as calculated by Barakat for a lens with one wavelength of 3rd order coma, in the 45 degree orientation. In this case the location

107

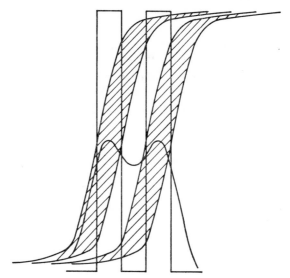

Fig. 4.13 Derivation of intensity profile for two bar image from edge spread function (aperture limited lens)

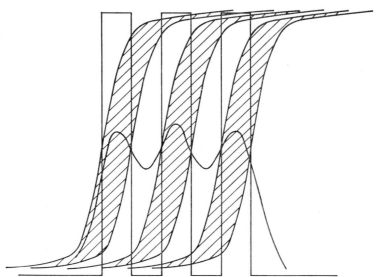

Fig. 4.14 Derivation of intensity profile for three bar image from edge spread function (aperture limited lens)

108

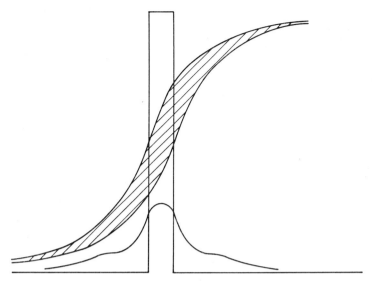

Fig. 4.15 Derivation of intensity profile for single bar image from edge spread function of lens with 1.7 wavelengths of spherical aberration

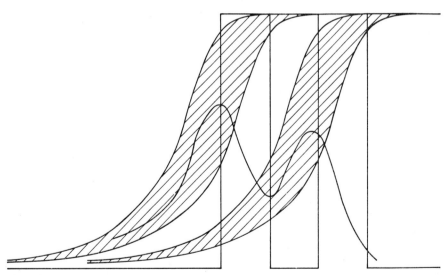

ig. 4.16 Derivation of intensity profile for two bar image from edge spread function of lens with one wavelength of third order coma

of the ESF, laterally displaced from the geometrical position of the perfect image, was assumed known, and the plotting was performed accordingly. The pattern as a whole is laterally displaced, and the peaks are of unequal height. More generally, and when working with images in aerial negatives, the actual location of the ESF will not be known, and an arbitrary location must be assumed, but the correct image profile can still be found. This kind of imagery obviously complicates both resolving power and the measurement of the location of objects in aerial photography.

As a practical example of an actual aerial system showing this effect, we will examine the image formed by an Aviogon lens in a Wild camera, using Plus X Aerecon film developed in D 19 B, using the data given by Charman.[2] The lens was used at f/6·8, the field position was 30 degrees, and the orientation of the edge was 45° to the radial direction. After microdensitometry and conversion of the density trace to effective exposure, the graphical method was applied to derive the image profiles for single bar and two bar images, yielding the curves shown in Fig. 4.17 and 4.18. Z-units would not be appropriate for the abcissa scale in this case, as a specific lens MTF and film MTF are concerned; the abcissa scale is in microns and the numbers against the curves

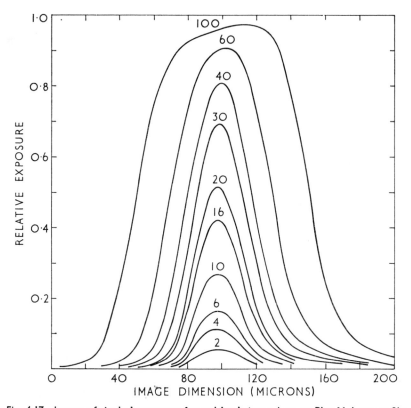

Fig. 4.17 Images of single bar targets formed by Aviogon lens on Plus X Aerecon film

110

indicate the nominal geometrical widths of the bar images. It should be emphasised that the ordinates are in relative exposure, at the effective exposure stage, and do not indicate the visual appearance of the negative images. Plotting the ordinates logarithmically, to simulate densities, would probably give an approximation to the visual appearance, but the full analysis of the negative and positive reproduction, taking account of the harmonic distortions, would be fairly complicated. An example of what is involved is given in section 4.5.

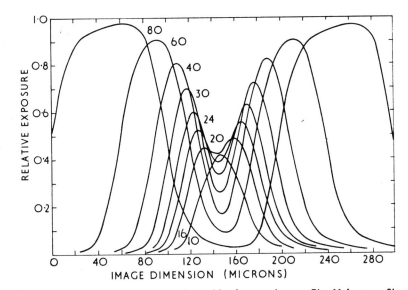

Fig. 4.18 Images of two bar targets formed by Aviogon lens on Plus X Aerecon film

The results for the Aviogon lens-Plus X combination are broadly similar to those for the aperture limited lens as given earlier. The effective cutoff of the lens on this film is in the region of 30–35 cycles per mm. From Fig. 4.17 we see that a single bar of geometrical width 30 microns has its peak intensity reduced to about 70 per cent. Its width is increased to about 40 microns at the half intensity point and about 80 microns at the base. The extreme distortion of the very narrow bar images is again noticeable. Of course, the narrowest bars will only record if their original contrast is very high, but we may assume that some white objects against a black background could have an effective log contrast, seen through haze, of the order of 0·6. A 5 micron bar of this contrast would be reproduced by the system at an image contrast of about 0·1, and would probably be visible, but its width at the half intensity point would be about 20 microns. There is a marked asymmetry in the images, due to the off-axis aberrations causing an asymmetric spread function. (It should be mentioned that this degree of asymmetry is relatively mild for a wide-angle lens.) Due to the asymmetry, the apparent centre line of the bar changes position according to the bar width. Normally, the

position of an image, e.g. a white marker as used in aerial survey, will be judged from measurements at the edges, perhaps at some constant low density. If this density corresponded to a relative exposure of $0\cdot1$ in Fig. 4.17, then the apparent position of the centre of the strip would move 6 microns when the bar width changed from 6 to 100 microns.

The two bar curves again exhibit the asymmetry, most noticeably near the cutoff point, when the barwidth is 16 microns (i.e. about 30 cycles per mm.) Throughout the range of barwidths the right hand bar is higher than the left, and the difference increases as the width decreases. The resolving power on the Plus X film would be in the order of 30 cycles per mm high contrast and 20 cycles per mm low contrast, and the asymmetries in this size region could well cause difficulties in deciding on the actual resolution limits.

For the Aviogon-Plus X combination, Charman also gives curves showing the actual log contrast in the images of single and two bar objects, for various original object contrasts, as a function of the reciprocal bar width and reciprocal bar spacing. Contrast is defined as $\log_{10}(I_{max}/I_{min})$ where I_{max} is the relative bar image intensity, and I_{min} is the relative intensity in the image of the background, for the single bar, or the inter-bar space, for the two bar images. These are given in Figs. 4.19 and 4.20. They give a convenient means of estimating the approximate image contrast for known input contrasts, and also emphasise the slow fading out of the single bar image, as opposed to the more rapid contrast decline and effective cutoff of the two bar image. As a practical

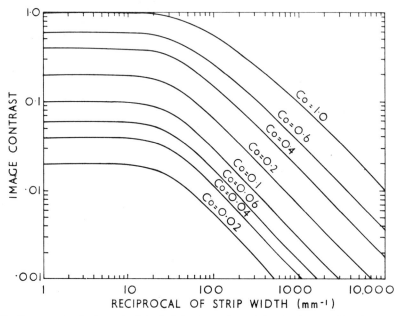

Fig. 4.19 Contrasts in the images of single bar objects formed by the Aviogon-Plus X combination. The figures on the curves indicate the contrasts of the original objects

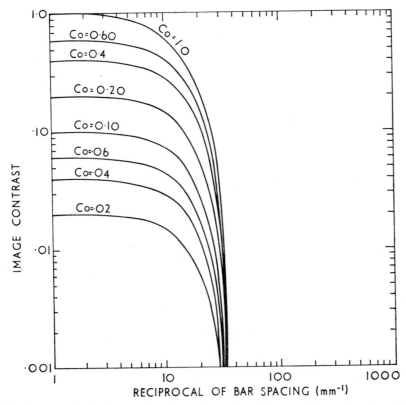

Fig. 4.20 Contrasts in the Images of two bar objects formed by the Aviogon-Plus X combination. The figures on the curves indicate the contrasts of the original objects

consequence of this different behaviour, observations on the width of high contrast single bar-like objects that can be distinguished in aerial photographs would give a very optimistic impression of the overall system performance, taking account of a range of contrasts and the need to separate adjacent objects. It may also be noted that the image contrast, and hence the detectability of a single bar object is much more dependent on the object contrast than is the resolved distance between two objects, though the latter is well-known to be quite sensitive to contrast. Photographic resolving power is notoriously inaccurate, but the resolving power measurements would not be practicable at all if the inter-bar contrast did not fall as rapidly as shown in Fig. 4.20.

4.4.3 DERIVATION OF THE MTF FROM THE ESF. Knowing the ESF of a system, its MTF can be found. The first stage is to derive the contrast transfer factor for a square wave at several frequencies, then the CTF is converted to the MTF for a sinusoidal target. For these operations we do not have to know the actual shape of the images, and the modulations can be found by a simplified procedure. Reverting to Fig. 4.11,

113

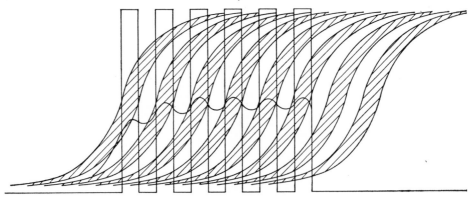

Fig. 4.21 Derivation of square wave image intensity profile from the edge spread function

the construction at the right shows that the central intensity in a single bar image is given by the ordinate differences corresponding to abcissa points symmetrically located about the midpoint of the ESF, one bar width apart. Fig. 4.21 illustrates the application of this to a square wave using the ESF of Fig. 4.15. In Fig. 4.21 the full construction is used, showing how the mean intensity level and the modulation drop at the left hand edge of the image, where there is less contribution from the other bars. The wave is assumed to continue indefinitely to the right, so that the modulation and mean level remain constant in that direction. Referring now to Fig. 4.22, if we centre the ESF on one of the inner bars of the geometrical image, well away from any edge effects, the contribution of intensity at the centre from the bar itself is represented by

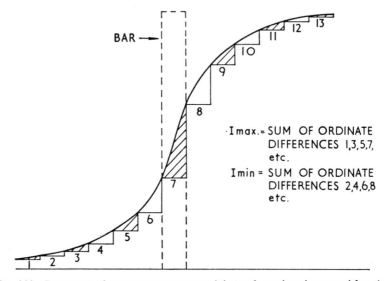

Fig. 4.22 Derivation of square wave image modulation from the edge spread function

114

the ordinate difference in the largest shaded area, 7. The contributions from the other bars are represented by the ordinate differences in the remaining shaded areas, 3, 5 etc., the total intensity being the sum of all of these. Similarly the central intensity in an adjacent space is given by the sum of the ordinate differences in the unshaded even-numbered areas. The squarewave modulation then follows as $I_{max} - I_{min}/I_{max} + I_{min}$. no averaging of peaks or troughs being required. By repeating the process for a range of bar periods, the CTF for the square wave can be found. This procedure saves much time when only the modulation, not the image shape, is required.

Assuming now that there is a need for the MTF, this can be obtained from the squarewave CTF by the following procedure, as described by Scott.[7] First the CTF for the squarewave is found as just described; this is shown in Fig. 4.23 as the curve joining the open circles.

Let \bar{M}_N = Square wave modulation at frequency N

M_N = Sinewave modulation at frequency N

N_{max} = cutoff frequency

Then, for \bar{M}_N = $1/3 N_{max} < N_{max}$,

M_N = $\pi/4 \bar{M}_N$

for \bar{M}_N = $1/5 N_{max} < 1/3 N_{max}$,

M_N = $\pi/4 \bar{M}_N + 1/3 M_{3N}$

for \bar{M}_N = $1/7 N_{max} < 1/5 N_{max}$,

M_N = $\pi/4 \bar{M}_N + 1/3 M_{3N} - 1/5 M_{5N}$

For frequencies lower than $1/7$ of N_{max}, correction for the higher harmonics is normally unnecessary and the curve can be extrapolated to $1\cdot0$ at zero frequency.

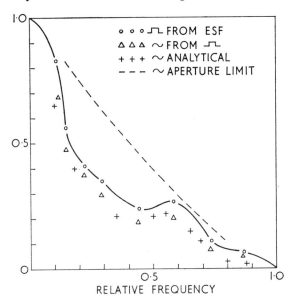

Fig. 4.23 Square wave CTF and MTF derived from edge spread function

115

Applying this procedure produced the triangular points in Fig. 4.23. The crosses are points taken from an MTF derived, for a lens suffering from $1 \cdot 7$ wavelengths of spherical aberration, by a rigorous analytical method. In fact, the edge spread function used for this demonstration has been derived analytically from the MTF. The agreement between the analytically exact MTF and the MTF derived graphically from the ESF is reasonable, except near the cutoff, where large errors in the modulation can easily occur. The method can therefore be quite useful in practice when an approximate MTF will serve and exact procedures using a computer are not available. It will be noticed that the relation between the sinewave MTF and the squarewave CTF differs appreciably from that for an aperture limited lens as shown in Fig. 4.3. The MTF used is of course very far from aperture limited. However, the ratio is approximately $4/\pi$ in the upper two thirds of the passband.

A qualitative correspondence can be seen between the shape of the MTF and the shape of the ESF in Fig. 4.21. The long sweeping toe and symmetrical shoulder of the ESF cause it to affect several bars simultaneously, hence it will have some effect down to quite low frequencies (i.e. large bars). This is the reason for the very rapid fall of the MTF at about $0 \cdot 1$ of the cutoff. The subsequent easing of the slope of the MTF is associated with the steeper mid-region of the ESF. The ESF for an aperture limited lens having the same cutoff frequency is steeper in the mid-region and turns over more sharply at top and bottom (see Fig. 4.11 for shape) hence the aperture limited MTF holds up better at lower frequencies and the general level of modulation transfer is higher. This illustrates the significance of the statement that a good response at the intermediate frequencies is more important, in aerial photography, than an extended high frequency response at low level. The slight rise of the MTF near $0 \cdot 6$ of cutoff must be associated with the particular shape of the ESF and the way the contributions add for bars of that frequency region. The cutoff frequency is not changed by the spherical aberration, but it must be remembered that such very low modulation levels have no photographic significance, especially in aerial photography, where the detail contrast is so low. In practical aerial photography, an MTF such as Fig. 4.23, which is not unrealistically different from the MTF's of actual aerial lenses, would effectively terminate at about $0 \cdot 5$ of the cutoff frequency, depending on the emulsion and the target contrast.

It should be mentioned that the slope of the ESF at the midpoint is proportional to the height of the line spread function relative to that of an aperture limited lens, which itself determines the central intensity in the image of a single bar. R. Dussault has shown that the CTF for a single bar, in a system having a symmetrical spread function, is given by the upper half of the ESF if the abcissa and ordinate scales are both doubled.

Scott[7] points out that when unsymmetrical spread functions are involved, giving rise to unsymmetrical ESF's the imaginary or sine part of the OTF can be derived by the procedure just described for the MTF, but with the bars displaced half a bar width from the central intensity of the ESF. This effectively introduces the required phase shift of $\pi/2$. The sine transform (or phase transfer function) should be zero, instead of

1·0, at zero frequency, if the derivation has been correctly performed. The cosine or real part is found with the bars symmetrically disposed as before, then the MTF is determined by taking the root sum of squares of the two functions, at each frequency.

It should be emphasised that all these operations must be carried through on linear co-ordinates for the ESF. If working from an edge in a photographic image the density trace must be converted into relative exposure then normalized by making the maximum relative exposure 1·0. The MTF so obtained includes, of course, the MTF of the film, which must be divided out if known and if the MTF of a lens or the system without the film is required. If the film MTF is not known, it can be determined by the same technique, by imaging, with a lens of adequate quality, or printing by contact, a sharp edge of moderate contrast made from evaporated metal or printed on a maximum resolution plate. From the ESF so obtained, the film MTF can be derived as already described for a lens-film system.

4.5 *Effects of Non-linear Factors on Image Shape*

In the previous sections of this chapter we have discussed the imagery of targets as affected by MTF's, i.e. in a linear system, with no reference to the known non-linearities of the photographic process. This simplification was necessary, but in practical photographic image recording various non-linearities complicate matters to such an extent that prediction of the shapes of target images by general rules becomes difficult or impossible. If the non-linearities have been thoroughly investigated and can be stabilised, then mathematical models can be constructed and predictions made for special cases, but this involves elaborate computations and is hardly applicable to daily problems. The well-known non-linearities are those associated with the H and D curves of negative and positive materials, and those produced by adjacency effects in development. The former are fairly repeatable, but the latter tend to be erratic except when kept to a minimum by suitable processing techniques.

Relatively little work has been done on this further distortion of the optical image in the photographic stages, and no attempt will be made at a comprehensive analysis. However, we shall summarize one very instructive exploratory study which illustrates graphically the orders of error involved.

Simonds, Higgins and Kelch,[9] set out to analyse the image distortions produced in a negative-positive reproduction by the interaction of the sensitometric non-linearities and the MTF's of the process. The first part of the study was a computational exercise in which an assumed scene luminance distribution, represented by an appropriate cosinusoidal series (Fig. 4.24) was passed through negative and positive imaging stages involving hypothetical but representative H and D curves and MTF's. The H and D curves were simplified to straight lines of gamma $0·5$ and $2·0$ respectively. ($D = 0·5 \log E$, $T = 1/\sqrt{E}$; and $D = 2 + 2 \log E$, $T = 1/E^2$). The MTF's 1 and 2, which might represent a negative (lens film) stage and a printing stage, are shown in Fig. 4.25. Now the macro tone reproduction would be identical, whether the negative

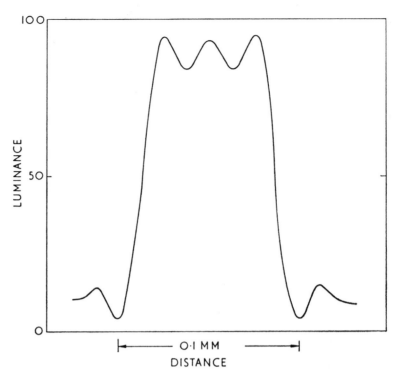

Fig. 4.24. Assumed scene luminance distribution

was exposed on the high gamma material, followed by printing on the low gamma material, or if the materials were used in the reverse order. The question was how the micro image quality would be affected by the ordering of the H and D curves and also the ordering of the MTF's. One might expect that it would be affected. For example, the use of the high gamma negative would generate extreme harmonic distortion, i.e. there would be a large proportion of higher harmonics in the negative image. If the MTF's were 100 per cent over the whole spatial frequency range in both cases, this distortion could be exactly cancelled out at the printing stage, in which the overall gamma would be brought back to unity. However, the very high harmonic orders likely to be involved would almost certainly be weakened by any conceivable printing MTF, and could not be recovered by a low printing gamma. In spatial terms, a smooth input waveform would produce a negative with sharp density peaks which would be blurred out by the spread function of the printing process, hence the correct original waveform could not be restored.

The MTF's and gammas were combined in four different ways, to give the hypothetical prints A, B, C, and D, as specified in Table 4.1. The calculated luminance distributions for the four prints are shown in Figs. 4.26 and 4.27. Print A has the most faithful reproduction and print D the least. D suffered both from the high negative gamma and

118

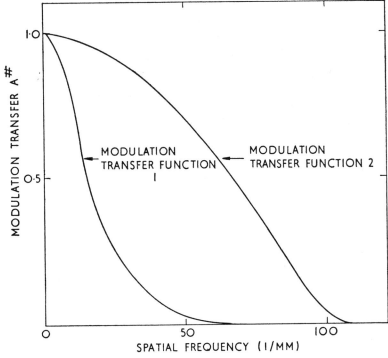

Fig. 4.25. Two hypothetical MTF's

poor MTF in the printing stage, which heavily attenuated the harmonic components of the negative image, distorting the amplitude as well as the waveform. C is surprisingly good in view of the poor printing MTF; the low negative gamma kept down the amplitude of the higher harmonics and less of the waveform was therefore lost. B is little if at all inferior to A; the harmonics developed in the negative stage have been fairly well preserved by the better MTF of the printing stage.

The experimental part of the study produced essential confirmation of the computational predictions. The authors' overall conclusion is that it is better to use a low negative gamma followed by a high positive gamma when the best, i.e. most faithful, reproduction of fine detail is required. They go on to say that this is current practice in most conventional photographic systems, which is true. Unfortunately, it is not generally true in aerial photography, in which the common practice is to use a high gamma negative material followed by a positive gamma which is usually above unity and may be as high as 3·0. The authors also emphasise that because of the harmonics present in the negative, the printing stage must be able to accept spatial frequencies much higher than those nominally recorded by the negative system.

This instructive study must provide aerial photographers with considerable food for thought. Taken in conjunction with the purely optical effects already discussed, there

TABLE 4.1

TRANSFER CHARACTERISTICS OF FOUR HYPOTHETICAL REPRODUCTION SYSTEMS

	Print A	Print B	Print C	Print D
Negative lens–film modulation transfer function	Modulation transfer function 1	Modulation transfer function 1	Modulation transfer function 2	Modulation transfer function 2
Negative film T–E curve	$T = \dfrac{1}{\sqrt{E}}$	$T = \dfrac{1}{E^2}$	$T = \dfrac{1}{\sqrt{E}}$	$T = \dfrac{1}{E^2}$
Printing stage modulation transfer function	Modulation transfer function 2	Modulation transfer function 2	Modulation transfer function 1	Modulation transfer function 1
Print material T–E curve	$T = \dfrac{1}{100E^2}$	$T = \dfrac{1}{100\sqrt{E}}$	$T = \dfrac{1}{100E^2}$	$T = \dfrac{1}{100\sqrt{E}}$

can be no doubt as to the extreme distortion of amplitude and shape that must be present in the finer details of aerial photographs, even when these are well above the detection threshold. It must be very common for such details to bear little or no resemblance to the original objects. Due to the wide variety of working conditions it is not possible to generalise, but a few relevant observations may be made.

The printing stage is notoriously a weak link in the aerial photographic chain. Poor printing contact is very common, and although its grosser effects are obvious, there must be innumerable instances of less obvious deficiencies which lose the more subtle qualities of the negative image. The MTF's of many enlarging lenses are so poor that, although the presence of details may be recorded, the waveforms, shorn of their harmonics, must be grossly distorted. In evaluating the performance of an aerial system it is normal for the engineer to insist on examining the negative, knowing from experience how much of the finer detail is usually lost in printing. While such losses are real, the possibility suggests itself that some of the preference for negatives may be due to a spurious sharpness caused by their harmonic distortion. Another relevant observation is that the MTF's of positive materials are not always all that might be desired. Sometimes, indeed, they are worse than the MTF's of the negative materials commonly used in aerial photography. There would undoubtedly be serious difficulties in making positive emulsions fast enough for normal printing, yet with MTF's good enough to meet the requirements now demonstrated. The writer has found noticeable

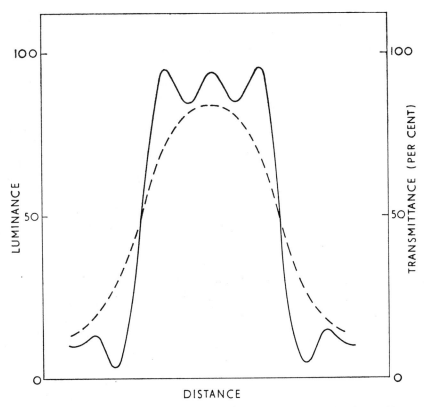

Fig. 4.26. Original luminance distribution (solid line) and print transmittance distribution (dashed line) for system A

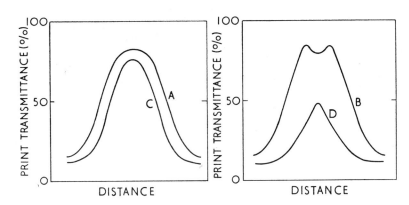

Fig. 4.27 Print transmittance distributions for reproduction systems A—D

improvement when printing aerial negatives, taken on Super XX type of emulsion, on to 3404 negative emulsion used as a positive material. In view of the wide difference in the MTF's of Super XX and 3404, this is qualitative confirmation of one of the conclusions of the study.

The use of a low negative gamma in aerial photography was advocated long ago by K. B. Jackson,[10] on a rather different basis. Jackson's concern was to preserve the resolution throughout the tone scale by avoiding an excessive build-up of negative density, which obliterated detail and made printing extremely difficult. One serious objection to the recommendation is the loss of speed which normally accompanies development to a low gamma, especially with many modern aerial emulsions which are designed to work at a high gamma. Another is the difficulty of avoiding "shouldering" of the H and D curve with under-development. Compromises in both problems are possible with special developers. In general, of course, aerial photography calls for maximum speed so that resolution can be preserved by use of the smaller lens apertures and higher shutter speeds, but when the illumination permits a lower emulsion speed, there is a great deal in favour of the lower gamma.

However, apart from the question of emulsion speed, the choice of optimum negative gamma involves other aspects of detail rendition. It is not certain that low gamma does optimise detectability of small details of extremely low contrast. This is essentially a question of signal to noise ratio, which for a given detail constrast is equivalent to the ratio of gamma to granularity. Full clarification of this subject would require a fairly exhaustive study, which does not seen to have been made.

References

[1] CHARMAN, W. N., *Phot. Sci. Eng.* **8**, 253 (1964).

[2] CHARMAN, W. N., *Canadian Surveyor*, **XIX**, 2, 190 (1965).

[2a] KOWALISKI, P., *J. Phot. Sci.* 17,1 pp. 20–24. (1969).

[3] KELLY, D. H., *Applied Optics*.

[4] COX, A., *NBS* Circular **526**, p. 267 (1954).

[5] SHACK, R., *NBS* Circular **526**, p. 275 (1954).

[6] WEINSTEIN, W., *Phot. Journ.*, Sect. B, 91 B, Nov.-Dec. 1951.

[7] SCOTT, F., SCOTT, R. and SHACK, R., *Phot. Sci. Eng.* **7**, 345 (1963).

[8] ATTAYA, W., Study of Image Evaluation Techniques. Reports 9048–2, 9048–3 (1963). Itek Corporation.

[9] SIMONDS, J. L., HIGGINS, G. C., AND KELCH, J. R., *Applied Optics*.

[10] JACKSON, K. B., *Canadian Surveyor*, **XIV**, 10, 454–464 (1959).

V. RESOLVING POWER

5.1 *Introduction*

Up to this point we have been concerned mainly with images in what might be called the blur stages, i.e. as they are determined by the MTF's of lens and film, before the imposition of detection thresholds. We now turn our attention to the very practical subject of the images in more or less grainy developed film, whose characteristics determine the information we can extract from aerial photographs. How small an image can we—detect—resolve—identify—? These are crucial questions for image evaluation as applied to aerial photography. Resolution is central among them; we can detect before we can resolve; mostly, we have to be able to resolve before we can identify. Well above the resolution limit we do not have to worry overmuch about image quality; around the resolution limit is the region where the usable passes over into the unusable. Thus resolving power, in a broad sense, is the natural evaluator for aerial systems. To-day, resolving power stands at an interface; it looks back into the frequency domain and joins the MTF on to real images, the other way into the space domain and links up to detectable size.

One of the first questions asked about any image forming device is "what is its resolving power?" The terms "resolving power" and "resolution" have entered into the technical vocabulary as a ready means of exchanging information about imaging performance. It is hard to avoid drawing some kind of parallel between the information content of an image and the smallest detectable separation of details within it. For rough evaluations, when we need only locate systems in a broad framework of performance, a rather loose concept of resolving power is adequate. When we require quantitative measurement, the ten per cent difference rather than the two to one factor, or when we desire to correlate resolving power with other aspects of image quality, we have to define our meaning with greater care. Resolving power is in fact a complex phenomenon, depending on the interaction of several more fundamental phenomena, whose nature and balance is not the same in all imaging situations. The more these situations differ, the less can we rely on resolving power as a guide to the practical performance of the systems. On the other hand, when the systems are essentially of the same nature, e.g. two aerial lenses used with the same emulsion, resolving power can be a realistic guide, though we must not expect too much precision. To appreciate the value as well as the limitations of resolving power, and to give it its proper place in image evaluation techniques, we must look behind its empirical measurement to the underlying physical and subjective phenomena.

It is not easy to say when resolving power entered photography or became prominent as a measure of photographic image quality. As long ago as 1858, Foucault used a target of light and dark bars for testing optical systems. According to Reid,[1] in his interesting account of the history of photographic lens testing, W. K. Burton[2] in

1886, clearly distinguished between spread functions of various intensity profiles, but strongly advocated "dividing power" for lens testing. Well before World War II, resolving power was being used as an emulsion test, but with relatively little interest in technical photography the results were not widely diffused or appreciated. Certainly during the nineteen-twenties, regular measurements of resolving power with bar targets were being made on aerial survey cameras at the United States Bureau of Standards. By the end of the nineteen thirties resolving power tests were sufficiently well established in England, at least for aerial photography, to be the subject of violent controversy between lens designers, photographic scientists, and practical users of aerial cameras. During World War II there was an intensive concentration on resolving power tests for reconnaissance cameras, and the use of low contrast targets as advocated by Selwyn was established, in the teeth of opposition from the older school of lens designers. At that time, therefore, the victory went to the user interests. Although, in the short term, this had beneficial results, it could be held responsible for the confusion between practical, operational or system tests, and tests suitable for controlling the quality of components, which has delayed the introduction of objective testing in photographic optics.

After World War II, resolving power testing became fashionable for a time among amateur photographers, who, like most camera users, felt a need for a meaningful test of image quality. However, resolving power has pitfalls, and is liable to give misleading results in unskilled hands. Partly for this reason, resolving power has declined in importance outside the aerial photographic community. The main reason for this decline, however, has been the more scientifically based assaults on the fundamental value of the test, originating with the advocates of acutance in the nineteen forties and continued by those early advocates of the optical transfer function who failed to understand that the obvious advantages of the new test in no way made it a replacement for resolving power. From the early days, when resolving power was a scientific innovation in photography, it has now fallen to such a low level in popular and quasi-scientific esteem that photographic engineers can scarcely admit to its use without embarrassment, for fear of being thought old-fashioned and out of touch with modern thought. To read the technical literature of the last few years, one might think that resolving power was a useless and misleading test, long outdated and not used by responsible laboratories. Nothing could be further from the truth; this is a good example of the human capacity for creating and perpetuating myths. Resolving power is misleading if it is not understood, it is inaccurate, imprecise, and provides incomplete information about a lens. However, it tells us more about the performance of a camera or the practical value of a lens than any other test that can be performed with simple apparatus, it is by far the easiest image quality test to carry out, and the errors to which it is liable are not worse than those involved in inexpert use of more complicated techniques. It is the only generally-accepted test which takes account of all the relevant factors in image quality, viz., the lens and film MTF's, the film gamma, the film granularity, and the characteristics of the human visual system. Measurements of the MTF or granularity, or qualities such as acutance, though more complicated to

perform, do not give the total measure of image quality which is necessary in aerial photography. Admittedly resolving power gives this total evaluation in a limited way, but no other simple test, and no measurement of a single quantity, such as the MTF, gives it in any kind of way. It will be appreciated that here we are speaking of resolving power as a criterion of the performance of an aerial photographic system (lens plus film); in this case we can accept some inaccuracy as part of the price of a comprehensive yet simple and tolerably realistic evaluation. Production testing of lenses of an accepted type is quite a different matter; here the way is open for designing simple tests, which, without abandoning realism, emphasise accuracy by excluding the system factors of granularity and human judgement.

A great deal of harm has been done by general and ill-founded statements that resolving power is an unsatisfactory guide to image quality. Essentially, resolving power has two kinds of weakness, inaccuracy in determination, and a potential unreliability as a guide to image quality. The inaccuracy is inherent in the statistical nature of photographic resolving power; it can be reduced by complicating the determinations, but in general we have to accept it. The potential unreliability can be largely avoided by making the test under realistic conditions, e.g. low contrast targets and the operational emulsion, for aerial photography. Of course, by using unrealistic conditions, e.g. film of too fine a grain, or high contrast targets, we run the risk of getting results that do not correlate with general image quality, but similar observations could be made about any test. The issues are further discussed in Chapter IX, but the essential point is that no formal test of image quality can exactly represent the whole gamut of practical conditions. A properly conducted resolving power test comes closer to doing this than any other current test of an aerial photographic system, or any other test that does not involve considerable complication. Partly for these reasons resolving power has persisted against all attacks in the aerial photographic community. There is of course a special reason why the aerial photographer favours resolving power, i.e. because he is always interested in the smallest ground detail that he can detect in his photograph, and there is an apparently obvious connection between this and the laboratory figure. In reality this kind of connection has limited value, but there is at least the concept of a connection, which is constantly evoked in discussion. We like to feel that we can pin down the performance of a system in easily comprehended terms having a direct relation to reality. By contrast, the optical transfer function, for all its merits, seems like a disembodied ghost.

Whatever our opinions may be, and whatever the technical literature may say, the hard fact is that in aerial photography resolving power remains paramount, in terms of numbers of tests performed on cameras and lenses. Undoubtedly it is often misapplied and more is expected from it than is reasonable, but it is an established institution and the most practical performance criterion when lens designers and camera users want to exchange ideas in common terms. Like all established institutions it is subject to constant criticism. Indeed, among photographic engineers, the errors, weaknesses, and (more rarely) the virtues of resolving power are discussion themes as common as crime and taxes in less sophisticated circles. Myths notwithstanding, when resolving power

125

tests are performed by the thousand every day, the test is important enough to warrant discussion.

5.2 *General Nature of Resolving Power*

In general terms resolution expresses the ability to separate adjacent small details, but the term "resolving power" has many different meanings, and in the past this has given rise to much unnecessary confusion and argument. For example, it used to be impossible to reconcile the opinions of lens designers, who knew that the "resolving power" of lenses diminished with decreasing aperture, with the experience of photographers, who knew that precisely the opposite occurs in practice. Such differences arose because the parties were talking about quite different things, and have long since been explained with the aid of the MTF, but it remains desirable to define what is meant by the different types of resolving power.

Observation of resolving power involves:

A *test-object* or *target* having within it an intensity difference between at least two adjacent areas.

An *imaging device* which produces a facsimile of the target in a spatial plane. This "aerial image" may be observed directly or recorded on some radiation-sensitive surface for immediate detection or later analysis.

A *detector* which scans the image, or records it for later scanning, and indicates the presence or absence of an intensity difference corresponding to that in the target.

Targets usually have a periodic structure, with equal alternating high and low intensities, e.g. lines or bars of uniform intensity on a uniform lighter or darker background. The essential point is the change of intensity between adjacent areas of the target, which is reproduced in a resolved image. One ought not to speak of "resolving" a single object, though this is often done. Targets of various kinds are illustrated in Plate 3.

In aerial photography the imaging device is a refracting or reflecting optical system, and the image is normally recorded on a silver halide emulsion. In observations of the aerial or photographic image the detector may be the eye or a photocell behind a small aperture which traverses the image. From the response of the detector we decide whether the object structure is still present in the image. Leaving aside the delicate questions of what we mean by "structure" and "present", we say that in general the resolving power is the limiting image size, the structural pattern still being detectable, when we make the image progressively smaller. Without specifying or implying all three elements, target, imaging device and detector, we cannot usefully quote resolving power figures. Unqualified statements such as "the resolving power of this lens is N cycles per mm" are meaningless.

Resolving power may be stated for the image plane, the object plane, or in angular form. The resolving power of emulsions, and usually the resolving power of lenses also, is stated as cycles per mm. ("cycles" is preferable to the older term "lines",

because of the possible confusion of photographic lines with television lines. Also, resolving power targets are more correctly described as having bars than as having lines.) The resolving power of cameras is normally stated as cycles per mm in the image plane, but is often converted to cycles per unit length on the ground from a given altitude, or "ground resolution". The latter may be expressed as "Ground Resolved Distance"; though inelegant and possibly misleading, the term is useful in system design. Reciprocal angular resolving power (Rf) is expressed as the product of cycles per mm in the focal plane and the focal length in the same units, e.g. 10 cycle per mm at a focal length of 1000 mm is an Rf of 10,000. The relationships between these definitions are shown in Fig. 5.1. Sometimes the angle is expressed as seconds of arc, but the Rf numbers are more convenient on the whole.

Resolving power measurements for aerial photography are nearly always concerned with images recorded on film, but it is often necessary to refer to the resolving power

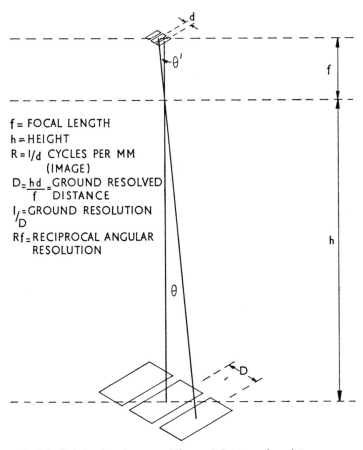

f = FOCAL LENGTH
h = HEIGHT
$R = 1/d$ CYCLES PER MM
 (IMAGE)
$D = \dfrac{hd}{f} =$ GROUND RESOLVED DISTANCE
$1/D =$ GROUND RESOLUTION
Rf = RECIPROCAL ANGULAR
 RESOLUTION

Fig. 5.1 Relationships between different definitions of resolving power

in the aerial image, and this is discussed in the next section. In general the aerial image resolving power of a lens is much higher than the photographic resolving power that can be obtained from it using common aerial emulsions.

5.3 *Aerial Image Resolving Power*

In optics, the "resolving power of a lens" has always meant the resolving power observed visually in the aerial image formed by the lens. This is reasonable, because the conditions of observation can be arranged such that the detector (i.e. the eye) imposes no serious limitation on the performance of the lens. Photographic engineers often speak of "the resolving power of a lens", meaning the resolving power observed when the aerial image has been recorded on photographic film, the properties of the lens then being only one factor. The confusion could be avoided by using the word "photographic" in front of resolving power whenever an emulsion is involved, but this would be clumsy, and it is probably satisfactory to rely on the meaning being clear from the context.

Visual observations of aerial image resolving power may be made with any kind of target, though for telescopes point or star objects are usual, and for photographic lenses bar targets are generally employed because they are available. As explained in Chapter II, there is an upper limit to the spatial frequency that can pass through the aperture of any lens, no matter how well corrected; for a sinusoidal or squarewave target the absolute limit of resolution, or the aperture limit, is therefore the cutoff frequency of the MTF. A very similar limit is the often quoted Rayleigh limit.

5.3.1 APERTURE LIMIT OF RESOLUTION. The cutoff frequency has already been defined in relation to the MTF (Chapter I) by $k = 10^6/\lambda f$, where k is spatial frequency in cycles per mm, λ is the wavelength of the light in nanometres, and f is the f number in the photographic sense. Thus a perfectly corrected f/8 lens will show no modulation in the image at about 200 cycles per mm, even with a high contrast sinusoidal or squarewave target.

One advantage of this definition is that it is unambiguous. At the cutoff frequency the MTF is zero, not a small value which could be different for a detector of higher sensitivity. Some might argue that this is not resolving power, because the image has no structure. However, an infinitesmal change of light wavelength or spatial frequency would at once produce modulation, so this may be regarded as a true and clearly defined resolution limit.

The threshold modulation just visible in the image of a sinusoidal target was investigated by Selwyn for yellow (sodium) light. He found that it varied with the apparent angular separation of the peaks in the manner shown in Fig. 5.2. If the separation lay between 6 and 12 minutes of arc, and the exit pupil of the apparatus did not exceed 2 mm diameter, the threshold modulation was 0·02 for bare visibility, or 0·036 for easy visibility. These figures were maintained over a very wide range of luminance,

128

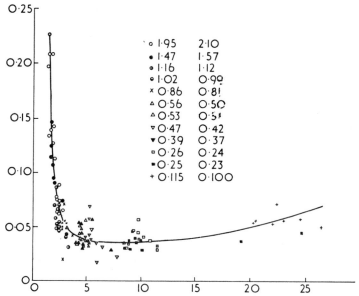

Fig. 5.2 Threshold contrast values for visual resolution of images of different sizes

o 1·95	2·10
• 1·47	1·57
● 1·16	1·12
● 1·02	0·99
× 0·86	0·81
▲ 0·56	0·50
△ 0·53	0·5⁴
▽ 0·47	0·42
▼ 0·39	0·37
□ 0·26	0·24
■ 0·25	0·23
+ 0·115	0·100

10,000 to 1, in the observed image. The figure of 0·02 in modulation, corresponding to four per cent difference between the highest and lowest image brightnesses, presumably also applies to the observation of a photographic image in complete absence of any irregularity due to grain, and hence is a factor in photographic resolving power, though normally swamped by the much higher modulation required for visibility in a granular image. The minimum at about 6 minutes angular subtense will be noticed; the existence of what amounts to an optimum contrast sensitivity of the eye at a certain size has been confirmed by other workers and is important in vision research.

5.3.2 RAYLEIGH LIMIT OF RESOLUTION. The so-called Rayleigh limit of resolution is defined in terms of the point spread function for an aperture limited lens. For a circular aperture this function has a strongly peaked central maximum surrounded by concentric alternating maxima and minima. The relative intensities of the central peak and the secondary peaks are as 100, 1·75, 0·40, 0·16, etc., the minima being at zero intensity. In actual observation of this diffraction pattern its visual appearance is like a bright disc, surrounded, in favourable conditions with enough light, by one or more rings. The eye is not very responsive to smooth changes in intensity, and does not see the peak in the central bright patch, which is known as the Airy disc, an appropriate name in view of its visual appearance. The size of the pattern is inversely proportional to the diameter of the lens aperture, for a given focal length, and directly proportional to the wavelength of the light, in accordance with Airy's formula

$$m = 1 \cdot 22 \, \lambda f$$

129

where m is the radius to the first minimum, λ is the wavelength, and f is the f number of the lens. Obviously the pattern will be developed in its full purity only in monochromatic light.

If we have two point sources, which are brought closer together until the central peak of one image lies on the first minimum of the other, we have the Rayleigh condition, for which the summed intensity profile is as shown in Fig. 5.3. There are now two maxima, with a drop of intensity between them, to 73 per cent. This contrast is easily detected by eye, and the images could be moved closer together while remaining resolved. However, the Rayleigh condition is properly regarded as a specification of the performance of a well corrected optical instrument in exact physical terms based upon diffraction theory. It also indicates an image separation for which the contrast approaches the visual limit, and therefore has useful practical applications. It would not be possible to specify a visual limit in such exact terms, because the visual contrast threshold is subject to perturbations due to noise in the nervous system. Nevertheless, the fall in central intensity in the double image decreases very rapidly as the image separation is further reduced, and for all practical purposes the Rayleigh condition does represent a visual resolution limit.

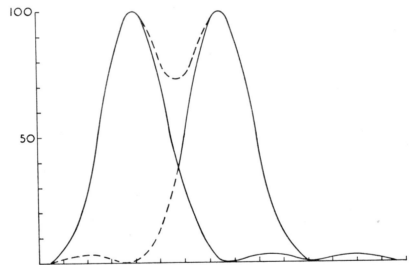

Fig. 5.3 Intensity distribution in the diffraction pattern for the Rayleigh resolution condition (ordinates of secondary maxima not to scale)

In practice the Rayleigh limit and the aperture limit are observed by eye, through a microscope. The magnification must be arranged so that they eye works under optimum conditions whatever the size of the primary image. The microscope optics must be good enough to preserve the contrast of the image, and the numerical aperture must be greater than that of the lens being tested, otherwise the latter will in effect be stopped down.

No surprise need be felt if lenses are found to be "better than the Rayleigh limit"; this is merely a consequence of the finite contrast associated with the Rayleigh condition, and well corrected lenses will often resolve somewhat smaller separations. On the other hand, observation of the Rayleigh limit does not necessarily mean that the lens is perfectly corrected. A small amount of aberration depresses the peak of the spread function without markedly broadening the pattern as a whole. In different terms, the MTF is depressed at intermediate frequencies without much effect on frequencies near the cutoff. (Compare Chapter II.) Thus it is conceivable that Rayleigh resolution could be observed with two lenses, one of which might be better at intermediate spatial frequencies.

5.3.3 VISUAL RESOLVING POWER: GENERAL. The aperture limit and Rayleigh limit are reference standards of optical performance. If a lens can be seen to resolve down to these limits it is well corrected, but inability of a photographic lens to reach them does not mean that it is a poor specimen. These are not strictly limits of resolving power in the sense of being determined by the contrast sensitivity of the eye and the MTF of the lens; they are defined in geometrical terms derived from diffraction principles, and seeing or not seeing resolution is incidental. It might be thought that visual observation of resolving power in the aerial images given by aberrated lenses, such as camera lenses, would be a useful evaluation method. The term "visual resolving power" is often used in this connection; it is an unfortunate term because of possible confusion with the resolving power of the eye, but the meaning is usually clear from the context. In practice, observations of visual resolving power are not of great interest or value, because they tell us little or nothing about photographic performance.

The situation in observing visual resolving power of a photographic lens is illustrated by a concrete example in Fig. 5.4. The horizontal line at a modulation level of

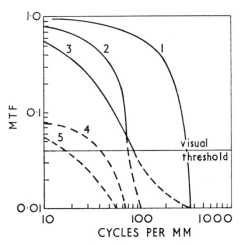

Fig. 5.4 Visual resolving power of lenses

0·04 is the minimum detectable contrast or visual threshold. This is kept independent of spatial frequency by adjusting the magnification so that the eye is always working on the flat minimum of the curve in Fig. 5.2. The curves show the on-axis white light MTF's of a 280 mm f/4·8 telephoto lens intended for the 24 × 36 mm format. The curve furthest right is the aperture limited MTF for f/4·8; being calculable it is known accurately right down to the cutoff at 375 cycles per mm. The third curve from the right is the actual lens MTF at f/4·8; being an MTF measurement its accuracy is not very good below about ten per cent modulation transfer factor, and from about five per cent down to the cutoff its course can only be surmised, as shown by the extrapolated dotted portion. The second curve from the right is the measured f/16 MTF; this has been extrapolated to its cutoff at 112 cycles per mm. This MTF comes much closer to the aperture limited f/16 MTF, omitted for clarity, which would have an ordinate value of 0·39 at 66 cycles per mm.

Although the full aperture MTF lies well below the f/16 MTF over much of the frequency range, it crosses the visual threshold at 150 cycles per mm, as compared to 100 cycles per mm, and on this observation would be judged superior. In practical photography we should expect better definition at f/16, and the MTF's at the lower spatial frequencies certainly suggest that this would be so. Depending on the emulsion used, and the contrast of the detail photographed, the highest significant spatial frequency in practice would be in the neighbourhood of 40 cycles per mm. At this frequency the f/16 MTF is more than twice as good as the full aperture MTF.

The two curves at the lower left represent the aerial image modulation at f/16 and f/4.8 when the target modulation is reduced to 0·1; they are obtained from the MTF's simply by displacing these downwards until they pass through the ordinate 0·1 at zero frequency, a convenience of the logarithmic plot. Now, the order of the resolving powers is reversed due to the crossing MTF's and the higher modulation transfer, at f/16, for lower spatial frequencies. With a suitably low contrast target, visual resolving power could therefore give a realistic ordering of the practical value of photographic lenses. However, there would not be any constant or predictable relationship between the visual resolving power and the photographic resolving power on various emulsions. Also, the observations would not be very accurate, partly because of the fluctuation of the visual threshold, but also because of the rather gradual slope of the MTF's at the lower spatial frequencies, compared to the steeper slope near the cutoff of an aperture limited MTF. The steep slope of the right hand curve as it passes through the threshold emphasises what was said about the Rayleigh limit being close to the effective cutoff, even though the residual contrast is appreciable. In relation to the logarithmic size decrement of the usual targets, the transition to the not resolved state occurs very quickly.

Fig. 5.4 represents one specific case, but is quite typical of photographic lenses in general. Visual resolving power with high contrast targets usually gives a completely false picture of the practical definition of aberrated photographic lenses. Low contrast visual resolving power may order such lenses correctly, but for any practicable target contrast the resolution is likely to occur at unrealistically high frequencies. The choice

132

of target contrast would be arbitrary, and there would be no basis on which a particular contrast could be chosen to give universal correspondence between visual and photographic resolving power.

5.4 *Photographic Resolving Power*

All resolving power determinations in which the image is recorded in a photographic layer are properly described as photographic resolving power, though the emphasis may be on the performance of an emulsion, a lens, or a lens-film combination which is the basis of a camera system. Recording the image on an emulsion introduces three additional factors, viz., the MTF of the emulsion, the slope of the H and D curve, and the granularity. All three are important, but the granularity is the source of the most fundamental difference between photographic and visual resolving power, because it makes the contrast threshold directly dependent on the spatial frequency. The thresholds are in general higher than the frequency-independent threshold that operates in aerial image resolving power, but the actual values are characteristic of each emulsion. Photographic resolving power is strongly dependent upon target contrast and hence also on the MTF of any lens used to form the image. In spite of this and other factors, the resolving power of an emulsion is a more definite thing and a more useful guide to its practical value than is the visual resolving power of a lens. For compact targets such as the Cobb or three bar, the resolving power of an emulsion can be specified within much closer limits (subject to experimental error). It can be measured using a lens which in effect imposes no limitation. We can then state, for example, that the resolving power of a medium speed aerial emulsion is 120 cycles per mm, plus or minus 20 per cent, at high contrast. As already explained, the visual resolving power of a lens cannot be specified so closely, because it depends so much upon target contrast, in ways which differ from lens to lens, according to the shape of the MTF. In addition, the MTF is of course different for every aperture, field position, focal setting and spectral sensitivity of the detector. Thus the high contrast visual resolving power of a wide angle f/5·6 mapping lens might be anything from 10 to 300 cycles per mm, depending on field position; only on axis would it even approach the aperture limit. For a given target contrast, the emulsion in actual aerial photography may be worked at about half of its limiting resolution, assuming a good lens on axis. The lens, in general, is not worked at more than one tenth of its theoretical aperture limited resolution. Again, the ratio between high and low contrast resolving power for emulsions, though not a constant, shows much less variation than the corresponding ratio for the visual resolution of aerial lenses. As a rough general rule the high contrast three bar resolving power of emulsions is about twice the resolving power for 2 to 1 contrast, though ratios up to 3 are sometimes reported for special high resolution emulsions. (Manufacturers' figures for 35 aerial negative and duplicating emulsions gave a mean ratio of 2·1, with standard deviation of 0·16). The resolving power figure for an emulsion provides a reasonable basis for approximate comparison with

other emulsions tested in the same laboratory, and in general is a useful summary of its image recording quality, in a way that the visual resolving power of a lens can never be.

In the past, a great deal of attention has been paid, understandably, to the problem of predicting the photographic resolving power, R, of a lens-film combination from the individual lens and film resolving powers, R_L and R_E. The combined resolving power was assumed to be obtainable from a reciprocal addition formula of the general form

$$\frac{1}{R^n} = \frac{1}{R_L^n} + \frac{1}{R_E^n}$$

where n has some value of the order of unity. The formulae were based on empirical studies and to that extent had good justification, but there is no theoretical basis on which they can be applied in a general way.

The essential difficulty in applying such formulae, having regard to all the possible variations in lens performance, is that we do not know what value to assign to R_L. If we choose the "visual resolving power", then even at a specified target contrast the relationship to R_E and R would be subject to wide variations from lens to lens, depending to the shape of the MTF. Another approach has been to use the resolving power given by the lens on an emulsion of such fine grain that it has little effect on the lens performance. But which emulsion? Any emulsion, short of the maximum resolution type, has some effect on all but the worst lenses. The maximum resolution type might even give higher resolving power than that observable visually. In general, we cannot define R_L in any satisfactory way.

As mentioned above, the emulsion resolving power, R_E, is a more definite thing, which, at least in principle, can be measured in an unambiguous way. Subject to the usual experimental errors in all resolving power measurements, it does not pose the same kind of difficulty as does the lens resolving power for all cases other than the aperture limited lens.

The reciprocal addition formulae have some value for the rapid computation of the order of resolving power to be expected in a given situation, and they are very widely used for such purposes. However, there is no prospect of improving them into universally applicable and more accurate forms, and there is no good justification for complicating them by making 'n' anything other than unity.

A different approach to the prediction of lens-film resolving power, based on the lens MTF, is discussed in Chapter VIII.

5.4.1 TYPICAL VALUES OF RESOLVING POWER. Lens designers and workers in other image-using technologies often ask for representative figures of resolving power achieved in aerial camera systems. For various reasons it is difficult to meet such requests in a truly representative way, and one can only indicate certain orders of magnitude.

Representative emulsion resolving powers are given in Table 5.1.

134

TABLE 5.1
REPRESENTATIVE EMULSION RESOLVING POWERS

Type of emulsion	High contrast 3-bar resolving power, cycles per mm.
Highest Speed Aerial Negative	60
Medium Speed Aerial Negative	120
Low Speed Aerial Negative	180
High Resolution Aerial Negative, and Document Copying	550
High Speed Duplicating Aerial	180
Low Speed Duplicating Aerial	1500

As already indicated, resolutions obtained in aerial cameras are lower than the emulsion resolutions, and in actual aerial photographs the resolutions may be lower, for equal effective target contrast, than those obtained in laboratory tests with the same apparatus, due to various factors such as residual image movement. Generally, in mapping photography, with cameras properly mounted in stable aircraft, the potential resolution is not seriously degraded. According to the type of lens, e.g. wide or super wide angle, the resolution obtained with a medium speed film is equivalent to a laboratory resolution, at 1·6 to 1 contrast, of 10 cycles per mm off axis, to 40 cycles per mm on axis. Anything much below 10 cycles per mm. would be regarded as unacceptably poor definition, while the axial definition is adequate for most mapping purposes. Low altitude reconnaissance cameras using film of medium to high speed may yield resolutions in the same general bracket, though the in-flight performance is more liable to disturbance, e.g. by unstable flight conditions. In high altitude reconnaissance, higher resolutions are obtainable, according to the sophistication of the apparatus.

5.5 Granularity

The grains in the emulsion are silver halide crystals in the order of microns in equivalent projected diameter. In any emulsion there is a range of grain sizes, but representative equivalent diameters run from nearly two microns for very high speed emulsions down to less than half a micron for the highest resolution aerial and duplicating emulsions. The grain shapes, according to the method of manufacture, may be anything from nearly spherical to flat hexagonal or truncated triangular plates. After exposure the grains are not visibly changed from their semi-translucent condition, and retain their original size. After development the grains appear to have suffered some distortion and may have moved slightly from their original positions, but essentially they are now opaque masses of silver whose structure is not visible under the optical microscope. In the electron microscope the mass is found to consist of clumps of

135

filaments spreading out beyond the original crystal boundaries. Some variation is possible in the filamentary structure, but since the filaments are below optical resolution and orders below the detail in aerial photographs, we are justified in regarding the grains as simply opaque lumps.

In general the emulsion layer is thick enough for the image to be made up of grains in depth, the depth occupied depending on the type of emulsion, exposure, and degree of development. With very fine grained almost transparent emulsions, such as micro copying types, the image tends to occupy almost the full depth of the layer. With faster emulsions of larger grain size and higher coating weight it tends to lie near the upper surface at normal exposure levels. The three dimensional distribution of the image has significant effects on image quality, as mentioned in other chapters.

The size of the developed grains depends to some extent on the exposure level, since the largest grains are the most sensitive However, the density depends mainly on the number of grains present per unit area. Remembering that the grain or lump diameter is in the order of microns, while the size of image details is in the order of tens of microns, the number of grains available for any "cell" of the image is evidently quite large. This clearly gives imaging situations different from those in half tone prints or television pictures.

The familiar grainy appearance of photographs observed under moderate magnification is due, not directly to the individual opaque lumps, but to the local variation in their number per unit area, which determines the density. If a piece of evenly coated, uniformly exposed and developed film is scanned with a small aperture in the microdensitometer, the resultant trace of density versus distance exhibits random or "noisy" excursions about a mean level. Finer grain emulsions naturally give smaller excursions for the same aperture size.

The visual impression of the density excursions is known as "*graininess*" and is important in general or pictorial photography. The physical density excursions themselves, measured in a standard way, are characteristic of each emulsion and are known as the "*granularity*".

The impression of graininess is strongly dependent on image detail. This is commonly seen in landscape or portrait photographs; the picture can look very grainy in sky areas or flesh tones where there are no abrupt density changes, but can be apparently free of grain in a pattern of trees or hair. The density fluctuation is approximately constant, but the eye chooses to ignore it in presence of competing detail. If however we look for detail under greater magnification it too suffers from the grain and if small enough will be obscured. In aerial photography a picture of a scene can appear grain-free if taken in clear weather, yet another picture taken in hazy weather can appear grainy, all other things being equal. This phenomenon is fundamental in photographic resolving power; the grain obscures detail that could easily be seen in a grainless film, and makes the resolving power strongly dependent on the image contrast.

In general photography we are not necessarily looking for the finest detail when conscious of the "noise", which is then unambiguously known as graininess. When

reading resolving power or interpreting an aerial photograph, we are primarily trying to identify detail while conscious of the grain which is obscuring it. Indeed, when observing a just resolved image we are simultaneously conscious of the target image, the local density fluctuations in areas of comparable size, and the finer pattern of grain running through such areas. (Plate 4.)

With such a close connection between the detail size and the density fluctuations which determine its visibility, it seems quite appropriate to speak of the obscuration of detail by granularity. We shall therefore use the term granularity both for the measured density fluctuation and for the effect which obscures the detail. This is a matter of opinion, and in a classical and very relevant paper[3] Selwyn and Romer took a different view.

5.5.1 MEASUREMENT OF GRANULARITY. The standard method for measuring granularity is the obvious one of making a microdensitometer trace and giving a physical summary of the result. The scanning aperture is usually circular and in the order of 50 microns diameter. If a number of density or transmittance readings are taken, randomly spaced over the uniformly exposed film, their distribution is expressed reasonably well by the Gaussian curve of statistics. Hence, if we have sufficient readings for which the mean density is D, the variation of the readings above and below D is defined by $\sigma(D)$, the standard deviation. From the definition of σ, this is known as the root mean square (R.M.S.) granularity, and has sufficient analogy with the electrical concept of R.M.S. noise to be useful in conjunction with the MTF for describing photographic image quality. Apart from sophisticated mathematical studies, the term "noise" has come to be applied to R.M.S. granularity as a convenient shorthand description.

In the actual measurement, the aperture is moved along a line or in a rotary scan, some 1000 readings being taken for the granularity figures published by film manufacturers. At an aperture diameter of 50 microns, this means a total scan length of some two inches. It is essential that the exposure and development be as uniform as possible over the whole of this area, likewise the emulsion coating must be quite uniform and the sample absolutely free from all blemishes. These conditions are not easily fulfilled outside the research laboratory.

According to the Selwyn theory of granularity, which requires that the density excursions be solely due to the statistical variation in the number of grains per unit area, all grains being of negligible size relative to the scanning aperture, there is a constant, G, characteristic of the deposit. This constant is known as the Selwyn granularity, defined by

$$G = [\sigma D] [a]^{\frac{1}{2}}, \text{ where } a \text{ is the area of the aperture.}$$

This indicates that the R.M.S. granularity, σD, should be inversely proportional to the diameter of the scanning aperture. Experiment has shown that this holds good, approximately, over a wide range of emulsions and aperture diameters, though according to Selwyn, G increases slightly but steadily with the diameter of the aperture, probably because of coating irregularities. This concept of R.M.S. granularity

proportional to the reciprocal of the scanning spot diameter is important in the theory of resolving power. It would not necessarily be true for extreme departures from the circular aperture shape, such as very long slits.

Some film manufacturers publish granularity data for their products, often for a circular scanning aperture of 24 microns diameter. More recently Eastman Kodak data have been given for a 48 micron aperture diameter, on the ground that the figures then indicate the magnitude of the impression of graininess that would be perceived if the sample were examined at 12 ×, a common magnification. It is also pointed out that the microdensitometer optical aperture is f/2. This is important, because the magnitude of the granularity excursions, like any other density differences, depends on the specularity of the light. An f/2 aperture is obviously more specular than contact printing, but less so than projection or enlargement in a condenser enlarger without diffusion.

Some representative values of granularity for Eastman Kodak aerial and other emulsions are given in Table 5.2. It will be appreciated that such figures are liable to become out of date as improved emulsions appear, but drastic changes are unlikely. The chief purpose of the table is to show the range of granularities, from 649 High Resolution, whose resolving power is beyond that of any optical system, to the fastest emulsions available. The data will often be found useful for approximate calculations.

TABLE 5.2

GRANULARITIES OF VARIOUS EMULSIONS

Emulsion type	R.M.S. granularity
649 High Resolution	0·003
3404 Aerial	0·008
SO 243 Aerial	0·008
AHU Microfile	0·009
Fine Grain Aerial Duplicating 8430	0·01
Aerographic Duplicating 5427	0·02
Panatomic X Aerial	0·025
Plus X Aerecon	0·04
Super XX Aerographic	0·05
Royal X Pan Recording	0·05
Tri X Aerographic	0·06

Based on Eastman Kodak data, revised for 48 micron scanning aperture in certain cases. Data mostly for nett density of 1·0, and appropriate developers for use, e.g. D 19 for Aerial emulsions.

Granularity increases with density, hence the exposure or density level is an extremely important factor in image quality.

Granularity is measured in spatial terms, but if we desire to evaluate an imaging system throughout in the spatial frequency domain, the granularity must be trans-

138

formed into its spatial frequency equivalent. This can be done from the microdensito-meter trace, just as it can from a target intensity profile. The Fourier analysis of the trace yields the "noise power" as a function of spatial frequency, and is known as the Wiener spectrum. Expression as the Wiener spectrum is essential if we need to cascade granularities, e.g. in predicting the granularity of a print from the granularities of the negative and positive materials. The Wiener spectra are multiplied together at each spatial frequency, as with MTF's, and the result is the Wiener spectrum of the noise in the print. Wiener spectra have been determined and cascaded, and the results are in accordance with theory. Since the granularity trace has very sharp spikes, its power spectrum must contain very high frequencies. These will be attenuated by the MTF of the print material and by losses in contact printers, etc. We should expect to find the balance of the power spectrum displaced towards lower frequencies in the print, and this kind of effect has been demonstrated.

In aerial photography we are primarily interested in the granularity because of its obliteration of fine detail, which can be explained fairly well in terms of the spatial density fluctuation.

5.6 *Granularity as a Determinant of Resolving Power*

When a sinusoidal target is imaged on an emulsion, the modulation in the effective exposure image is $M_i.T_e$, where M_i is the aerial image modulation and T_e is the emulsion MTF. In practice resolving power is measured with bar targets, and T_e would be replaced by the appropriate bar target function. After development the image density difference would be approximately $M_i.T_e.\gamma$. In complete absence of granularity the resolution limit would be the spatial frequency at which this product was $0\cdot04$ or thereabouts, and the density difference would be independent of the actual spatial frequency. When granularity is a significant factor, however, the threshold contrast required for resolution increases in proportion to the spatial frequency, corresponding to the effective increase in granularity with magnification. Considering the image to be distributed in adjacent cells corresponding to the equal bar and space areas, then in presence of grain the density within any cell is liable to fluctuate above and below a nominal value, according to where the cell happens to be, its area, and the basic granularity of the emulsion. For example, if we image a three-bar target, contrast $0\cdot3$, on Plus X Aerecon emulsion, using a lens which effectively has no losses, we obtain a resolving power of about 60 cycles per mm. The effective granularity for this cell area is about $0\cdot1$, i.e. the actual density of any cell can be of the order of $0\cdot1$ above or below its nominal value, though substantially greater or smaller excursions can occur, since the granularity is an R.M.S. value. Clearly, random variations of this order would be liable to mask the systematic variation of $0\cdot04$ which would be adequate for resolution in a grainless image. To get well clear of the grain we evidently require an image density difference greater than $0\cdot04$, and in fact the product of the target contrast, emulsion MTF and gamma is found to be about $0\cdot18$ (subject to the usual uncertainties due to imperfect knowledge of the MTF and micro-gamma, definition of

modulation in a three-bar image, etc.). Thus at 60 cycles per mm the grain has necessitated a fourfold increase in the image contrast required for resolution. By increasing the target contrast up to the limit we can obtain a resolving power of nearly 120 cycles per mm. The effective granularity is then $0 \cdot 2$, and the calculated image density difference is about $0 \cdot 33$, i.e. it has been increased roughly in proportion to the spatial frequency.

The existence of this rising grain threshold is the source of the principal differences between visual and photographic resolving power of lenses. It will be clear that if the target is imaged on the emulsion by a lens for which the modulation transfer factor is less than unity, this is equivalent, so far as the emulsion is concerned, to a lower initial target contrast, imaged without loss. The resolving power of the lens-film combination is then the spatial frequency at which the product of the target contrast, lens MTF, emulsion MTF, and gamma intersects the grain threshold. Fig. 5.5 shows the lens MTF no. 3 of Fig. 5.4, and the product of the same MTF with the MTF and gamma of Plus X Aerecon, together with the grain threshold. The intersection of the lens-film-gamma curve with the grain threshold (circled) gives the high contrast resolving power. Clearly, if we know the grain threshold and MTF for the emulsion, we can predict the resolving power that it will give in combination with any lens whose MTF is known. In practice it is more usual to employ a different type of threshold which is discussed in Chapter VIII, but this example serves to illustrate the role of the granularity. It also demonstrates the relative unimportance of those regions of the lens MTF at higher frequencies, where the modulation transfer is below $0 \cdot 1$, especially when the target is of low contrast.

The concept of the image consisting of neatly defined cells of the nominal geometrical dimensions, within which the density is uniform, though liable to vary according to the location of the cell, is useful, but a great simplification. One obvious difference from reality is that the image is quasi-sinusoidal and distorted in size, without sharp boun-

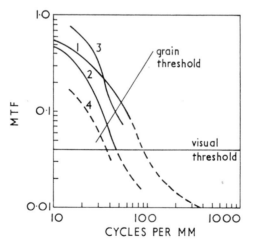

Fig. 5.5 Photographic resolving power of lenses. (I) Lens MTF. (2) I × MTF of plus X.
(3) 2 × γ of 2.4 (4) Same as (3), but target contrast 0.2

daries. Another is that a granularity figure merely expresses the density averaged over the area of the scanning aperture, and says nothing about the local variations in grain concentration, i.e. density, within that area. Needless to say, under sufficient magnification the grain pattern can be seen running through the resolvable images. It might then be thought that the idea of cells varying randomly in density is so far from the truth as to be valueless. However, in practice it does have some correspondence with what we see.

Looking down the microscope, at a magnification substantially greater than we would use to read the resolution, all we can see is the grain pattern, which looks much the same, though on a larger scale, as at lower magnifications. (Unless, of course, the magnification is so great that we see individual grains and the spaces between, but this is outside the region covered by the theory of granularity and the limits that concern us here.) Within the area of images that could be resolved at lower magnification, we see nothing but grain. If now we reduce the magnification, the apparent magnitude of the grain luminance variations diminishes and we begin to see the bar patterns.

At a very low magnification the grain pattern will not be visible at all, but the bar images may subtend such a small angle that their contrast is affected by the MTF of the eye and they cannot be resolved. The optimum magnification is a compromise between giving undue emphasis to the grain at one extreme, and having the image too near the resolution limit of the eye, at the other. In effect, it is an unconscious optimisation of the viewing signal to noise ratio. Authorities often state the the optimum magnification is approximately $0 \cdot 6$ of the resolution in cycles per mm, but this varies from person to person and with different kinds of image.

Many workers, including the writer, find that factors between $0 \cdot 3$ and $0 \cdot 5$ give them the highest resolution. There is usually a tolerance of about plus or minus 25 per cent on the optimum value, though some "difficult" images are more critical on magnification. Taking $0 \cdot 45$ as a representative value, a 30 cycle per mm image would be viewed at $\times 13$, and would appear to subtend the same angle as a $2 \cdot 3$ cycle image viewed at the normal distance of 250 mm. This is an angle of 1 in 570, or about 6 minutes of arc. Reference to Fig. 5.2 shows that this is close to the maximum contrast sensitivity of the eye, as found by Selwyn. However, this eye threshold curve is nearly flat over a range of angular subtense of five to one, so there is considerable flexibility in magnification to deal with different grain situations and individual characteristics, without moving far from the optimum sensitivity.

If now, while using this optimised magnification, we allow our eye to roam over the whole area of the target image, we can describe our impressions on the following lines. We are most conscious of the grain in the lighter background (assuming we are looking at a low contrast target) even though we know that the physical granularity must be somewhat greater in the denser bar areas. By concentrating on the largest bars, or any large area such as a photometric patch, we can see the grain there also. As we look down to smaller and smaller images, the grain becomes progressively less obvious within the bar areas, and near the resolution limit we tend to be conscious only of the density differences between the bars and spaces, and the mean density of the

bars relative to the background. The presence of the small areas of image density apparently depresses our ability to see within them the grain which is obvious in the adjacent background. (High contrast targets are normally exposed so that the background density is near fog level, and no appreciable grain would then be visible outside the image areas.) We see, as it were, the collective density within the image, so long as this helps to construct a mental pattern resembling the basic target unit, or indeed any organised pattern. Due to the choice of the optimum magnification, we may imagine the situation to be paralleled by a scanning of the image by an aperture which always has the approximate dimensions of the target bar at the resolution limit. We might find in this an analogy with the fact known in communication theory, that the best filter for extracting a signal from a noisy channel is one which has the functional shape of the signal itself. To this extent, the concept of the image density differences suffering random disturbances due to the granularity seems reasonable. However, the smaller scale oscillations of grain concentration, which collectively make up the density fluctuations within a cell area, will not always fall nicely within the cell boundaries. They may add up to a local increase of density at the edge of an image where the light intensity is actually decreasing, or a decrease of density in the middle of a bar where the light is at its maximum.

Depending on circumstances, various phenomena may occur: bars may be apparently displaced or rotated; edges can become serrated, or bars cut in two; one bar of a pair may disappear while the other remains plainly seen; all bars may disappear, then reappear at some smaller size, and so on. Needless to say, these random effects are not duplicated in nominally replicate exposures. In general we try to hold on to resolution as far as possible into the grain, and we accept images as resolved which may be quite grossly distorted in shape, size and position. This is all part of the uncertainty of looking for signals in noise, and makes the resolution test inaccurate or realistic, depending on the point of view. When measuring resolving power to establish the performance of a lens, the statistical fluctuations inseparable from a signal to noise limit are a serious problem. Resolving power as a measurement tool can only be significant if numerous observations are made and the average taken. In relation to actual aerial photography, the statistical fluctuation emphasises that there is no hard and fast limit of detectable size, even when the contrast is known.

Fortunately, the objects studied in aerial photographs extend over a range of sizes, and although some parts of them may be on the limit of resolution, other parts are above it. Also, objects in general being above the resolution limit, the granularity is averaged over an area substantially greater than that of one resolution target group. Thus the resolving power test is to be regarded as defining system performance in a way that parallels practice but does not directly indicate the minimum size of objects that can be recognised.

References

[1] REID, CHARLES D., *Phot. Sci. Eng.*, **10**, 5 pp. 241–258 (1966).

[2] BURTON, W. K., *Brit. J. Phot.*, **33**, 336–354 (1886).

[3] ROMER, W. and SELWYN, E. W. H., *Phot. J.*, LXXXIII, 17–20 (Jan. 1943).

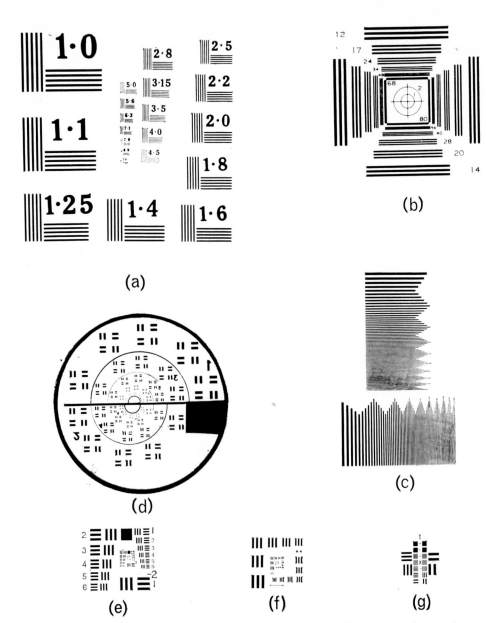

Plate I. Resolving power targets. These reproductions are so scaled that the period of the biggest element is the same in all targets. This gives a realistic impression of the relative area occupied by each target. (a) NBS 1010 (b) NBS 1952 (c) Sayce (d) British Cobb (e) USAF 3-bar (f) USASI 3-bar (g) NBS 25X

VI. MEASUREMENT OF RESOLVING POWER.

6.1 *Introduction*

The procedures and apparatus used in resolving power measurement are too well known to photographic engineers to need any detailed exposition. This chapter is more in the nature of a commentary on current practice. The topics chosen for discussion are those which many years of experience and observation have shown to give most difficulty or to indicate a need for rationalization.

In measuring photographic resolving power the objective may be:

(a) the limiting resolving power of an emulsion, possibly at several different contrasts;

(b) the resolving power of a lens in conjunction with some specified emulsion, usually the operational emulsion;

(c) the resolving power of a camera, statically or in some dynamic operating condition, e.g., in the laboratory with the image movement compensation in use, or in actual flight.

There is much in common between (b) and (c), but in (b) the emphasis is on the lens alone, and in (c) it is on the camera as a working system including the lens. In (c) many factors in addition to the inherent quality of the lens will affect the result, and in general one will not expect the same resolving power as in the static condition in the laboratory.

Certain controls and precautions required in all resolving power tests can be observed fairly completely for cases (a) and (b), but in case (c) there are additional complications due to the specific nature of each test which cannot be laid down as general guidelines. For example, the test conditions may preclude accurate exposure, which is a necessary condition for (a) and (b). The tester must then be aware of the general principles and the consequences of departures from them.

6.2 *Targets*

6.2.1 GENERAL ACCOUNT. The common resolving power targets are repetitive patterns of bars on a uniform background, representative types being shown in Plate 1. The illustrations are negative, the bars being usually lighter than the background, the ratio of bar and background luminance being the target contrast. In present-day targets the bars and spaces are of equal width. The intensity profile is rectangular so that the pattern is "square wave" or "crenellate". Resolving power is sometimes measured by projecting interference fringes on to the emulsion, the intensity profile then being sinusoidal. Sinusoidal targets could of course be imaged by a lens

on to an emulsion just as with regular bar targets, but they have not been used to any significant extent, due to the problems of making sinusoidal targets at reasonable cost. There is something to be said for the use of three-cycle sinusoidal targets for measuring resolving power, because the modulation in the image of such a target is the same, within a few per cent, as in the image of an infinite sinewave of the same frequency. Thus the prediction of resolving power from lens MTF's (Chapter VIII) could be accomplished with greater reliability. However, there is no immediate prospect of sinusoidal targets being made of sufficiently high quality and low cost to warrant their universal introduction.

A complete *target* is made up of *bars*, *elements*, and *groups*, arranged in some way, e.g. a spiral, to occupy least area while covering the necessary range of spatial frequency. An element consists of two or more bars, e.g. three in the USAF target. A group contains one or more elements. In targets for lens testing, at least two elements in orthogonal orientation are provided, the bars in one element being aligned radial to the lens axis, the other direction being designated tangential. Targets for emulsion testing only do not need the orthogonally oriented elements, because the light diffusion is isotropic. The ASA three bar target is an example. One advantage of this simplification is ease of reading, another is reduced area, which is often important because of the limited covering power of the microscope objectives used in emulsion testing. When covering power is adequate the targets with orthogonal bars can of course be used for emulsion testing also, and have the advantage of requiring fewer exposures for a given number of replications.

The size of the elements in successive groups diminishes in geometric progression, the factor by which each element is smaller than the next in the series being the *group size ratio* (GSR). Typical GSR's are 0·95 in the Cobb target, and 0·88 in the USAF three bar target. (The nomenclature used here is not universal. In the U.S.A., "element" corresponds to "group", and "group" refers to a series of elements covering a range of two to one in size.)

The nominal spatial frequency of a bar target is the reciprocal of the bar plus space distance. This corresponds to the centre to centre distance between bars, or the distance between points of equal phase in the fundamental frequency of the equivalent squarewave. The frequency is preferably expressed as "cycles per mm", rather than the older "lines per mm", which risks confusion with television terminology. In television practice, N cycles per mm, as just defined, would be called 2 N lines.

Targets used by different organisations differ in contrast, in the characteristics of the bars, the number of bars in an element, the number of elements to a group, and the number of groups in the complete target. Target types proposed or in use have been surprisingly numerous, although the bulk of the world's resolution testing is done with three or four types. At least nine kinds of target are in actual use, and if one includes all those seriously proposed, and the various contrasts, the total must be nearer twenty. It could reasonably be argued that the majority of these are unnecessary, and that while each target does give somewhat different results, nothing would be lost and much gained by having a world-wide universal target. A selection of well-known,

144

frequently used targets, plus others to be found in the literature, is given in Table 6.1. In explanation of two of the column headings, "Bar Aspect Ratio" is the ratio of bar length to bar width; "Group Area" is the relative area of one group at a given spatial frequency, the area of a Cobb group at the same frequency being unity.

The GSR and the group or element area have practical consequences which are not always appreciated. The USAF three bar element covers nearly three times the area of the Cobb, which from one point of view is favourable, because a larger image area is sampled and there should be less liability to disturbance from grain. On the other hand, the full target assembly, other things being equal, would occupy more space, and in lens testing the field position would vary more according to the group at which resolution was read. However, the lower GSR of the Cobb means that more than twice as many groups are required to cover a given size range, and on balance the Cobb occupies the larger area. (It will be appreciated that these remarks apply to the Cobb target as used in Great Britain with a 0·95 GSR, and not to the Cobb pattern as such.) Taking the pitch of the largest element as the unit of length, the overall diameter of the Cobb target is 33·6 units, and of the USAF target is 15 units, while the overall area of the Cobb is nearly four times that of the USAF target.

The uncertainty about field position due to the large area of the Cobb target is not altogether an academic problem. The target must be positioned such that the centre is at the nominal field angle, since one does not know in advance which group will be resolved. Inevitably, therefore, the resolved group will have an offset from the nominal

TABLE 6.1
RESOLVING POWER TARGETS

Target	Bar aspect ratio	Relative group area	Contrast ratio
Cobb 2 bar	3	1·0	1·6
USAF 3 bar	5	2·8	1·6
			2·0
			1000
ASA 3 bar	5	2·8	2·0
			6·5
			1000
Japan 4 bar	6·5	5·4	1000
NRC annulus	—	0·8	1·6
NBS 25 × (3 bar)	7	4	1000
NBS 5 bar (microcopy)	25	25	1000
Sayce	24 to 290	8 to 80	1000
Fringes	> 50	> 100	variable

angle. The target will be reproduced at such a scale that some group, n, is judged resolved, the bar plus space distance being, say, d, then the group is at a distance about 15 d from the target centre. This determines the error in the angle, when ratioed to

145

the focal length. But one will need to examine the image over a range of at least two groups above and below the group at first judged resolved; this means moving in and out radially over a distance of about 30 d. (The error cannot be avoided by imaging the target at a smaller scale.)

Near the limit of the field of a lens the resolution, especially on tangential bars, often falls very rapidly, and it is possible to have a situation in which the resolution actually observed remains unchanged over several groups, or resolution may even occur at smaller groups when larger groups are not resolved, because the improved performance at smaller field angles counteracts the diminishing element size. The effect is of course more serious with a smaller GSR. The magnitude of the effect depends on the level of resolution. With high values of n, hence low values of d, the angular offsets are less. In typical practical cases the groups to be examined cover about two degrees, and it is sometimes extremely difficult to reach any decision because of the rapidly falling tangential definition.

Similar effects occur with the USAF target, though in this case their magnitude depends strongly on the actual group (U.S. sense) and position in the group at which resolution is found, and in general they are smaller because of the larger GSR. However, large displacements occur when moving, for example, from the minus 2, 6 to the minus 1, 1 positions.

Fig. 6.1 Area comparison of resolving power targets

These problems occur because users expect one target to cover all their testing needs, which may include a wide variety of image scales and resolution levels. If it were possible to have individual targets for each application, containing few groups in a restricted size range, and orientated in the optimum way, most of the difficulties could be avoided. However, resolution testing is normally regarded as something to be done very quickly, and few organizations would tolerate frequent target changes, with possibly, repeat exposures when the resolution fell just outside the selected range.

Many targets contain group numbers, to assist the reader in orientation. Sometimes these numbers are dangerously close to the target bars; for example the "3" on the Cobb target is so close to a bar that it must seriously distort the image at small scale and cause spurious errors in the reading. The USAF target also suffers this way, but not so seriously.

Fig. 6.1 shows one element of the annulus, Cobb, USAF and NBS targets at the same scale, i.e. all have the same spatial frequency. In view of the great differences in form and area of film covered, "resolving power" must have a different meaning for each target.

Some notes are now given about the three targets which have been most used in connection with aerial photography, viz., the USAF three bar, the Cobb, and the Canadian annulus, also the Sayce and radial targets, which have been used to some extent.

6.2.1.1 *USAF Target—Mil. Std. 150.* This target is believed to have originated at the Avionics Laboratory, Wright Air Development Center, Dayton, Ohio. Its GSR of $0 \cdot 88$, or $\sqrt[8]{2}$, is understood to have been settled by experiments performed at Boston University.

Originally it was used in high contrast only, but to-day contrasts of $1 \cdot 6$ to 1 and $2 \cdot 0$ to 1 are also used. More resolution tests are performed with the USAF target than with any other, but it is not used very widely outside the U.S.A. Targets to this specification are manufactured by several American companies, with maximum spatial frequencies in the actual target going as high as two hundred cycles per mm in some cases.

6.2.1.2 *Cobb Two Bar Target.* The Cobb pattern of two equal rectangles inscribed in a square was originally used by Cobb and Moss in the U.S.A. for vision studies. It was adopted by Selwyn and Tearle in England during 1940 for their well known study of the performance of reconnaissance lenses, after preliminary work in which the seven bar targets, then currently used by the Royal Aircraft Establishment, and letter targets, had been tried and discarded. It has been stated that the lower aspect ratio of the Cobb was preferred because it resembled the outline of a city block and hence had relevance to the analysis of bomb-damage assessment photographs. However, this does not seem a sound argument, because the analysis of such photographs would have involved images at scales well above any resolution limit. The author's recollection is that it represented a deliberate move away from the long

lines of the seven bar target because of the observed tendency of the eye to join up clumps of grains lying in the same direction, thus giving what seemed to be a spuriously high resolution in relation to the kinds of details occurring in aerial photographs. The same effect had been observed more strongly with the Sayce target. However, to adopt this argument is to look for a much closer correlation between resolution and the reproduction of real objects than seems reasonable, and although the Sayce target can be criticised on many grounds, this is not one of them.

The Cobb shape does represent about the smallest aspect ratio which has a specific directional property, and hence economises space for a given GSR. The Cobb target is normally used in Great Britain with a GSR of 0·95 (approximately $^{13}\sqrt{2}$). Sometimes it is used, rather illogically, in high contrast form for focussing, but its normal contrast ratio is 1·6 to 1. Cobb targets are manufactured on a limited scale in England, usually in low contrast. The maximum spatial frequency normally available in the target is ten cycles per mm, but the bar shape and spacing are held within close tolerance throughout the size range.

6.2.1.3 *Annulus.* The annulus target was devised by L. E. Howlett, at the National Research Council, Canada, in 1942. Its concept is entirely logical, especially for lens testing, since it combines all orientations in a single target element, and to this extent solves, by an arbitrary but sensible assumption, the problem of how best to average the differing radial and tangential resolutions. Using only one element also gives the maximum possible economy of space for a given GSR. On the other hand, the shape of the annulus makes it the most suceptible of all targets to disturbance by grain, sometimes evident in statements that it is "inaccurate". This would not be a valid complaint if many replications were made in statistically organised experiments, but resolution is rarely measured this way.

As another aspect of the same complaint, the annulus is stated to be difficult and tiring to read; here the writer cannot speak from experience. The annulus target is normally used at 1·6 to 1 contrast, So far as is known, it has never been used outside Canada, except to Canadian specifications.

6.2.1.4 *Sayce Target.* The Sayce target, originally introduced for measuring resolving power in 1940, is still used for this purpose by a few organisations, and is also used as a source of single bars for measuring single bar contrast response. As an existing target, it is convenient for the latter purpose, but for the former and original purpose there are no good arguments in its favour. The Sayce target, like some others rarely used, substitutes a continuous size progression for the usual stepped series. The spatial frequency increases by an arithmetical progression, while the aspect ratio is very large and increases with frequency.

As a device for displaying some aspects of image quality the Sayce chart can be useful, but for measuring resolving power it has no advantages and many disadvantages, not least that it occupies a great deal of space.

148

6.2.1.5 *Radial Targets.* The radial or "pie-chart" target gives very clear and impressive demonstrations of asymmetrical aberrations and image movement blur, and is extremely useful in diagnosis, especially in high contrast form. It is much less useful for measuring resolving power because of the difficulty of locating the limiting position along the radii, and of measuring the distance from the centre when the limit has been located. The full 360 degree chart is sometimes reduced to 180 degrees or less, especially in aerial photography trials at high altitude. At a ground resolution of, say, 30 feet, a full radial target can be very large and presents serious handling problems. The number of sectors is not standardised; larger numbers allow the direction of blur to be determined with greater accuracy. The radial target is also used in the photomechanical industry as a test of printer contact, and can be very effective for this.

6.2.2 WHY SO MANY TARGETS? One naturally wonders why so many targets have been designed and put into use; why could not agreement have been reached at the outset for all laboratories to use the same kind of target? The present chaotic situation has come to pass because of a confusion, and slow evolution, in the photographic user's mind, about the purpose of a resolving power test. In older and more fundamental disciplines such as spectroscopy and astronomy, the imaging tasks related to stars and spectral lines; the object of the resolution test was clear, and the targets were ready made. When photographers came to take over the test for their own purpose, they failed, for a long time, to appreciate how profoundly it was affected by the characteristics of the photographic detector. Also, they have never been quite sure whether photographic resolving power was, so to speak, a low grade version of the Rayleigh limit, or a more or less controllable stand-in for the uncontrollable and inconvenient business of testing by actual aerial photography. In fact, the test serves both purposes according to the needs of the moment, that is to say, it is used to evaluate the optical quality of a lens at one moment, then the same numbers are applied to estimate the minimum size of ground objects that can be detected. Useful as the resolution test is, it is not ideally suited to either purpose, but performs some kind of service in both. According to current ideas, emphasis has shifted from one purpose to the other. About 1940, the operational or system performance aspect came very strongly to the front. This caused a pressure away from the targets with many long bars, an apparently artificial or unrealistic type, to the more compact types such as the Cobb. For similar reasons, the contrast was lowered by what then seemed a drastic reduction. But other users, such as those in the microcopying area, naturally saw no reason to lower their target contrast, since they were concerned with copying high contrast material. Also, they would probably have felt that a multi bar target would give clearer indications of variations in optical performance. At the opposite extreme from the aerial photographer's use of the Cobb target is the physicist who measures the resolving power of an emulsion by projecting on to it interference fringes, i.e. long lines of sinusoidal distribution, covering many hundreds of times the area of a Cobb target of the same spatial frequency. The argument for this is that by averaging the grain over a large area the resolving power can be substantially increased. From the

operational point of view this not relevant, because the "resolution" may be invisible without special diffraction techniques.

In general, each target has been adopted because its promoter felt that its evaluations correlated best with his own special needs, and so long as resolution testing remains in use we are not likely to see much change in this sort of outlook. It is certainly true that different targets can place systems in different orders according to the nature and balance of their spread functions and granularity, and that the corresponding correlations with practical performance will depend upon the kind of detail to be photographed. The only question is where we stop in proliferating types of target, because no resolving power test, of any kind, can give perfect correlation with practical photography under all conditions. In modern terms, it is probably better to regard the test as establishing a practical working bandwidth for the system, rather than seek too close a correlation with operational performance. The actual form of the target then becomes of minor importance, and the majority of needs could probably be served by one form, in two contrasts. Any more detailed performance analysis than is provided by such a resolution test would then be better carried out by the more sophisticated approach of the MTF and granularity.

In attempting to agree on a universal target, one immediately runs into the problem of vested interests. All interested organisations have in their archives the results of numerous resolution tests on current and obsolete lenses or emulsions. Continuity is obviously desirable, but how can it be achieved if all but one organisation change to a different target? There are no universally applicable rules for converting resolution data from one target to another. There is no solution to this problem, except time, and one can only register the opinion that very little would be lost, in the long run, by giving up all past resolution data for the sake of future standardisation. In any case, the amount of resolution data that matters for continuity is rather small relative to the total current output used for manufacturing and operational test purposes, and the amount of redetermination needed would not be excessive.

Choice of the standard target is an equally difficult problem. In the writer's opinion based on practical experience, the USAF three bar target comes closest to the best compromise, and since the overwhelming majority of all to-day's tests are performed with this target, it seems the obvious candidate. Of course, it would be even better to design a new target based on the experience of the past thirty years.

6.3 *Factors Affecting Resolving Power*

6.3.1 GENERAL. In measuring the resolving power of a lens or camera to a given specification, basic factors such as the type of target, its nominal contrast, and the type of emulsion, will be laid down. The actual resolving power obtained can still be affected by various factors in addition to the quality of the lens. Since resolution is essentially a question of signal to noise ratio, anything that affects gamma (including adjacency effects) MTF, or granularity must be controlled if reliable and interchange-

able results are to be obtained. This includes the spectral composition of the exposing light, the kind of developer, degree of agitation and duration of development, and the exposure time so far as this affects gamma. The actual target contrast, as distinct from its nominal contrast, must be checked. The conditions of observation for reading the images should be standardized at an optimum level. It should be appreciated that the effect produced by minor deviations in some of these factors may not be demonstrable in single exposures, but will inevitably bias the results taken over a long period.

6.3.2 TARGET CONTRAST. Photographic resolving power is so sensitive to target contrast that the utmost care in contrast calibration is essential. With high contrast targets, of course, there is no problem, but in low contrast targets, a small error in density can have an appreciable effect on resolution. The actual error will depend on the slope of the MTF of the lens being tested as well as the departure from nominal density difference, but in most practical cases, as a rough general rule, a ten per cent error in target density difference will cause a five per cent change in resolving power. In practice it would not be possible to observe a five per cent change of resolving power without a rather elaborate experiment involving many exposures, but the effect would be present nevertheless, giving a general bias to the results. Ten per cent may seem a big error in density, but at a nominal density difference of $0 \cdot 2$ it is close to the probable error in any densitometer not specially calibrated. Experience shows that target contrast is one of the most serious sources of disagreement between laboratories.

In fact, it is extremely difficult to determine the true effective target contrast in any given setup. The optical path in most densitometers, e.g. diffuse incident and normal acceptance, is similar to that in collimators, but if the target material is not free from scatter it is still possible for the measured density to differ from the collimator effective density. In case of doubt the target can be replaced by a sufficiently large area of the same material, and the density difference between this and the plain glass base observed with a telephotometer from the collimator lens position. The target should also be checked with a microdensitometer, to ensure that its background density is constant over the whole area, and that the bar to background density does not decrease with decreasing bar size. The spectral transmission of the target should be checked, and allowance made if necessary for any differences between the spectral sensitivity of the densitometer or photometer and the emulsion-filter combination used in the actual resolution testing. The collimator should be checked for scattered light arising from lens surfaces, reflections from the tube, etc. In general these give little trouble, but no effort should be spared to ensure that the true effective contrast of the target is known.

It is sometimes suggested that the contrast quoted in specifications should be the contrast at the exit pupil of the collimator, but it is difficult to define what this means.

6.3.3 EXPOSURE AND PROCESSING. Exposure and processing are to some extent interdependent, since speed depends on degree of development, especially for aerial emulsions. As is well known, resolving power varies quite rapidly with exposure, there fore processing and exposure should receive equally careful control. The conditions

for processing in resolution testing should be standardised with as much attention to detail as in good sensitometry. In general the type of developer will be specified, and for aerial systems full development is usual. This helps to ensure uniform processing, but time, temperature and agitation should be controlled as accurately as possible. Strictly speaking, if the tests are for controlling lens quality, it is not essential to use the operational developer, and any development technique should be assessed with particular attention to its reliability.

Although the dependence of resolving power on exposure is so well known, surprisingly large deviations from the optimum density are often seen. To underline the importance of correct exposure, a typical example of the rate of change of resolution with density is shown in Fig. 6.2. This refers to exposures made on FP 3 Aerial film with a 3 inch f/2 reconnaissance lens; the upper points are for axial exposures, and the lower for off-axis exposures, where the peak resolution is some eight Cobb groups lower. The scatter of points is typical of the spread of resolving power in replicate readings, but the general tendency is clear enough. The exposure is quite critical for maximum resolution, and is not less critical at lower resolution off axis, as might perhaps be thought. The optimum background density, including base plus fog, is 0·8 in this example; a deviation of 0·3 towards under-exposure lowers resolution by two groups on the Cobb target (GSR—0·95). The drop is not quite so rapid, but of the same order, in the over-exposure direction.

Fig. 6.2 is sufficient indication of the importance of keeping to the correct density, but this has to be established for each emulsion. It will usually lie between 0·7 and

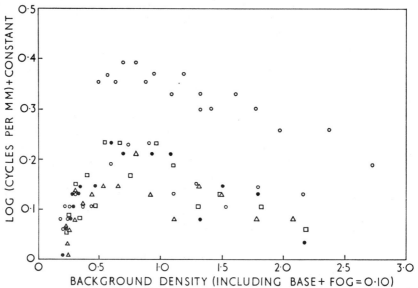

Fig. 6.2 Variation of resolving power with density for FP3 Aerial Film, developed in Teknol 0·2 Cobb target—3″ f/2 lens, 0° and 20°)

152

1·5, the higher values being found for some of the modern emulsions of very fine grain. The optimum density will also depend to some extent on the development, thus in the unlikely event of an aerial emulsion being developed to a very low gamma in a resolution test, optimum results might be found at some density lower than 0·7.

The interpretation of "optimum density" can cause confusion; where is the density to be measured? In the example of Fig. 6.2, the target was of low contrast, and the densities were measured on the background, as stated quite explicitly in British Standard 1613:1961. Some targets include an area of the same luminance as the bars, and this is useful for measuring contrast, but on the whole the background is preferable for the reference density because, unlike the bars, whose density varies with image size, it is constant. Of course, if the target is high contrast, there is no really suitable place to measure, because the background is normally at fog level, and the large area density may well be too high for accurate measurement, when using high gamma aerial films.

The sensitivity of resolution to density raises a problem with many lenses, because the illumination varies markedly across the field, and at high gamma this is translated into substantial density differences. With an axis to corner illumination ratio of 4 to 1, the resolution could vary by nearly two to one if the same exposure is given at all points in the field. Even if the density errors are shared there is still an appreciable loss of resolution. There is no unique solution to this problem; if testing a camera then the best procedure is simulate what would normally happen in aerial photography by giving constant exposure, including any anti-vignetting filter that may be fitted, and working at a compromise density levels. But if testing lenses, then the governing requirement is for the greatest accuracy in establishing performance relative to the prototype or specification. The illumination or exposure time should then be adjusted to give optimum resolution in all parts of the field.

6.4 *Reading Resolving Power*

6.4.1 GENERAL. Although the conditions of observation are not highly critical, they should be adjusted for optimum results. The most important factor, and one almost impossible to specify, is the criterion of resolution, but attention must also be paid to the conditions of illumination and the magnification. The ambient illumination should be adjusted for comfort; a dim light, neither darkness, nor bright enough for ordinary reading, is least tiring. Care should be taken to avoid any lights at a high level which might be reflected from the microscope eyepieces and reduce contrast by glare.

6.4.2 ILLUMINATION. Diffuse illumination is usually employed for moderate magnifications, up to say 40 ×. The grain of a silver image is least prominent under fully diffuse illumination, and this is the easiest condition to standardise, so it is usual to have the film strip in contact with opal glass. A field stop to eliminate the surrounding glare is desirable, the best form being an aperture in a neutral density area of about the same density as the images; this gives least trouble from ghost images in the microscope. For greater magnifications and dense images, sufficient light cannot be obtained

with an opal diffuser, and the normal substage condenser of the microscope, arranged for Kohler illumination with a controllable field stop, is best. Trouble is often encountered when reading high resolution images, of the order of 200 cycles per mm, on certain aerial films which have a "matt" backing, designed to prevent ferrotyping in the roll. The backing appears to contain small spherical particles which in some conditions of lighting and magnification cause disturbing diffraction effects and make it difficult or impossible to read resolving power. This problem does not seem to have been adequately studied, or at any rate reported. It is presumably due to an undue degree of coherency in the illumination, and can usually be overcome by attention to the condenser aperture. At low magnifications diffuse light can be used, and at very high magnifications the small depth of focus seems to eliminate the effect.

6.4.3 MAGNIFICATION. Reading resolving power in aerial films calls for a wide range of magnification, in view of the resolutions, as low as 5 or as high as 500 cycles per mm, that may be met. As mentioned earlier, the magnification for optimum resolution is of the order of half the number of cycles per mm and this always gives a good starting point. Up to about 30 cycles per mm, good magnifiers are almost as effective as a microscope, indeed some observers prefer them. In general, a microscope is essential, and some care should be taken to ensure adequate definition. The important requirement is for good image contrast at the small magnifications, $\times 100$ or less, that will be used most often. Not all microscopes, by any means, are above reproach, and it may be necessary to use a colour filter to reduce the effects of colour fringing. When a target image is on the verge of resolution, any loss of contrast in the viewing optics may just turn the scale. These remarks apply particularly to zoom microscopes. It is common, though not entirely logical, to use stereo microscopes for reading resolution. At least this gives the advantage binocular viewing, which is less tiring.

From a scientific or operational point of view, the exact figure to be put on the resolving power of a lens or system is not very important. Whether an observer reads 20 or 21 cycles per mm in a resolution test does not affect the practical performance, and a system should not be chosen on such fine distinctions. However, when accepting a lens or system, in production, to a specification, it is necessary to adopt a more legal standpoint. If a specification says 20 cycles per mm, as the minimum, it is up to the supplier to do everything possible to obtain 20 cycles on every item. This includes making quite sure that the optimum magnification is used, and for this purpose a zoom microscope can be extremely useful. Without it, there is a strong tendency to keep at one magnification, or to use a "favourite" magnifier, which may be just outside the optimum range for a particular negative. Also, when different observers consult, it is a great convenience for each to be able instantly to find the magnification that suits him best, which would probably not be done if objectives had to be changed.

Because of the great difficulty of agreeing on resolution limits, it is often suggested that optical means should be provided so that two or more observers could jointly examine the image and compare their impressions. This is quite feasible, either with projection or shared eyepiece systems, and can be useful for research and instruction

154

but cannot be advocated for routine testing. It does not solve the problems of reading resolution, for each image simply becomes the occasion for prolonged argument.

6.4.4 CRITERION OF RESOLUTION

Bernardo	:	"'Tis here"
Horatio	:	"'Tis here"
Marcellus	:	"'Tis gone"

(Hamlet, Act 1, Scene 1)

Defining criteria of resolution is a subject in which the impressions of the novice, if firmly and candidly given, and accorded a fair hearing by the entrenched "experts", could have introduced a much-needed breath of realism. An intelligent tiro, on receiving directions for reading resolving power images, and then looking down the microscope, might be forgiven a certain amount of scepticism. Unfortunately, most people are willing to believe in the superior wisdom of those with greater experience, and it is rare to find new readers who have not been conditioned to the idea that there is "a" resolving power, which they can always determine without ambiguity if only they will use the recommended criterion. Within wide limits, say plus or minus 20 per cent, this may be true, but when we try to push the figures to five or even ten per cent we immediately come into the region of opinion.

The root cause for this fundamental problem of resolving power is that no two images are exactly alike, any more than the "noisy" picture on a television screen is the same at different instants. The grosser differences are sufficiently obvious; images of the same resolving power given by a lens-limited and a grain-limited system look utterly different. Deciding that they are equivalent involves personal opinions that the target pattern is as well represented by a string of separated grains as by a smooth pattern of vanishing contrast, and there is no *a priori* reason to suppose that any definition can be framed that will eliminate personal differences. But even in the more usual case, where a lens is being tested on a given film, nominally identical exposures can look very different. What we are trying to define is the disappearance of some characteristic feature of the target pattern, and the only feature that survives is the number of bars and, more or less, their direction. Thus for a three bar target we must be able to see three "units" (we can hardly call them bars any longer) whose direction is sensibly the same as in the larger, clearly reproduced bars. Whatever the number of bars in the target pattern, that number must appear in the image for resolution to be accepted. In certain imaging conditions it is possible for a periodic structure to appear, but with an incorrect number of units, e.g. three instead of four, or two instead of three; this is not resolution. This basic criterion is unambiguous, but it remains a matter of the observer's opinion whether a distorted or broken unit is acceptable. He will vary magnification to get the most plausible effect, or may "ride" the focus through the depth of the image and concentrate the weight of the different layers in different ways. A skilled observer will do everything possible to force the

155

maximum resolution out of an image (especially if he is on the selling end of a test) but ultimately his judgement has to be guided by what can only be called rules of fair play. In general it is considered fair play to accept an image as resolved, so long as there is an arguable case that it might represent the correct number of units pointing in the right direction. Such images are very far removed from what a naïve observer might regard as resolved beyond any doubt. In between the naïve standard and the extremes of accepted standards, there is room for almost unlimited exercise of personal opinion and argument.

The differences between nominally identical images are inseparable from any situation in which a signal vanishes into noise. There is a size above which there is nearly 100 per cent probability that all images will be resolved, and a size, of the order of half that value, below which no resolution can be imagined in the images. In between is a region of uncertainty in which the probability declines, as shown by Romer and Selwyn long ago and discussed in Chapter VII. If the images were sampled by a detector of constant properties, the accuracy of resolution reading could be increased by taking a sufficient number of observations. But since the human detector varies from person to person and in one person on different occasions, and reacts on the changes in the images seen, the improvement through many replications is somewhat limited.

Over the years, numerous attempts have been made to ease these difficulties by explicit definitions, e.g. "the lines must be clearly separated throughout their lengths", or "there must be some density difference between the lines throughout their lengths". This merely puts the problem one stage further back, since no two observers are likely to agree on "clear separation" or "some density difference". Again, one is sometimes instructed to identify the lines and their separation without reference to the larger groups. The logical application of this principle would involve working from unresolved to resolved, masking out the larger groups, which does not seem to have been seriously tried. An objection to this idea is that the resolution limit is often so indefinite that it "comes and goes" as one progresses down the scale, and a final judgement often requires the observer to look at several groups in quick succession.

The conceptual difficulties in defining a criterion of resolution may be appreciated by considering the following quotation from Nelson.[1] "These two methods are called the 'pattern recognition method' and the 'line count method'. With the first method, the limiting point is the smallest pattern in which a pattern can be recognised—. The lines do not have to be intact the full length of the pattern; all that is necessary is that there be no doubt that the pattern is there—. The line count method requires the inspector to be able to see and count five separate lines with certainty—". At first sight these are excellent criteria for dealing with five bar images at two somewhat different levels of quality; one *feels* that five lines are there, and, at a higher level, one is *certain* that five lines are there. On further consideration it becomes impossible to find any difference between the two definitions. The difficulty is that one *knows* that five lines ought to be there; how can one say that a pattern of five lines can be recognised unless five complete lines can be counted? If one can do so, then the further

156

stage of seeing five intact lines is unnecessary. In his further analysis, Nelson indicates the difficulty of defining the difference between "a hint of five lines" and "five good lines".

In attempting to cope with the same sort of philosophical difficulty (akin to H. G. Wells' complaint that if a door was clearly not open he could only say that it was shut) the American Standards Association has tentatively proposed as a criterion of resolution that "the number of bars could be counted with reasonable confidence even if the number were not known—". The authors then get around the obvious difficulty that it always is known, by defining "reasonable confidence" as a level of confidence halfway between full confidence and no confidence at all. This is not so nebulous as might appear; in the standard it is explained in terms of *a priori* and *a posteriori* probabilities. It is assumed that the exposures *may* have been made with, say, a three bar target, or *may* have been made with some other target, the *a priori* probability for either kind being typically 50 per cent. After examining the image, an estimate is made of the *a posteriori* probability that the three bar target was used; if this probability is above 70 to 80 per cent, the image is considered resolved. How the observer arrives at his estimates of percentage *a posteriori* probabilities is not explained, but whatever he does would still appear to involve personal opinions.

In practice one often finds that resolution ceases at a certain group, then reappears two or more groups further down. This is sometimes called "spurious resolution", but must be distinguished from the genuine spurious resolution associated with a phase change in the OTF, notably with severe image movement. The reappearance now referred to is due to the granularity fortuitously suppressing resolution at a certain size and permitting or enhancing it at a smaller size. Of course, given sufficient replications, this would be seen merely as an aspect of the probabilities. The effect is more likely to be seen when the GSR is small, there being then less chance of moving from a high to a low probability region with a step of one group. It also seems to be more common with the squat shape of the Cobb target than with longer bars, no doubt because a random grain clump has a greater chance of being accepted as a Cobb bar. From such considerations, and also based on direct experimental evidence, it seems best to use a resolution criterion which does not push recognition too far into the grain. A criterion which accepts anything remotely resembling the pattern, no matter how many previous groups are unresolved, runs considerable risk of random error. Therefore it is felt that that the recommendation of the American Standards Association, that no group be considered resolved unless all preceding groups are resolved, should be adopted. It is implicit that several replications are made, but this applies to all serious resolution testing. A suggested criterion would therefore be:

"A target element is considered resolved if the correct number of bar units, in the correct orientation, can be distinguished. No element shall be considered resolved unless the next larger element is resolved."

It is well appreciated that to state this criterion does not solve the problems of using it. The criterion explains what one *aims* to do, but beyond a certain point there has to be a straining of the imagination, which cannot be defined. Instruction in reading

resolution can proceed rapidly through the novice stage, but given a necessary minimum of experience and agreement on a criterion, all observers are equal, there is no absolute right or wrong.

6.4.5 PRESENTATION OF RESULTS. Lens or camera resolving power is normally presented as a graph showing the variation of resolving power, R, as a function of field angle, θ. As always, it is desirable to have a tabulation even if a graph is shown, so that users of the data do not have the labour and error involved in interpolations from small scale diagrams. Lenses are nominally rotationally symmetrical, but errors in centring and departures of the mechanical axis from the optical axis are nearly always present, and it is desirable to make measurements along several meridians. The OTF is of course far more sensitive than resolving power to the presence of such errors.

In assessing a new design, some weighting of the R variation over the picture area is necessary. The AWAR method of the American Mil. Standard 150 considers the format to be overlaid by annuli whose boundaries lie at angles midway between the angles at which resolution has been measured, the effective area of the annuli being that part lying within the format area. The resolution for each angle is multiplied by the effective area for its annulus, and the AWAR is the sum of the products. Since the radial and tangential resolutions are different off-axis, they are averaged to obtain a single value for each angle. Ideas differ on the best way to average, some maintaining that the geometric mean is best, and others advocating the lower figure as the best indication of image quality. When there is little difference between the two there is also little difference between the arithmetic and geometric means; when there is a big difference it is very apparent in the "streaky" appearance of the images, which is so objectionable that it is probably best to use the lower value. Much of the superiority of the new breed of mapping lenses lies in the relative symmetry of their point images off-axis, as compared to the older lenses, and this is best brought out by using the lower figure. However, the formal definition of the AWAR is based on the geometric mean, but using the arithmetic mean if the ratio of the two resolutions is less than 2 to 1.

$$\text{AWAR} = \sum \frac{A_i}{A} \sqrt{R_i T_i}$$

A $=$ format area
$A_i =$ area of an annulus
$R_i =$ radial resolution for annulus mid-point
$T_i =$ tangential resolution for annulus mid-point.

The AWAR method is widely used in the United States, but lenses are rarely judged solely by the AWAR, in spite of its logic. Users always like to see resolution as a function of field angle, but there is always a danger of being overimpressed by a high axial performance. If one believes in resolving power at all, he must logically base the choice

158

of a lens on its AWAR. An incidental advantage is that since numerous exposures are required, the inevitable errors of resolution testing tend to average out, and the overall result has some chance of being a fair estimate of the performance of the lens.

References

[1] NELSON, *Microfilm Technology*. McGraw Hill.

VII NATURE AND ACCURACY
OF RESOLVING POWER MEASUREMENTS

7.1 *Introduction*

Measuring "the" resolving power of a photographic system is essentially an impossible task. Even when every effort has been made to standardise critical factors such as contrast, we are left with the fundamental difficulty that each image in a nominally identical set of exposures differs from its fellows in the statistical distribution of the grains that make it up, while each observer will interpret these differences in his own way. The best that can be done, in ideal circumstances, is to make a large number of replicate exposures, each being interpreted according to the agreed rules in the particular community, and the results presented as a "mean" or most probable resolving power, with standard deviation. In general it is not economically practicable to work in this way. Too few exposures are made for statistical analysis, and unwarranted faith is placed in the numbers. Disappointment then results when laboratories cannot agree.

In view of these remarks, the enormous output of resolution data, especially in aerial photography, and the economic importance of the decisions based upon them, it may be wondered why so little attention has been given to accuracy. While some studies have been made, they have not been well publicised, and the effort has been small in relation to the magnitude of the problem. One reason for this neglect is that any adequate study would be tedious, and would not be considered sufficiently interesting for scientific publication, especially in view of the unfashionable nature of resolving power, whose early demise has been predicted for so long. Also, it is fairly certain that such investigations would not lead to any way of increasing the accuracy of resolving power without additional labour. In general, scientific publications tend to come from people concerned with establishing basic principles rather than with apparently petty detail. Much of the early (and very excellent) work on the mechanism of resolving power was of a basic nature. Accuracies that appeared perfectly adequate under limited quasi-academic conditions were not sustained when the test moved out on to the factory floor and agreement between different organisations was required for the numerous applications of resolving power in photographic engineering. The lack of any discussion of the errors of resolving power measurement in the writer's previous book, which appeared in 1952 (and was written in 1947) exemplifies the inadequate appreciation, at that time, of problems which in subsequent experience have caused endless trouble through a general failure to understand their significance.

If resolving power were universally regarded in the only reasonable way, as a broad indication of the performance of a system, capable of reasonable precision within any group of observers, but not capable of high accuracy, and in any case not suitable for specifying the performance of lenses to any better accuracy than ten per cent or

160

thereabouts, there would be little need for the discussions in this chapter. However, to show that discussion is needed, let us recall that lenses and cameras are regularly purchased on the basis of resolving power tests. Items may be accepted or rejected on the evidence of a ten or even five per cent deviation from a nominal figure, often in a limited number of observations, or only one observation, in circumstances where the standard deviation is ten per cent or so, even for one observer. Adequate precautions are rarely taken to provide for observer variations. Of course, the "subjective" nature of resolving power is widely proclaimed, but this does not seem to be appreciated when using resolution as an acceptance test.

The errors that afflict resolving power can be broadly divided into two classes, those that affect the formation of the photographic image and are potentially controllable, and those inherent in the nature of the test, about which little can be done. The controllable factors, such as target contrast, have been mentioned in the last chapter; before discussing the uncontrollable ones it is as well to clarify our interpretation of the term "accuracy".

In general and much scientific usage, "accuracy" and "precision" are employed amost interchangeably, with a broad meaning that needs no explanation. In studies of the errors of observation, however, the words are used in a more restricted sense. Precision expresses the spread about the average in repeated determinations of a quantity. Accuracy is concerned with departures from a "true" value, knowledge of which depends on analysis of systematic errors and is often hard to come by. In the measurement of physical quantities it is not unknown for two laboratories to produce results which differ by more than can be accounted for by an analysis of the precisions; the inference is then that some unrealised systematic error in one or both determinations has caused a departure of the best-estimated values from the true value, which will again be sought after a more rigorous study of the experimental procedures. Unfortunately, photographic resolving power is not in this class of measurement; it is ultimately a matter of personal interpretation, no matter how closely the rules have been defined, and there never is a "true" value, just over the horizon. This causes serious problems when resolving power is used for control purposes, e.g. acceptance of lenses to a specification. To achieve and maintain reasonable agreement between the parties, very close personal liaison is essential; written rules are necessary but not sufficient.

7.2 The Nature of Resolving Power Measurements

> *"Believing is seeing"* Lowenstein. (*The Senses*)

The significance of the numbers that come from a resolving power test is often overemphasised because the nature of resolving power and resolution limits are not properly appreciated. We can clarify this statement by an analogy.

161

Consider the measurement of voltage across a resistor through which a perfectly steady current is flowing, the level being well clear of thermal noise and other random fluctuations. If the voltage is recorded on a digital instrument, then all observers will agree that the displayed figure is, say, 10·1 volts; no one will say that it is 10·0 or 10·2 volts. Also, no matter when we make the reading, it will always be 10·1. Now increase the accuracy of the instrument to include more significant figures; the display may then read, say, 10·1001 volts at a particular instant, but 10·1002, etc., at other instants, due to minor circuit fluctuations. Nevertheless, at any instant all observers will read the same voltage, there is no possibility of disagreement, because opinion does not enter into the situation. Again, consider a mechanical gauging test. We are offered a rod exactly one inch in diameter, and a plate with holes 2 inches, 1·01 inches, and 0·5 inch in diameter, and asked to select the hole which accepts the rod with least sideplay. In this case opinion plays some part, but again there is no possibility of disagreement; all observers must reach the same conclusion.

Reading resolving power is not like this. We are not noting numbers on a scale, or solving a sole-solution puzzle, but forming our personal judgement as to where, in a descending scale of size, the essential nature of the unit pattern can no longer be discerned against the distractions of the background in which it is embedded.

What is the "essential nature" of the pattern in, say, the image of a three bar target? It is not the intensity-distribution of the target, for this is degraded to a quasi-sinusoidal form at sizes well above the resolution limit. It is not the original contrast, for obvious reasons. It is not an unbroken sinusoidal structure of three elements, because the grain breaks up this structure. Thus we can eliminate every characteristic of the original target structure but its threefold nature and the direction of its three parallel—. Parallel what? Not bars any longer. Barrel shapes, ovals, flares to one side or other, asymmetric distributions of all kinds, clusters of grains lying roughly in the right direction; considering all combinations of aberrations, grain, gamma, target contrast, image motion, etc., the variety of image appearances is almost infinite. At least we can agree that the direction must be correct. This is essential, because it is not unknown to find three "bars" clearly resolved but pointing at right angles to the correct direction, or even to find that the apparent direction of the bars changes with magnification. While such extreme cases are often freaks of the grain statistics, where do we draw the line? At the least detectable error of direction? But what is least detectable, when there are no clean edges from which to judge?

The efforts made to lay down rules for reading resolution images are useful up to a point, for example they narrow the range of sizes within which reading will be attempted, and they help to avoid disagreements due to spurious resolution, but in the end we have to fall back upon our personal opinion. Controlled experiments show beyond doubt that any observer's opinion will vary from time to time, and will not necessarily agree with any other observer's. It is common to find, in random presentations of replicate resolution test exposures A, B, C, D, etc.—, that the difference between, say, B and C is recorded by one observer as a decrease and by another as an increase. Likewise, either observer may reverse his opinion as to the relative order of B and C

on another presentation. This does not occur with much of the material commonly handled by statisticians; there is never any disagreement that a lamp has failed, or about the numbers of births, deaths, or natural disasters.

All of this shows that reading resolving power calls for decisions quite different from those involved in making scale readings or counting units. Most resolution images are finally limited by grain, so that essentially we are trying to recover, or force ourselves to recover, a familiar pattern in a jumble of "noise". Perhaps psychologists would say that we have a Gestalt of the three bar target, which we use as a mental reference. At any rate, we have the concept of an ordered arrangement, which we try to detect within a chaos of random luminance variations. As Gregory[1] remarks, on a similar theme, "If the brain were not continually on the lookout for objects, the cartoonist would have a hard time". An analogy can also be found in our contemplation of some modern paintings. At first we see nothing but a meaningless jumble of colour, shape and tone; the canvas is without form, and void. Then, as we continue our struggle, we may suddenly recognise familiar, if distorted, objects; an eye in one corner, half an egg in another, part of a nose somewhere else, and so on. Depending on the artist's skill in obscuring his message, we may even find some overall pattern or meaning in the picture as a whole, while still remaining aware of the all-pervading chaos. Here we see the remarkable human faculty for latching on to the meaningful elements in a chaotic presentation, seeing the wood and the trees together yet separate. Something like this clearly goes on when we read resolution in a grain limited case. When the grain plays no part, which is very unusual, the analogy is less obvious: the noise threshold in such cases lies largely within our visual system, and we are conscious of its as a fluctuation in detection sensitivity for an apparently smooth and constant image. Electrical engineers are familiar with a similar situation in the audio field, defined by Cherry as the "Cocktail Party Effect". A pair of guests entering a cocktail party are subjected to a formless chaos of sound at a high level, roughly describable as white noise, against which it might be thought that vocal communication was impossible. The sound pressure from the partners' own voices may be very little, if at all, above the random local pressure variations, indeed a microphone placed between them may fail to record anything but noise when they speak, yet the miraculous human skill in extracting the wanted and ordered signals enables them to understand each other (albeit with difficulty) and even to recognise familiar voices across the room.

It is only to be expected that observers will differ in this kind of ability; in our analogies, one guest will be more worried than another by the noise, one observer will seen an eye in the painting where another can detach no familiar form from the chaos. Similarly, as we approach the resolution limit, with the triple something vanishing into grain, some observers are more adept than others at holding on to their three-bar Gestalt. One will honestly believe that the clumps of grain can be connected up to form the triplicity, another cannot bring himself to this point. Such effects are not be be confused with those due to use of too much or too little magnification; they are genuine subjective differences between people, and in one person on different occasions.

They may be regarded as individual variations on a general tendency to order

observed facts into familiar patterns, thus reducing the number of situations to be dealt with (e.g. "the man in the moon"). Our particular human physiology achieves particular and rather remarkable results in pattern recognition, but it does not follow that all physiologies would work in quite the same way. Lowenstein states that insects cannot distinguish three bar targets from open squares. It is an interesting reflection that Martians would not necessarily obtain the same results as we do in reading resolving power from grainy images, though they would inevitably agree (within experimental error) with our measurements of granularity or the MTF. From this point of view, the frequent suggestion that resolving power could be measured with greater accuracy by physical scanning of the images is seen to have little value; whatever was then measured would not be resolving power as at present understood. (In fact, it is often easier to decide that a compact object such as a three bar target is resolved, or not resolved, from a visual inspection than from a noisy microdensitometer trace. On the other hand, when the image consists of many long lines, the microdensitometer or equivalent can often detect a pattern when nothing at all is visible to the eye.)

The influence of the three bar Gestalt is sometimes apparent in curious ways. Thus, many observers find that their opinion on a resolution limit, quite definite in the first few moments of observation, becomes much less positive on more prolonged study, "to make quite sure". Frequently, the result of a more considered inspection is to set back the resolution limit by one or more groups from that accepted in the first glance. Sometimes, masking out the larger images leads to the opinion that the already-chosen group is not, after all, resolved. As might be expected, sellers of lenses will genuinely believe that they see resolution in images where buyers can find no trace of a pattern.

In agreement with these remarks, reading resolution is not an occupation in which training will bring readers up to a common level of ability, so that they will agree in all situations. Where opinion plays so large a part, intelligence is hardly a factor, given sufficient to permit understanding of, and agreement on, the basic rules. But once this requirement is met, highly trained engineers with a lifetime of experience do not achieve more consistent reading than comparative newcomers. They may even do worse through their stronger technical conscience and greater awareness of the problems and pitfalls.

So far we have emphasised the subjective sources of error in reading resolving power, but these are inextricably mixed up with the differences that occur among nominally identical images, due to arbitrary alteration of the bar to space contrast and breakup of the outlines by the random density changes of the granularity. Although the image and grain are not separable, one can have the concept of an image without grain, but degraded by the lens and emulsion MTF's, plus an added noise due to the granularity of a uniformly fogged area of film developed to the appropriate density. If one physically imitates this concept by superimposing the appropriately produced negatives (Plate 4), the profound effect of the granularity is quite surprising. It does not seem reasonable that so great an effect on resolution can be produced by local random density variations on such an apparently small scale. Possibly the intensity of

the effect is associated with a phenomenon similar to that observed with additive colour materials. The Autochrome plate was three-colour additive, the colours being analysed and synthesised by a mosaic of dyed starch grains strewn at random on a sticky varnish, over which the emulsion was coated. The Dufaycolour process used a regular mosaic of ruled lines and squares, which were much larger than the starch grains. Nevertheless, the Dufay mosaic was less visible, because it was not subject to the laws of chance which made it inevitable that here and there large numbers of starch grains, all of one colour, would fall adjacent to each other in chains or clumps. These larger agglomerations were easily visible and gave the unpleasant coloured granular effect. In similar fashion, the random agglomeration of groups of larger grains may break up a resolution image more seriously than would be expected from a casual impression of the overall pattern of the grain. Such effects may work either against or in favour of decision in reading the resolution limit. In a series of nominally identical exposures, in which observers may differ by four groups for most members of the series, certain exposures are sometimes found on which all observers agree, and any one observer will consistently repeat his readings in random presentations. Possibly, in these cases, the random grain clumps have fallen in a favourable way to extinguish resolution very positively after a certain group, with no interference on the larger groups. In the opposite case, the clumping may suppress resolution or make it doubtful at a certain point, then aid it at a smaller group or perhaps for several smaller groups in succession; resolution is then indefinite and observers are liable to disagree. This effect would be expected especially in grainy images, with a slowly falling MTF, and when using targets in which the group size ratio is small. In the writer's experience, the most definite resolution readings have certainly been obtained with "well-behaved" images on fine grained emulsions, with the limit set by a sharply falling MTF.

While our account of these phenomena is far from complete, enough has been said to show that reading resolving power is fundamentally different from reading numbers on a digital scale, or even taking readings off an analogue scale. The resolution limit is not something definite and universally agreeable; it is a personal opinion, often reached with great difficulty, that the basic target pattern loses its identity at a certain image size. This does not mean that the resolution test is useless, but simply that its results should be treated with caution and due regard for the precision that is inherently possible.

7.3 *The Significance and Application of Resolving Power Figures*

7.3.1 USING THE NUMBERS. The inherent limitations on the accuracy and precision of resolving power suggest that caution should always be used in applying the figures, either to estimate the suitability of a lens or system, or to accept or reject one unit of a production set for which a specification exists. Resolving power has been used for many years in such applications; there is no reason why it should not continue to be

used when for various reasons better techniques may not be practicable, but too much should not be expected, and the limitations should always be borne in mind. Acceptance tests should always be designed to take account of the likely precision, and the figures should not be regarded as the sole indicator of the image quality of the system. Unfortunately these principles have not been generally observed, and it is common for more weight or significance to be laid on the numbers that emerge from a resolution test than the precision or accuracy of the observations can justify. The tendency to state quite unrealistic tolerance seems to be increasing, and some amplification of the basic principles appears to be worth attempting.

Two different aspects of this problem require consideration: first, to what extent are we justified in using the resolving power figure as the sole criterion of imaging performance; second, how ought we to apply the figures, having regard to the precision of the measurement? The first question may seem illogical, for if the object of the exercise is to produce a figure, what more should be attempted? In a legal sense, this attitude is correct, but it sometimes conceals useful information. The usual fate of resolving power figures is to go into reports which are used to make decisions, by people who have not seen the images in question. Thus the figures, rather than the images, become the object of discussion. This is natural and inevitable, and would not matter if the figures enshrined everything that could be said about the images. (Quite apart from the fact that that they may not be the most truly representative figures.) However, as every tester knows, there are qualities of images which cannot be put into the single resolving power figure. It is well known that different kinds of aberration, or different balance of grain and MTF, can result in images which have the same resolution yet look quite different. This is the larger question, which is discussed in another chapter. Our present argument is related to the more restricted case, in which we are testing a series of lenses of the same type, so that for a given aperture and field position the images should be substantially the same. In practice, as every observer has experienced, among such images, for which he can do no other than record the same resolving power, some may be inferior or superior to the general run, by small but unmistakable amounts. Such differences are very difficult to describe, and are sometimes noted by the reader as "a good (or poor) 50 cycles per mm"; a "soft core (or hard core) image", and so on. The better images are often characterised by a well defined resolution limit and good agreement between observers, while the poorer images have a rather indefinite end-point and observers tend to disagree. In fact, the occurrence of unusual disagreement is sometimes taken as an indication of a poor lens, whatever the resolving power figure may say. In general a minimum resolution, even if the mean of many replications, is not a sufficient indication of acceptable image quality for accepting a lens; the observer may have mental reservations based upon his visual impressions, yet he cannot project these into the reported figures. Such quality differences must have their origin in physical causes. Although resolving power is largely affected by the lens MTF in the region of the dominant target frequency, the broad spectrum of bar targets leaves scope for differences of sharpness or contrast to be caused by local elevations or depressions of the MTF within the bandwidth, even

166

though the resolution may remain much the same. It is rarely practicable to stop and follow up such observations, yet useful information about the image quality slips through the net and does not appear in the report. It is not suggested that there is any way round this problem, which will always exist so long as we attempt to summarise image quality by one number. In any case, it is not significant when selecting a lens for a new system, because in that case we are looking for quite substantial improvements, but it is frequently the source of doubts when a lens is marginally acceptable on a production specification.

Turning now to the second question, what precautions are necessary when applying resolution figures, assuming that we put all our trust in them? To some extent this is a matter of common sense, not, unfortunately, too commonly applied. It should be obvious that, considering the wide range of resolving powers used in aerial photography, a significant change at any point on this wide scale will be represented by a constant fraction of the nominal figure accepted for any application. While this general statement might be subject to qualification when dealing with systems having substantially different balance of grain and aberration, it seems entirely logical that the relative effect on practical image quality of a change from, say 10 to 11 cycles per mm, should be the same as that of a change from 100 to 110 cycles per mm. One would not expect a change from 100 to 101 cycles per mm to have any noticeable effect. (It would be difficult to measure such a difference, seeing that the standard deviation for single exposures is in the order of ten per cent.) If one required any further justification, it would only be necessary to remember the results of various experiments on subjective image quality, in which a constant fractional change of resolving power at any point on a wide range corresponded to a just detectable change of picture quality at each such point.

Yet it is not unusual to find resolving power being discussed in terms that would require accuracies much better than ten per cent, and arguments in which one or two cycles per mm are debated with reference to a nominal figure of, say, one hundred cycles per mm. Such requirements for an unattainable precision and accuracy might be a little more realistic if accompanied by an insistence on an adequate number of exposures and a statistical analysis, but this is rarely done. In any case, there is a natural limit to the accuracy that should be expected. If, to achieve even a five per cent error one has to make thirty exposures, then, apart from the economic problem, one must appreciate that in practice there will be little chance of seeing any difference between lenses differing by such a small amount. Of course, one cannot dogmatically exclude all chance of seeing any difference in the pictures, because any appreciable area of a picture, on which the image quality is judged, will be much larger than the area of a single resolving power group. At 10 cycles per mm the Cobb target covers about $0 \cdot 1$ square mm, whereas a picture of this resolution will normally be examined over at least one square mm. Thus the picture is equivalent to the average of one hundred or more resolution test exposures, and may show differences which could not be reliably predicted from any one of them; this is purely a matter of luck with the grain statistics.

7.3.2 INTERPOLATION. Observers often feel a need to interpolate between groups; they may have a "good" resolution at group n, but group n + 1 is not resolved, and it is tempting to feel that the true resolution limit is halfway between n and n + 1. This feeling would only be justifiable if resolution were a smooth function of size, but in most cases the apparently good image at group n is a fortuitous appearance due to the luck of the granularity draw. Another nominally identical replicate might put the limit much less definitely at n, or even plus or minus two groups from n. In fact, the analogy with interpolating between scale divisions when measuring a length is not good.

In the length measurement the scale divisions and the object measured have definite locations, the object is quite clearly between two divisions and we have some idea of its location on an imaginary scale of subdivisions. When estimating a resolution limit we rarely have this kind of confidence; the coincidence of the limit with any group is usually subject to some doubt, and interpolation is hardly justified. Of course, if the group size ratio is large, say $\sqrt[2]{2}$, or more, the situation is different. Usually, however, the ratio is small enough that one's confidence in the location of the limit is subject to some uncertainty. In other words, the scale is already subdivided as finely as is necessary for the task, and interpolation is no more than guesswork, introducing another unknown factor.

7.3.3 AVERAGES AND SPREADS. In reading the target images the unit of measurement is the group. When comparing two lenses, all one knows is that they differ from each other or from the specification figure by a certain number of groups. Preferably, however, there will be several replicate exposures; does one then perform the averaging by groups or by cycles per mm? Again, which of the well-known measures of central tendency does one use, the mean, the median, or the mode?

The mode, being simply the most frequently occurring value, is convenient when we need a quick impression of the central tendency of our group of observations, especially if we work in group numbers rather than cycles per mm. The observations are recorded in the form of a scatter diagram, as in Fig. 7.1. The group number as read from each exposure is entered as a stroke in the appropriate row, every fifth stroke being drawn horizontally to mark a block of five. This example represents the measurement of axial resolving power for a three inch focal length reconnaissance lens, working at f/2, on FP 3 Aerial film. Nineteen replicate exposures were made, and were read by one observer in eight separate sessions. The first set of four sessions took place during two days, and the second set also within two days, two weeks after the first set. The negatives were presented to the reader in a different random order at each session. The target was the low contrast Cobb, with 0·95 group size interval.

Fig. 7.1 shows that the mode is not always well defined, and its location differs in the separate reading sessions. In the totalled readings in the last column there is a wide spread for both sets, but a more clearly defined mode for the second set. Such observations about the mode can be made very quickly from a scatter diagram, since there are no arithmetical calculations, and in many cases this is all the averaging required. The

168

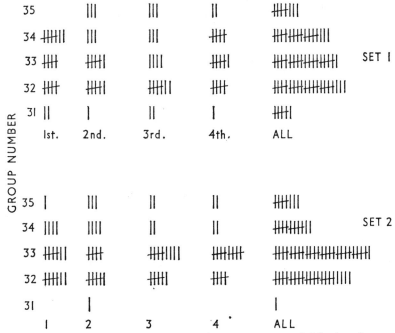

Fig. 7.1 Scatter diagram for resolving power. 19 replicate exposures read eight times by one observer

modal group number will usually be translated into cycles per mm, of course, after it has been found from the diagram.

Some authorities on resolving power advocate the median, which is defined as the value, in an ordered set of quantities, above and below which an equal number of the quantities will be found. Thus in the set: 32, 32, 32, 33, 33, 33, 33, 34, 34; the median is the underlined 33. In this case 33 would also be the mode, but in general the median and the mode are different. (They coincide for a symmetrical, Gaussian, distribution.) In the first column of the upper row of Fig. 7.1 the median is 33 but the mode is 34. In the last column of the second row the median and mode are both 33, this being a more symmetrical distribution. Since the median cannot be seen at a glance, and offers no obvious advantage over the mode, one may conclude that the mode is more generally useful.

When we wish to go beyond the summary of a single number, and present concise information about the spread of observations around the measure of central tendency, the arithmetic mean must first be calculated. As is well known, the arithmetic mean is the sum of all the quantities divided by the number of quantities. This is straight-forward when we can go direct from the observation to the calculation based upon it, as with births, marriages and deaths. In reading resolving power, however, we observe sizes, record group numbers and present results as cycles per mm. When we need the arithmetic average, ought we to average by group numbers, cycles per mm or

169

size, converting the first and last to cycles per mm after averaging? Clearly it would not be strictly correct to average group numbers, which are on a logarithmic scale, and then convert the average. Fortunately it happens that the differences are trivial, whichever averaging procedure we use, for the usual spread of figures. Taking the 76 readings in the lower part of Fig. 7.1, the mean cycles per mm is 26·1 if the group numbers are converted to cycles per mm before averaging, and 26·7 if averaged by group numbers and converted afterwards.

The precision of observations is commonly expressed by the standard deviation, which is a widely understood parameter, providing the basis for many further calculations. In particular it enables us to estimate the confidence which can be placed in our results. However, the justification for using the standard deviation, at least in any simple way, is less clear for the very small number of observations usually made in resolving power tests, and also when the distribution departs markedly from Gaussian symmetry, which is often the case in resolution testing. The choice between group numbers and cycles per mm again raises problems. At first sight the linear scale of numbers offered in effect by cycles per mm seems appropriate to statistical calculations. On the other hand, the unit of reading is certainly the group; all one knows from observation is that the resolution falls in this group or that, and though the group scale is logarithmic it is quasi-linear in its subjective effect.

Some degree of skewness is usually observed in the distribution of a set of resolving power readings, but experience does not suggest any general tendency to either positive or negative skewness. Skewness is certainly shown when the totalled data of Fig. 7.1 are presented as histograms, in Fig. 7.2. In Fig. 7.2a, the bars are centred on group numbers. In Fig. 7.2b the bar limits are located at the change from one group to the next, thus group 30 is deemed to extend from 28·4 to 30·0 cycles per mm. The bars therefore become wider with increasing resolution, thus accentuating by a few per cent the inherent positive skewness of the diagram. According to one's outlook, this can emphasise the feeling of unreality in presenting such diagrams on a base of cycles per mm; intuitively, the plot by group numbers is felt to be realistic.

In spite of the problems of mathematical rigour, there is a greet need for some parameter to express the spread of resolving power readings, and the standard deviation will be invoked to some extent in these pages. There is scope for a thorough study, however, by a professional statistician.

7.3.4 GROUP SIZE RATIO. In a resolving power target, the size of the bars decreases from each group to the next in a uniform geometrical progression, defined by the group size ratio. (GSR) The earlier targets had fairly large GSR's such as $\sqrt[4]{2}$. This was adequate for demonstrating the approximate resolution limits of emulsions, but was felt to be inadequate when resolving power came into general use as an acceptance test for lenses and an aid to system design. It is natural to feel that finer steps will give greater accuracy, and obvious that there is a limit to the practicable subdivision, but it is not easy to locate the point of diminishing returns. One practical consideration is that with too small a GSR the target becomes unduly large for a given range of

170

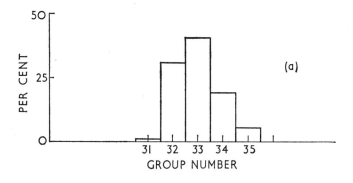

(a)

PER CENT

50

25

O

31 32 33 34 35

GROUP NUMBER

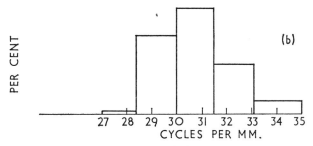

(b)

PER CENT

27 28 29 30 31 32 33 34 35

CYCLES PER MM.

Fig. 7.2 Histograms for data of Fig

resolution. An interesting question is whether one can achieve a greater accuracy for a given area of target by having many groups all the same size, allowing more replications at each exposure, or only one group at each of a closely spaced set of sizes. If many observations are to be made, it might be argued that the GSR should then be small, otherwise all readings will tend to cluster in one or other of two groups and statistical analysis will not be possible. When only a few readings, or one reading, will be made, it might be better to use a large GSR for the sake of more positive if less precise reading. It would be difficult to produce a universally correct answer to such questions. For example, the optimum GSR for grain limited resolution would probably be larger than for grainless images, because in the former case the grain statistics inevitably cause a wider spread in the readings.

With the lack (or at any rate the inaccessibility) of satisfactory evidence, preference for GSR's is largely a matter of personal opinion. Standard GSR's currently used in aerial photography are $0 \cdot 95$ ($^{13}\sqrt{2}$) for the Cobb target, and $0 \cdot 88$ ($\sqrt[6]{2}$) for the USAF three-bar target. Bigger steps are often used in flight testing when the number and area of targets has to be kept to a minimum. The writer regards the GSR of the USAF target as the smallest desirable for general use, but many others feel that the closer steps of the Cobb are preferable. It is sometimes claimed that the true resolution limit

lies between two groups on the target, and that with more steps one could locate it with certainty. As already mentioned, there is little substance to this feeling. The contrary argument is that one can rarely locate a resolution limit with complete certainty, and is often undecided over a range of plus or minus one $(^{13}\sqrt{2}$ step; adding more steps then merely adds to the confusion and causes a sense of frustration, which with the greater reading time lowers accuracy. In general the measuring instrument should be matched to the task; no one would try to measure the length of a raggedly sawn plank with a millimetre scale, because individual settings would differ by more than one millimetre, yet it is not unknown to hear suggestions for reducing GSR's to figures such as $^{20}\sqrt{2}$, in spite of the common experience that repeat readings of any image may differ by two or more $\sqrt[6]{2}$ steps. At present there is no agreed solution to this problem, which should certainly be investigated if resolving power tests are to remain in use.

7.4 *Some Fundamental Factors Affecting Precision*

In earlier sections of this chapter we referred to the subjectivity of resolving power reading, largely associated with personal interpretations of images in grain. That discussion raised questions without answering any of them in quantitative terms. In the next section we shall review some specific practical examples in a quantitative way, but as a background we shall now briefly examine the limitations on reading accuracy imposed by the grain, as demonstrated many years ago by Romer and Selwyn.[2] The Romer-Selwyn paper dealt primarily with a method for measuring graininess by its subjective suppression of resolution; the accuracy of reading resolution in grainy images was a side issue and has not been adequately appreciated.

In this study, the target images were equally sharp and of constant contrast at all spatial frequencies, and in themselves were grainless, but they were projected in focus with an appropriately enlarged image of the grain in a uniformly exposed area of film. The targets contained ten low contrast Cobb groups at each size, the GSR being 0·9. At some image size, resolution was extinguished by the random grain noise, but the actual limiting size depended upon the relative location of the target image and grain pattern, because of the statistical variation in the latter. At each size, the observer recorded the number of groups he could resolve, which in general was less than ten. However, at some large size all groups were resolved, then with decreasing size the percentage resolved began to fall, slowly at first, then more rapidly, then more slowly again, after the 50 per cent point had been passed. The normalised results, taken over a wide range of granularities, are shown by the curve in Fig. 7.3. The significance of this for reading resolution needs no emphasis. The steepest slope is near 50 per cent probability, hence the resolution limit is best defined in terms of this. However, many exposures are obviously required to locate the point. Single exposures could, by chance, fall anywhere between, say, the 10 per cent and 90 per cent points. There is, of course, an increasing chance that a single exposure will be resolved or not resolved,

respectively, as we move above or below the image size for 50 per cent probability; nevertheless, chance obviously plays a large part in determining resolution over a wide range of sizes. The actual size range between ten and ninety per cent is about 2·2 to 1, i.e. about 17 groups on the Cobb target, or seven on the USAF target.

Fortunately this rather terrifying picture is not the whole story. In practice the target images are not constant in shape or contrast, they degrade with decreasing size, through the operation of the system MTF's. It is not easy to predict with any accuracy just how the basic probability curve of Fig. 7.3 will be modified by the MTF. Clearly the

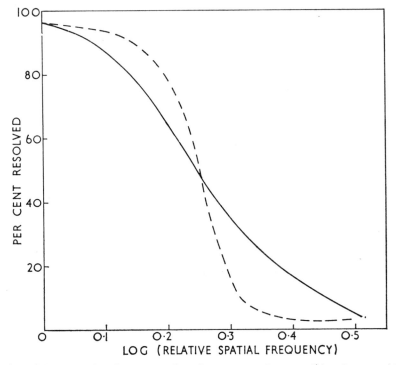

Fig. 7.3 Probability curve for obscuration of resolution targets by grain. (After Romer and Selwyn)

change will be in the general direction shown by the broken curve in Fig. 7.3, but the displacement in any given case will depend on the actual slope of the MTF, the contrast required for resolution at specific grain levels, and other largely unknown factors. Moreover, the Romer-Selwyn experiment imitates the effect of grain, but does not necessarily correspond in all respects to the real situation, in which grain and image are indissoluble.

We can get some feeling for the situation when MTF's are involved, by devising a model for a specific case. A high grade lens, whose MTF is known, images a three-bar target of 2 to 1 contrast (0·33 modulation) on 3404 film, whose gamma, MTF and

173

granularity are known from published data. First, assuming a complete absence of grain in the developed image, we derive, from the MTF's, gamma and target modulation, the average density modulation across the image at several spatial frequencies. At 120 cycles per mm, for example, the density modulation is found to be 0·099. This is shown, centred on a mean density of 1·0, to correct density scale, in the left hand side of Fig. 7.4a. The sinusoidal shape of the image is schematic only; in reality the central bar image would be somewhat higher than the outer images. With increasing spatial frequency, the average density modulation falls, as shown by the upper curve in Fig. 7.4b. The R.M.S. granularity is calculated for each spatial frequency, assuming a scanning aperture having the area of one bar at image scale; the increase of R.M.S. granularity with spatial frequency is shown by the lower curve in Fig. 7.4b. The

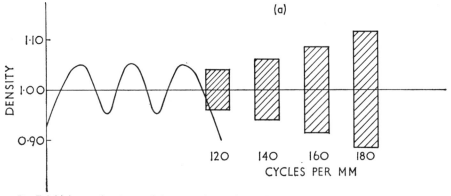

Fig. 7.4 (a) Image density modulation and granularity fluctuations near the resolution limit

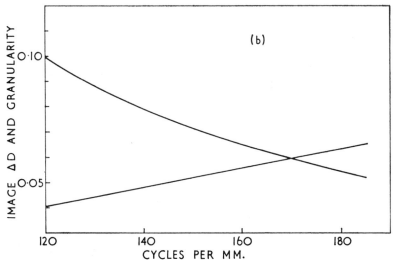

Fig. 7.4 (b) Decrease of image density modulation and increase of granularity near the resolution limit

174

systematic image density modulation approaches the R.M.S. granularity with increasing spatial frequency and falls below it beyond 170 cycles per mm. We should not expect to find resolution occurring very frequently above 170 cycles, but there is a region of uncertainty within which the image density modulation is not much greater than the grain density fluctuation or noise, and resolution is not obviously inevitable. Reverting to Fig. 7.4*a*, at the right hand side the shaded bars define the extent of the random density excursions at the indicated spatial frequencies. The bar lengths correspond to the plus and minus R.M.S. values, but in individual cases the actual density excursions would frequently be as little as $0 \cdot 7$ or as much as $1 \cdot 4$ times the R.M.S. values, and even smaller and greater excursions would occur. For economy in presentation, only one image profile is shown, the basic granularity values for each frequency being scaled up in proportion to the decreasing image modulation.

Examining Fig. 7.4*a* the randomness of resolution is emphasised. For example, at 120 cycles, the most probable random density excursions are appreciably less than the systematic image modulation. Depending on the excess of signal over noise required for resolution, the image might or might not be resolved, according to the local fall of the random density values. If a minus value happened to coincide with an image trough and a plus value with an image peak, then very definite resolution would be obtained. If the opposite happened, there might be no resolution. The higher or lower random density excursions would exert correspondingly greater or lesser influence; on the whole we might reasonably expect to see resolution quite often at 120 cycles. At 180 cycles, the R.M.S. density difference is substantially greater than the image density modulation, and we should expect resolution to be a rather unusual event. At the intermediate frequencies, appropriate comments can be imagined. We could deduce from the model that resolution will occur most of the time below 120 cycles, and quite rarely above 180 cycles. This is an uncertainty of something like two $\sqrt[6]{2}$ target steps, which is decidedly more optimistic than Fig. 7.3 suggested.

It will be appreciated that this is a highly simplified picture of a complex situation. The concept of the effective granularity corresponding to a scan with a rectangular aperture equivalent to one perfectly imaged bar is no more than an artificial assumption introduced to provide a starting point for analysis; the three bar image shape varies with image size; there are end effects on the short bars, not taken into account by one-dimensional calculations; the MTF's are not known to any great accuracy, and there are many other unknowns, so the model should only be regarded as providing a qualitative explanation for the random nature of resolving power readings. Nevertheless, it is perhaps worth revealing at this point that the actual resolving power measured in production practice for this lens-film-target combination varied from 130 to 180 cycles per mm, depending on the particular lens and on the readers.

It is worth stressing, too, that the closing in of the limits of uncertainty in resolution reading in Fig. 7.4 as compared with Fig. 7.3 is partly due to the high gamma of 3404 film. At a lower gamma, the slope of the image density modulation curve would be correspondingly less, and the image modulation would remain in the uncertain region of grain noise over a larger number of target groups.

An interesting qualitative illustration of the importance and interaction of the fundamental factors of granularity, MTF and gamma can be found in an experience involving HP 3 Aerial film. This film, of relatively low gamma, was rather grainy and had a poor MTF, as was inevitable because of its high speed. It represented a good compromise between speed and image quality, and the gamma was conveniently low, for low altitude and poor light aerial photography. Following the philosophy that aerial lenses must be tested on the operational emulsion, HP 3 was used for resolution tests on certain short focus lenses. The philosophy is basically sound, since it forces the test into the operationally significant part of the lens MTF, but there is need for compromise, which was not fully appreciated before image evaluation had progressed to its present status. The balance of factors was such that, at least on axis, the resolution was determined by the emulsion, the lens MTF having no significant effect. Whatever effect it may have had could not be determined, because the number of exposures was inadequate to establish the precision, and it was swamped by the granularity in conjunction with the poor MTF and low gamma of the emulsion. Thus the lenses were, in effect, being selected by a process of random choice. Changing to a finer grained, higher gamma film greatly improved the situation. In general, lens resolution tests should be done on the finest grained of the films likely to be used in practice. (It might be fair comment that one has to know the MTF of a lens before the optimum conditions for its resolution testing can be defined.)

7.5 *Analysis of Practical Examples*

Some readers may feel that the picture so far drawn of the problems of measuring resolving power is much too pessimistic. The instinctive reaction is to feel that one can do better, and to think of cases in which good repetition and agreement were obtained. Few people subject themselves or their techniques to really searching tests, and it is very hard to be truly objective about resolving power. To bring the previous discussions down to earth, it seemed worthwhile to devote some space to practical examples, not out of the way or artificial, but representative of common experience. The detailed study of individual cases is often more revealing than the bald summaries of large-scale statistical analyses, essential as these are. The first three examples relate to lens resolution measured with standard equipment and procedures as in regular production testing. They formed part of investigations undertaken specifically because of disagreements between laboratories, but differed from routine practice only in the numbers of exposures made and observers used, plus the random presentation of images and repeated readings. The last examples relate to emulsion resolution testing.

EXAMPLE 1. This example relates to the testing of a high grade lens on 3404 emulsion. The balance of MTF and granularity was such that under the required magnification the images did not look much less grainy than those more commonly experienced in, for example, the testing of mapping lenses on a film such as Plus X

Aerographic. The images were not noticeably distorted by asymmetric aberrations, at the off-axis angles used. The target was the USAF three bar, contrast 2 to 1.

We are concerned with two readers, X and Y, who read independently, and had no clues which might bias them, e.g. knowledge of lens serial number, field position, focal plane, etc. Both were experienced in reading resolving power and the evaluation of photographic images. The criterion of resolution, not defined at length, was familiar to both observers from much use; the requirement was to read the smallest group in which the threefold pattern could be discerned, irrespective of whether larger groups could be resolved. This criterion forces reading well into the grain, and accentuates observer differences, but is sometimes used when the highest possible figures are desired. Twenty exposures, made in the normal course of a routine acceptance test, including various focal planes and field angles, were presented in a randomized sequence, each observer making one reading on each exposure. The results are shown as a parallel serial plot in Fig. 7.5a. As a general rule, Y reads higher than X, but not by any constant number of groups. At one extreme (exposure 20) X reads higher than Y, but this is exceptional. At the other extreme (exposure 14) Y reads five groups higher than X. In six cases the readings are the same. One notices that the difference of resolution found by the observers between one numbered exposure and the next in sequence is not always in the same direction. (The actual reading, it will be recalled, was done in two different random orders, not in numerical order.) Passing from 8 to 9,

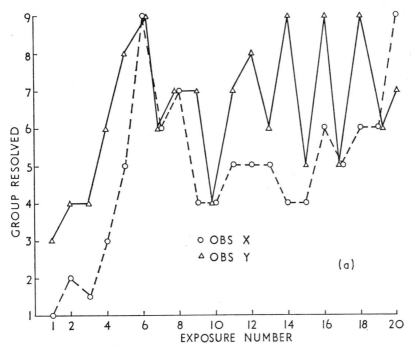

Fig. 7.5 (a) Comparison of resolving power read by two observers. (a) Twenty exposures read once each

177

Y records no change but X records a drop of three groups; passing from 9 to 10, X records no change but Y records a drop of three groups; passing from 13 to 14, X records a drop of one group but Y raises his estimate by three groups. The average difference between the observers is 1·8 groups, but while Y reads higher on average, he often reads exactly the same.

In a more extended comparison, X and Y read seven exposures, representing different field and focus conditions, for each of nine lenses of the same type as before. The averages of the seven readings for each lens by the two observers are plotted in Fig. 7.5*b* thus the observers are compared over a total of sixty-three exposures read once each. The mean difference is now about one group, and there is broad agreement on the general trend of quality among the lenses. Again, however, there are cases in which one observer indicates a fall or no change of resolution between one lens and the next, while the other indicates a rise. This is the more remarkable, as we are now considering averages of seven different images, at each point.

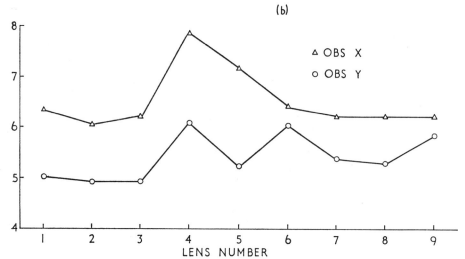

Fig. 7.5 (b) Means of seven exposures read once each on each of nine lenses

Overall, one might say that there is a strong probability of Y reading one group higher than X, but many cases must be expected in which their readings will be the same. It hardly seems possible to calibrate the observers in a consistent way. The facts seem to be explicable in terms of ability (or desire) to believe that a particular grain arrangement does resemble a three bar target pattern rather than any inherent physiological difference of threshold contrast sensitivity. Similar differences were found between other readers in the same investigation.

EXAMPLE 2. In this example we consider the resolution data from nineteen nominally identical exposures, taken on axis with a three inch f/2 aerial lens, using FP 3

178

Aerial film and a Cobb target, GSR 0·95, contrast 1·6 to 1. The observers, A and B, were experienced in reading resolving power, but had not been so closely associated as X and Y in the first example. They agreed to use the criterion that no group should be considered resolved unless the preceding group also was resolved. "Resolved" meant that two separated, correctly orientated units could be discerned. Each observer read the images four times, in random order which was changed for each session, the sessions being spread over two days. In addition, B repeated his four sessions after two weeks. To avoid any memory effects, the serial numbers were not known to the observers while reading. The results are shown as histograms in Fig. 7.6. Observer B (the more experienced) does not repeat his performance very well. In his second series he shows a more definite mode at group 33, agreeing with A. However, B consistently shows an appreciable number of readings at 35, while A shows none. On this evidence we would not find it easy to decide what resolving power should be assigned to the lens. One could only state "between 31 and 36, with a tendency to 33". It would be fair comment that this result could be partly due to the small GSR. Seventy-five per cent of A's readings, and seventy per cent of B's second series, are in group 32 or 33. However, B would still record many readings higher than A's.

The histograms (or scatter diagrams) give a very good display of the overall situation, enabling the mode and variance to be seen at a glance, but lose the identity of the individual exposures and hence the curious differences between observers and

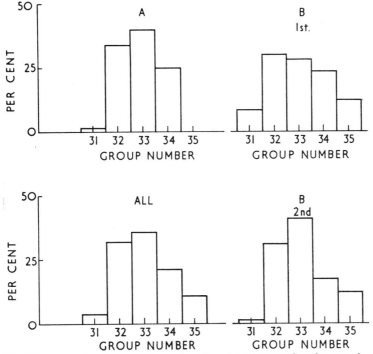

Fig. 7.6 Histograms showing percentage of readings by group number, for two observers

occasional agreements. In this example the full serial plots are too lengthy for reproduction, and are summarised by the histograms of Fig. 7.7. These show the percentage of exposures on which the disagreement between the four readings of any image was n or less than n, where n is 0, 1, 2, 3, etc. On 25 per cent of the exposures observer A repeated his reading on all four occasions; over the whole 19 exposures his spread does not exceed two groups on any image. B was less consistent; in his better session his four readings agreed on 31 per cent of the exposures, but considering all the exposures his spread was three groups in both sessions. When the results for both

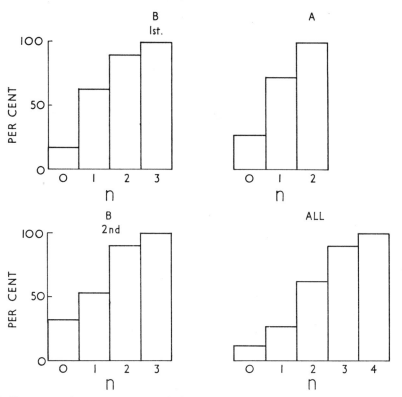

Fig. 7.7 Histograms showing percentage of 19 exposures for which disagreement in four repeated readings of resolution ≤n groups

observers are combined, agreement is obtained for only ten per cent of exposures, and over the whole nineteen exposures the spread is four groups. Thus there is only a one in ten probability that these two observers, who had discussed and agreed on the criterion, will agree in their reading of any image; there is about the same probability that they will disagree by three groups.

In examining individual cases in the serial plots, exposures 2 and 3 were remarkable, because both observers recorded 33 on every reading, i.e. there was complete agreement

in twenty-four independent readings well separated in time, by two observers. This contrasts with exposure 7, for which observer A recorded 33 in all four of his readings, but B recorded from 31 to 35 in his eight readings. Similar examples could be multiplied, and can also be found when comparing the two separate reading sessions of B. The skewness of the histograms in Fig. 7.7 suggests that the "true" resolution may have varied among the exposures, but if any such effect exists it is swamped by the disagreement in the repeat readings of identical images. For instance, in going from 18 to 19, B in his second series recorded a drop to 32 in all four readings. (The readings were not, of course, made in numerical order, but in a random sequence.) This might be taken as clear proof that 19 was really worse than 18. However, in B's first series he had recorded a rise to 34 in three out of his four readings, as had observer A also. Again, the single case of 31 recorded by A was on exposure 11; was 11 therefore a poor exposure. Turning to B's readings, he was found to have recorded four cases of 31; however. not one of these was on exposure 11!

The means and standard deviations calculated from these readings are as follows:

	Mean	*Standard deviation*
B, first session	33·0	1·1
B, second session	33·1	0·9
A	33·0	0·6

Although the distributions are far from Gausasin, the standard deviations do give a reasonable summary of the spreads. For a perfect Gausasin, 95·5 per cent of the observations should fall within plus or minus two standard deviations from the mean, and this does express the spread in groups from the mean, fairly well. It is somewhat remarkable that the means should agree so well, seeing that the differences on individual exposures were often so great. Presumably this simply means that the reading is so much a matter of chance that given enough observations, all of which must lie within certain limits of resolution (e.g. all observers would almost certainly agree that any image five groups above the mean was resolved) it becomes inevitable that all sets having sufficient observations will give the same arithmetic average or mean value.

According to statistical theory, confidence in the mean value increases in proportion to the square root of the number of samples, the standard error of the mean being defined as $\frac{\sigma}{\sqrt{n}}$. For these 19 observations, therefore, the standard error of the mean is about 0·23 of one group. Thus we should expect the "true" resolving power to lie within plus or minus two standard deviations, 0·46 group, from group 33. However, this simple use of the theory would only be valid for one observer, and on the assumption that his criterion did not wander. It is extremely difficult to define what we mean by the true resolving power, for more than one observer.

We can make the following summary of the results:

Between two observers, the readings on any one image may differ by four groups.

Any one observer may show a spread of three groups in repeated readings on one image.

There is a ten per cent probability that two observers will agree on any image.

For certain images, two observers will agree on every occasion of reading.

The averages of 19 exposures (76 readings for each observer) agree within 0·1 group.

These conclusions apply to the particular experimental conditions, and would not necessarily be repeated exactly in other conditions. Experience suggests that worse spreads would sometimes be found (e.g. with very asymmetric or grainy images). This experiment was of course an introductory study rather than a thorough investigation, and the statistical analysis was not adequate to define, for example, conditions such as the number of exposures and readings necessary for a given confidence level. Without more thorough study and analysis, one might perhaps draw the tentative conclusion that at least three exposures, read four times each, are necessary to establish a resolution figure correct within one group.

EXAMPLE 3. It is sometimes suggested that random presentation of images for reading does not give a fair picture of the precision that can be obtained when observers know the general level of resolution to be expected for the kind of lens under test, or can predict a trend, as in a through-focus test, or are constantly making readings at about the same level. However, following an imagined trend in focus determination may well lead to error. Here, as always, several replicates at each position, rather than smoothing a curve through scattered points along an expected path, is the only safe course. Some authorities recommend keeping transparencies of standard images, which have been read many times and assigned a "true" resolution, for frequent reference and correction of one's criterion. Within limits this can be helpful, but in practice one does not always find it easy to get agreement between observers even when present together with freedom to discuss and re-examine images in the light of criteria defined and agreed on the spot, this being the opposite of the random presentation used in the second example. In an attempt to test the agreement attainable under these "ideal" conditions, five observers, all experienced, agreed on a criterion of resolution, which demanded that the highest group deemed resolved must not be preceded by more than one unresolved group. They then read seven images from a test of a three inch aerial lens on FP 3 Aerial film, on and off axis, ranging from 13 to 31 cycles per mm. There was complete freedom to vary magnification, and to discuss and re-read images for which there had been any difference of opinion. Nevertheless, differences of three Cobb groups on two of the images, and two groups on another, had to be accepted. Two images yielded agreement within one group, and two (actually the highest and lowest resolutions) yielded unanimous agreement. Evidently different observers see differently, even when all possible physical and conceptual sources of disagreement have been removed. As a further comment on the difficulty of maintaining a standard of resolution, two of the observers, who had not disagreed by more than one group during the session with consultation, were found, several weeks later, to differ by four groups when reading in isolation.

EXAMPLE 4. The previous examples are drawn from the lens testing experience of different organisations. We will now briefly refer to experience in measuring emulsion resolving power, which might be expected to be less precise, because the fall of image contrast is essentially due to only one MTF.

In the determination of emulsion resolution thresholds, which is simply the measurement of emulsion resolving power for a wide range of target contrasts, it was found by Itek Corporation (1962) that a standard deviation of the order of ten per cent for one reader could be expected. This indicates that resolving power must be specified for limits of two to one, if we are to have 99·7 per cent confidence that all observations will lie between these limits. In practice, of course, a manufacturer would never specify resolving power of an emulsion in this way. He would be more likely to quote a single figure, in the hope that the user would appreciate that this would represent the mean of several determinations, and that in practice single observations could lie quite far from the figure. The histogram of Fig. 7.8 shows the distribution of standard deviations found from the readings of three observers, seven contrasts ranging from 1000 to 1 down to 1·05 to 1, and three emulsions ranging in high contrast resolving power from 800 to 25 cycles per mm. There was no systematic tendency for the standard deviations to be worse at either higher or lower contrasts, in spite of the observers' complaints that the low contrast images were much more difficult to read. From Fig. 7.8 it appears that the most probable standard deviation is eight per cent, but values between five and thirteen per cent can be expected. Since other workers have reported standard deviations of fourteen per cent[3] for the resolving power of lens-film systems, it does not seem that the errors are worse for the resolving power of emulsions alone.

Finally, we may note an exercise in the determination of emulsion resolving power, conducted by a committee of six prominent American laboratories for the United

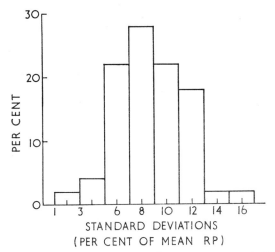

Fig. 7.8 Histogram showing frequency of occurrence of given per cent standard deviations in emulsion resolving power measurements

183

States of America Standard Method for the Resolving Power of Photographic Materials. The writer, in expressing appreciation for the privilege of quoting from this study, wishes to make it clear that the comments and conclusions are his own and are not necessarily endorsed by the Chairman of the Committee (Dr. R. Clark Jones).

The laboratories first qualified their cameras using 649 high resolution emulsion, and all obtained more than 1700 cycles per mm. Seven materials, ranging in resolving power from 20 to 800 cycles per mm (excluding the 649) were tested at three contrasts, with nine replicate exposures on each material. The median value was quoted. As a guide to the criterion of resolution, photomicrographs of typical images, with the resolving powers read by different observers, were circulated. It is not possible, at this time, to indicate any precaution that was not taken, or any way in which the experimental technique could have been bettered.

The results showed differences in the resolving powers found by the different laboratories, ranging from five per cent in the best case to ninety-five per cent in the worst case. It was strange that the highest figure recorded, for AHU Microfile emulsion, 800 cycles per mm, was returned by the laboratory which had the next to lowest figure in the camera calibration. There was no clear indication of better agreement with the high contrast target. The best agreement, at both high and low contrast, was obtained with the most grainy emulsion of the set. The programme was subsequently extended by having some of the images evaluated by all laboratories. A statistical analysis of 1944 observations showed significant differences between readers, cameras, and camera-reader interactions. The standard deviation of the reader-camera combination was between 12 and 24 per cent of the average resolving power.

7.6 Consequences

Enough has been said to sustain the case that resolving power does not allow high standards of precision or accuracy. One justification for having proved what is generally accepted is simply that it is generally accepted without adequate evidence, and nothing is done about the fact. Through one of the curious paradoxes that afflict photography, both those who fix requirements and the engineers who test their own products proclaim the failings of resolving power but do not insist on properly controlled measurements with sufficient replications to establish the precision from which alone realistic limits can be derived. As we have seen, remarkable consistency sometimes crops up, and no doubt the memory of such events generates a broad optimisim. No one can quarrel with the continued use of resolving power, even as a lens test, until there is an equivalent, generally accepted and easily applied, to replace it. One can object, however, to the way in which resolution tests are often applied. Thus it seems desirable to conclude this chapter with some reference to practical applications.

Resolving power is used to specify or measure the performance of emulsions, lenses, and systems, the latter statically, dynamically, and in flight. Our outlook on accuracy and precision is not quite the same in all these categories.

184

Emulsion resolving power is largely the concern of the manufacturer, for whom there need be no difficulty in making enough replications to establish precision. He does not change his products very often, and he holds their properties constant by other tests, so there is no need to repeat resolution tests on a constant product. (Resolving power would be unthinkable for batch control.) Accuracy is another question, and we can only accept the evidence that it is just not possible for different laboratories to agree well enough for us to compare the figures issued by different manufacturers. However, this does not stop us using one manufacturer's figures as a reasonable guide to the relative performances of his product line. There is no occasion for non-manufacturing laboratories to be concerned if their measurements of emulsion resolving power do not agree.

System performance is commonly a two-way affair, in which the purchaser states a figure. There is, or should be, sufficient liaison between the parties for alignment of their resolution techniques, so that the accuracy problem can be faced in a reasonable way, if not wholly overcome. It is essential to have enough replicates for precision, or, if this is not possible, as sometimes in flight tests, allowance should be made for the consequences. System comparisons are not often made between parties who have no arrangements for intercomparison, and system performance data are rarely published. (When they are, they should be treated with reserve.)

Lens performance, like system performance, is commonly a two-way affair, with the same options for meeting the accuracy problem. Experience shows, however, that advantage is rarely taken of the test being a wholly laboratory affair, to establish either accuracy or precision on an adequate basis. In general no special precautions are taken until an item falls (or appears to fall) below specification limits, then emergency action is taken and the problem settled by negotiation until honour is satisfied rather than on scientific evidence. It may be that this is more reasonable economically than establishing tolerances by adequate initial experimentation. Properly conducted resolution tests are certainly very expensive, but one cannot over emphasise the need for a realistic approach.

It is not possible to give hard figures, universally applicable, for either accuracy or precision, these being affected differently in every case by the interactions of the factors discussed in this chapter. However, we offer in conclusion a series of precepts or guidelines, primarily aimed at lens testing, but also having general application.

1. Recognize that single exposure are meaningless in any application of resolving power, and that the standard deviation is typically of the order of ten per cent.

2. Fix acceptance limits on the basis of adequate precision and accuracy measurements.

3. Establish the precision for each situation by an adequate experiment.

4. Monitor the accuracy by the inclusion of a standard lens, incognito, in every test, this being the only safe check on drift of reading criteria.

5. Make at least three exposures for every test condition. Waste no time on results that are more than two standard deviations above the acceptance limit. Be prepared

to retest, with an increased number of replicate exposures, items nearer to the acceptance limit.

6. Do not use a resolution criterion which involves observations far into the grain, as this increases the opportunities for disagreement through personal interpretations.

References

[1] GREGORY, R. L., *Eye and Brain*, World University Library, New York (1966).

[2] ROMER, W. and SELWYN, E. W. H., *Phot. J.*, **LXXXIII,** 17–20 (Jan. 1943).

[3] CHARMAN, W. N. and OLIN, A., *Phot. Sci. Eng.*, **9**, 385–397 (Nov.–Dec. 1965).

VIII. EMULSION THRESHOLDS
AND THE PREDICTION OF RESOLVING POWER

8.1 *Introduction*

The critical dependence of photographic resolving power on target contrast is often a source of difficulty; we cannot alter this, but we can make use of it, in a technique for predicting resolving power from the lens MTF.

In the early enthusiasm for lens MTF's, which were proclaimed, many years ago, to be about to replace resolving power by a much more accurate and informative measurement, few gave serious thought to the question of how these interesting graphs were to be interpreted in practically significant terms. As it happened, actual MTF measurements (as distinct from papers about the advantages of the MTF) were sufficiently rare, and inaccurate, for the question to be less than urgent. Now that measurements are common, with promise of very good accuracy to come, it cannot be indefinitely sidetracked. Apart from the interpretation of actually measured MTF's, an important question in system engineering has been the evaluation and choice between projected lenses for which the MTF's have been calculated from the design data.

We appear to be in a dilemma. If we opt for accurate measurements made on the lens alone, untrammelled by the vagaries and inherent errors of photographic emulsions, we must get rid of photography and use the MTF. This tells a lot about the lens, but nothing, directly, about its practical value. Of course, we can apply intuition; the experienced lens designer or engineer is unlikely to make serious errors of judgement in choosing between different MTF's. But it seems a poor return for an elaborate and expensive measurement if we end up with an intuitive interpretation of the results. And how do we specify or operate manufacturing tolerances on the lens MTF if they must be based on intuition? Somehow the interpretation of the MTF has to be brought out of the frequency domain and down to earth, in terms appropriate to the images we record and interpret. Since that means relating it to images on film, we appear to be back where we started.

The fundamental difficulty is that all MTF's are decreasing functions of spatial frequency; we cannot make *a priori* decisions about the limiting value or the relative significance of different levels or slopes within the bandwidth. Clearly there is a need for some kind of weighting function, which when multiplied into the MTF will suppress or weaken irrelevant regions and evaluate the lens by the more significant regions. How do we find the right weighting function? One approach, already being applied with praiseworthy energy for amateur and general photography, is to organise vast statistical experiments, in which (literally) thousands of observers are asked to state preferences among photographs, representative of various applications, taken with controlled MTF changes, the results being correlated with the use of different weighting functions.

187

We might be tempted to start similar experiments for aerial photography, in spite of the experimental difficulties, did it not occur to us that in effect they have already been performed, in the countless thousands of aerial photographs taken with lenses of known resolving power. In other words, we are arguing that the ready made weighting function for the MTF's of aerial lenses or at any rate a limit for their useful bandwidth, is given by the resolving power on the film that would be used in practice.

At first sight it may seem absurd, having argued in favour of the MTF because of its greater content of information about the lens performance and potentially greater accuracy of measurement than resolving power, that we should propose to evaluate its practical worth by turning it back into resolving power. Admittedly this is an expeient, pending something better, but there is no real inconsistency of principle. Measurding the MTF of the lens retains all the advantages of objectivity and potential acuracy, and provides information that can be referred to in case of need. The qualitative differences between lenses are accurately analysed and recorded, but we have no simple direct way of evaluating the practical significance of the observed differences, especially off-axis when marked phase errors may occur at the higher frequencies. If the MTF's are converted into low contrast resolving power, we can form a more balanced judgement of their probable consequences in actual photography. It may be objected that we are begging the question by ignoring the "fact" that resolving power is not a satisfactory guide to image quality. However, there is no reason to change the view, well expressed by Howlett and Carman,[1] that no evidence has ever been produced to show that low contrast resolving power is an unreliable guide to system performance in aerial photography. To be more precise, we should say that within the range of operationally viable systems, systems placed in a certain order by low contrast resolving power will not be placed in a different order by actual aerial photography. The qualifications to this general rule for unusual systems having a marked unbalance between MTF and granularity are discussed in Chapter IX.

Accepting this premise, there is a great deal to be said for converting MTF's into resolving power at the present time, which is no doubt why it is done on so large a scale. The assessment of quality by resolving power is a long established tradition in aerial photography, and the figures are widely understood in the different associated disciplines. While resolving power is not necessarily the best way of translating the MTF into practically useful terms, and may not always remain in use, it is certainly very useful on a temporary basis, say for the next ten years or so.

We have seen that resolving power can be regarded as the spatial frequency corresponding to the intersection of the system MTF, i.e. in the simplest case, product of lens and emulsion MTF's, with a rising threshold determined by the granularity. This could be made the basis of a resolution prediction method, in which the lens MTF would have to be multiplied by the emulsion MTF and gamma. In practice there is no need to derive the grain threshold as such, it is simpler to work directly with an "emulsion threshold", i.e. an empirically determined curve which is essentially no more than an expression of emulsion resolving power as a function of target contrast. No attempt is made to separate the emulsion factors that contribute to resolving

power; the emulsion is simply regarded as a "black box" which when exposed to a bar target image of a certain modulation will yield, after development, a certain resolving power.

8.2 *The Emulsion Threshold*

Possibly the first determination of emulsion thresholds with the specific objective of predicting resolving power from lens MTF's was made by Powell in 1956.[2] At that time the universal measurement of lens MTF's appeared imminent, but the problems of interpreting the MTF suggested that resolving power would not disappear immediately. The complexities of working from the MTF to bar target resolving power were appreciated, and sinewave resolving power seemed to offer a solution to more than one problem. Powell's thresholds were therefore determined for long line sinusoidal targets. As the targets contained 19 cycles, their Fourier spectra were relatively pure. The targets were imaged on to the emulsions by a photographic lens, corrections being applied for losses due to its MTF. More recently, thresholds for three-bar targets have been issued by Itek Corporation,[3] and by F. Scott.[4] Scott's thresholds are described as "three-bar target modulation detectability curves"; the term AIM curves (aerial image modulation curves) has also been used. The targets are imaged by microscope objectives in the more recent determinations, as in the measurement of emulsion resolving power. When working with some modern aerial emulsions, whose limiting resolving power may be over 500 cycles per mm, microscope optics offers the only practicable way of obtaining an adequate lens MTF. The experimental procedure involves the determination of resolving power for a range of target contrasts, from high contrast down to the lowest that can be measured with acceptable accuracy, usually about 1·2 to 1. The focusing is optimised by experiment, and the exposure is varied to obtain maximum resolving power at each contrast. Development is carried out under standardised conditions in the solution normally recommended for use with the emulsion. The exposing light is usually of daylight quality, sometimes supplemented by a minus blue filter. The images are read by two or more observers using the same criterion of resolving power. The results are averaged and expressed as single curves for each emulsion, but it will be appreciated that these represent the most probable figures; individual exposures read by individual observers would not necessarily lie on the curves. Also, any predictions made from the thresholds would only be valid for the optimum exposure and standard development conditions, with the specified target. This, of course, is not a peculiarity of thresholds, but applies to all resolving power determinations.

Fig. 8.1 shows the Itek 3 bar thresholds for Tri X Aerecon, Plus X Aerecon (SO 102) Panatomic X (SO 130), and SO 132 emulsions. Target contrast is plotted as modulation, to fit in with the use of the thresholds. Scott's detectability curves agree with these quite reasonably in view of the inevitable differences in determination of resolving power by different laboratories. It should be realised that while the batch to batch

variations in resolution for a given type of emulsion are very small, the emulsions represented by Fig. 8.1 may well be replaced by improved versions. In general, numbers or names are changed when such replacement is made, but this is not invariable. The thresholds are given to explain the method and indicate the kind of result that is obtained, but for actual working predictions it may be necessary from time to time to make new determinations for the then current materials.

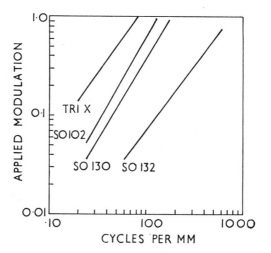

Fig. 8.1 Emulsion thresholds for three-bar targets

The fact that all the curves are approximately linear and parallel suggests that any new black and white aerial negative emulsions will give thresholds of the same general form, and that all such thresholds could be represented by a single curve, appropriately located on the frequency axis for each emulsion. Substance is given to this idea by the earlier Powell thresholds, which, as he showed, could indeed be represented by one curve. The emulsions measured covered the full range of aerial films available in England at that time, from the fastest, as used for night photography, to the slowest fine grain types. The resolving powers, for the sinusoidal targets at full modulation, ranged from 80 to 300 cycles per mm. However, the use of a single threshold curve must be qualified in one respect. Any threshold must eventually turn under, at its lower end, to meet a horizontal line on which the resolution is limited by the contrast sensitivity of the eye when the spatial frequency is too low for granularity and MTF to exert any influence. Measurement in this region is extremely difficult, and few results are available, but the levelling off must occur at a modulation in the region of 0·02 to 0·04. When the emulsion gammas are all the same, as broadly, they are for some modern series of aerial films, the horizontal line will be at the same modulation for them all. If the gammas are different, the line will be at a lower modulation for those of higher gamma, and conversely. Powell in fact observed this effect in 1956, and proposed to characterise all the emulsions he measured by the limiting high

190

contrast resolving power, the basic threshold curve, and the level of the horizontal threshold portion.

The approximate equality of slope for all emulsions is presumably a fortuitous result of the way emulsions of different speed are made, with a roughly similar balance of MTF and granularity. There is no reason to suppose that this is a fixed relationship for all time, though drastic changes seem unlikely. Scott (loc. cit.) has shown a markedly different shape for a reversal colour material.

8.3 *Use of Emulsion Thresholds*

The concept and use of the threshold curve involve some approximations which will be discussed later, but in outline the procedure is as follows. The MTF of a lens expresses the modulation in the image of a high contrast target. The threshold expresses the modulation required in a target image projected on the emulsion, if resolution is to be just visible in the developed image. If the two curves are plotted on the same co-ordinates, their intersection must occur where the required and applied modulations are equal; that spatial frequency is the resolving power for the particular combination of lens, target contrast, and emulsion. For any lower target contrast the ordinates of the MTF must be multiplied by the actual target modulation; on a logarithmic plot this is easily accomplished by moving the MTF downwards so that at zero frequency it passes through the target modulation ordinate. Alternatively, the threshold may be moved up by a corresponding amount. The procedure is illustrated in Fig. 8.2. The MTF of a 4 inch aerial lens at f/5·6 is drawn on the same diagram as the thresholds of Fig. 8.1, at ordinate values corresponding to target modulations of unity and 0·2. It is best to regard these two curves as image modulation curves

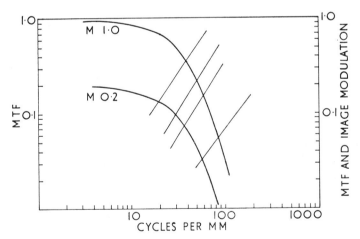

Fig. 8.2 Prediction of resolving power at different target contrasts from lens MTF and emulsion thresholds

191

corresponding to the operation of the MTF on the target at the two contrasts; clearly we cannot regard the lower curve as an MTF. The intersection of the MTF with the threshold lines indicates the resolving power that would be obtained when using the lens with each emulsion. The thresholds themselves show how the modulation needed for resolution at any spatial frequency decreases as we move to the slower finer grained emulsions. For example, at 80 cycles per mm, Tri X requires full modulation but 4404 requires only 0·065. At constant applied modulation the range of resolving power among the emulsions is approximately 8 to 1, almost independent of the actual modulation. However, the resolving powers obtained with the lens on the various emulsions lie within a narrower range according to the target contrast and the way the MTF cuts across the thresholds. At high target contrast the intersections occur on a steeper part of the MTF and the range of resolutions is smaller, in other words, the lens is a more important limiting factor at high contrast than at low contrast. As we reduce the target contrast, the intersections move towards the less steep part of the MTF and the resolving power tends to be determined more by the emulsion. This does not mean that aerial lenses should be tested at high contrast. It would not be reasonable to base our assessment of the lens on its performance in a region of the MTF (determined by the high contrast) which would have little or no significance in practice. Of course, this difficulty would not exist if all lens MTF's had the same shape, but if they did, there would be little practical need for measuring them.

A horizontal image modulation curve, i.e. an effectively perfect lens, would clearly give the greatest difference between high and low contrast resolving power and between the different emulsions. As a corollary, it would be futile to test the resolving power of a lens if the image modulation curve ran nearly horizontally across the threshold of whatever emulsion was being used; an approximation to this condition exists for the low contrast intersection with the Tri X threshold in Fig. 8.2.

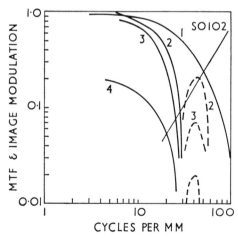

Fig. 8.3 Prediction of resolving power after combination of different MTF's

The image modulation curve is not necessarily restricted to that corresponding to a lens, as in Fig. 2. It may represent the overall product of target contrast and more than one system MTF, and the reduction of target contrast by atmospheric haze may also be taken into account. An example is shown in Fig. 8.3. The image modulation curve, no. 1, is for the lens imaging a high contrast target. 2 is the MTF for 33 microns linear image movement, the broken portion being the first negative lobe of the sin x/x function and hence in reversed phase, the so-called "spurious resolution" region. Curve 3 is the image modulation curve resulting from the product of 1 and 2. 4 is the image modulation curve corresponding to 3 when the target contrast has been reduced by haze to 0·2 modulation. (By no means a low contrast for aerial detail.) The lens MTF extends beyond 100 cycles per mm, but the resolving power is only 20 cycles per mm even for a target modulation of 0·2. Details of lower contrast, say 0·02, would not be resolved at all. The prominent negative lobe of curve no. 2, after multiplication by the lens MTF, is so reduced that the image modulation curve lies below the emulsion threshold even for the high contrast target. On an emulsion whose threshold lies further to the right, curve 3 might result in two degrees of spurious resolution, since the threshold could intersect the negative lobe in two places. The "true" resolution might not be observed, because the intersection would occur at an extremely low modulation.

8.4 *Limitations of the Threshold Technique*

Prediction of resolving power from thresholds has been of great value in the evolution of lens designs, the development of aerial camera systems, and generally as an aid to understanding the probable behaviour of photographic systems when parameters are varied. Nevertheless it remains an approximate and not rigorously sound method. This is not to say that it cannot be used at all, but merely that its limitations and the approximate nature of the predictions should be well appreciated. The limitations arise from the fact that the thresholds are determined under optical conditions which differ from those that obtain when resolving power is actually determined with a camera lens. In general, the reduction of bar target modulation by the camera lens is only approximately known, and images of nominally equal modulation produced by the camera lens and in the threshold determinations are not identical, hence one cannot expect the resolving power predicted from the threshold to agree exactly with that found by experiment. The normal uncertainties of resolving power measurement tend to hide some of the possible discrepancies, but their existence should be realised.

8.4.1 MODULATION. In measuring a threshold we find that a certain resolving power, R, corresponds to a certain contrast in the aerial image formed on the emulsion. We express this as a modulation, M_t. In predicting the resolving power that will be given by a camera lens and target contrast on the same emulsion, we again express the target contrast as modulation, multiply it by the lens MTF, and find another aerial

image modulation, M_1. If $M_1 = M_t$, we say that the resolving power of the camera lens on this emulsion is also R. This implies that "modulation" has the same meaning in both cases, that it is legitimate to multiply the target modulation by the MTF, and that the images are identical in all respects. These statements are not a true description.

Strictly speaking, modulation should be applied only to sinusoidal targets or images, for which it is defined as $C - 1/C + 1$, where $C = I_{max}/I_{min}$. If the target extends indefinitely (very large number of cycles) its Fourier spectrum is pure, and the image modulation is given directly by the product of the target modulation and the MTF. If it has only a few sinusoidal cycles, the error in multiplying the target modulation by the MTF amounts to only a few per cent. But if the target consists of a few rectangular bars, say three, the definition of modulation becomes arbitrary, and the image modulation is not simply the product of target modulation and MTF.

One convention is to state the modulation of a three bar target as though it were sinusoidal, ignoring the square waveform and harmonic content, i.e. the modulation is defined as $C - 1/C + 1$ as before, C being now the ratio of maximum and minimum intensities in the three bar target. The actual intensities are of course just the same as in a sinusoidal target of the same stated contrast, but the modulations of the two targets when imaged do not decrease in the same way when operated upon by the same MTF. As we saw in Chapter IV, this is taken into account by providing a "three bar function" which expresses the modulation in the image (averaged between centre and side bars) as a function of reciprocal bar spacing. In general the three bar function lies above the MTF for any reciprocal bar spacing or spatial frequency. The relationship between the two functions is definite for an aperture limited lens, but for other MTF shapes it varies and must be derived for each case by Fourier transform methods.

In the derivation of the threshold, the targets are imaged on the emulsion by microscope objectives, which are assumed to be aperture limited, then if any correction to the target modulation is needed, it is made from the assumed three bar function for a lens of the same aperture as the microscope objective. In fact, microscope objectives, though very highly corrected, are not necessarily aperture limited, especially in the intermediate region of their MTF's, which is of the greatest importance in this application. As the measurement of these MTF's is not simple, it is usually omitted, and the assumption is made that any degradation of target contrast by the objective will be very small. For example, in determining the threshold for an emulsion like SO 102, the microscope objective would have an N.A. of $0 \cdot 25$ to $0 \cdot 30$, the cut off would be at about 1000 cycles per mm, and even at 100 cycles per mm the loss of modulation, if aperture limited, would be as little as 13 per cent or thereabouts. However, Schade has shown,[5] that the assumption of aperture limitation can be far from correct, even with good quality objectives in narrow band illumination. Actual MTF's may be of the order of 20 per cent below the theoretical in the intermediate frequency region, due presumably to manufacturing difficulties. Again, the aperture limited MTF is different for every wavelength of light, and if using a wide bandwidth, say from 450 to 700 nanometres, the estimation of an appropriate weighting and the influence of any aberrations that may be present introduces further uncertainties. Scott (l.c.) has avoided this particular

194

problem by determining the effective MTF of the objective from an edge trace on a fine grain emulsion, then dividing out the emulsion MTF. However, this introduces another possibility of error, since the MTF's of emulsions are not known with certainty.

Subject to these uncertainties, the values of M_t used in the threshold determination are taken to be the "modulation" of the targets multiplied by the three bar function of the microscope objective. In general the actual values of M_t are likely to be lower than is assumed.

In predicting the resolving power of the camera lens, the target contrast is first converted to "modulation" as before, then multiplied by the lens MTF. To be correct, it should be multiplied by the three bar function, but this is not available without special calculation based on the MTF. Consequently the image modulation assumed to be applied to the film will be too low, the actual error depending on the shape of the MTF and the relevant spatial frequency region, but being typically of the order of 30 per cent. It is interesting, therefore, that when a lens is made, and the resolving power measured experimentally, it is often found to be higher than the resolving power predicted from the calculated MTF. This is the more interesting, in that the measured MTF's of lenses are usually lower than has been predicted from the design calculations. All this suggests that the losses in imaging the targets during the threshold determinations may be greater than suspected. The accuracy of measuring lens MTF's is not yet sufficient for a satisfactory clarification of this situation.

8.4.2 IMAGE APPEARANCE. Apart from the uncertainty as to the exact modulation in the threshold and predicted images, there are differences in intensity profile and appearance. For equal resolving power, the camera lens will require a higher target contrast and will degrade the target quite substantially, while the threshold will be found from lower target contrast and little degradation will occur. For example, in Fig. 8.2 the high contrast resolving power of the lens on SO 102 is 50 cycles per mm. Obviously the lens MTF will cut off the third and all higher harmonics, so the aerial image will be quasi-sinusoidal in profile. The microscope objective, however, will pass frequencies out to, say, 300 cycles per mm without much loss and higher harmonics will be present. Therefore the threshold aerial image will be much "squarer" in outline even if modulation is the same in both cases. However, any differences of this sort do not cause very marked differences in the shape of the image actually seen, because there is a common factor in the emulsion MTF which follows both lens MTF's. As this is very much lower than the MTF of the microscope objective, it must largely eliminate differences at the effective exposure stage of the image formation. Another, and possibly more serious difference between the imaging conditions for threshold and actual resolving power measurement stems from the same difficulty that the threshold target contrast must be much lower, for equal resolving power. Again referring to Fig. 8.2, the camera lens MTF, presented with a target modulation of $1 \cdot 0$, reduces it to $0 \cdot 23$ in the aerial image, to yield a resolving power of 50 cycles per mm high contrast. The threshold determination used a target contrast of $0 \cdot 23$, imaged without

loss, to give the same resolving power. Because the resolving powers are the same, we suppose that the physical density modulations in the developed images are the same, or at any rate very similar. Nevertheless the images will look quite different. In making the threshold negative, the reducing camera sees a bar target pattern at a low contrast, i.e. three bars whose luminance is only slightly greater than the background luminance. The exposure is adjusted so that the background image is at some density of the order of 1·0, optimum for resolution. At the resolution limit the image then appears as a faint ripple on a uniform background of density about 1·0. When measuring the high contrast resolving power with the camera lens, the exposure is adjusted for maximum resolving power, which, as is well known, is obtained when the images of large clear areas having the same luminance as the target bars are reproduced at a density of the order of 1·0. The smaller images near the resolution limit will then have a mean density less than 1·0, while the background is at fog level. The situation is schematically illustrated in Fig 8.4. The threshold image is a small ripple in a large uniform density

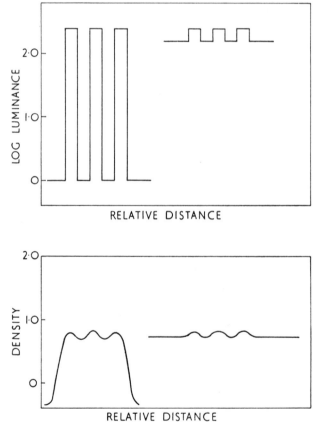

Fig. 8.4 Schematic representation of target luminances and image densities, for high contrast and low contrast targets each exposed for maximum resolution

area, while the image given by the camera lens is a similar ripple on a small area of density isolated in a substantially clear background. Clearly, although the modulation in the two images may be very similar, their appearance will be quite different, and we have no reason to suppose that equal "modulation" will result in equal resolving powers. Prediction of high contrast resolving power does of course represent an extreme case, in which there are very great difference between the two images. In prediction of low contrast 'resolving power there is less cause for concern, but the fundamental difficulty remains. Needless to say, these particular problems would not exist if thresholds and practical resolving powers were both measured on truly continuous sinusoidal or squarewave targets. The modulation would then be wholly within the target area, and the appearance at the edges, or different contrast with the background, would not enter into the question.

8.4.3 CONE ANGLE. In forming the target images on the emulsion during the threshold determination, we use a microscope objective of large numerical aperture so that the degradation of target modulation will be minimised. Thus the need for corrections is almost eliminated, and subject to our doubts about the real MTF of the objective, we hope that this approach gives us the most accurate knowledge of the applied modulation. But the camera lenses whose resolution is to be predicted will in general work at much smaller apertures, and the cone of light entering the emulsion will not be so wide. The objectives used with high resolution emulsions typically have a numerical aperture of $0\cdot65$ (f/0\cdot59), while the camera lens may work at f/8. Because the emulsion layer has a finite thickness, the internal light distributions resulting from these very different cone angles might lead to effects on the image modulation rather different from those predicted by the respective lens MTF's and the common emulsion MTF. In other words, the degradation of the aerial image by the emulsion, i.e. the effective emulsion MTF, may depend on the cone angle. Little work seems to have been done on the magnitude of such effects. Hendeberg has claimed that the emulsion MTF, for Pan F, is worse for a wide cone angle. At first sight this effect could be very marked for fine grain emulsions such as SO 132, which are almost transparent and non-scattering for red and green light. The emulsion layer is about six microns thick, and at a numerical aperture of $0\cdot65$ a one micron wide image at the surface could spread out to the order of ten microns near the base. However, in spreading the intensity would fall very rapidly, which would tend to concentrate the effective exposure near the surface. Some such concentration must take place because of the high contrast resolving power, some 800 cycles per mm, achievable with this emulsion, which would not be consistent with an image spread much greater than a micron (though non-linear effects may also affect the issue at high contrast). More generally, the cone angle effect must depend in a very complicated way on scatter and absorption, and hence on emulsion grain size. There is no evidence that it is of major importance at present, but it should not be overlooked.

It is not essential to use a large numerical aperture in measuring thresholds for aerial emulsions when the resolving power of the operational lens is not expected to be

very high. Suppose we are interested in a lens whose resolving power at a target modulation of 0·2, on Plus X Aerecon, is expected to be of the order of 40 cycles per mm corresponding to an applied modulation of about 0·15. In generating the threshod to cater for such cases, applied modulations up to, say, 0·3, would be more than sufficient. An aperture limited f/16 lens has a CTF value of about 0·6 at 60 cycles, thus the target modulation would have to be about 0·5. It would be relatively easy to ensure aperture limitation in an f/16, or even larger aperture, lens, especially if narrow band illumination is used. The MTF and TBF would then be accurately known, and the cone angle would be closer to the cone angles of operational lenses. Naturally, the thresholds could not be extended to very high target modulations, but this is not an important restriction for aerial photography. Larger apertures would be necessary to obtain even the lower part of the threshold for the finer grained emulsions, but f/5·6 would cover most requirements, and an aperture limited lens of this aperture would be perfectly practicable. If the threshold prediction technique remains in use, it would be much better to determine future thresholds for aerial photography using small lens apertures and correcting target modulation for the three bar functions, which could then be very accurately known.

8.5 *Accuracy of Prediction*

In spite of the common use of the threshold technique for predicting resolution, little systematic work seems to have been done, or at any rate published, on the degree of success achieved. Most of the evidence is indirect, such as the lens designer being tolerably satisfied with the correspondence between the values predicted from design calculations and the values measured on the manufactured lens. There seems to have been no extensive performance of the obvious crucial experiment, in which the MTF of a lens is accurately measured in a precisely known focal plane, using the exact spectral quality of light required to match the effective emulsion sensitivity, the resolving power measured with necessary refinements, again in the exact focal plane used for the MTF measurement, then the measured MTF intersected with the threshold and the measured and predicted resolving powers compared. In fact, it is doubtful if lens MTF's are yet commonly measured or even defined with the exactitude necessary for the proper performance of this experiment, which would certainly be very expensive to carry out. It would not be worth the trouble were it not that resolving power is so much used and relied upon.

Because of this lack of good evidence, it is not possible to give satisfactory data on prediction accuracy, which, like everything to do with resolving power, depends so much on individual circumstances. The most satisfactory comparisons have been done with aperture limited lenses simulating the operational lens, so that their MTF's were known with considerable accuracy. Under such conditions, the differences between predicted and properly measured resolving power did not exceed 15 per cent and were often much smaller. However, these were favourable conditions, with

symmetrical, "well behaved" images. Most of the more practical experience has been with good quality, rather narrow angle lenses, on axis or near axis; in general users of the technique seem satisfied, but again these were fairly good images. It is quite conceivable that greater differences could occur between prediction and measurement with wide angle lenses, whose off-axis images are considerably affected by asymmetric aberrations, which can affect the reading of resolving power in unpredictable ways. In general, one should not be surprised to find differences of 20 per cent between measured and predicted resolving power. In practice the difference is sometimes a good deal less, for reasons which are not clear, but presumably there has been a favourable balance of errors.

8.6 Calculated Thresholds

The emulsion threshold as so far defined represents the aerial image modulation applied to the emulsion in a bar target image when the developed image can just be resolved by visual inspection. Thus it has all the advantages and disadvantages of a resolving power measurement. It has been proposed by Williams,[7] that empirically determined thresholds be replaced by calculated thresholds which serve the same purpose but are free from uncertainties associated with resolving power measurement.

At first sight it may seem absurd to speak of calculating thresholds, since resolving power is a visually observed quantity, which tells us the smallest image of the target pattern we can recognise. However, we can argue on the following lines. Resolving power is a signal to noise limiting condition; we say a target image is just resolved when we can just recognise, above the granularity noise, the density pattern representing the target. Over a wide range of image sizes, the signal to noise ratio required for visual resolution is constant. The thresholds in Fig. 8.1 though determined empirically, can equally well be considered as lines of constant signal to noise ratio, in terms of image density difference relative to granularity. This being so, it is not essential to introduce the human observer at all. Now it happens to be an experimental fact that if one calculates, for various sizes of a three bar target image, the aerial image modulation which will give a developed image density difference whose value is twice the R.M.S. density deviation due to the granularity, measured with a scanning aperture having the area of one target bar image, the line joining these points also represents the empirically determined threshold points. But by specifying the threshold in purely physical terms by the calculation, it is freed from the uncertainties associated with the experimental determination of resolving power. All workers using the same data for MTF, gamma and granularity must obtain the same thresholds. At the same time, the resolving powers predicted by these calculated thresholds are not divorced from practical reality, because they come very near to the mean resolving power that would be obtained by a sufficiently careful experimental determination. It is of no significance that the resolving power derived from the calculated threshold may not be exactly the same as would be found experimentally. In fact it is difficult to define exactly what we mean by the resolving power of a system, except in statistical terms. The difference

199

between the value predicted by the calculated threshold and the mean of many experimental determinations is not greater than the spread among individual determinations. Granularity and MTF can be determined once for all by the emulsion maker, and we would be able to specify performance in universally repeatable terms, which nevertheless are essentially interchangeable with the long familiar resolving power figures.

These are essentially sound arguments, but the case suffers from the need to use the emulsion MTF, which as we have seen is sometimes in doubt. This would not matter if all users agreed to employ a "standard" MTF, but such agreement is unlikely. Given a satisfactory clarification of the emulsion MTF position, Williams' proposal certainly offers a very attractive approach to standardisation.

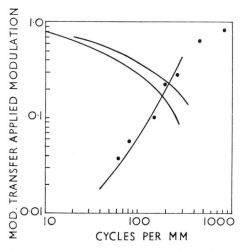

Fig. 8.5 Lens MTF and tri bar contrast transfer function, with calculated threshold and points for experimentally measured threshold

Williams stressed the necessity for using the tri bar function of the lens rather than its MTF, for accurate prediction. Fig. 8.5, from his paper, shows the MTF and tri bar function of a particular lens, with the calculated threshold for the SO 132 type of emulsion and points for the SO 132 threshold taken from Fig. 8.1. Clearly the assumption of a 2 to 1 signal to noise ratio has made the calculated threshold agree well with the empirical derivation over the important working range.

The proposal would naturally require a good deal of further investigation and extension to other emulsions and lenses.

8.7 *An Anomaly at High Resolving Powers*

Although the thresholds for negative materials in general are straight lines up to high target modulation values, Scott's thresholds show a decreasing slope above a

modulation of about 0·4. The effect is particularly marked for SO 243, for which the threshold is horizontal from 300 to 550 cycles per mm, an apparently impossible condition. There is a suggestion of the same effect in the Itek threshold for SO 132, but only at the very high modulations. Following up this observation, we recall that in the theory of resolving power it is assumed that the ratio of image density difference to effective granularity is constant, whatever the actual resolving power, for a given emulsion. If this is indeed true, then taking threshold data and multiplying the applied modulation M_1 by the appropriate value of the emulsion MTF T_e for each spatial frequency, the products should increase with spatial frequency up to the high contrast resolution limit. (The gamma can be omitted, being constant.) This does not always happen. Fig. 8.6 shows the products $M_1.T_e$ for the Itek thresholds and also for Scott's SO 243 threshold. For SO 243 and SO 132 the product does not increase above 300 cycles per mm, but actually decreases rapidly. For Tri X and SO 102 there is a suggestion of reversed slope, (SO 206 has a flat maximum) but SO 130 shows no departure

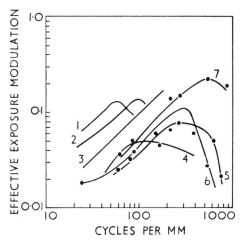

Fig. 8.6 Modulation in effective exposure images, derived from thresholds, showing anomalies at higher resolutions. (1) Tri X. (2) SO 102. (3) SO 130. (4) SO 206. (5) SO 132. (6) SO 243 (Scott data). (7) SO 132 Schade MTF)

from linearity. The full explanation of these phenomena is probably complicated, but one possibility is that the MTF's used do not really represent the behaviour of the emulsions at the higher frequencies. The MTF used for curves 5 and 6 was that published by the manufacturer for SO 132 and SO 243, but extrapolated beyond 300 cycles per mm (admittedly liable to error). However, if the MTF published by Schade for 4404 is used (curve 7) the product continues to increase up to a much higher frequency, and only begins to turn down at 550 cycles per mm. The possible significance of the MTF gains some support from the linearity of curve 3 in conjunction with the SO 130 MTF, which shows a tendency to level out above 100 cycles per mm. Another

possibility is the extreme non-linearity of the recording when measuring high contrast resolving power. The target bar images near the resolution limit are recorded at some moderate density, e.g. 0·8, to ensure maximum resolution, and the background luminance then lies well below the toe of the H and D curve, hence records as fog density only. Near the high contrast limit, the bar images are approaching the diameter of the line spread function. If we think of recording the spread function itself under these conditions, there will be a tendency for the lower intensity but broader base region to be cut off, and only the narrower peak to be effective, so that the emulsion would behave as though it has a superior MTF. (The actual light diffusion in the emulsion layer would of course remain linear.) If genuine, this effect could explain the turn down of curves 1 and 2, for which the MTF's are not likely to be in much doubt. Again, the multiplication of a bar target modulation by a one dimensional MTF breaks down as an indicator of image contrast when the length of the bar images approaches the width of the spread function.

Fortunately these effects do not affect the validity of the prediction technique, because we make no explicit use of the emulsion MTF in deriving or using the threshold. Our only assumption is that equal applied modulation will give equal resolving power (other reasons for querying this assumption are given in section 8.4). Moreover, the effects occur at much higher resolving powers than would be given by any lens for which we would wish to make a prediction. Nevertheless their existence does suggest a preference for this kind of threshold over the alternative grain threshold.

References

[1] HOWLETT, L. E., and CARMAN, P. D.,
[2] POWELL, P. G., *The Resolution Threshold of Photographic Materials for Sinewave Test Objects*, Report from Kodak Ltd., Harrow (April 1956). Ministry of Supply Contract No. 6/Inst/10622/ C.B.22 b.
[3] *Photographic Considerations for Aerospace*,
Itek Corporation, Lexington, Massachusetts. Page 68 (1966).
[4] SCOTT, F., *Phot. Eng.*, **10**, 49 (1966).
[5] SCHADE, O., *J. Soc. Mot. Pic. Eng.*
[6] WILLIAMS, R., Paper presented to S.P.S.E. meeting, Boston (June 1968).

IX. DETECTION, RECOGNITION AND SUBJECTIVE IMAGE QUALITY

9.1 *Introduction*

The history of image evaluation in aerial photography exhibits an intriguing counterpoint on the themes of objective and subjective image quality. Variations appear, disappear and re-surface according to the shifting emphasis in the appreciation that there can be no progress in accuracy without taking the human being out of image evaluation, and no confidence in its significance without putting him in again.

Subjective image quality, or "picture quality" has come to signify the value of the aerial photograph for conveying information to a human observer about the ground scene. This is to be distinguished from objective evaluation by some form of quality index based solely on physical variables such as the MTF or granularity. The subjective and objective scales should, desirably, run parallel. Certainly the subjective quality must be ultimately referrable to the physical variables, but the objective quality index is compounded of at least two variables which themselves are not necessarily describable by a single parameter, and it is not *a priori* inevitable that the desired parallelism will exist. The objective quality index is a necessity, since we cannot appeal to photographs for every change in the physical variables, but its validity as a guide to subjective quality can only be verified by experiments involving the examination of photographs. Nowadays, purely objective quality indices can be derived from the MTF and granularity, but for many years the only quality index, i.e. the only numerical scale of photographic image quality, was provided by resolving power. Notwithstanding the considerable subjective element in resolving power, great interest has always been taken in its agreement, or lack of agreement, with subjective image quality as seen in pictures. Investigations on this question have been made, both by comparing resolution with the detection and recognition of non-periodic targets, and by subjective evaluation of photographs of known resolving power. Scott[1] has used the term "Summary Measure of Image Quality" to signify the integration of physical variables into a single-numbered evaluation of subjective quality. Resolving power, although it includes more than physical variables, is certainly a summary measure, and is still more widely recognized than any other criterion in aerial photography. Its relationship to subjective picture quality therefore figures largely in this chapter.

Subjective quality, or picture quality, in aerial photography does not necessarily agree with the picture quality sought by a pictorial photographer. For instance, it is often desirable to print aerial photographs at a much lower contrast than would be acceptable to a pictorialist, in order to retain information in highlights and shadows.

In general, "subjective" distinguishes the quality experienced by human observers from the quality measured by some physical means. Psychologists sometimes object

to this interpretation, stressing that "subjective" means personal or individual rather than "human" in the wide sense. Their preferred description would then be "psycho-physical image quality". While appreciating the logic of this view, it does not seem to be universal. The dictionary is perfectly clear, but not helpful, since it tells us that "subjective" can legitimately carry both connotations. To conform to common practice, we shall take "subjective" to mean human as distinct from physical or "objective". An objective evaluation is not dependent on human interpretation or opinion, but relies solely on physical measurements or mathematical combinations of them.

Subjective image quality has the implication that the picture resembles something familiar, sufficiently closely that we can recognize it, or classify it, or agree that it is a picture of some unfamiliar object if the latter is available for comparison. This does not include the specialised skills of the photo-interpreter, who, having recognised the object, can go on to identify its functions or relationships to other objects. These statements are not fully satisfactory, since we sometimes deal with differences of degree rather than kind. In examining an image, a microdensitometer would record a certain spatial distribution of tones, any human being would recognise an assembly of pipes, but a photo-interpreter might identify an oil refinery. By itself, the microdensitometer could not recognise the refinery or even the pipes, but it might form part of a pattern-recognition system programmed to recognise a particular arrangement of pipes which would identify a refinery. However, the microdensitometer is then being given some of the human functions, combining scanning, recall of stored information, and comparison with the observation, which operate whenever anyone looks at any picture. There is no essential conflict with the basic difference between a measurement of a physical variable and the human utilisation of the information in an image. With regard to the photo-interpreter's skill, Scott (l.c.) has shown that photo-interpreters judge the subjective quality of aerial photographs in the same way as other people, and that the value of a picture for photo interpretation tasks runs parallel with its subjective image quality as judged by people in general.

Controlled experiments which permit observation of the subjective effects of known steps in objective quality can provide answers to numerous questions, in fact it is best to have some quite specific questions in mind when designing the experiments. Among such questions we could list: the least change in bandwidth of constant shape MTF's, detectable in pictures; the significance of changes in MTF shape; the correlation between resolving power and the detection and recognition of various shapes; the extent to which scale can be traded for resolving power; the general validity of various summary measures of image quality, and so on. Naturally, changes in physical variables must operate and be observed in an environment which is appropriate, realistic and representative of the relevant branch of aerial photography, and the imaging task must push the system to its limits within the range of the applied variations. It is difficult to investigate objective-subjective relationships by actual aerial photography, because of the near-impossibility of controlling the variables such as image movement, lighting, haze, etc., over lengthy periods of work. Flight testing can

usefully be applied to restricted comparisons of two or three systems which can be flown simultaneously. Large scale aerial tests can of course be arranged with statistical control and analysis, but the effort required is very great and it is usually more practical to work in the laboratory. This is essential when comparisons are required over a wide range of variations in one quantity, with many steps of variation, or in certain investigations which require relatively long exposure times.

Laboratory studies usually follow one of three lines: photography of simple geometrical shapes, of aerial transparencies, and of models. The first method, like resolving power itself, simplifies the aerial scene to two tone levels, and seeks correlations between bar target resolution, or physical criteria, and the detection and recognition of non-periodic detail. Thus it is confined to effects at or near the limiting size. The other two methods aim at a complete simulation of the sizes, shapes, contrasts, and luminance ranges of aerial scenes, thus providing a realistic environment within which the effects of changing various image quality parameters can be observed. This gives scope for observing differences at all sizes and not merely at the limit of detection or recognition.

Accounts of all such experiments are somewhat unsatisfactory; because of the expense and difficulty of adequately reproducing the original images the discussion is necessarily about numerical or graphical data, and the experience of the actual images cannot be directly communicated. Nevertheless, a great deal can be conveyed, and the technique and results of certain studies will be described.

9.2 Experiments on Detection and Recognition

9.2.1 INTRODUCTION. The earlier work in this area was done before the MTF had become very familiar, and when the work on acutance had cast doubt on the value of high contrast resolving power, which was commoner then than to-day, especially in the United States. The objective was to investigate the possible limitation of high contrast resolving power as an index of the ability to detect isolated objects of compact shape, and to distinguish between, or recognise, shapes such as squares and circles. More recent work has included a variety of resolving power targets.

Much of this investigation has been done with aperture limited optics, which provides exactly known MTF's of constant shape with any desired cutoff up to the point where the lens ceases to be aperture limited. The MTF shape is of course not representative of all of the possible MTF's or OTF's found for practical lenses, especially in off-axis imagery. However, the standardisation and easy reproducibility are very great advantages, and, as we have previously remarked, the MTF's of practical lenses can often be reasonably well approximated by aperture limited MTF's of chosen cutoff. The equalising influence of the emulsion MTF also helps to make the results realistic in many cases.

9.2.2 CARMAN–CHARMAN STUDY: EXPERIMENTAL PROCEDURE. Although the classic experiment was that of Macdonald and Watson,[2] we shall discuss the more recent study

of Carman and Charman,[3] which employed emulsions rather more representative of to-day's practice, included resolving power targets of different types and contrasts, and also determined the MTF's of the systems used.

The experimental setup was essentially the same as Macdonald and Watson's. A 35 mm camera with 128 mm f/4·7 lens was rigidly mounted and provided with stops giving apertures from f/25 to f/485. The lens was found to be effectively aperture limited over the whole of this range. Photographs were taken, at distances up to 150 metres, of a transilluminated target array, containing resolving power targets of various types, and circles and squares for detection and recognition. The resolving power targets consisted of:

> USAF high contrast three-bar
> Cobb 0·2 contrast two-bar
> Annulus 0·2 contrast.

Additionally, Cobb and annulus resolving power were determined at the very low contrast of 0·07 by giving flash exposures to the unobstructed opal glass of the illuminator after a reduced exposure to the 0·2 contrast targets.

The detection and recognition targets were of three log contrasts, 0·038, 0·15, and 0·29. For detection, eight circular targets 7·17 mm in diameter were distributed at random among 16 positions in a matrix, each target being separated from its neighbours by 5 cms., thus effectively representing isolated objects, in contrast to resolving power. The detection task, when examining the negatives, was to correctly indicate the presence or absence of a target at each of the 16 positions. For recognition, eight squares of equal area to the circles were added, thus filling all the 16 matrix positions with either square or circles distributed at random. The recognition task was to correctly indicate the presence of either a circle or a square at each position. The target arrays were photographed on Plus X Aerecon, Tri X, and Royal X emulsions, developed to gammas of 1·2, 0·65 and 0·9 respectively, using all the nine apertures, at a range of scales chosen so that the targets were completely recognisable or detectable in the largest scale negatives, and vanishingly so at the smallest scales. The detection and recognition negatives were examined on an opal glass illuminator at optimum magnification and luminance, by observers experienced in the use and interpretation of aerial photographs; the resolving power negatives were read under the same conditions by laboratory personnel. The detection and recognition negatives were read six times by at least four observers, and the numbers of correct indications for each negative were averaged and divided by eight to give a probability value P. P ranged from 0·5, representing pure chance, to 1·0, representing virtual certainty. The values of P were plotted against the reciprocal of the scale, and the reciprocal scale corresponding to P = 0·75 was arbitrarily chosen as the threshold for detection or recognition of each combination of aperture, target type and contrast, and emulsion. The diameters of the geometrical images of the just recognisable or detectable discs were then calculated from the scales and known test-target diameters. The MTF for each

206

emulsion-aperture combination was derived from microdensitometer traces of the image of a long low-contrast straight edge included in the target array.

9.2.3 CARMAN–CHARMAN STUDY: RESULTS.

9.2.3.1 *Detection and Recognition.* The detection and recognition capabilities of the systems were characterised by the reciprocal diameter of the just detectable or recognisable disc at the threshold value P = 0·75. In a system limited solely by diffraction, both this quantity and the resolving power would be directly proportional to the absolute aperture of the lens. Figs. 9.1 and 9.2 show the reciprocal disc diameters

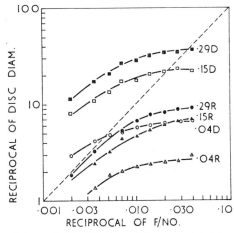

Fig. 9.1 Reciprocal of the diameter in the film plane of the geometrical image of the just recognizable or detectable disc at threshold (P = 0.75) for the lens-Royal-X system plotted against the reciprocal of the *f*-number of the diffraction-limited camera lens

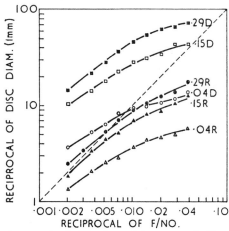

Fig. 9.2 Reciprocal of the diameter in the film plane of the geometrical image of the just recognizable or detectable disc at threshold (P = 0.75) for the Plus X Aerecon system plotted against the reciprocal of the *f*-number of the diffraction-limited camera lens

207

at threshold for Royal X and Plus X, plotted against the reciprocals of the corresponding f/numbers. (Results for Tri X were similar to those for Plus X.) We would not expect these systems to be diffraction limited over the whole range of apertures. At the relatively large aperture of f/25 (cutoff 65 cycles per mm) we should be nearing an emulsion-limited condition, at least for Royal X, in which the detection and recognition would be independent of aperture. At the very small apertures, the emulsions would contribute little to the image degradation and the limit would be set by diffraction. Thus we would expect the detection and recognition curves to be asymptotic to two lines, one at 45 degrees and the other parallel to the abcissa axis. The experimental results are broadly in agreement with these expectations. Figs. 9.1 and 9.2 show that the detection and recognition capabilities with Royal X are markedly less than with Plus X, as would be expected. In general the curves for detection and recognition, and for detection or recognition at different contrasts, do not run parallel, therefore no single parameter based only on the aperture can describe the results for all contrasts. The ratio of the disc diameters required for detection and recognition is not constant, but varies with aperture, emulsion, and target contrast. In general, however, recognition needs 2·5 to 5 times the scale that suffices for detection. One curious feature is that the 0·29 R and 0·04 D curves curves cross each other for all emulsions; as we move to larger apertures, detection of extremely low contrast objects is not improved to the same extent as the recognition of medium contrast objects. At first sight this seems strange; one might expect the effect of the improving MTF to be more noticeable on recognition, which requires finer detail discrimination, but would not detection also be improved? The effect can be explained in terms of the very low contrast and the granularity. On Royal X the detection curve at 0·04 contrast levels out at a disc diameter of 0·14 mm, no improvement in lens MTF making any smaller size detectable. At this diameter the random granularity density variations would be about

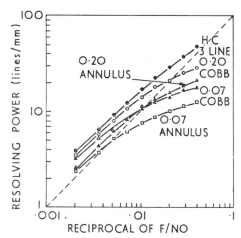

Fig. 9.3 Resolving power in the film plane for the lens-Royal-X system plotted against the reciprocal of the f-number of the camera lens

0·02, R.M.S.; this is sufficiently close to the target density difference for the observed threshold value to be understandable. A contrast of 0·29, however, gives a much greater signal to noise ratio, sufficient even for recognition at 0·11 mm diameter. At the lower end of the curves, where diffraction plays a greater part, the detail of the squares is evidently so weakened by the aperture limited MTF's that recognition falls away rather rapidly. Grain is then less pronounced, however, and detection is still possible down to smaller diameters, e.g. at 0·33 mm, the smallest detectable diameter shown for Royal X at 0·04 contrast, the granularity would be 0·008, well below the target contrast. (It will be remembered that the contrast reducing effect of the MTF is less marked for an isolated object.) Qualitative explanations on these lines could be devised for all the effects shown; exact quantitative explanations would obviously call for a very sophisticated approach, and it would still not be possible to put in the human factors affecting detection and recognition. Empirical studies such as these therefore perform a very useful function.

9.2.3.2 *Resolving Power.* The measured resolving powers merit some discussion apart from their relationships to the detection and recognition results. In Figs. 9.3 and 9.4 the resolving powers for Royal X and Plus X are plotted against reciprocal f/number for the five targets. (The Tri X results were again very similar to the Plus X.) With the high contrast three bar target the Plus X systems behave as though diffraction

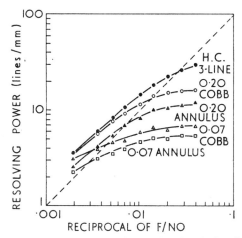

Fig. 9.4 Resolving power vs reciprocal f- number for the lens-Plus-X system

limited over much of the aperture range, but with decreasing target contrast the curves bend over, indicating the onset of emulsion limitation. Similar effects are shown by Royal X, with an earlier appearance of the emulsion limitation. It is very noticeable that the ratio of high contrast to low contrast resolving power is far from constant, depending on the target form and contrast, and on the emulsion. The three bar high

209

contrast and the 0·2 contrast Cobb targets give nearly the same resolving power in the diffraction limited region, but separate to a ratio of about 2 to 1 in the emulsion limited region. The annulus always gives lower resolving power than the Cobb target at equal contrast, the ratio being almost constant at 0·75. The 0·07 contrast Cobb curve crosses under the 0·20 annulus curve towards the emulsion limited region, again suggesting the effect of grain. In general we cannot find rules whereby the resolving power for one target can be derived from the resolving power found for some other target.

9.2.3.3 *Detection and Recognition in Relation to Resolving Power.* As the authors point out, in an ideal practical situation an improvement of resolving power by a factor N would allow us to reduce the scale of aerial photography by the same factor N without change in the quality of reproduction of ground detail. For this to be so, a plot of the reciprocal diameters of the just recognizable or detectable discs against the corresponding resolving powers would have to give a series of parallel straight lines at 45 degrees, on the logarithmic axes. But neither resolving power nor detection and recognition plot on straight lines against aperture, so resolving power and detection and recognition cannot be in any constant relationship. The question remains, as to which resolving power target gives the best correspondence with detection and recognition.

Figs. 9.5, 9.6 and 9.7 show the reciprocal disc diameters at threshold of detection and recognition for the various contrasts, plotted against resolving power for the USAF high contrast target, the 0·20 contrast Cobb target, and the 0·07 contrast Cobb target respectively. These graphs all relate to Plus X. The curves show that recognition is more nearly proportional to resolving power than is detection. This confirms what

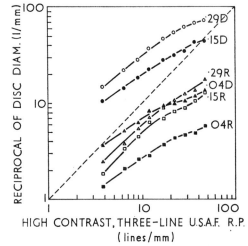

Fig. 9.5 Reciprocals of the diameters of the just recognizable or detectable discs at threshold (P = 0.75) for the lens-Plus-X system plotted against the high-contrast 3-line RP

210

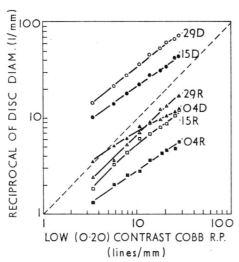

Fig. 9.6 Reciprocals of the diameters of the just recognizable or detectable discs at threshold (P = 0.75) for the lens-Plus-X system plotted against the low (0.2) contrast RP

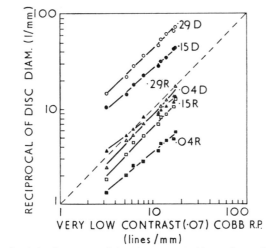

Fig. 9.7 Reciprocals of the diameters of the just recognizable or detectable discs at threshold (P = 0.75) for the lens-Plus-X system plotted against the very low contrast (0.07) RP

might be expected, since the act of reading resolving power is much more akin to recognition than to detection. In general the constancy of the relation between detection, recognition and resolution improves as the contrast of the resolving power target is lowered. With the three bar high contrast target all the curves have a slope markedly lower than 45 degrees, showing that with increasing aperture the improvement in detection and recognition lags behind the improvement in resolving power. The 0·2 contrast Cobb target still shows this tendency, to a lesser extent, but with the

0·07 Cobb target most of the curves lie quite close to a 45 degree slope. (The annulus targets gave very similar results.) However, when resolving power is measured at 0·07 contrast it still increases more rapidly than detection at 0·04 contrast.) 0·04 is of course an extremely low contrast, and detection of most of the details in aerial scenes would run reasonably parallel to resolving power at 0·07 contrast.

Similar relationships between resolving power, detection, and recognition, were found for the Tri X and Royal X films.

9.2.3.4 *The MTF in Relation to Detection and Recognition.*

Since the MTF is no more than an abstraction from the spread function, and takes no account of granularity, we would not expect to find any correlation between it and the detection or recognition of details in aerial photography, except over the small and artificial range in which grain is negligible. In this study the MTF was characterised by N_e, Schade's

equivalent passband, defined by $N_e = \int_0^\infty \frac{|T(k)|^2}{|T(0)|^2} dk$, where $T(k)$ and $T(0)$ are the values

of the MTF at spatial frequencies k and zero. A good feature of this figure of merit is that it minimizes the importance of the low level high-frequency regions of the MTF's, where the experimental results would be least accurate. On the other hand, the high frequency regions would probably have more effect on recognition, while the low frequency regions would have more effect on detection. Fig. 9.8 shows the plots of detection and recognition on Plus X film at the different contrasts against the N_e's calculated for the corresponding apertures. Clearly the equivalent passband would be quite unreliable as an index of detection and recognition at any contrast. This was

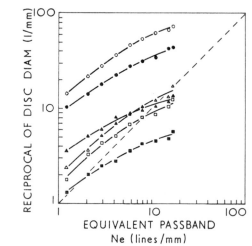

Fig. 9.8 Reciprocals of the diameters of the just recognizable or detectable discs at threshold (P = 0.75) plotted against the equivalent passband

also found for Tri X and Royal X. The authors add that other criteria derived from the MTF alone, or from microdensitometer scans made in the usual way with long slits, such as acutance or edge widths containing certain fractions of the density change, were equally unsatisfactory. While it would indeed be surprising if any criterion such as the MTF, whose definition specifically excludes granularity, gave satisfactory indications of image quality in conditions where granularity is a factor, this is useful confirmatory evidence based on actual human observations.

9.2.4 DETECTION AND RECOGNITION: GENERAL CONCLUSIONS. It might be thought a limitation of the Carman and Charman study, and other similar studies, that the objects were photographed at only one exposure level, whereas in real aerial scenes the detail is distributed through a range of luminances. However, this limitation is more apparent than actual. The range of luminances in aerial scenes, in conditions where detection, resolution and recognition differences have any importance, is quite small, say 5 to 1, and allowance can be made for the consequences of details being exposed on to different parts of the H and D curve. To have included this as an experimental variable would have lengthened and complicated the work and would have necessitated three-dimensional plotting. Some workers have included exposure as a variable, but without the wide range of other variables in the study under consideration. Their results do not conflict with the present findings, to the extent that the enquiries were common. It will be appreciated, however, that the Carman–Charman results could be modified if the negatives were printed on paper after being exposed to targets at markedly different luminance levels, because of the limited print density scale over which maximum image quality can be retained.

It is difficult to make any general prediction as to modification of the conclusions if the work were extended to include MTF's less "well-behaved" than the aperture-limited MTF's used. In general, the aperture limited shape probably gives rise to less difference between detection, recognition and resolution than the MTF shapes of actual aerial lenses having substantial aberration, but the constraints of system design normally enforce the use of an emulsion whose MTF weakens or eliminates the long low-level regions of the lens MTF. On the other hand, strong asymmetric aberrations near the edge of the field can give rise to marked asymmetric distortion of small image details, and with particular orientations and shapes greater differences between resolution and detection can be expected than are shown by the aperture limited results, It does not seem that we can anticipate the elimination of such aberrations when very wide angle cover is required, and it would be desirable to extend the detection and recognition studies to such cases.

Although resolving power, even at the lower contrasts, is not an exact guide to detection and recognition over the whole range of sizes studied, it should be appreciated that this was a wider range than is encountered in practical aerial systems. On Plus X, for example, the high contrast three-bar resolving power ran from 4 to 45 cycles per mm. In systems actually used for aerial photography we would be more likely to find, say, 20 to 50 cycles per mm for Plus X with this target. Over this restricted range the

differences in system performance as judged by resolution, detection and recognition, would be less marked than over the full range, which is justification for saying that in practice low contrast resolving power is unlikely to be misleading. If we can improve the resolving power of a system, its detection and recognition performance, hence its practical value, will also improve, though not necessarily to the same extent. Nevertheless, the differences are real. One of the consequences is that when resolving power is improved by an improvement in the MTF, scale cannot necessarily be reduced in the same proportion. Carman and Charman derived correction factors for this effect; these are discussed in 9.4.2.2, in relation to results obtained in model photography, which are in qualitative agreement with these detection and recognition experiments.

A common problem is the conversion of resolving power measured with one target to resolving power with some other target form and contrast; e.g. knowing the resolving power for the 0·2 contrast annulus, what would we find for the high-contrast three-bar? Again, a general answer covering the whole range does not exist. Even within the operational or practical range the ratio is not constant but depends on the target and the emulsion concerned. It would be quite unsatisfactory to assume any particular ratio when attempting to assess whether a system tested with one target contrast would pass a specification based on a very different contrast. However, one could make approximate estimates, close enough to decide whether actual testing would be justified. Over much of the range, the Cobb and annulus resolutions run almost parallel, at a separation corresponding to a ratio of 1·5, for Plus X at 0·20 contrast, for example. The ratio between the high contrast three bar target and the lower contrast targets is not even approximately constant, even over the restricted operational range; it would be necessary to estimate a conversion factor from data such as Fig. 9.3 knowing the level of resolution required.

Operational users of aerial photography often ask the question: "What resolving power is needed to recognize or identify an oil refinery, tank, aeroplane, automobile—etc?" Translated into ground scale, this is sometimes expressed as: "How many lines per object?" This another question to which there is no single answer, because recognition depends on so many factors in the system, the scene and its lighting, and the observer. For example, an infra-red system, because of its contrast enhancement in favourable circumstances, might well detect a water area at one-tenth the scale required by a panchromatic system of superior image quality. The recognition or identification of any complex object, such as a ship, must depend on the recognition or at any rate the detection of smaller units which make it up, and which in general will be simpler. The simplest possible objects are areas of uniform tone against a uniform background, as used in the detection and recognition work. No fixed relationship was found between resolution and detection or recognition. The model and transparency photography described later in this chapter provided examples of discrepancy between resolution and recognition in pictures when grain and MTF are widely varied. All one can say, by way of generalisation, is that for equal effective object contrast, detection can be done at sizes markedly smaller than the reciprocal of the resolved distance, while recognition is possible at sizes slightly larger than the resolved distance.

214

"Markedly" corresponds to a factor of about 2, but the actual value depends on the target type and contrast, as well as on the emulsion.

Some relevant evidence on this question of "How many lines per object?" may be found by departing from the strict context of the discussion. The details of typescript may be regarded as somewhat closer than squares and circles to much of the detail in aerial photography, although the high contrast constitutes a substantial difference. With this reservation we may note the resolving power levels established by the United States Bureau of Standards for different degrees of excellence in microcopying. Many years ago an empirical relationship was found between the resolving power, R, in cycles per mm; the reduction ratio, r; the height in millimetres, e, of the lower case "e" in the text being copied; and a quality factor, q. No subsequent work has shown any reason for serious change in this relationship, expressed by:

$$R = \frac{qr}{e}$$

If q is 3, the copy can be read, but with some difficulty, since the letters e, c, and o are partly closed and hard to differentiate. If q is 5, the copy can be read without difficulty, but serifs and fine details of the type are not clear. When q reaches 8, the quality is excellent, details being clearly reproduced. Again, in a study of systems in which the picture is built up by line-scans as in television, Scott[4] has found that for good identification of objects such as vehicles 13 to 20 scans per object are required. This could be interpreted as being equivalent to about 8 photographic lines or cycles per object, which is in the same order as the Bureau of Standards requirement for excellent recognition of typescript. These examples may help to establish the orders of magnitude involved; without reducing each object to an exact specification, with individual experimentation, it is hardly possible to be more specific.

9.3 *Photography of Transparencies*

9.3.1 INTRODUCTION. Although detection and recognition experiments can provide most, possibly all, that is needed for checking the reliability of image quality criteria applied to system design, they do not give the sense of complete satisfaction that comes from observing the effect of changing a physical variable in actual aerial photography. The photography of transparencies made from high quality aerial negatives is one way of closing this gap. It cannot be quite closed, because no pictorial simulation can imitate all the variables of real scenes and atmospheres, or even provide realistically wide angle of cover. Moreover, one is obviously limited to the scenes and lighting conditions available in accessible aerial negatives. The model technique discussed in the next section is not quite so restricted in the latter respect. Conclusions reached from transparency photography or any laboratory simulation must be condensed into test cases suitable for proving in actual flight.

The principle of the transparency method is that a large scale aerial negative, taken at a low altitude, or at any rate free from appreciable haze, with the finest possible definition, is printed as a diapositive, which is then re-photographed at a greatly reduced scale on the bench with controlled variations of image quality factors, to simulate their effects on aerial photography from high altitudes. Ideally the transparency should be at an overall gamma of unity. Its luminance range must then be reduced to simulate the effects of atmospheric haze at high altitudes. This can be most conveniently effected by adding uniform fogging light directed into the copying camera lens from a subsidiary illuminator by a beam splitter. The simulation of the high altitude view can be quite good for the haze condition corresponding to the original taking condition, but, at least in principle, realism must suffer when simulating widely different haze conditions. In the real scene, light of intensity L_1 is scattered downwards from the haze volume and illuminates the shadows diffusely, adding to any light reflected into the shadows by clouds and giving a certain contrast C_1, lower than in a perfectly clear atmosphere; this is the contrast seen by the low altitude camera. A camera at high altitude over the same area would see a further reduction of contrast to C_h, due to the uniform fogging light scattered upwards by the haze. If we add fogging light to the transparency so that its contrast C_1 is reduced to C_h, we have simulated the high altitude contrast of the original scene. If, however, we need some lower contrast than C_h, to simulate a heavier original haze condition, we can only vary L_h; L_1 is fixed in the transparency. Thus for a certain lower simulated contrast we shall have a greater proportion of upwards-scattered light than in an original scene of lower contrast, and the simulation is not quite correct. This is probably not a very vital limitation in actual experimental work, but should be appreciated. It is one reason why model photography is a superior experimental tool.

Since the contrast of the transparency has been reduced to the same order as a high altitude aerial scene, the copying can be done using standard aerial emulsions developed as in normal operational practice. The distribution of local contrasts throughout the tone-scale, as distorted by the haze light, is therefore seen and photographed with a close simulation of practical conditions. This technique is suited to the investigation of general principles rather than the comparison of actual aerial lenses, since it is applied at finite conjugates. Transparencies can of course be used in a collimator just like resolving power targets, but the angle covered is so small that realism suffers. For general studies nothing is lost by having to work at finite conjugates; apart from the use of aperture limited lenses, at small apertures, devices such as the use of obstructed apertures, or regular photographic lenses of appropriate correction, may be used to simulate any desired MTF. The essential condition is of course that the MTF measurement technique should be adequate to ensure that the MTF actually operative in the focal plane of the test-bench camera is accurately known. Granularity can be introduced as a variable by using different emulsions or changing the copying scale. One advantage of doing such experiments in the laboratory is that the ability to give long exposure times without movement allows the use of high resolution emulsions that might not be practicable in actual aerial photography; when the exposure times run

beyond a second or so, however, care should be taken that reciprocity failure does not cause the gamma to be substantially lower than in the normal use of the emulsion.

The negatives produced by the transparency technique will be examined under magnification in any case, but if also printed on paper or as diapositives, great care must be taken to ensure that the printing or enlarging process does not introduce losses which could completely mask the primary effects under investigation. Enlarging is a particularly dangerous stage. If the copying system's resolution is above 50 cycles per mm then no ordinary enlarging lenses will be satisfactory, and sectional enlargement in photomicrographic apparatus will be essential. The difficulty of the requirement can be seen by noting that if we have a negative resolution of 100 cycles per mm, then presumably we would prefer something like an 80 per cent response at this frequency for the enlarging lens. But this would involve an MTF of aperture limited shape cutting off in the order of 1000 cycles per mm, which is absurd in relation to enlarging lenses.

The quality of definition required in the low altitude negative depends on the scale of reduction on the bench and the orders of resolution to be studied, but in general it must be of the best standard obtainable. Clearly, the effective spread function of the transparency when reduced into the focal plane of the copying camera must be of negligible size relative to the spread function of any of the systems to be studied, "Negligible" is hard to define with greater precision, because it will depend on individual circumstances, but as a rough rule, the transparency should contain details which, when reduced into the image plane, are no larger than one fifth of the reciprocal resolution of the system being studied. Thus a transparency having detail as small as one twentieth mm would allow investigations at 100 cycles per mm if reduced by a factor of 25 in the copying camera.

In evaluating the subjective quality of pictures, the general approach is to grade them into rank order by direct comparison with the original transparency, the only criterion being the success with which information about the scene has been recorded. The variables will usually be MTF and grain, and extreme precautions must be taken to avoid judgements about micro quality being confused by unwanted variations in macro density and contrast. Most observers find it very difficult to given an unbiased opinion about information content in a picture if accompanied by a noticeable difference of tone reproduction. It is by no means easy to produce prints or transparencies of the requisite constancy in macro quality, and the same care is needed as in high grade sensitometry. Observers should be cautioned to avoid any swaying of their judgement by impressions of excessive grain or blurring, or lack of interest in the scene, such as might influence pictorial opinions.

Original aerial negatives are also used to make positives of varying image quality by a different technique,[5] in which the definition is lowered in a controlled contact printing method involving a shaped light source whose dimensions and distance, in conjunction with the separation between the negative and the printing material, determine the effective spread function. This method has greater flexibility, in that spread functions and hence MTF's of any shape can be simulated without the problems

of MTF measurement on lenses and adjustment to meet the requirements of the experiment. For example, the spread functions corresponding to image motion and asymmetric aberrations can be simulated with less difficulty than they can be produced experimentally. This method has considerable advantages when it is not necessary to work at a specific level of resolution with given emulsions and lenses, but rather to establish general principles.

9.3.2 INVESTIGATIONS USING TRANSPARENCY COPYING METHODS

9.3.2.1 *Introduction.* Several investigations have been made with these techniques, but we shall restrict ourselves to two which seem to bear most closely on aerial photography. The first, using the printing technique, is a very full and thorough study by Scott,[1] which is of interest because it makes no reference at all to resolving power, but deals solely in terms of the MTF and granularity. The other is a shorter experiment using the method of photography on the bench.

9.3.2.2 *Investigation by Scott.* Scott's investigation dealt essentially with three questions, the least significant change of MTF, the effect of grain, and the relationships between the subjective judgements of general observers and the information extractable from photographs by trained photo interpreters. Positive transparencies with Gaussian spread functions were made from aerial negatives of four scenes, all at the rather large scale of 1:3000. The paper does not state whether haze light was added; the inference is that it was not. Each of the four aerial negatives was transformed into 17 transparencies of progressively worsening definition, all being effectively grainless. The MTF's being Gaussian like the spread functions, all had the same shape. They were characterised by the parameter k_u, the spatial frequency at which the modulation transfer factor was 0.61. The k_u values ranged from 2.00 to 0.21 cycles per mm. (These values are of course far below those in good aerial photographs, but this is no limitation, since the objective is merely to establish principles.) Thus the definition was changed by steps of $\sqrt[5]{2}$ (15 per cent). The transparencies were judged by 30 observers, 18 of whom were technical personnel used to viewing aerial photographs, and 12 were trained photo interpreters. All were specially cautioned to order the pictures of each scene according to their estimate of its excellence for transmitting information, without bias by aesthetic considerations. Relatively few differences occurred in the rank ordering; errors were never greater than one place in the sequence: statistical analysis revealed no significant differences between the four scenes, nor between the errors made by the photo interpreters and other observers. It was inferred that the 15 per cent steps were too large to establish the least discriminable step in MTF, which was probably more like 5 per cent. When the experiment was repeated in a form which involved the ranking of different scenes, no significant differences were found. From statistical analysis of the combined results it was concluded that both photo interpreters and viewers who are not professional interpreters can distinguish the spread functions of grainless photographs with ten per cent sensitivity, and that

equally satisfactory judgements could be obtained in any time longer than about ten seconds.

The study was then extended by adding transparencies into which various degrees of granularity had been added during the printing, at different k_u levels. Four had σ (D)'s of 0·22, at k_u values of from 2·00 (sharpest) to 0·37 (most blur); four had σ (D)'s of 0·48 with the same range of k_u; three had σ (D)'s of 0·75 with k_u from 2·00 to 0·65.

A "normalised granularity parameter", P, was defined by

$$P = k_u.\sigma (D)$$

An interpretation of this is that the product quantifies the granularity in relation to the blur. When k_u is small the definition is inevitably poor and the limitation of a given amount of granularity is less than when k_u is large and the definition is potentially good. In any given case, grain will reduce the subjective image quality. It was postulated that the subjective information value of a picture with grain can be equated to that of a grainless picture of lower k_u. Then a "dimensionless quality reduction factor", DQRF, is defined as:

$$DQRF = \frac{k_u \text{ of grainless photograph having same quality as a grainy photograph}}{k_u \text{ for the grainy photograph subjectively matching the grainless photograph.}}$$

In the absence of grain, the DQRF is equal to unity, and it diminishes with increasing grain.

The transparencies were viewed by 39 observers, who were asked to match each grainy transparency for information quality against the set of 17 grainless transparencies of one scene arranged in k_u order. In Fig. 9.9 the DQRF is plotted against P for viewing of the same scene and of different scenes; granularity increases to the right. Clearly there is a large spread in the DQRF's, increasing on the whole with granularity, and worse for many scenes than for one scene. The greatest spread amounts to a difference of 5 to 1 in the DQRF, i.e. in the extent to which grain has "spoilt" the pictures, evaluated by their equivalent grainless matches. However, these data points were averaged and plotted along with similar data from an earlier experiment, as shown in Fig. 9.10. The agreement between the two sets of data is remarkable.

The third stage included a true photo interpretation exercise. 32 professional photo interpreters were each given four transparencies, each of a different scene, with a list of ten questions for each scene, dealing with the nature, number and dimensions of objects shown. These photo interpreters had not previously seen the transparencies nor taken part in the experiments. The answers were scored for correctness on a scale from 0 for zero correct replies to 1·0 for all correct replies. The sums of the scores were reported as percentages. The per cent correct responses were then plotted against the subjective image quality of the transparencies. For grainless examples, subjective quality was defined as simply the k_u value; for grainy examples, the k_u value multiplied by the DQRF, as found from previous evaluation of subjective quality. Fig. 9.11

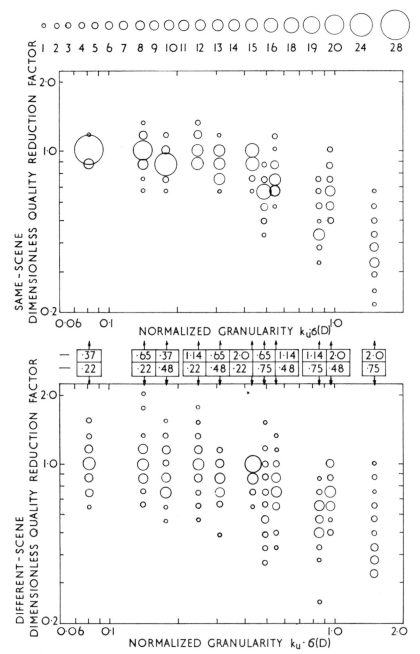

Fig. 9.9 Dimensionless quality reduction factors as a function of normalized granularity for same scene (top) and different scenes (bottom). The number of coincident data points is represented by the size of the circles, as given at top of figure. The data points are at the centres of the circles

shows the plot of per cent correct responses against subjective image quality, for the four scenes, including both grainless and grainy transparencies. Again there is a very large spread, but a general tendency for correspondence between subjective quality as judged by experienced subjects, not professional photo interpreters, and success in an actual photo interpretation task. It was concluded, from the averaged data and the standard errors of the means, that the correlation was good. Scott's study therefore established a number of important points, viz., that observers, either trained photo interpreters or technical staff used to viewing aerial photographs, could distinguish

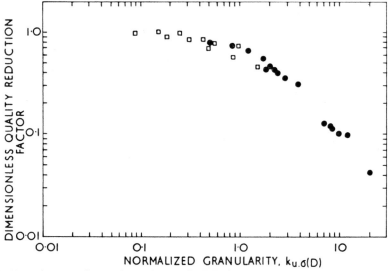

Fig. 9.10 Mean dimensionless quality reduction factors of same scene and different scenes combined as a function of normalised granularity of second experiment (open points) and earlier data (closed points)

differences of definition, in grainless transparencies, corresponding to less than 15 per cent changes in the MTF; that the effect of granularity could be expressed, at least for the conditions of this experiment, as an equivalent reduction in MTF; and that subjective image quality evaluated without specific photo interpretation tasks, correlates with success in actual photointerpretation.

9.3.2.3 *An Experiment With Transparency Photography.* Though performed several years ago,[6] this experiment is worth describing because it illustrates and links together a number of significant points about the MTF, resolving power, and subjective image quality. It was largely exploratory, as little was known at that time about various relevant factors, such as the sensitivity of the eye to MTF changes, the variation of emulsion MTF's with exposure level, and the accuracy possible in measuring lens MTF's. As is the case with most experiments, a repeat would be desirable, with closer

221

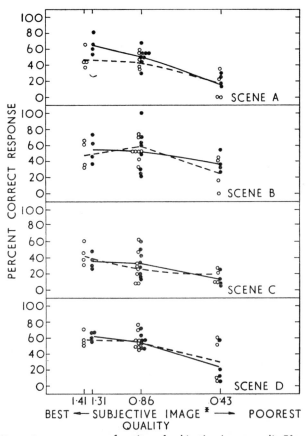

Fig. 9.11 Percent responses as a function of subjective image quality for each scene

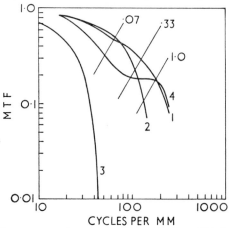

Fig. 9.12 Lens MTF's in Transparency Experiment. (1 = f/6. 2 = f/11. 3 = f/40 .4 = obstructed aperture f/6

control of many variables. The experiment is also of some interest because, though performed in a different way, at a much higher level of negative resolution, it is in broad agreement, where comparison is possible, with the results found by Scott.

The transparency was made from a negative exposed over a town at 1000 feet with a 6 inch survey camera. Definition was judged adequate, since a low contrast periodic pattern (corrugated roof) was clearly resolved at 15 cycles per mm, and, among more natural detail, the arms of a cyclist could be distinguished from the handlebars. The reduction factor was \times 20, giving a copy scale of 1:40,000, typical of much high altitude photography. Haze light was added to bring the overall luminance range down to $4 \cdot 5$ to 1. Resolving power targets of 1000 to 1 and 2 to 1 contrast were included, but did not receive the haze light. The detail in the transparency was not quite as fine as could have been desired, but was probably adequate. High contrast resolving power of 200 cycles per mm was obtained with some of the systems investigated, indicating a need for a minimum preferred detail size of one fiftieth mm. However, within the transparency area, after the contrast reduction due to the haze light, the resolution was well below 200 cycles per mm, and the detail size was probably adequately small. Certainly none of the copy negatives came near to reproducing the finest ground detail shown in the transparency.

The copying emulsion was SO 243, developed to a gamma of $2 \cdot 0$. The evaluation was done first on the negatives, then on \times 30 enlarged diapositives. Laboratory staff performed the subjective judgements, paying attention only to information transfer. The camera was of special design to ensure perfect film flatness over the image area (1 cm circle). A 6 inch f/6 lens of special design was used, approximating to aperture limitation at f/8, and below, in narrow band green light. Exposures were made at f/6, f/11, f/40, and f/6 with a central obstruction designed to depress the MTF at intermediate frequencies and simulate the MTF's of typical aerial lenses. At f/6 the resolution was above the Rayleigh limit, but as we have seen, this does not guarantee aperture limitation at all frequencies. Measurement of lens MTF's out to 200 cycles per mm and beyond presents difficulties; the curve I in Fig. 9.11 represents the best estimate after using 3 different methods. Figs. 9.12 and 9.13 show the lens, and lens-film, MTF's, on log co-ordinates. Fig. 9.14 shows the lens-film MTF's on linear coordinates. The dramatic effect of the film MTF in reducing differences at the higher spatial frequencies is shown by a comparison of Figs. 9.12 and 9.13.

The ranking by subjective judgements produced no disagreements, among three observers used to examining aerial photographs. As would be expected, MTF 3 (which had been included for a different purpose) was easily judged the worst. The interest centres mainly around the other three MTF's. Although the film had so greatly reduced the difference between lens MTF's 1 and 2, a difference of picture quality could be seen in the negatives. The differences are more marked at the higher frequencies, but this result is in qualitative agreement with Scott's conclusions. MTF 4 extends to higher frequencies than 2, yet its picture quality was markedly inferior, and it is interesting to consider the reasons for this. In Fig. 9.12 the resolution thresholds for SO 243 emulsion have been drawn, for target modulations of $1 \cdot 0$, $0 \cdot 33$, and $0 \cdot 07$. Actual resolving

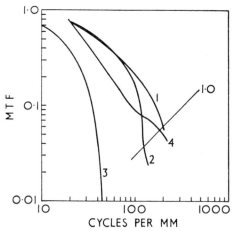

Fig. 9.13 Lens-film MTF's in transparency experiment, numbers correspond to Fig. 9.12

power measurements for the $1 \cdot 0$ and $0 \cdot 33$ modulations were in reasonable agreement with the threshold intersection values. At high contrast, MTF 4 gives substantially higher resolving power than MTF 2; at $0 \cdot 33$ contrast, this is reversed. However, the small difference of resolving power, 10 per cent, at $0 \cdot 33$ contrast, was felt to be out of scale with the substantial picture quality difference. A somewhat greater resolution difference is shown at $0 \cdot 07$ contrast, where the MTF's are further separated, but the ratio is still not very great. Now the essential difference between the MTF's above the

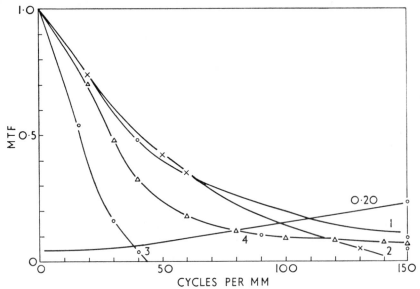

Fig. 9.14 Lens-film MTF's in transparency experiment, with grain thresholds. Numbers correspond to Fig. 9.12

crossing point is the generally higher level of 2; in the pictures the chief impression was of a generally higher level of micro contrast stretching over a wide range of image sizes. The area under the MTF, which is also a measure of micro contrast, has often been suggested as an index of image quality. It does not seem appropriate, in a photographic system, to consider the whole MTF, because that part below the grain threshold can hardly be significant. In this case grain was not a major limiting factor. However, in Fig. 9.14 the MTF's of Fig. 9.13 are replotted on linear scales, with a grain threshold for an object contrast of 0·2. This is not intended to be more than a schematic demonstration of the relative effective areas of the MTF's when the low-level tails are cut off by a grain threshold of some sort. While one should not take this frequency domain plot as a literal indication of what is seen in pictures, it is worth noting that the area of MTF 4 above the threshold (or above any low contrast threshold) comes about midway between the corresponding areas of MTF's 2 and 3, and this was felt to be in qualitative agreement with the subjective impressions of relative picture quality.

The significance of the MTF area can also be demonstrated in a different way. In making the subjective judgements it had been noticed that much of the detail examined consisted of isolated bars or other objects rather than periodic patterns. The contrast response for a bar of a given width is proportional to the common area between the MTF and the sin X/X spectrum of the bar, at image scale. The single bar contrasts were therefore calculated, over a range of bar image widths, for the MTF's 2 and 4, and these are plotted in Fig. 9.15. Being a spatial presentation, this gives a better idea of the relative image qualities, or at any rate the micro contrasts, for a range of image sizes. No grain threshold is included in this graph, but the curves do not cross, and clearly MTF 2 is superior over the whole range of sizes. Naturally, for very large sizes the MTF's would be equally good, and for extremely small sizes they would again be equal, or equally poor. But 2 is better than 4, even for images whose width is less than the reciprocal of the cutoff frequency of the lens. The pictures agreed with this deduction; 2 was much better even on details whose geometrical images were in the order of 3 microns. This is important, since it is sometimes thought that reproduction of small details is equivalent to reproducing high frequencies. Here the MTF with the higher cutoff frequency is inferior on the smallest details. The reason for this apparent paradox lies in the very low level of modulation transfer of MTF 4, below the grain threshold over much of the high frequency region. This region therefore can make little or no effective contribution to the image contrast. The response at lower frequencies is well below that of MTF 2. The latter MTF can therefore give greater contrast on small details, even when their Fourier spectra extend well beyond its cutoff. Admittedly the shape of the details cannot be well reproduced, in absence of the defining higher frequencies, but it may be better to see a detail in distorted size and shape than not to see it at all.

This experiment therefore established that the high contrast resolving power test could be quite misleading when comparing systems having crossing MTF's, on detail of mainly low contrast. In a sense this was not new, indeed it recalled the famous

225

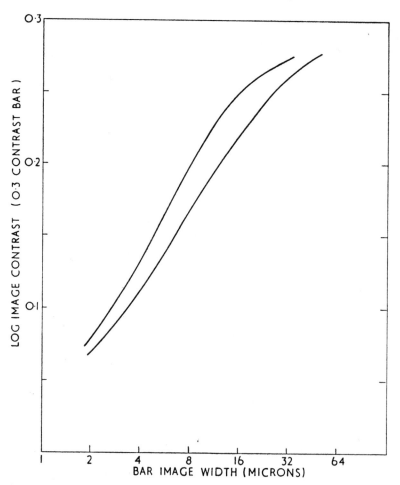

Fig. 9.15 Single bar contrast responses for the lens-film MTF's 2 & 4 of Fig. 9.13

Higgins–Jones experiment that introduced acutance. (That was before the days of MTF's, but one may assume that the lens with heavy spherical aberration used in the acutance experiment had a long tailed MTF like MTF 4 in the present study.) The qualitative superiority of low contrast resolving power was confirmed. As another way of looking at both these facts, the useful part of the MTF was seen to be the part above the threshold. While low contrast resolving power certainly placed the systems in right relative order, it did not separate them by as much as the picture quality suggested. This may have been due to the relatively low level of granularity that was effective; the emulsion was not being used to more than half its maximum resolving power at any contrast. The experiment also appeared to demonstrate the important of a good response across a wide range of intermediate and low frequencies, since this

governs the micro contrast and is important in the detection of low contrast detail over a wide range of sizes above and below the resolution limit.

A very significant point was that under appropriate magnification the eye could detect differences of picture quality due to lens MTF differences in the region of 100 to 200 cycles per mm, which were difficult to measure by physical means, in the sense that the agreement between different lens MTF measuring techniques was not very satisfactory.

9.4 *Photography of Models*

9.4.1 INTRODUCTION. Model photography offers advantages over transparency photography, admittedly at far greater cost. The problem of image quality in the transparency does not exist; the model details are always perfectly sharp. The lighting angles can be varied to simulate different solar altidudes. The balance of the upwards and downwards scattered haze light can be adjusted at will in the simulation to imitate any natural condition. The three dimensional model allows stereoscopic evaluation. By altering the balance of the light from "sun" and "sky", any natural condition from full sunlight to heavily overcast can be introduced. Colour photography of a colour transparency is not very satisfactory, but can be successfully applied to a model. In general, the model technique, if adequately worked out, can do all that the transparency technique can do, but provides additional variables and realism with which the behaviour of systems in various operational environments can be studied.

In general, aerial cameras as such are too large, and the conjugates too small, for use on model photography. However, the smaller type of reconnaisance camera, with focal lengths of three inches or thereabouts, could be used with appropriate refocussing, at conjugates of fifty feet or so. The more usual approach is to simulate the MTF of the required systems with very short focus lenses, such that the ratio of image detail size to spread function diameter is the same as in the use of the operational system in actual aerial photography.

The general philosophy of simulation by model photography should be explained. The intention is not to delude observers into thinking that the pictures are of a real scene, though this sometimes happens. The model performs a function rather like that of the standard subjects formerly used by some photographic manufacturers for practical yet controlled evaluation of their products. The essential need is for an assembly of three-dimensional objects which are broadly similar in shape, reflectance, and size-frequency distribution to those found in full-scale scenes, and can be photographed under similar lighting conditions. Thus the simulated aerial camera systems are presented with tasks which broadly correspond to those of their full-scale counterparts in actual aerial photography, including all the essential elements of size-spectrum, reflectance, and luminance ranges, relief, texture, and wide variety of luminance differences, gradual as well as abrupt, which enter into picture quality and photo-interpretation. The model itself is the reference for the evaluation of picture quality.

227

Nothing much is either lost or gained if the pictures suggest a model, or, on the other hand, deceive an observer. This is a midway position between a three-dimensional version of the single-sized squares and circles (such as Macdonald originally used) and an absolute facsimile at reduced scale of some real scene. One of the important requirements is a sufficiently broad size-spectrum. This imposes a minimum practicable scale factor. In practice 1:100 is about the smallest scale at which the necessary range of sizes can be provided. Unfortunately this means that a useful area of "ground" requires a large floor area. A model constructed by Bertil Okeson of Itek Corporation (Plate 2) had a scale of 1:87, so that sixteen feet square represented roughly one-third of a mile, a relatively small cover in aerial photography, which nevertheless contained a great variety of objects. This model was housed in a theatre and photographed from a height of fifty feet above the stage. The lighting consisted of a large collimated beam to simulate the sun and banks of diffused floodlights to simulate the dome of the sky. By altering the sun-shadow ratio, and reflecting fogging light up into the camera, any condition of sunlight or overcast, clear or hazy, could be simulated.

Model photography can be used for many studies relevant to aerial photography, e.g. basic research on image quality, effects of lighting and haze, choice of optimum lighting conditions for photography of specific scenes, mensuration and stereo investigations, photo interpreter training, automatic recognition, change detection, etc. It would not be practicable to describe all these uses, and in view of the present context we shall restrict ourselves to an account of one experiment which could hardly have been carried out by any other technique

9.4.2 EXPERIMENT ON GRAIN AND LENS LIMITATION.

9.4.2.1 *Description.* A given resolving power can be obtained by different combinations of MTF and granularity. If, in the design of aerial systems, we have any choice, is it better to aim at a good MTF combined with a high granularity, or achieve the same resolution with a lower granularity and a poor MTF? There is evidence from work by Romer,[7] and the Carman Charman study previously described, that the low granularity system is better when detail contrast is extremely low. In practice the designer does not have much choice, since the necessity for brief exposure times forces the use of emulsions of relatively high speed, and this fixes the granularity within fairly narrow limits. Nevertheless, there has always been a belief in the aerial photographic community that, for a given ground resolution, better interpretation quality is found at larger scales, i.e. in effect at lower granularities. Katz[8] has translated this feeling into the statement: "Goddard's Law, Rule One: There is no substitute for focal length". This again suggests that limitation by MTF is better than limitation by grain. Although the operational constraints tend to make the question somewhat academic, it is obviously desirable to clarify the principles by actual experiment involving visual judgement of pictures, and the model technique was applied, to produce simulated aerial photographs of equal resolving power in the ground plane but having a very different balance of granularity and MTF blur.[9]

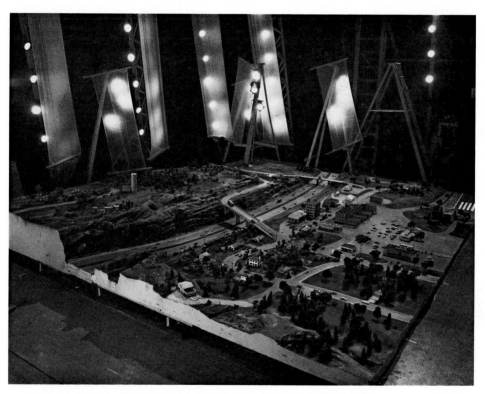

Plate 2. Model scene for simulated aerial photography

Plate 3. (a) Grain limited and (b) lens limited photographs of part of model

Because of the scale requirements, only a small part of the model could be used, as shown in Plate 3(a) & (b). However, there was ample detail for a realistic test. The overall scene luminance was set at 3 to 1, which is lower than the average for clear high altitude scenes, but higher than is found on very hazy days. A three bar target, of contrast 3 to 1 (modulation 0·5) as seen through the "haze" provided resolving power data. Two sets of photographs were taken on SO 243 film, one set with a 16 mm microscope objective (infinity corrected) at an equivalent scale of 1:87,000, the other with a 90 mm regular camera lens at an equivalent scale of 1:8700. When enlarged to the same scale (enlargement respectively 156× and 15·6×) the first photographs are mainly grain limited and the second set mainly lens limited. It is not possible to make a purely grain limited photograph, even with perfect optics, because the emulsion MTF always causes some blur. In this small scale negative the lens MTF approximated to that of an aperture limited f/2, which at the observed resolution limit of 220 cycles per mm has a value of about 0·6. At this spatial frequency the MTF of SO 243 is 0·25, and its granularity, for an aperture $2·5 \times 12·5$ microns, is about 0·06. Certainly grain is very prominent when looking for image detail. The large scale negative was taken at f/60, and at the resolution limit of 22 cycles per mm, which was close to the lens cutoff frequency, the emulsion MTF was 0·8, i.e. this was a mainly lens limited condition. The granularity of SO 243, for an aperture of 25×125 microns, is about 0·006, i.e. equivalent to a vanishingly small contrast at the resolution limit, hence granularity is a negligible factor, as the pictures show. In the original enlargements the resolving powers are equal in terms of ground scale, within the limits of subjective agreement for such different images, but the picture quality is much better in the low grain example. The difference is so great that it will probably show in the half tone reproductions.

While the superiority of the low grain picture, in spite of its equal resolving power, is undoubtedly associated with the fact that most of the detail is of lower contrast than the resolution target, a more detailed analysis is necessary, and for this we shall make use of the threshold technique for estimating resolving power.

In Fig. 9.16, curve 1 refers to the small scale image and is a graph of the product $M_t T_1 T_e \gamma$, where M_t = target modulation (0·5) T_1 = MTF of lens (16 mm f/2 objective) T_e = MTF of emulsion (SO 243) and γ = development gamma, (1·5). Thus curve 1 approximately expresses modulation versus spatial frequency in the developed image. Curve 2 is a grain limited threshold for SO 243, i.e. a graph of the developed image modulation required to make a three-bar target image just recognisable at any spatial frequency. It is derived from the regular thresholds discussed in Chapter VIII.

The intersection of curves 1 and 2 indicates a resolving power of 220 cycles per mm, which also happens to be the experimentally determined resolving power, but there is no special significance about this agreement because the data are not known very exactly. The negative resolving power is converted into ground resolution in the model plane by scaling, giving 5·5 cycles per inch.

In the large scale picture, T_1 is the aperture limited MTF for f/60, cutting off at 25 cycles per mm. M_t and gamma are the same as before; T_e is nearly 1·0. In Fig. 9.16, curve 3 is the large scale MTF and curve 4 is the threshold; the spatial frequency scale

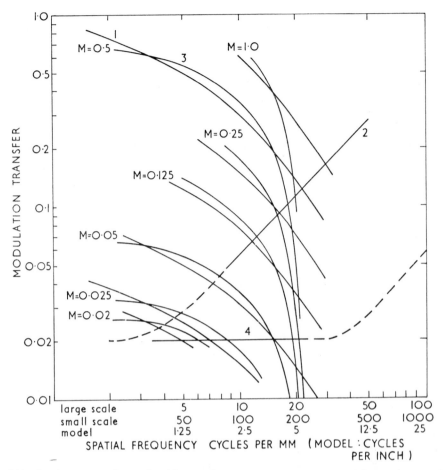

Fig. 9.16 Resolving power for small and large scale systems at various target modulations (see text for explanations of curves 1, 2, 3 and 4)

at the image plane has been shifted one decade to the right, so that the ground resolutions for both small and large scale images can be displayed on the same scale of cycles per inch (lowest scale in Fig. 9.16). Resolution is now determined by the intersection of curves 3 and 4, and occurs in the grain free region where resolution is determined by gamma and the contrast sensitivity of the eye. A value of $0 \cdot 02$ was assumed for the latter, but clearly the conclusions are not critically dependent on the actual value.

The variation of ground resolution with contrast for the two systems may conveniently be studied by moving curves 1 and 3 together to different modulation levels and observing the threshold intersections; this has been done in Fig. 9.16 for modulation values of $0 \cdot 5$, $1 \cdot 0$, $0 \cdot 25$, $0 \cdot 125$, $0 \cdot 05$, $0 \cdot 025$, and $0 \cdot 02$, and the results are plotted in Fig. 9.17 as the ratio of large-scale to small scale ground resolution. Although the

resolutions are equal at a modulation of 0·5, and the large scale system is inferior at high modulations, it is superior for all modulations less than 0·5. Fig. 9.17 also shows an approximate averaging of the Carman and Carruthers data for frequency of occurrence of contrasts of various values in aerial views of cities, observed from 4000 feet in clearer conditions than were simulated for the model photography. The general correspondence of the peaks is interesting.

The superiority of the grainless system for reproduction of low contrast aerial scenes can be explained by reference to Fig. 9.16. As target modulation is lowered from 0·5, the intersection of the steeply falling curve 3 with its horizontal threshold hardly changes until modulation falls below 0·1. The less steep MTF of the small scale picture, however, moves rapidly down its 45 degree threshold, and its resolution correspondingly falls further and further behind. However, the intersection is moving up curve 3 towards its less steep region, while eventually the small scale MTF curve comes off the grain limited part of its threshold, and the resolutions draw together again. Going from 0·5 to higher modulations, the intersection of curve 3 and its threshold cannot move appreciably to the right, but curve 1 is still on the 45 degree threshold slope and finishes at a high contrast resolution of 300 cycles per mm. While the picture resolutions were equal only at a modulation of 0·5, which is a good deal higher than the common "low contrast" of 0·2, Fig. 9.17 shows that even at 0·2 the difference is

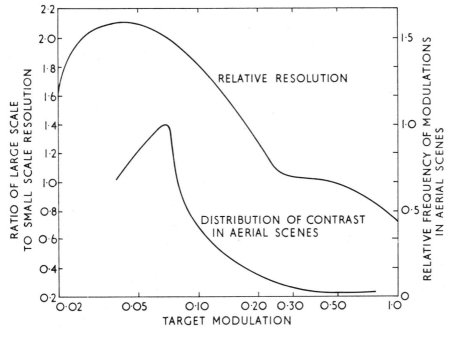

Fig. 9.17 Relative ground resolution as a function of target resolution

231

only 30 per cent, compared to a factor of 2 at the contrasts most representative of aerial photography.

9.4.2.2 *Discussion.* Clearly this experiment bears on the question asked in 9.2.4—"If resolution increases by N, can scale be reduced by N without loss of information?" A glance at Plate 3 is sufficient for a negative answer. We increased resolution in the image plane by 10 and reduced scale by 10, but the result was a great loss of information about the scene. Admittedly the resolution test referred to was done at a target modulation of $0 \cdot 5$, which we know to be too high, but Fig. 9.17 shows that even at $0 \cdot 07$, which is more representative of the contrast of aerial scenes, the small scale picture would still have been predicted to be half as good as the large scale one. Is Plate 3 (a) half as good as 3 (b)? Obviously this is an unsatisfactory question; we can only answer—"Good for what?" If we mean "for resolution of tri-bar targets of $0 \cdot 5$ modulation", then (a) is if anything a little better. If we mean the faithful reproduction of subtle tones and very low contrast details that give realism to subjective impressions of the scene, then (a) does not even enter the competition. We can only get exact answers to exact questions. No single evaluation criterion can provide answers for all situations, and it is hard to say what we mean by one picture, which is a complex of situations, being half as good as another. However, it is reasonable to ask if there is any possibility of getting results subjectively equal to (b) from negatives of intermediate scale and resolution. For example, if the scale of (a) is doubled and its cycles per mm for $0 \cdot 5$ contrast halved, will the picture quality then be equal to (b)'s? Further experiment showed that it would not. Enlargements from negatives having these characteristics were superior to (a) but not equal to (b). More work would be necessary to provide adequate and convincing evidence of the permissible reciprocity between optical blur and granularity, but it does not seem likely that resolving power at any contrast will be a fully reliable index of subjective picture quality when this reciprocity is stretched to its limit.

Fortunately, in practical systems other constraints free us from worry about scale and resolution interchanges in the order of 10 to 1 or even 5 to 1. Just where low contrast resolution would begin to lead us astray is hard to predict, but from the limited further experiments mentioned it seems that we might be safe within a reciprocity of 2 to 1, which would probably cover all practical cases.

At first sight these conclusions conflict with the Carman and Charman detection and recognition study, which appears to show good correlation between resolution at $0 \cdot 07$ contrast and detection and recognition at all contrasts. The exception was detection of extremely low contrast objects, which did not increase as rapidly as resolving power. While one feels that the superiority of Plate 3 (b) lies in easy recognition, it could be argued that recognition is based on a foundation of detections, often at vanishing contrast. The limitation imposed by the f/25 maximum aperture in the Carman and Charman work restricted the resolution, on Plus X, for example, to 45 cycles per mm at high contrast, which is less than half the maximum obtainable with this emulsion. Thus their images did not go quite so far into the grain as in the model experiment; if the resolutions had been extended by a wider optical bandpass the curves might have

232

dropped well below the 45 degree slope. However, there were departures from strict proportionality between resolving power and detection and recognition. The investigators took account of these by correction factors which attempt to show how much scale reduction can be tolerated when resolution is increased by a known amount. Thus if resolving power is increased by some factor N over the extreme range of conditions studied, scale should not be decreased by 1/N, but some other factor C/N, to keep the same image quality, as evaluated by detection and recognition of objects at the three different contrasts. Such correction factors, C, were worked out for resolving power as measured with the different targets, averaged over the range of detection and recognition targets, and weighted for the known distribution of contrasts in aerial scenes. Typical values of C were then; High Contrast 3 bar: 2·82, 0·20 Cobb: 1·95; 0·07 Cobb: 1·31. It is emphasised that these provide correction over the whole range of lens cutoffs studied, corresponding to a range of 10 to 1 in high contrast resolving power, or about 5 to 1 for 0·07 Cobb resolving power, on Plus X. These ranges correspond roughly to the range in the model experiment, but are much greater than would normally occur in system design. No factors were of course available for low contrast 3 bar targets, which would have been useful in relation to the model experiment, but it may be inferred that these would be somewhat greater than those for the Cobb targets.

Applying these factors to the model experiment, we can deduce from Fig. 9.17 that for equal image quality the scale ratio should have been, not 10, but approximately 4, no matter which of the three target contrasts we work from. In fact the repeat model experiments showed that equal quality was not obtained at a scale ratio of 4, but the one-tenth scale negative was closer to the absolute limit of resolution of SO 243 than was the case for Plus X at the highest resolution used in the detection and recognition experiments. In attempting to make this comparison, correction factors derived when one emulsion is taken over a wide range of resolutions from a nearly grainless to a largely grain limited condition can be expected to apply very broadly when another emulsion is taken over a similar range, but exact agreement cannot be expected, and naturally it would be much better to do detection and recognition experiments on SO 243. Nevertheless, it is at least encouraging that in these circumstances the correction factors derived from the Carman and Charman experiments should be qualitatively correct when applied to the model photography experiment.

The technique of model photography was extremely useful in attacking this kind of problem, because by allowing us to study the relevant factors when stretched to extremes their influence on image quality and information transfer was made clearer. We can draw the general conclusion that caution should be used when predicting the operational performance of systems which work at different scales, when the smaller scale is alleged to be offset by higher resolution. If the scale difference is more than 2 to 1, it is unlikely that the performances will be equal in practice, even if judged equal by low contrast resolving power. However, this kind of comparative prediction rarely arises; a more usual situation is the comparison of two systems giving the same

scale, but one having a somewhat higher resolution, say 30 per cent higher. The likelihood of error is then much smaller and can be disregarded.

9.5 Review of Investigations

The work we have discussed represents only a fraction of what has been done, and the principles of the subject could be explored in much greater depth. Nevertheless, we have taken a fair cross-section and can form some tentative conclusions.

The most important question, on which the answers to other questions depend, is whether there is a satisfactory summary measure of image quality for aerial photography. The system variables, which in principle can be combined in different ways, are the bandwidth and shape of the MTF, and the granularity. A satisfactory measure would be one which ordered systems in the same way as the evaluation of picutre quality, whether the balance of MTF and granularity remained constant or varied in either direction. Enough has been said to show that no simple measure can be satisfactory in this sense over the full range of variation of MTF and granularity. Aerial photography is not one imaging task, but a variety of tasks, and optimisation of the MTF/granularity balance for one task may not give the best results on others. However, the practicable range of reciprocity between MTF and granularity is restricted by operational considerations, also the range of imaging tasks is limited by the low luminance range of aerial scenes, and within these two limitations, approximations to a satisfactory measure can be found. One such measure is the traditional resolving power; the lower the target contrast, the wider the limits of acceptable reciprocity.

In general, resolving power will not lead to anomalies, in the sense that systems predicted to be better by resolving power will not show up worse in aerial photography, but the degree of difference in practice may not be felt commensurate with the resolving power figures. The improvement in detection and recognition of two dimensional objects such as squares and circles does not keep pace with the improvement in bar target resolving power when the MTF bandwidth of a system is changed while keeping the granularity constant. There would be no gain from exchanging resolving power for a criterion based on detection or recognition, because adjacent details requiring separation, i.e. resolution, are certainly not unknown in aerial scenes, also the unique convenience and simplicity of the resolution test would be lost.

One very important check on the general validity of a summary measure is its success in predicting the change of scale allowable, after a given change in the image quality evaluated by the measure, to ensure no change in the information available in the aerial photographs. With an ideal measure, doubled quality according to its evaluation should allow the scale to be halved, and the proportionality should hold however wide the variation in balance of MTF and granularity. The Carman and Charman experiments showed that this proportionality does not hold for resolving power in relation to detection and recognition. When the resolving power was improved

by changing the MTF while keeping granularity constant, the scale could not be reduced in the same proportion; to keep the same levels of detection and recognition, scale correction factors in the order of 3 to 1 had to be applied. The model photography was in agreement with this finding; it indicated that the picture quality for a low contrast simulated aerial scene was not proportional to the three bar resolving power if the MTF/granularity balance was varied. Where resolving power indicated that a change of scale of ten to one should be acceptable, the model photography showed that the permissible change would be in the order of three to one. As a very broad generalisation, we could say that the square root of the resolving power, rather than the resolving power itself, would be the better indicator of true image quality. This might be felt to have a certain plausibility from the fact that the resolution in grainy images does depend on the joining up by the eye of grains lying in the right direction, an effect which is less marked for two dimensional shapes in general. If grain is entirely absent we should expect the information content to be proportional to the square of the resolving power. When changing from one emulsion to another of higher resolving power, the lens being so good as to impose no limitation, we should expect the image quality to increase in the ratio of the squares of the resolving powers, at least to the extent that the ratio between emulsion MTF and granularity remains constant. In a discussion on the information capacity of document copying systems, McCamy[10] shows that the information capacity of emulsions under these ideal optical conditions does in fact increase as the square of the resolving power.

If we forget the convenience of resolving power as a simple test, then in the light of these investigations it becomes just one, and not necessarily the best, among possible summary measures making use of the MTF and granularity. Normally, of course, we argue that there must be an involvement of human vision in the evaluation, hence the need for resolving power, but the investigations have shown that this is largely illusory once we move away from the particular form of the resolving power target. A measure such as the quotient of the equivalent bandpass by the granularity, with a suitably chosen constant, might be more generally valid than resolving power.

Scott omitted all reference to resolving power and worked directly from the subjective picture quality to the MTF and granularity. He regarded the granularity as a quality reduction factor and showed that a grainy photograph was equivalent in subjective quality to a grainless photograph of narrower MTF bandpass. Although the effect of scale change was not specifically tried, this seems to suggest that there is a reciprocity of blur and grain, which conflicts with the model photography and detection and recognition experiments. In an earlier investigation, not discussed here in detail, Shannon[11] had found that the picture quality of simulated aerial photographs taken with different scales and MTF's by the transparency photography method was proportional to the quotient of the equivalent bandpass by the granularity, again implying the reciprocity. The writer has examined such photographs, and although many observers had ranked the pictures in order of value for conveying information about the scene, he did not find it possible to make a satisfactory ranking over more than a few steps of a series, which covered eight to one in resolving power with four

to one in granularity. As with the model photography (Plate 3) one does not feel able to equate images of different granularity. Obviously there will be image interpretation tasks for which this equivalence can be agreed to exist. (The resolution of three bar targets of 3 to 1 contrast, for instance.) To adopt a colloquialism, we are trying to compare apples and oranges; only to the extent that we take some common factor, and not the whole apple or orange, can we make valid comparisons. For example, we could regard them as quasi-spheres and compare their diameters. Admittedly, observers are cautioned to avoid being impressed by grain or blur, but it is excessively difficult to be objective about one's subjective impressions, and the suspicion remains that the observers were doing all that the writer found possible, i.e. to arrange them in order of "quality", i.e. not information content. This suspicion cannot reasonably be entertained about Scott's photo interpreters; on the other hand the spreads of up to five to one in their estimates of the quality reduction factors due to granularity (judged, it will be recalled, on photographs) suggests that there may have been some uneasiness. A further possibility is that the original scene contrast in both Scott's and Shannon's pictures was higher than in the model photography, and hence too great for the grain limitations to be obvious. In view of the difficulty of getting agreement even on resolving power, perhaps it is not surprising that the subjective judgement of picture quality also gives rise to problems of interpretation, and there we must leave this matter.

The investigations of objective-subjective image quality can provide guidance on the subject of production tolerances for components, notably lenses. When a system has been designed, neither the lens nor the emulsion will be changed, but the question of realistic manufacturing tolerances remains. In relation to the emulsion, any variations are usually ignored, and it is assumed (possibly with justification) that the normal manufacturing control also keeps the micro image qualities within reasonable bounds. Lenses, however, are well known to exhibit appreciable variation from one specimen to another of the same design. The existence of such variations is detectable, with difficulty, by resolving power; we must expect much greater sensitivity and accuracy when use of the MTF becomes universal. The question will then arise, as to what is a tolerable variation in the MTF. If no shape changes occurred, we could say from Scott's work that a change of more than five per cent in a characteristic parameter of the MTF would be detectable. More likely, changes of shape would occur at the same time, and it would be safer to work from the area under the MTF, preferably the area above the emulsion threshold. Model photography experiments performed by the writer with substantially aperture limited MTF's indicated that a change of ten per cent in the area could be detected without difficulty. Actual working tolerances would naturally be settled after experience of the kinds of MTF variations actually occurring in production runs, and with consideration of the degradations occurring throughout the manufacture and use of the system, but this data would form a useful guide. Of course, another approach would be to assume that low contrast resolving power is a valid summary measure, and to evaluate the effect of given MTF changes by intersection with the emulsion threshold, as resolving power changes. Again, a ten per cent change of low contrast resolving power could be taken as the greatest tolerable.

236

For comparison of lenses this would be quicker and more precise than actually measuring the resolving power. As was shown by the transparency photography, even low contrast resolving power may not be an infallible guide if large variations in MTF shape are concerned, but in batch variation of lenses this is not too likely.

References

[1] SCOTT, F., *Phot. Sci. Eng.*, **12**, 3, 154–164 (1968).

[2] MACDONALD, D. E. and WATSON, J., *J. Opt. Soc. Am.* **46,** 715 (1956).

[3] CARMAN, P. D. and CHARMAN, W. N., *J. Opt. Soc. Am.*, **54,** 9 pp. 1121–1130 (1964).

[4] SCOTT, F. (To be published. S.P.S.E.).

[5] SCOTT, F., *J. Phot. Sci.* **12,** 3 pp. 139–142 (1964).

[6] BROCK, G. C., *Phot. Sci, Eng.* 11, 5, 356–352 1967).

[7] ROMER, W., *Sci. and Ind. Photo.*, **18,** 193 (July 1947).

[8] KATZ, A. H., OBSERVATION SATELLITES, *Astronautics* (1960). (Reprint of RAND Paper P-1707: RAND Corporation, May 1959.)

[9] BROCK, G. C., Limitations of Resolving Power as A Measure of Image Quality, *Photogrammetric Record*, **VI,** 31, pp. 32–40 (April 1968).

[10] MCCAMY, C. S., *Applied Optics*, **4,** 405 (1965).

[11] SHANNON, R. R., *J. Opt. Soc. Am.* (April 1967). (Summary only.)

X. FUTURE NEEDS

We shall conclude with a brief discussion of the matching of the current concepts and techniques of image evaluation to the needs of aerial photography, as distinct from the needs and interests of research workers. Aerial photography is supported by a wide range of technologies, disciplines and activities, from the calculation of a lens design to the practical utilisation of a finished print. A diversity of evaluation techniques is inevitably required, and in general it is the business of the specialist at each stage to select his own tests to suit the needs of his particular stage. Well back up the line, measuring wavefronts on the interferometer can be extremely valuable to the lens designer and manufacturer, but this technique has only a remote connection with the quality of the finished aerial photograph. It is valuable, where it is applied, because it measures one very relevant and fundamental physical factor. As we get nearer to the practical use of the complete system, we have to include more factors. Resolving power is a fairly reasonable guide to the probable performance of an aerial camera system in practice, because it takes account of most of the relevant parameters. For the same reason, it is insensitive and unreliable for monitoring the variations of production lens performance around a specified norm, although due to historical accident it has been committed to this use for very many years. Modern research has at least clarified this situation, and has emphasised that testing the whole is fundamentally different from testing the parts, though both kinds of test are necessary. One merit of the OTF is that it serves as an excellent "part" test while enabling us to link the contribution of the part to the performance of the whole.

Leaving aside the specialised tests, further back, the photographic engineer now has the ability to measure, derive or look up numerous parameters of image quality, e.g. the OTF for lenses; the MTF, gamma and granularity of emulsions; the effective MTF's of image motion, atmospheric turbulence, etc.; the line and edge spread functions; the CTF's for bar targets; and the resolving power for various targets. He can make at least an approximate estimate of the subjective quality that will go with any chosen synthesis of these parameters. Instrumentation for measurements on apparatus and photographic images is well advanced, or at any rate much more commonly used.

Are we then in a satisfactory situation—do present concepts and techniques meet all the needs of aerial photography? It is merely a question of detail improvements to known procedures, or do we need new concepts, or new interpretations? How far is it worth proceeding on present lines, especially in view of the complications of colour, which we have not discussed at all, but which may make much current arguement seem like hair-splitting?

The answers to these questions depend on the point of view. Probably the physical research workers have most reason to be satisfied, because they have had the most benefit from the advances of the past few decades, which is only natural, since they have taken the forward strides. A cynic might say that the chief result of the vast

growth of theory and experimental study has been to provide more and better tools for further research. While that is not necessarily a bad thing, one might have hoped that by this time there would have been a greater payoff in simple, easily applied, yet accurate and meaningful tests for wide general use. Research is only the visible tip of the iceberg; out of sight, (i.e. out of the learned journals) is a relatively vast body of workers who apply image evaluation in or to their daily tasks, checking cameras and lenses, looking at, interpreting and measuring actual aerial photographs by the thousand and putting them to constructive practical use. From the aerial photographer's point of view ("aerial photographer" meaning all in the lower part of the iceberg) there has been very little change in three decades. Admittedly there is now a much wider use of microdensitometry, but so far as evaluation of image quality is concerned, the concept and the practice is still mainly resolving power. This is largely because the modern concepts have not yet produced a satisfactory substitute of equal simplicity and practical convenience. It is not inevitable that they will or can do so, or that practical workers will be prepared to pay the price of any advance. Seeing that aerial photography, a craft based in science, involves the production and intensive examination of pictures by intelligent people whose technical education has involved a good deal of science, it is possibly surprising that all the major advances in image evaluation should have originated with physicists. Perhaps more cross-fertilisation is required.

So far, the research workers have been chiefly concerned, quite properly, with taking the photographic system to pieces, to see how it works. Having done so, they should now be in a better position to find practical solutions to practical problems. Opinions will differ as to which problems are currently of greatest importance. One opinion, based (it is hoped) on a practical outlook, is that there are three really important problems at this time, viz., accurate measurement of the OTF; clarification of the position on a summary measure of image quality; an accurate yet simple replacement for resolving power as a general purpose test for lenses. The list does not include anything to do with measuring emulsion parameters, because in practice the micro image qualities of any given type of emulsion tend to be taken very much for granted. If there are serious variations of gamma or granularity, they are certainly not obtrusive, and one feels no need for tightening up on production control. Among lenses of given type, however, significant variations of performance are common, at least in mass-produced models, and pinning down the realities of these variations by the resolving power test is a potent consumer of effort and source of argument. This is curious, inasmuch as lens manufacture is a matter of precise control of opto-mechanical tolerances, whereas emulsion manufacture involves complex and apparently hard to control colloid chemistry.

10.1 *Measurement of the OTF*

At the risk (or, rather, certainty) of censure, the writer offers the opinion that up to date the majority of OTF measurement techniques have left much to be desired in the

way of accuracy. To be explicit, by "accurate" we mean that different laboratories using their own equipment but with agreed standardisation of such obvious essentials as spectral sensitivity, spectral bandwidth, focal planes, etc., should automatically produce results in better agreement than resolving power tests. Experience has shown that this does not happen automatically, just by buying an OTF measuring equipment and putting it into use.

In fact it has been very difficult to get agreement, even when the precision of measurement in each laboratory is satisfactory. Again, when one laboratory compares different techniques, the agreement is often poor. When known aperture limited lenses are measured, the apparent OTF is sometimes not in agreement with that calculated from the aperture and wavelength. In an experiment carried out some years ago, several reputable laboratories measured the OTF of an aerial lens, working to a detailed specification of focal planes, etc.

The disagreements overall were at least as great as would be found in resolving power tests and were far outside the accuracies claimed by the laboratories. It has been objected that this merely showed that measuring the OTF is a highly technical business, and that some laboratories had not adequately qualified their apparatus. That, of course, was precisely the justification for doing the experiment. So much had been said about the inevitably superior accuracy of the OTF that it was necessary to see what would happen in practice.

There is no need to be surprised at the result, since there are so many potential sources of error, some of which are mentioned in Chapter II. More recently, progress in standardisation of measurement of the OTF is being made through the efforts of the British Scientific Instrument Research Association, in a programme based on sound principles and advancing step by step from simple rigidly specified conditions. In measurements of simple lenses, using monochromatic light, agreements in the order of $0 \cdot 02$ on the modulation transfer factor are being obtained between numerous laboratories employing the highest quality equipment. It will be interesting to see how well this quite adequate agreement is maintained when measurement is extended to a wide variety of lenses, e.g. long focus, wide angle, large aperture, in wideband illumination, and including many more laboratories. Unless satisfactory agreement can be sustained in all conditions, the great potential of the OTF for establishing lens performance in unimpeachable terms will not be realised. It is not enough merely to produce a falling curve; there must be confidence that the curves from all laboratories are essentially interchangeable.

To reach this standard of excellence will require very thorough qualification of apparatus and frequent recalibration with standards. Moreover, for some time to come the measurements will have to be made by highly qualified personnel. They will therefore be expensive, and this would seem to exclude the OTF as a routine lens test.

The situation is somewhat comparable to photographic sensitometry. Any laboratory can produce H and D curves and measure speeds, which will be reasonably consistent among themselves, but to achieve and maintain good agreement between different laboratories is a major exercise.

240

10.2 *Summary Measure of Image Quality*

Aerial photographers have always needed a summary measure of image quality, i.e. they need a scale on which image quality can be expressed by a single number which takes the major relevant parameters into account. Resolving power has filled this need for a long time, and still does, this one of its several roles being probably better understood now than ever before. Optimisation of system design will always need a summary measure, but resolving power is not ideal, as explained in Chapter IX. Modern concepts such as the OTF do not by themselves take us any nearer, in fact, individually, they represent a move in the opposite direction, analysis instead of synthesis. We need to achieve some better synthesis than resolving power now offers, and once the criterion is established, it does not now seem to be essential for the actual evaluation to involve visual observation of photographic images.

The more limited and better defined the imaging task, the easier it becomes to specify a quality criterion. Even within the relatively limited area of aerial photography, the variants of contrast and scene detail make it sufficiently ill-defined that no single measure of quality is likely to be equally successful in all applications. However, we ought to know how far we are from a median position and whether we can do much better than resolving power. In principle we have two major variables to balance, the MTF and the granularity. Some work suggests they are reciprocally interchangeable, bu the evidence is conflicting. It may be that separate specification will always be preferable, e.g. the size (of some standard target) at which the modulation falls to, say, 90 per cent, plus the size at which the modulation equals the granularity noise. In any case, further work is necessary to establish a measure which can be generally agreed, and which would offer sufficient advantage over low contrast resolving power to be a realistic and economic replacement.

10.3 *Replacement for Resolving Power*

As a criterion of system performance, whether regarded as a limiting size for recognition or a noise-limited bandwidth, resolving power has advantages and is useful if not ideal. Its inaccuracies are not critically serious because one cannot design systems to very fine limits and during the development the typical resolving power will have been established by large numbers of exposures. In its common role as a production lens test, when one is trying to establish performance of individual items within a few per cent, the inaccuracies are much more serious, and the necessity for many replicate exposures is rarely accepted. The variations among the lenses then tend to be masked by the emulsion MTF and the random granularity effects, so much so that one often tests the random variations in emulsion resolving power and not the lens at all. It will be appreciated that the significance of these remarks depends upon the way in which the resolving power test is performed. If tests are made with many replicate exposures at various field positions and in various focal planes, amounting to say 50 or more

exposures in all, the overall performance of the lens will be thoroughly sampled and the statistical errors will be averaged out to a substantial degree. Too often, however, the test is restricted to one or two exposures at what are thought to be critical field positions. The acceptance or rejection of the lens is then evaluated by what can be seen within a minute area of film, say 1/20 mm square, where one knows that marked statistical variations of density must occur. It is arguable that much of the trouble in using resolving power arises from this simple fact, which is equivalent to saying that the Cobb target is quite unsuitable for testing lenses, whatever its merits for testing systems. The logical course would then be to conduct the resolving power tests with a target containing many long lines, preferably sinusoidal. The test would then have to be organised in a different way, and it would not be possible to use just one target graticule for all focal lengths and lens-film combinations, as in the present Procrustean procedures. However, that would be a small price to pay if it led to a genuine improvement in accuracy of measurement.

To represent a real advance on resolving power; for the kind of lens testing the user needs, any proposal must satisfy the following requirements: (a) physical measurement of a quantity must replace judgement or opinion that a grain-broken distorted image still retains enough semblance of "twoness" or "threeness" to be deemed "resolved"; (b) the measurement must not be subject to the accidental errors of grain statistics, i.e. measurements must be made well away from the grain noise threshold, if photographic recording is used; (c) the results must be expressible as a single number which is known to correlate with image quality, over the small range of variation that is relevant; (d) the precision and accuracy must represent a significant advance on resolving power; (e) the test must be simple and quick to use, and must not involve elaborate or expensive apparatus, highly skilled labour, or debatable interpretations.

No test can score one hundred per cent in all these respects; the question is whether any conceivable test can score high enough to warrant general use in place of resolving power. The full OTF, which many would consider the obvious solution to this problem, is not ideal for production control, since if done properly it is expensive and the interpretation of any variations is not always obvious. From a practical point of view, we are more interested in the spatial image we see than in its dissection into amplitude and phase in the frequency domain. Having performed the dissection, we must do some kind of integration to establish the quality of the image, which seems a long way round, to say the least, for a routine checking operation. A shorter test, measuring the MTF only (without phase) at one or two chosen frequencies would be more practical, and would get rid of the photographic errors, but the narrow frequency bandwidths carry some risk of missing significant differences at other frequencies. (The relatively broad spectra of bar targets do give some weight to a large proportion of the whole MTF, though concentrating near the nominal frequency.)

However, the preference for a physical measurement does not compel us to operate in the frequency domain. If we ask ourselves what we would like in a lens test for aerial photography, we always return to the idea of a measure of image quality as a function of image size. Quality cannot be described by a single variable; the image

242

degrades in both shape and contrast with decreasing size. Change of shape cannot be expressed as a single variable. However, we may reasonably ask why a measure of contrast should not serve our purpose. We are not very sensitive to the intensity profile of the details of small images. It is highly important that the detail should have enough contrast to be visible; the exact image profile is less important because we cannot resolve it; the object is identified by its shape and relation to its surroundings. For example, we identify a crane by the pattern of its girder-work, without ever reflecting that the intensity profile of the the image of the girders is not rectangular, as in the object, but more or less rounded, depending on the scale and definition. This leads us to the idea of microcontrast, i.e. the relative contrast in the image at small sizes, referred to the contrast at sizes very much bigger than the spread function. The simplest object is a single bar, as proposed by Lewis and Hauser.* At large image sizes, the contrast and intensity profile of the bar are perfectly preserved. With decreasing bar width the edges become rounded off, the image being defined by a pair of opposed, separated ESF's; the contrast or central intensity at this stage may not be reduced. With further decrease in size the ESF's meet and overlap, the profile changes drastically and the contrast falls. The fall in contrast would appear to have as good a claim to represent "image quality" as any other single parameter.

Although the single bar contrast has been justified in spatial terms, it also represents the area under the MTF after weighting by a function which is the sin $\pi X/\pi X$ spectrum corresponding to the nominal bar image width. By choice of the bar width, the weighting can be made to select the portion of the lens MTF which is most relevant to the practical use of the lens with the operational emulsion. Then variations at low frequencies, which affect contrast, would be taken into account, and high frequency variations beyond the emulsion threshold would be excluded. For many years we have been told that (a) the MTF is superior because it displays the lens performance over the whole gamut of frequency, unlike resolving power (b) to evaluate the practical worth of the measured MTF we must integrate it, with some weighting function, and not be swayed by any specific frequency region. It seems reasonable, then, to try an evaluation technique which goes straight to the integration, with the correct weighting function, without wasting effort on the frequency display, which we do not need for a routine test, valuable as it is for research and the study of new designs.

In the single bar test as proposed by Lewis and Hauser, for systems rather than lenses, the performance criterion was the bar width at which the intensity fell to 0·87 of the macro or "full" intensity. The measurement was therefore made at a bar width for which the quality was just below maximum; this is very different from resolving power, in which the image is just perceptibly better than useless. In applying the test to lenses it would be unnecessary to have more than one or two bar widths, chosen for each lens type. Limits of intensity could be set for each field and aperture position. The ratio to full intensity could be high or moderate as deemed best, but would always be greater than, say, 50 per cent. This is a more rational way of specifying performance, akin to electronic amplifier practice. At the resolution limit the signal to noise ratio is

* Ref. 7. Chap. 1.

between 1 and 4; in amplifier practice, at the bandwidth limits of "3db down", the signal to noise ratio is still in the order of 100.

So long as the spread function is symmetrical (no phase error in the OTF) there seems little doubt that the single bar contrast would run tolerably close to image quality. With asymmetry there could be a shift of position of the central intensity peak, which would not matter to image quality. Potentially more serious is the other possibility, that the phase shifts could cause a spuriously great contrast which would not be a realistic reflection of quality. In principle it is possible for the redistribution of phases to give a spurious peak higher than that of the original target, but the phase shifts normally occur when the MTF has already fallen substantially, and the harmonics are too much weakened to cause this trouble. Orientation of the bar in at least two directions, as in resolving power and OTF measurement, to take account of the asymmetries, would of course be necessary.

The single bar intensity measurement could be performed on the aerial image or in photographic records as expedient. In principle the aerial image is preferable, for lens testing, since it avoids all photographic errors. In practice photographic recording followed by microdensitometry could be advantageous, always provided that an emulsion could be used whose spectral sensitivity matched that of the operational emulsion, but whose MTF and grain imposed no limitations. This would be possible if the operational emulsion was of the commonly used high speed type, e.g. Plus X Aerecon. For lenses to be used with such emulsions, (it would be necessary to avoid errors due to Eberhard effect) the nominal bar image width would be in the order of 30 microns.

Applying our five requirements to the single bar test, we can make the following comments: (a) it is a purely physical measurement; (b) it is free from grain disturbance if made on the aerial image, and can be made essentially free, in photographic records, for many practically important cases; (c) quality is expressed as a single number on a scale which is intuitively felt to be realistic and which has some theoretical justification; (d) the precision and accuracy should be inherently better than resolving power, but firm experimental evidence is lacking; (e) the test would require instrumentation beyond that needed for resolving power, but for equal precision it would probably not require any longer time. Of course, there must be some recourse to instrumentation in any test that will give greater accuracy.

Obviously much more could be said about pros and cons, but this is not the place for a detailed analysis. Two ancillary advantages should however be mentioned. Though discussed here as a lens inspection test, the single bar test could be applied right through the photographic system; lens, film, camera, printer, enlarger and viewing equipment. The concept of critical bar width (e.g. width for 90 per cent intensity) is just as well adapted as resolving power for operational performance specification and translation into ground scale. In one respect it is better, because it gives an accurate figure for a "just noticeable" degradation, but does not specify the "just not recognisable" size, emphasising that this is not definable except as a probability. It would be possible to include the granularity by specifying the bar width at which the contrast (for a given

aspect ratio) became equal to the R.M.S. density modulation, but the use of the single bar test as an index of system performance is not specifically proposed at present.

In production control of lens quality it is not absolutely necessary to express the results of any measurement by a single number. If the edge spread function were measured, the control limits could be established in terms of standard curves, within which the edge spread function for each lens must lie. While having a less direct connection to the practical imaging quality of the lens, this offers another attractive alternative to resolving power, since the edge is the simplest of all targets to make, and the scanning can be performed on the aerial image with relatively simple apparatus. The edge spread function thus made available for every lens could be converted into the MTF and thence into resolving power by those who required this information, either by the graphical technique or, more rapidly, by computer, where this facility is available. As with the single bar test, the edge spread function could be applied either in photographic form or on the aerial image. Thus there are at least two alternatives to resolving power for routine lens testing in production, and there appears to be no need to accept, indefinitely, the errors inherent in the resolution test. As previously explained, however, resolving power tests will always have some value for expressing system performance, and the OTF will always be necessary in design and research.

To those brought up on resolving power it might seem strange to propose displacing this old-established pillar of aerial photography. However, the proposal is for supplementing rather than displacing. There is much to be said for regarding resolving power as a concept and a rough evaluation rather than something to be accurately measured. It is largely a question of outlook and usage, and our systems will do the same jobs however we measure their performance. If we can increase confidence in our image quality measurements while maintaining and improving their significance, we shall have done something worth while.

10.4 *Conclusion*

The immediately preceding discussions are not intended to be all-embracing, but merely to suggest that in spite of the advances made in recent years there is still scope for opinion and for attempts to better the situation, particularly at the working level. The book as a whole has given a survey and commentary from a particular point of view, has omitted much detail and some promising techniques, and whole areas of fascinating investigation in image analysis and manipulation. However, within its limited scope, the writer hopes that what has been said may prove interesting and possibly instructive to some readers.

APPENDIX I

DEFINITIONS AND TERMINOLOGY

The modulation transfer function has been known by other names, some of which are still in use. Among these we may list: Sinewave response (Schade, 1945); Amplitude reduction function (Selwyn 1940); Contrast transfer curve (CT curve) (Ingelstam, 1947); Contrast transfer function (German "Kontrastubertragungsfunktion", Frieser); Frequency response; Response/Frequency. The names reflect the dominant interest of the workers who originated them; thus frequency response and sine-wave response tend to be used more frequently by workers in the television field. No term yet devised is entirely satisfactory, but at least there is now an internationally agreed definition firmly based on the physical derivation of the transfer function as the Fourier transform of the spread function. In July 1961 a Subcommittee of the International Commission for Optics (ICO) representing France, England, Germany, Japan, and the United States unanimously agreed on recommendations, abstracted as follows.

Nomenclature for Fourier Transforms of Spread Functions

(1) The function indicated in the heading, the curve representing it, and its value for a given spatial frequency shall be called the optical transfer function/curve/factor.

 The function as described is the complex function. When the modulus is referred to it shall be denoted by the terms: Modulation transfer function/curve/factor. The argument of this shall be referred to by the terms: Phase transfer function/curve/value. It is to be understood that the prefix of transfer may be omitted when confusion cannot arise.

(2) The variables of these functions shall be termed: Spatial frequency.

(3) The unit of spatial frequency shall be described by: Cycles per mm, lines per mm. (The latter when no confusion can occur with television lines, since 2 lines equal one cycle.)

APPENDIX II

MEASUREMENT OF EMULSION RESOLVING POWER

Although detailed discussions of measurement techniques are outside the scope of this book, it is desirable to describe the measurement of emulsion resolving power, because of its close connection with the determination of emulsion thresholds and hence with the practical utilisation of the MTF, as discussed in Chapter VIII.

Work on the attempt to standardise the measurement of emulsion resolving power proceeded in several major American laboratories during the period 1956 to 1968, and a document embodying recommendations was produced as a "Draft United States of America Method".[1] While this is not an official standard, it describes the latest version of a technique which has evolved and been widely used over many years. The following recommendations are based on it, with permission, and indicate the methods and precautions.

Target

The recommended target is basically similar to the USAF three bar target, but contains bars in one direction only, since emulsion MTF's are isotropic. The GSR is $^{10}\sqrt{10}$, which is very close to $\sqrt[6]{2}$. Contrasts of 1000 to 1, 6·5 to 1, and 1·6 to 1 are stipulated. The target is well designed for compactness and easy orientation. With the small field of microscopes objectives in mind, only one element is provided at each size, necessary replicates being obtained by successive exposures.

Camera

The camera consists of compound microscope optics in reverse, comprising objective, eyepiece and drawtube; a reference surface rigidly located so that it can receive the reduced focused imaged formed by the optics; a magazine to hold film, and a means for holding the film accurately and repeatedly against the reference surface. Fuller descriptions of such apparatus are given by Hariharan[2] and Altman.[3]

Target Illumination

The target is transilluminated by location against a uniformly illuminated opal glass. Tungsten light is almost always used, at a colour temperature between 2800 and

3200 K for black and white materials. (It would seem preferable to use daylight plus a red or yellow filter for aerial emulsions.) Resolving power of an emulsion may vary with the colour of the exposing light, and the combination of tungsten light with an extended red sensitivity is heavily weighted towards red. The colour of the light should not have any serious effect on the definition of the apochromatic objectives, but there will be a slight effect due to the differences of dominant wavelength changing the cutoff of the MTF. Thus a change from an effective green at 500 nanometres to an effective red at 650 nanometres would alter the cutoff by a factor of $1 \cdot 3$. This will not normally be significant but should be remembered when dealing with high resolution emulsions.

Microscope Objectives

Apochromatic objectives, blackened on inner metal surfaces to reduce glare, and adjusted to work without cover glass, are recommended.

Up to 300 cycles per mm, a 16 mm, N.A. $0 \cdot 25$ to $0 \cdot 30$ objective is recommended. Above 300 cycles per mm, an 8 mm, N.A. $0 \cdot 60$ to $0 \cdot 65$ objective is substituted.

Eyepiece

A $10 \times$ compensating eyepiece, designed to be used with the objective, is normally recommended, but a $5 \times$ may be used for resolving powers below 20 cycles per mm. The tube length should be as advised by the maker of the microscope optics.

Reference Surface

The reference surface must be flat, and preferably made of stainless steel. It contains a small central hole through which the image is focused on the emulsion. The film is held flat against a vacuum back, which is pushed against the reference surface when exposing. Thus the emulsion side of the film is firmly located up to the edges of the hole, while within the area of the hole any tendency of the film to bulge forwards is restrained by the vacuum. The utmost care should be taken to avoid dust and dirt, which can be a serious obstacle to reliable location of the emulsion in the focal plane. It is hardly possible to over estimate the importance of accurate and repeatable focus, and hence cleanliness, when working at high resolutions.

Reduction Ratio

The reduction ratio is typically 200 with the 16 mm objective and 400 with the 8 mm objective.

Qualification of Camera

The ability of the camera to perform satisfactorily is checked by exposing Kodak 649 GH Spectroscopic film, a very high resolution material which is limited by available optics. With the 8 mm objective, resolving powers of 1700 cycles per mm at high contrast and 900 cycles per mm at $1 \cdot 6$ to 1 contrast, should be obtainable. With the 16 mm objective, resolving powers of 900 cycles per mm and 600 cycles per mm should be obtainable.

General Procedure

To establish the maximum resolving power of an emulsion with reasonable confidence, both the exposure and the focus setting must be optimised. The optimum exposure is first determined, having set a provisional best focus by any convenient means. Then, with the exposure approximately correct, a series of pictures is made at a sufficient range of focus settings, at least nine replicates being desirable at each setting. The median value of the resolving power at each setting is then plotted against the focus to establish the optimum position. Another set is then exposed at this optimum focus position, varying the exposure over a sufficient range to ensure that the optimum has been found. These precautions are essential because of the sensitivity of resolving power to exposure level and the very critical nature of the focus setting. For satisfactory work with high resolution emulsions, the microscope mechanism must be of first class quality, capable of repeating its focus settings within two microns.

References

[1] United States of America Draft Standard Method for Determining Resolving Power of Photographic Materials. Final (Tenth) Draft. 1 May 1968. (R. Clark Jones).

[2] HARIHARAN, P. *J. Opt. Soc. Am.* **46**:5, 315–323 (May 1956).

[3] ALTMAN, J. H. *Phot. Sci. Eng.* **5**:1, 17–20. (Jan–Feb. 1961).

APPENDIX III

TABLE 1

MODULATION TRANSFER FUNCTION FOR A CIRCULAR APERTURE

Fraction of Cutoff Frequency	MTF
·0	1·0
·05	·9364
·10	·8729
·15	·8097
·20	·7471
·25	·6850
·30	·6238
·35	·5636
·40	·5046
·45	·4470
·50	·3910
·55	·3368
·60	·2848
·65	·2351
·70	·1881
·75	·1443
·80	·1041
·85	·0681
·90	·0374
·95	·0133
1·00	0

$$\text{Cutoff frequency} = \frac{1}{\lambda f} \quad , \qquad \text{where } \lambda = \text{wavelength}$$

$$f = \text{f/no. of lens}$$

Example: Light wavelength = 550 nanometres

$$= 5·5 \times 10^{-4} \text{ mms.}$$

$$\text{Aperture} = \text{f/10}$$

$$\text{Cutoff} = \frac{1}{5·5 \times 10^{-4} \times 10} = 180 \text{ cycles/mm.}$$

250

TABLE 2

EQUIVALENT VALUES OF MODULATION (M), DENSITY
DIFFERENCE (ΔD), AND CONTRAST RATIO (C)

M	ΔD	C
1·00	∞	∞
0·99$_9$	3·0	1000
0·98	2·0	100
0·96$_5$	1·75	56
0·94	1·5	32
0·90	1·3	20
0·86	1·15	14
0·82	1·0	10
0·78	0·90	8·0
0·73	0·80	6·3
0·66	0·70	5·0
0·60	0·60	4·0
0·50	0·50	3·0
0·43	0·40	2·5
0·33	0·30	2·0
0·23	0·20	1·6
0·11	0·10	1·26
0·06$_5$	0·05	1·14

TABLE 3

VALUES OF THE SINE FUNCTION

X, *degrees*	$\dfrac{\text{Sin } X}{X}$
0	1·000
45	0·900
90	0·637
135	0·300
180	0·000
225	−0·180
270	−0·212
315	−0·129
360	−0·000
405	0·100
450	0·127
495	0·081
540	0·000

APPENDIX IV

The Role of Grain in Resolving Power

The importance of grain as a limiting factor and a source of error in resolving power is discussed in Chapter 7. Plate 4 (opposite) provides graphical illustrations of these effects.

Examples (a) to (e) illustrate the effect of grain in obscuring fine deatil. These are positives, all made from the original negatives at the same magnification (approximately 30X), and therefore represent the appearance of the originals as seen in the microscope. When actually reading resolving power, most observers would use a magnification giving a smaller angular subtense than appears here at normal viewing distance, but the 30 X was chosen to display the effects of the grain most clearly.

Original (b) was an exposure of a USASI resolving power target, contrast 2 to 1, on Tri-X film developed fully in Teknol developer. (similar in activity to D 19) The lens was a 5 cm f/1.9, used at f/8. Resolution is considered to cease at group 2–5 in the negative, corresponding to 36 cycles per mm. Original (e) was a uniformly fogged area of the same fast film, developed along with (b); it has the same densityas thebackground in (b), and therefore represents an approximation to the grain which limits resolution. Original (d) was an effectively grainless image, also taken with the 5 cm. lens but at a very small aperture, such that the MTF was effectively similar to that of the combined lens-film MTF in (b). Thus (d) may be regarded as simulating the appearance that (b) would have if its grain could be eliminated. The resolving power limit of the original negative (d) was considered to be at group 3-5, i.e. twice as great as (b). In (a), the originals (b) and (d) were brought into optical contact and enlarged as one, thus simulating a re-combination of the grain and MTF of (b). (c) and (f) were identical to (a), except that the originals were slightly displaced with respect to each other. Thus (a), (c) and (f) represent the grainless image falling on three different positions in the grain pattern. The appearance of these three composite images is not identical, but all of them bear a fairly close resemblance to (b) and the resolving powers also are quite similar.

This experiment illustrates the severe effect of grain in lowering resolving power, by confusion of the image pattern. The composites are not, of course, perfect models of what actually happens in the direct exposure of the fast film. The MTF's are not known exactly, nor could they be perfectly matched if known. A constant-density grainless image superimposed on to a grain pattern is not precisely the same as an integral image having the same MTF and background granularity. Thus it is hardly surprising that the Tri-X image is not perfectly matched by the composites. (Note, for example, that the line of the USASI target does not appear in the composites) Nevertheless, the differences may fairly be regarded as small relative to the profound effect of the grain

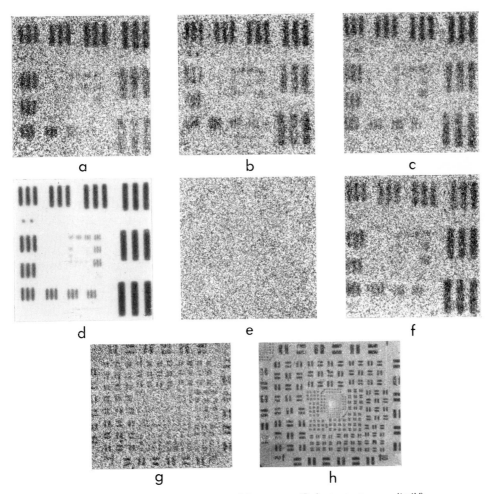

Plate 4. The role of grain in resolving power. (Refer to text-appendix IV)

on the resolution. It may be noted that this experiment differs from the Romer-Selwyn work (Chapter 7), in which the grainless images were of constant sharpness at all sizes, i.e. the system MTF was effectively constant at unity.

Examples (g) and (h) illustrate the effect of grain on the precision of resolving power measurement. The Romer-Selwyn studies showed that due to the random incidence of the grain, resolution does not cut off sharply at a certain size of pattern. Taking "the" resolving power to be the mean of many determinations, then at sizes well above this mean there is virtual certainty that any single exposure will show resolution. At some much smaller size there is virtual certainty that no exposure will show resolution. The probability that resolution will be obtained in a single exposure at any given size will progressively decrease as we move down the target in the direction of decreasing size. The width of the zone of uncertainty, within which we cannot guarantee resolution, will depend on various factors, such as the slope of the MTF and the extent to which grain is a limiting factor.

The target used for examples (g) and (h) contains groups of twelve Cobb units, contrast 2 to 1, at each size, the group size interval being ten per cent. The orientation of the units is immaterial, as the lens was used on axis. The exposures were made with

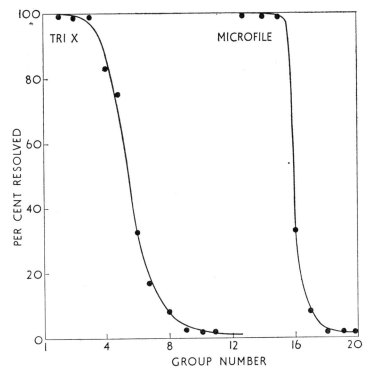

Fig. IV–I. Spread of the resolution limit for Tri-X and Microfile films

the same 5 cm lens, used at f/16 in both cases. (g) was taken on Tri-X developed in Teknol, (h) was on AHU Microfile, a film of much finer grain. (The complete target is not shown) The number of Cobb units resolved in each group in the original negatives was read, and is plotted in Fig. IV-I as percentage resolved versus group number. For Tri-X, the gap between one hundred per cent resolved and none resolved extends over five groups. (1.6 to 1) For Microfile it extends over two groups. (1.2 to 1) The Tri-X image was largely grain-limited, the MTF's of lens and film being of about equal significance. The Microfile resolution was limited almost entirely by the MTF of the lens, the grain playing relatively little part, and hence able to cause relatively little random disturbance. The steeper slope of the MTF near the resolution limit, and the higher gamma of the Microfile emulsion, were factors contributing to the sharper cutoff of the resolution.

The mean resolving power in the Tri-X image was determined from observation of the twelve individual positions of the Cobb units in each group, using the criterion that no unit was considered resolved unless the next biggest was resolved. The resolution limit so determined was about 23 cycles per mm., and fell at the 70 per cent probability point on the curve in Fig. IV-I. The Microfile image resolved about 66 cycles per mm.

This experiment goes some way towards demonstrating that the precision of resolving power is reduced when grain is an important limiting factor. However, this does not mean that the resolving power of aerial lenses should be determined on very fine-grained films such as Microfile; the higher figures then obtained would relate to regions of the lens MTF's that had no relevance to operational use with faster, coarser-grained films.

254

SUBJECT INDEX

AUTHOR INDEX

258

Date Due